Design Secrets:
Products

50 Real-Life Projects Uncovered

GLOUCESTER MASSACHUSETTS

ROCKPORT
PUBLISHERS

IDSA (Industrial Designers Society of America)

ROCKPORT

First published in the United States of America by
Rockport Publishers, Inc.
33 Commercial Street
Gloucester, Massachusetts 01930-5089
Telephone: (978) 282-9590
Facsimile: (978) 283-2742
www.rockpub.com

ISBN 1-56496-638-0

10 9 8 7 6 5 4 3 2

Production: *tabula rasa* graphic design
Cover: Madison Design and Advertising

Printed in China.

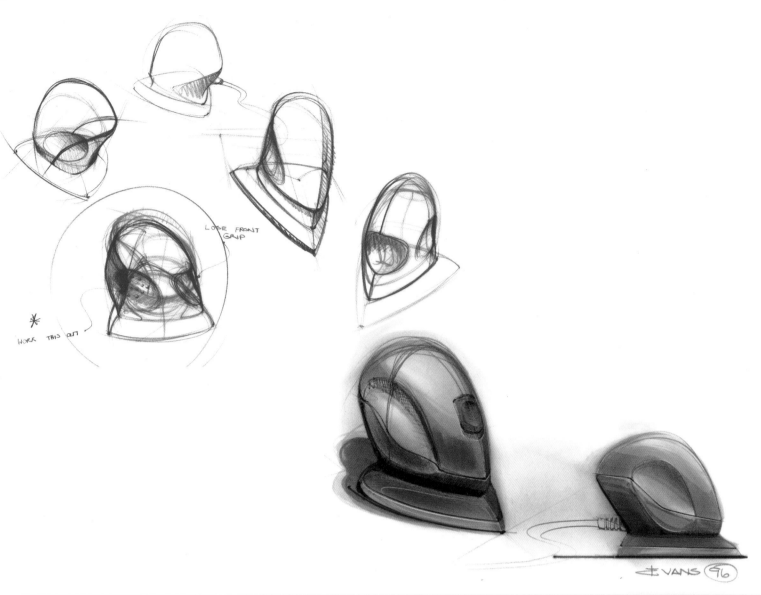

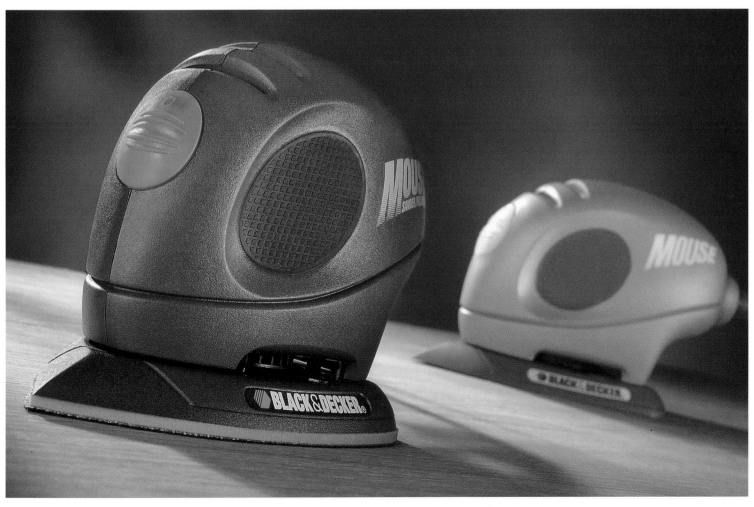

contents

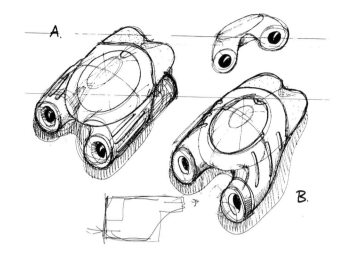

A.

B.

2.23

4.921

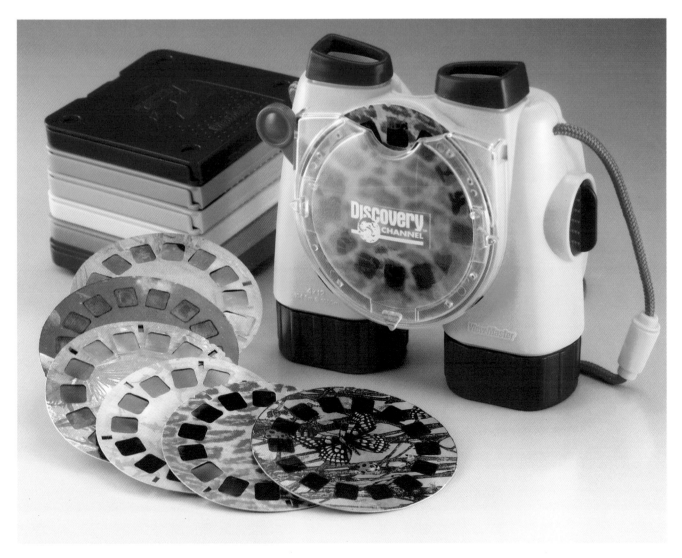

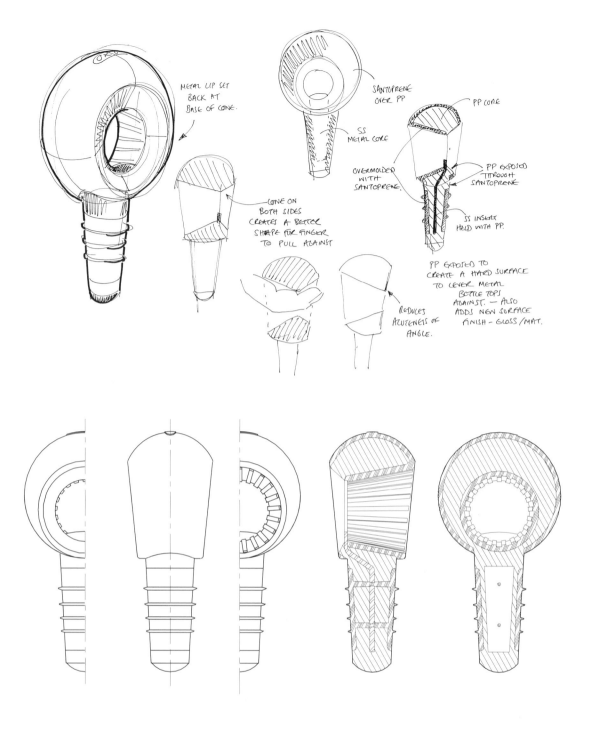

METAL LIP SET BACK AT BASE OF CONE.

SANTOPRENE OVER PP

SS METAL CORE

PP CORE

OVERMOLDED WITH SANTOPRENE

PP EXPOSED THROUGH SANTOPRENE

SS INSERT HELD WITH PP.

CONE ON BOTH SIDES CREATES A BETTER SHAPE FOR FINGER TO PULL AGAINST

REDUCES ACUTENESS OF ANGLE.

PP EXPOSED TO CREATE A HARD SURFACE TO LEVER METAL BOTTLE TOPS AGAINST. — ALSO ADDS NEW SURFACE FINISH - GLOSS / MAT.

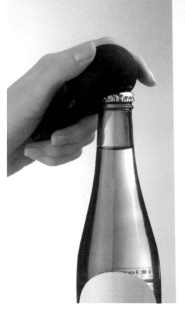
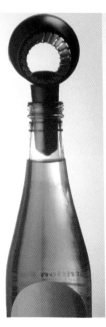
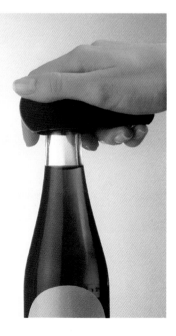

Introduction

The Industrial Designers Society of America (IDSA) had compelling reasons to partner with Rockport Publishers on this book: It meets a growing, real, and broad hunger for information and inspiration on industrial design.

Recently, industrial design has emerged as a profession that fascinates people of all ages. This interest is fed by business magazines, fashion magazines, nationally noted newspapers and talk shows, along with museum exhibits and even advertising. The outcome of industrial design—the product—has become an icon for the reemergence of the U.S. economy. Discovering that the product is not an accident or only the offspring of marketing or engineering is fresh air to people just beginning to understand that their purchases are about more than money and function— they are about culture and lifestyle and experience.

For the profession of industrial design, this book feeds a vital longing and real need. With no textbook, students and educators need case studies on which to base the experiential, highly kinetic, exploration-based form of learning that prevails. Professionals need a source of inspiration and insight to fuel their quest for innovation, for true functionality. How better to learn how to blend and balance function with aesthetics, usability with business constraints, ecological responsibility with appeal?

But where to start? How could we select the fifty designs we wanted to capture? Feeling that we needed an objective basis for selecting these designs, we turned to the Industrial Design Excellence Award (IDEA) winners of the past few years. The annual IDEA competition is sponsored by *Business Week* magazine and IDSA to honor designs that achieve precisely those goals: innovation, benefit to user, benefit to business, ecological responsibility, and appropriate aesthetics. Unlike previous reports on IDEA winners, each of these stories is crafted by a writer based on interviews and information, focusing on the early conceptualization and decisions about what the product should be and do and how it should be presented.

The resulting book, rich in visual appeal, provides compelling insight into one of the new decade's most intriguing professions.

We hope you find in these stories a source of wonder and knowledge. Especially, we hope that this book opens doors for you, whether you are an attorney, a nurse, a politician, a homemaker, a teacher, or a designer.

Kristina Goodrich
Executive Director
Industrial Design Society of America

Resolve System for Herman Miller

Today's technology allows people to **work virtually anywhere.** Given the **flexibility** afforded by cellular phones, modems, and portable computers, why do they still go to **the office?**

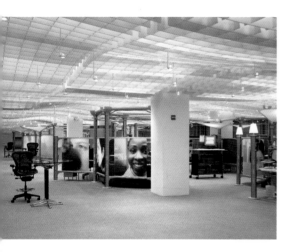

Above: The translucent fabric used for the boundary screens presents a culturally transparent framework upon which a company can express its identity or corporate mission and also allows natural light to bathe the entire office, not just a select few who are lucky enough to win a window location.

Below: An overhead system of trusses carries power and data to the poles and virtually eliminates the clutter that results in workstations from complicated, messy cables.

Experts say people crave sharing, learning, and socializing, yet the familiar cubicle system often inhibits interaction. Herman Miller, Inc., the company that introduced traditional panel-based, right-angle systems three decades ago, recognized that the time had come for an alternative. After all, work has shifted from a horizontal pen-and-paper surface to the vertically oriented computer.

Herman Miller tapped Ayse Birsel, principal of the New York design firm Olive 1:1, for guidance. She asked that Herman Miller form a concept team to help her conduct observational research on the office setting. Members were chosen from every corner of the company. They conducted site visits with two objectives: to see how people work and to develop a common understanding of what is happening in offices today. Birsel uncovered one overwhelming fact—she wouldn't want to work in any of these offices herself. "They felt oppressive and all of them looked the same," she says. Additionally, facilities managers complained that ordering furniture was too complicated. "Could we design a system with so few pieces that you could remember them off the top of your head?" Birsel asked.

The team met every two weeks. The first three months were dedicated to design exploration and ideation. Birsel was then able to articulate an idea close to the final concept of Resolve. Prototypes followed from mock-ups to increasingly developed designs—all built to human scale; Olive 1:1 models in 1:1 scale rather than the traditional 1:8 architectural scale. "My work methodology is a true demonstration. Things that on paper or the computer might look one way are experienced differently when you do them in full scale," says Birsel. "Some things can be appreciated only at full scale."

The first prototypes "didn't have any design form intent. They were all about the idea," says Birsel. Olive 1:1 built prototypes from off-the-shelf parts, including a lightweight scaffolding product used as the basic structure. They bought inexpensive soft blankets at IKEA, sewed transparent pockets onto them, and cable-tied the blankets to the scaffolding to represent a privacy screen between two people. Finally, they attached a flexible sweater bag from Hold Everything to the screen to simulate a potential storage option.

"These mock-ups were about the fundamentals of Resolve but, at that early stage, we had no idea what that would mean in terms of actual design details, size, and shape. With every iteration, we improved on the details as we learned more about the system, until we ended up with the final design," explains Birsel.

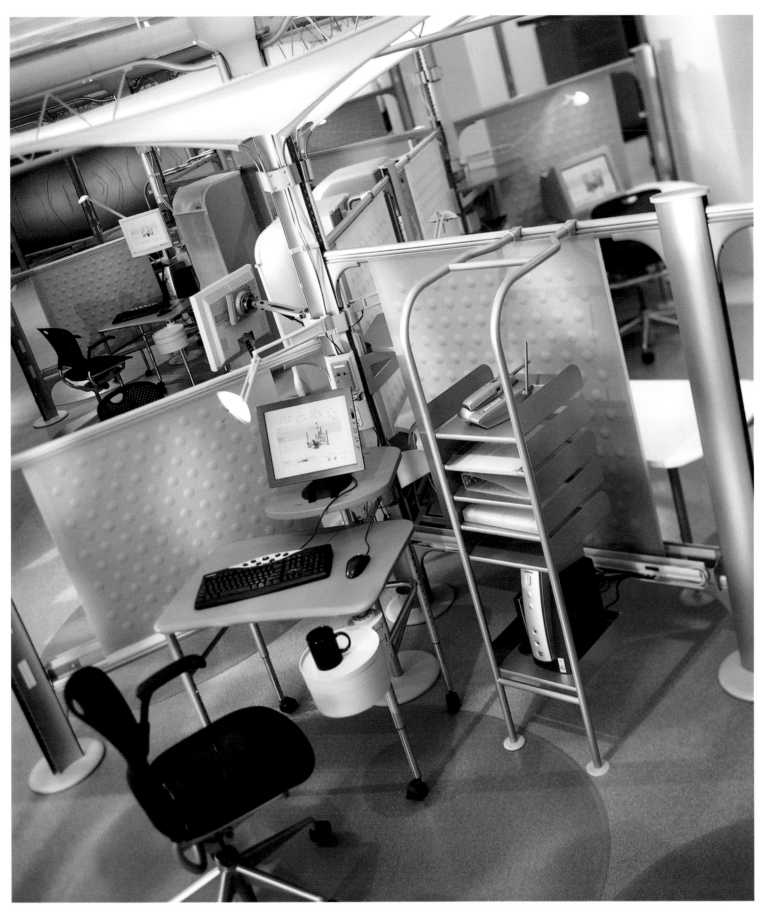

Resolve is based on a 120-degree geometry—the centerpiece of which positions the user and their technology in a 120-degree corner that is nurturing, yet open and considerably more generous than the 90-degree corner found in a traditional cubicle.

The first mock-up, built in the corner of Olive 1:1's office, grew too big for the space. Birsel suggested that, as the project was all about work, her own personnel work in it. Olive 1:1 moved into Resolve, becoming the first test group for the system.

With each of the six iterations, Birsel sent prototypes to an outside company of about fifteen people for two months to gather user feedback; she was surprised at some of the findings. Designers were concerned that acoustics might be a problem with such an open office configuration. But one company, accustomed to panels, reported that the acoustics were the same.

The design called for dividers made of translucent screens that would not block natural light, yet could function as bulletin boards. The engineering team suggested that Velcro be incorporated as well. The fabric was opaque and, while test groups liked the idea of a Velcro-able and tackable display screen, they didn't like that it was not translucent. Birsel's group therefore invented Bubbletack. They also tweaked other parts of the system. After a year, the flexible storage accessory simulated by the sweater bag was dropped in favor of hard storage, sturdier for storing books and binders. "That was one thing that changed radically, but we had the flexibility to do it," says Birsel.

The elements differentiating Birsel's concept from traditional office systems became increasingly evident. Unlike traditional panel systems, Resolve is based on a 120-degree geometry, the centerpiece of which positions users and their technology at a boomerang-shaped table in a gently angled corner that is nurturing, yet open

and more generous than the usual 90-degree corner. Main components are roll-formed of stamped steel or plastic and comprise an overhead system of trusses that carry power and data to the poles, virtually eliminating cable clutter. The layout makes workstations more open and easier to plan and change while allowing more efficient use of space. The translucent fabric used for the boundary screens presents a framework on which a company can express its identity and permits natural light to bathe the entire office.

A company in India was chosen as one of first gamma sites to receive the nearly completed system. The experience was overwhelmingly positive and taught the group a lot about Resolve's advantages. Because it is one-third the weight of a traditional system, Resolve's shipping costs were relatively low and, because of its flat lines, it was easy to pack. The best news was that the company had no problems installing it.

The ease of installation is due, in part, to the simplicity of the system, which boasts a vocabulary one-quarter the size of traditional systems. Birsel points out that planning, specifying, installing, inventorying, and reconfiguring is faster, easier, and more affordable. In fact, the company states that reconfiguring, upgrading, and restyling the system is more than 50 percent faster than with traditional systems.

"Resolve is made up of fewer than twenty products," and the variety of configurations possible with those few pieces is considerable, says Birsel.

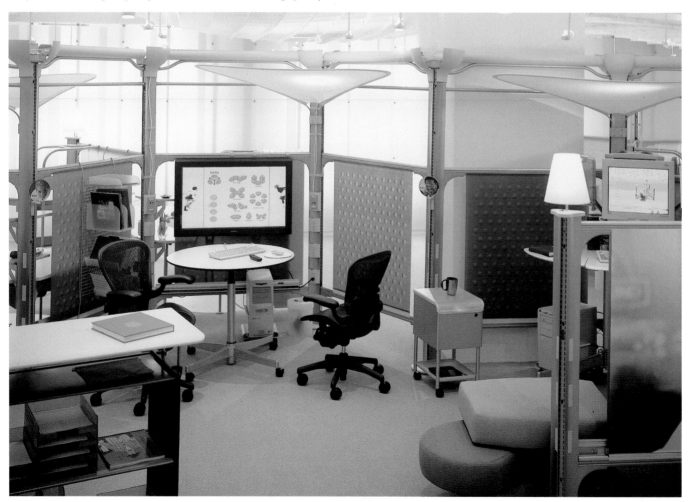

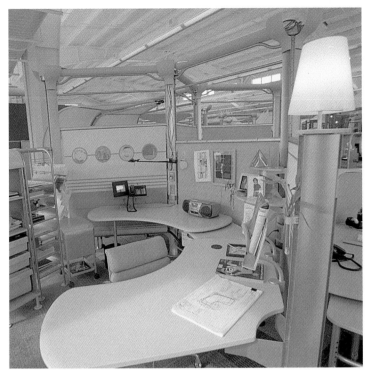

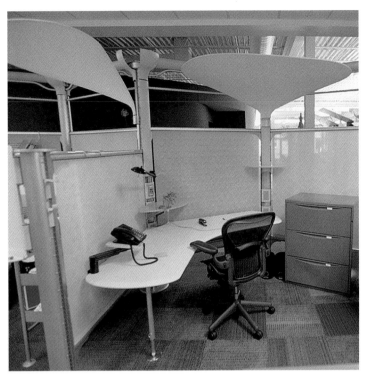

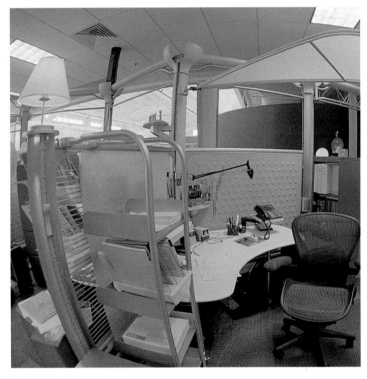

⬡ These shots of the final incarnation of the Resolve system, as it stands in Herman Miller's design showroom, show off its unique geometry and simplicity.

◇ Experts say we go there to belong to a community—a craving to share, learn, and socialize—yet the panel-based system of cubicles often inhibits interaction by compartmentalizing its inhabitants into a 90-degree corner. This system's goals were to bring people together, not separate them.

Leap Chair The human spine is not a **single, solid unit.** When a person **reclines** in a chair, for instance, the upper back moves **backward,** but the lower back arches **forward.**

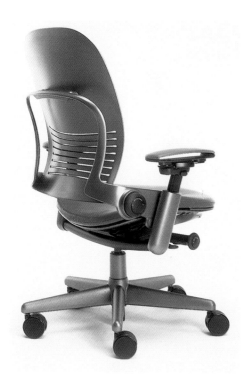

By exposing the Leap Chair's skeleton and using a technology that lets the chair move exactly as the user does, Steelcase and IDEO designed an unusual, healthy, and comfortable chair.

This causes a gap between the seat and the lower back, which, in turn, causes the person to sag and hunch his or her back in an unhealthy way.

Another dilemma: Every spine is as unique as a fingerprint. Every person has his or her own unique "spine print," and that print changes as the person's posture changes. Sitting down, sitting up, reclining, and every posture in between requires a chair that provides almost customized support.

Yet another chair design problem: There is an ideal "vision and reach zone" that most people naturally position themselves into when seated at a desk. The zone provides the best place for you to see and reach your work. Unfortunately, when you recline, you leave this comfort zone. The distance between you and your work increases, causing you to stretch, squint, or struggle back to your original zone.

Steelcase presented IDEO with all of these challenges. They wanted a chair that conforms to the person rather than the other way around. The chair back should change shape with the person's back as his or her posture changes. The upper and lower back support mechanism should be independently adjustable. Finally, the chair should allow the sitter to recline without changing his or her orientation to the work at hand.

Unspoken but understood, another design mandate was that the chair had to be beautiful and appropriate in an office setting, says IDEO's Scott Underwood. "There was no model that came before [what would become] the Leap Chair that had any kind of genetic link to the [final] chair's design and mechanism," he says. "Certainly there have been many high-end, ergonomic task chairs from Steelcase over the years, but Leap—as its name implies— represents a bold leap forward."

Steelcase had spent many dollars over four or five years of research—eleven studies, 732 test participants, four university study settings, and twenty-seven scientists—in developing what the company calls its Live Back technology. Live Back mimics the human back, moving as the person moves and providing support in all positions. IDEO's job was to apply the technology to an aesthetic and manufacturable framework.

Addressing the technology in a visual way was a challenge. Says IDEO designer George Simons, "When engineering is such a dominant part of the design statement, the question is how to keep a chair a chair. We took a very straightforward approach. We brought forward, in a very honest way, the mechanism of the chair. We didn't try to hide it under covers or behind other elements."

IDEO designer Thomas Overthun says the final chair design is both mechanical and organic. "We tried to make it as light and elegant as possible while tying it all together. So, for example, the back frame has a skeletal feel to it, and we picked this up in the design for the loop arm." Two controls allow different settings for the upper and lower back, and the Natural Glide System lets the seat move forward as it reclines.

The goal of the controls, Simons adds, was to bring a simple clarity to the design. "Our goal was not to design lots of parts that became objects in themselves but to design something that added up—and remained clearly within the furniture vernacular."

The result was a form that is both mechanical and organic. From the exposed structure of the back and the feel of the armrests to the straightforward nature of the controls and the many upholstery solutions that Steelcase offers—more than ninety configurations of arm, back, frame and upholstery styles are available—the chair is remarkable enough in function and design to have become the company's flagship chair. Customer response has been overwhelming.

Underwood says the response to the Live Back technology alone has sparked interest in other areas of industrial design. He believes Steelcase is interested in licensing it to manufacturers of airplane seating, auto and truck seating, and others.

Above: Various arm studies exploring articulating armrest designs.

Below: Ribbon backframe prototypes.

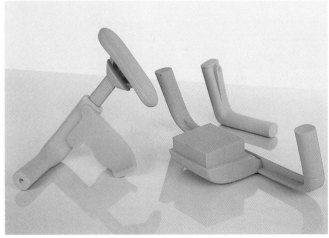

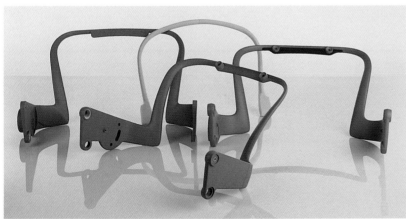

Very early foam studies for arm and seat mechanisms.

The final industrial design prototype for a see-through arm.

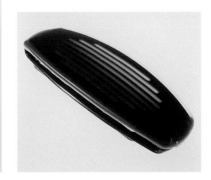

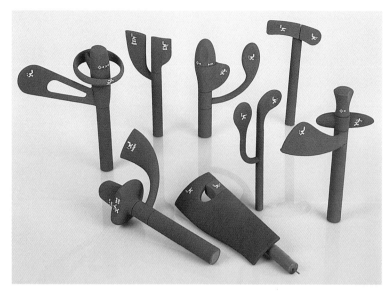

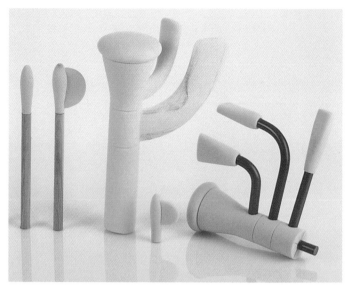

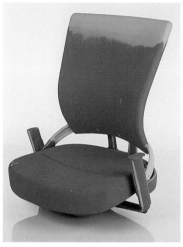

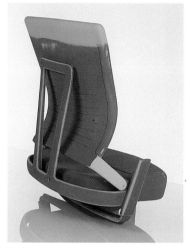

⊘ Above: Studies of the chair controls.

⊘ Below: An early frame study explor-
ing an alternate seat back, seat,
and arms.

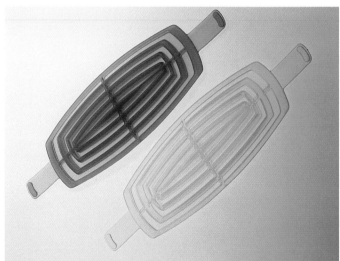

⊘ Above: Later foam studies of the
chair controls.

⊘ Middle: Chair base studies.

⊘ Below: Cast silicone foam study
of the lumbar pad.

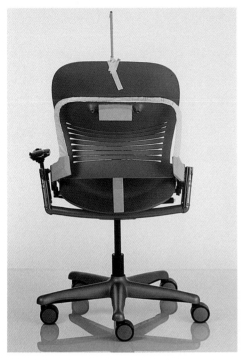
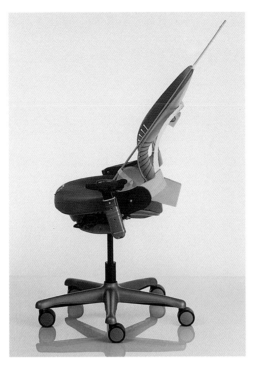
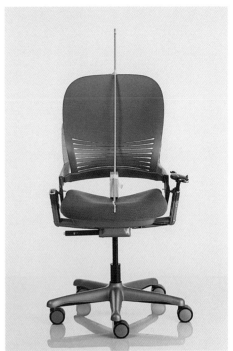

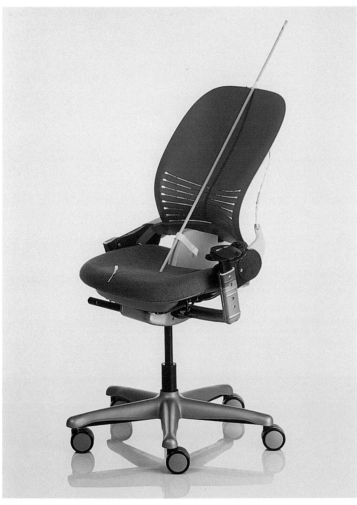
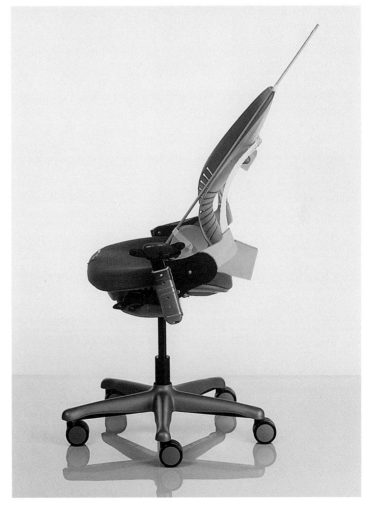

A series showing views of the ribbon frame as it was first fashioned from two pieces of wire and tape. The dowel is in place to support the back of the chair.

OXO Good Grips Bottle Stopper/Opener

It was a **simple product:** Oxo wanted a **stopper** that would **preserve wine** once the wine bottle was **uncorked.**

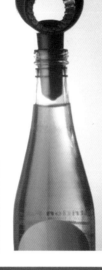

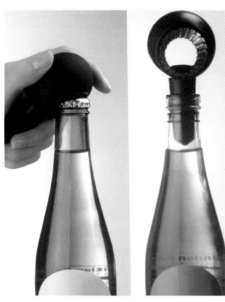

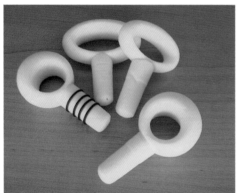

⌃ Above: The Oxo Good Grips Stopper/Opener is a multipurpose kitchen tool that can be used to pry or twist off metal or plastic caps and to seal bottles. Although the assignment was to design a bottle stopper, the designer looked for ways to add functions. When used as a bottle opener, the stopper feature provides leverage.

⌃ Below: Godfrey used foam models to explore how comfortable various shapes would feel in the hand. Some did not have holes, but Godfrey determined early on that the best grip was possible with those that did. These models gave Godfrey the idea to give the hole a function.

So Cyan Godfrey, the Refac/Human Factors designer assigned to the project, began with a simple solution—a solution that resulted in an award-winning design and a product that was much more than the client had expected.

Godfrey got to work sketching simple geometric forms for the stopper. Because it was a fairly straightforward project, she began working with foam models early. To ensure the stopper would work with most wine and beer bottles, she took neck castings of various bottles to obtain accurate measurements. She also reviewed the stoppers on the market to look at what she did—and, more important, what she did not—like about them.

"Basically, I was looking for comfortable shapes," Godfrey explains. "Shapes that feel good in the hand and are easy to grip in various positions." Bulbous forms on the handle made the stopper easy to grasp.

Godfrey created half a dozen foam models to show different directions the stopper could take. Some of the models had holes in them; others did not. "I saw early on that the forms that worked best had holes in them," says Godfrey. "The addition of a hole in the handle gave another grip position. A finger could be hooked through to gain extra pulling grip. Then, when I was making models, I realized that the hole could have additional functions." This was the beginning of the idea for the stopper/opener.

She shared her idea with Oxo and credits much of the product's innovation to Oxo's willingness to listen. This wasn't the first project that Refac/Human Factors had done for Oxo, but it was the first time that Godfrey had primary responsibility for an Oxo project. "They're a great client to work for because they're open to new ideas and flexible with the brief if a new opportunity arises," she says. "The project meetings were informal and relaxed, which encouraged creative thinking and the sharing of ideas. I felt comfortable bringing them the idea I had for a bottle stopper that would also serve as an opener."

Oxo liked Godfrey's suggestion and gave her the go-ahead to explore it. She again searched the housewares aisles, this time picking up bottle openers. "We looked at the stoppers that were already on the market, and we looked at bottle openers. But we couldn't find any products that combined both these functions," says Godfrey.

From that point, the design process was relatively short and straightforward. Godfrey made hard models of what was now a stopper/opener, adding rubber to the molds to test the bottle stopper and opener functions. Her explorations showed that a rubber conical ring worked well as an opener on twist tops of various sizes. The angle and depth of the conical ring was refined to fit the most popular twist-off bottle tops, from the smallest to the

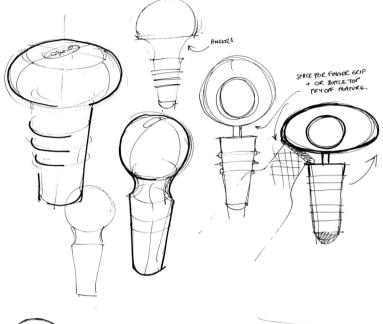

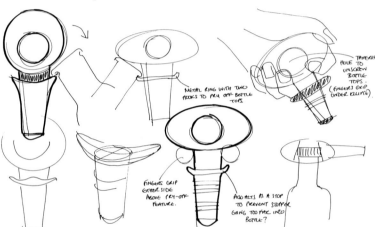

largest. Further informal testing of prototypes was done with colleagues as Godfrey refined the product's form to get just the right feel for different hand sizes and shapes, as well as for the various sizes and shapes of bottles.

The result is a multipurpose kitchen tool that can be used to seal bottles, pry off metal caps, and twist off metal and plastic caps of almost any size. The patent-pending design blends with Oxo's line of Good Grips kitchen tools.

The product's round, bulbous ring handle is ergonomically optimized for a range of grip postures. When used as a bottle opener, the stopper feature becomes part of the handle, providing leverage during the prying and twisting actions. The conical hole through the ring accepts a wide range of cap sizes, and the internal ribs interface with the folds of a metal cap or the knurling of a plastic cap to provide a more positive translation of torque. The pry-off edge is integrated into the overall design, with the conical hole used to hold onto a pried-off cap.

Godfrey says that, sometimes, even the simplest solutions are seemingly overlooked. "Looking back," she adds, "when I started designing bottle stoppers, the product seemed almost redundant because wine comes with a cork. So I wanted to make it more useful. I was looking for ways to add functions."

At $2.99, the Oxo Good Grips Stopper/Opener does more than the competition.

◭ Early sketches, as shown above, explored simple geometric shapes that could be used for a stopper. Godfrey saw that a hole would provide added grip for pulling out the stopper. Once Godfrey got the idea for a stopper/opener, she began sketching alternative forms, as shown in the sketches below.

◈ Godfrey continued using sketches throughout the design process to refine her idea. These sketches were used to finalize the design. Among the items considered here were the materials and construction of the stopper/opener, and how these might affect the aesthetic.

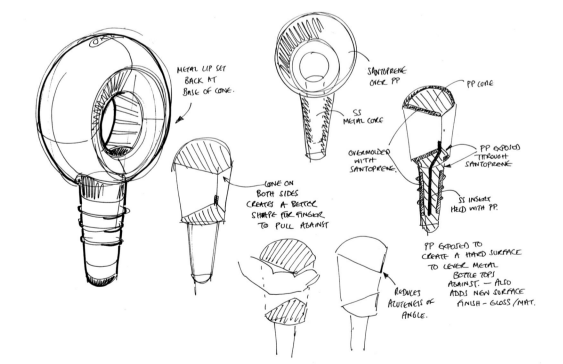

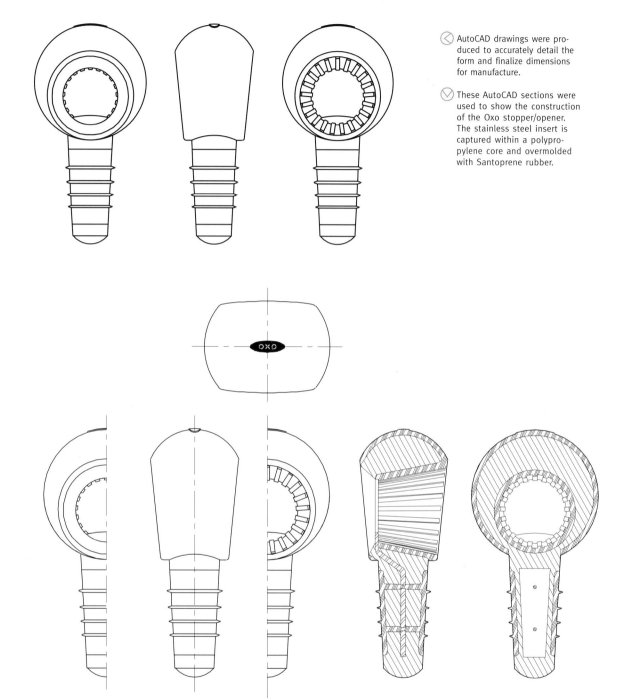

AutoCAD drawings were produced to accurately detail the form and finalize dimensions for manufacture.

These AutoCAD sections were used to show the construction of the Oxo stopper/opener. The stainless steel insert is captured within a polypropylene core and overmolded with Santoprene rubber.

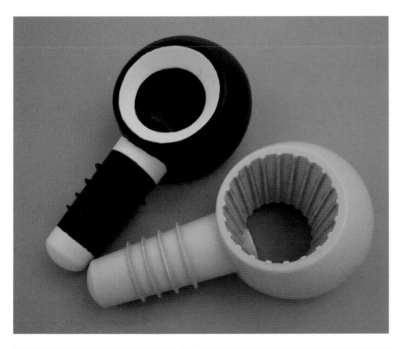

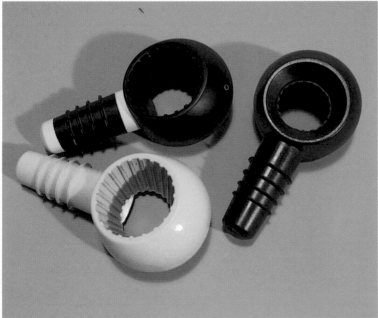

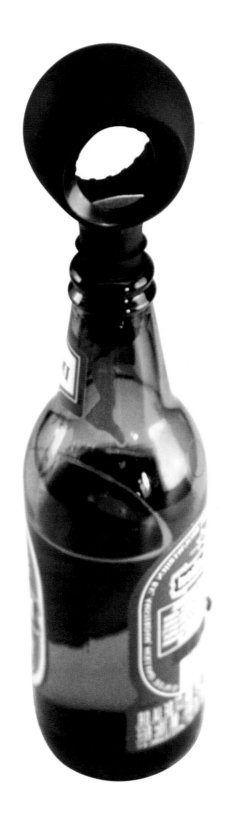

⌃ Above: The white areas on the model at left indicate where the polypropylene is exposed, showing what the stopper would look like in two colors. The hard yellow prototype at right was cast with the metal lip to test the pry-off feature.

Below: The black model on the right was cast in rubber to test the twist-off and stopper features.

⌄ The bulbous ring handle is ergonomically optimized for various grips, making it easy to use. The patent-pending design blends in with Oxo's complete line of Good Grips kitchen tools.

Target Toaster

Target, the discount retailer, enjoined Michael Graves to design more than two hundred **household products** exclusively for its stores. Graves's specific task was to generate **affordable** items

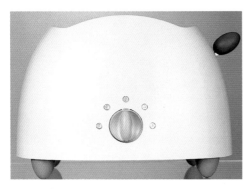

In creating the line of kitchenware products for Target, Michael Graves drew inspiration from the egg—an organic form that he says "is particularly comfortable in the hand." With its slightly inflated form and comfortable curves, the Target toaster brings to mind the kitchen appliances of the 1930s and 1940s.

The toaster was the first of over two hundred items to be designed by Michael Graves Design for Target. This original sketch, drawn by Michael Graves, served as the framework not only for the toaster but for the entire collection.

without sacrificing design originality or quality of craftsmanship. In addition, the appliances had to be ready for the retail market in just nine months.

As the first item designed for this commission, the toaster set the design standard for the entire kitchenware collection. Graves established the general egg-shaped form of the toaster, its dial, and its handle. "The egg" he reasoned, "is an organic form, understandable to all, that is particularly comfortable in the hand." With its slightly inflated form and comfortable curves, the Target toaster is reminiscent of kitchen appliances of the 1930s and 1940s, but its functionality is modern and convenient.

The team's goal was a unique design that is intuitive to use. They accomplished this with simple forms and minimal details. The yellow, egg-shaped dial is simple to understand. Its blue Santoprene lever signals that it is cool to the touch. Extra-wide slots allow bagels and other wide-sliced foods to be toasted.

Although the toaster required only one concept sketch, several sketches were needed to capture the egg-shape language that serves as the foundation for the many types of products included in the collection. The design language is expressed in dissimilar product categories, from small kitchen appliances to cleaning supplies to outdoor garden tools to pantry items. "This type of

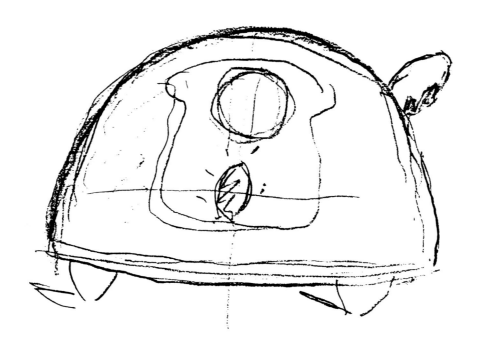

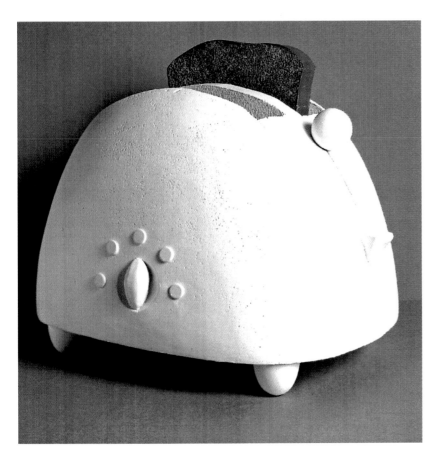

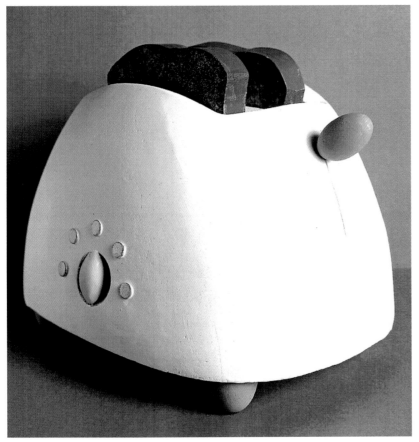

Roughly painted pink insulation foam models were used to present the idea to the client. Feedback from the presentation of the first model (above) was incorporated with the design of the second (below). The egg-shaped, elliptical form is exaggerated in the lever, the rounded feet, and the control knob.

undertaking had never before been accomplished," explains Donald Strum, senior associate of product design at Michael Graves Design, "mainly because most companies specialize in one or two categories of product, not twenty."

The toaster's design sketch was drafted in AutoCAD and modeled in roughly painted pink insulation foam to present to the client. Feedback was incorporated with the next generation of model, which was completed in just three weeks. The designers reduced the overall scale of the product and carved the arcing shape to allow heat to rise properly without melting or heating the housing. It was decided that the dial control should have radiating numerals rather than dashes to indicate toast setting. At the second design presentation, the vendor manufacturing partner evaluated the design and discussed feasibility.

The client embraced the toaster design. However, given the tight production schedule, Graves had to shell over existing internal mechanisms while attempting to preserve his design objectives. Target paired Graves with Black & Decker, which provided the internal machinery.

Although most of the toaster's design was formulated before the design team was paired with Black & Decker, technical questions remained, including how to preserve the arcing top while directing heat away, how to integrate the dial and lever devices with the design, whether the dial should glide freely or click when turned, how to manage the cord, and where to attach the feet. The design team originally planned to use stainless steel for the cover, but this proved impractical because of the heat it would generate and its manufacturing time and cost. ABS plastic was selected instead. In resolving these and other issues, the team worked to maintain the integrity of Graves's original design.

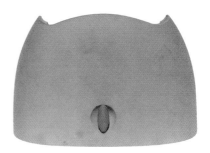

Models were used to capture the general size and shape of the toaster.

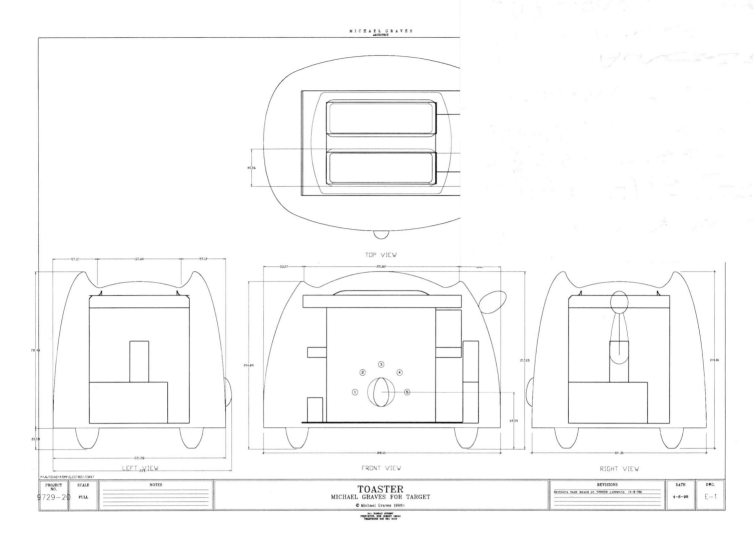

MICHAEL GRAVES
ARCHITECT

TOP VIEW

LEFT VIEW

FRONT VIEW

RIGHT VIEW

PROJECT NO.	SCALE	NOTES		REVISIONS	DATE	DWG.
9729-20	FULL		TOASTER MICHAEL GRAVES FOR TARGET © Michael Graves 1998	Revisions made based on YAMADA comments (4-8-98)	4-8-98	E-1

The initial and conceptual design processes were completed in just six weeks. Only a bit of tweaking was needed for the composition and color assignments. Before production began, CNC-milled, Ren Shape™ models were executed as check prototypes.

The resulting product challenges the existing market with a jaunty form that is slightly inflated, with comfortable curves, a simple dial, and an easily operated lever. Strum credits the success of the product line to the Target vice president whose vision was "to establish a large program based on high design at an affordable price and sold by a discount retailer." He emphasizes the role that luck played in enabling a good design to be implemented so quickly. Finally, Strum adds, the Target toaster resulted from the "total cooperation and great excitement generated from all parties—Graves, Target, and Black & Decker."

The Target program continues to build as new opportunities arise in many categories—all based on the Graves notion of a humanized approach to product typology. "Treat a toaster like a toaster," Graves says. "My rule is to give it back to the fingers, to make the dial readable, and to do it in a way that might make you smile!"

◇ Because of the extremely tight production schedule, the design team used existing internal mechanisms produced by Black & Decker. Once the design was in place, a three-dimensional schematic, as seen here, was developed to create the tooling needed to create the Target toaster.

◇ The design language established by the Target toaster continues to be applied to hundreds of other items—from small kitchen appliances, as seen here, to cleaning supplies and outdoor garden tools. The common language establishes a family of products from diverse categories while setting the retailer apart from its competitors.

◇ Far right: The Target toaster's egg-shaped language and accents in soft colors have been applied to kitchen items and tools. Using an "egg" as a handle adds a bit of whimsy to the kitchen utensil holder.

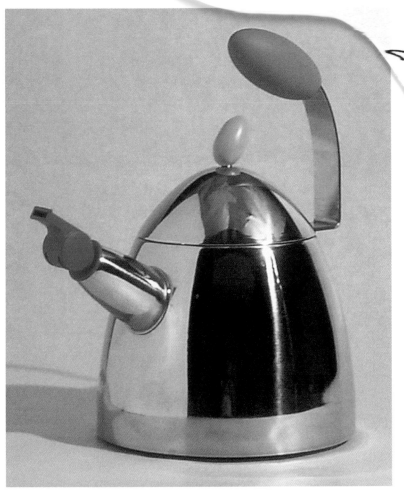

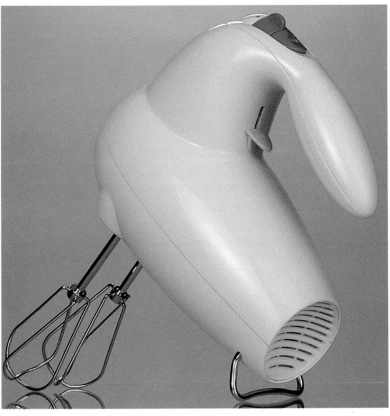

OrangeX OJex Manual Citrus Juicer

OrangeX, the **leading supplier** of juicers to the commercial food-service industry in South America, **successfully** introduced their **juicers** to the American restaurant and food-service industries

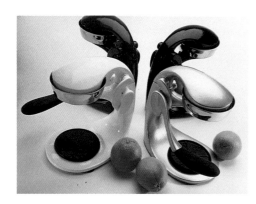

The emotive, fluid form language of the OJex Juicer is friendly and inviting. The visual hierarchy in which the base, neck, and head of the juicer are fused unites the components. The rounded edges and larger parts also accommodate the cast-iron manufacturing process, while the hollowed center helps minimize the product's weight.

in 1998. Recognizing an opportunity to move into the home market as well, they approached Smart Design with an idea: "Make a juicer that works just as well, but for the house."

The project team at Smart recognized the importance of understanding the client's process in making juicers as well as its goals for this product. "We wanted to integrate the client into the design process as much as possible," explains Anthony Di Bitonto, the team leader for the project. Just a few weeks into the design process, part of Smart's product-development team—an engineer and an industrial designer—visited OrangeX's foundry in Venezuela, where the juicer would be assembled.

The design team learned about the high-volume iron casting process so as to maximize its possibilities. This set important criteria for the final design. The sand casting process doesn't allow for small details or sharp edges; they get lost with the coarseness of the sand mold. Because parts must withstand the tumbling process used to remove mold sand, large section parts are preferable. Corners have to be rounded so that paint adheres well. Iron is heavy, resulting in considerable shipping costs. Thus, another project goal was to reduce the weight of the product.

Another goal was to improve employee relations. To this end, the design team interviewed assembly-line workers to consider how the manufacturing process might help foster a sense of pride among foundry employees. The goal of the design team was to give each person in the foundry a series of interrelated tasks that would help them see how parts fit together and convey a sense of ownership of the final product. The product design team sought to design the product so it would fit into OrangeX's manufacturing process.

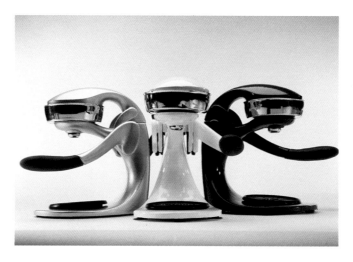

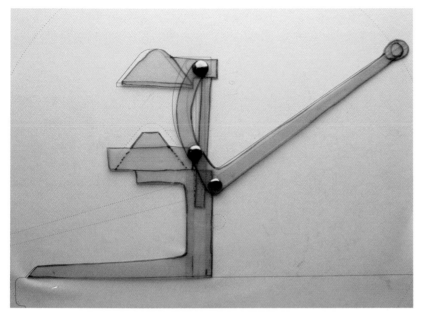

The project team at Smart researched the household and professional juicers already on the market. After squeezing lots of oranges, the team determined that the best-performing juice-extraction mechanism was a rocker crank with a long lever, as found in professional juicers. However, professional juicers were too large for the home market.

Engineering and industrial design worked together to solve these problems. First, the team worked on the rocker crank. Two-dimensional card sketches were done to analyze movement. Next came a functional model, used to test the lever and footprint of the juicer. The team brought together people of all ages and hand sizes, asked them to try the model, then used what they learned to refine the rocker crank. The result was the development of an inverted rocker-crank mechanism that allowed a reduction in the size of the unit while without sacrificing mechanical advantage. The lever's pivot point was placed at the back of the product for maximum length; stability was maintained within a minimal footprint. This makes manual juice extraction substantially easier for people with limited arm strength, including children.

Two-dimensional mechanical motion studies were used to explore various configurations for a rocker-crank mechanism. The challenge was finding a layout for a juicer with a smaller footprint than professional juicers.

Three-dimensional foam studies were done to explore variations on the chosen design direction. This design was chosen for further refinement.

The final foam model, shown here, was used to study the juicer design and to illustrate the final shape and assembly of parts. Because weight was an important consideration, the parts were hollowed to closely resemble cast parts. This allowed the team to estimate the final weight of the product.

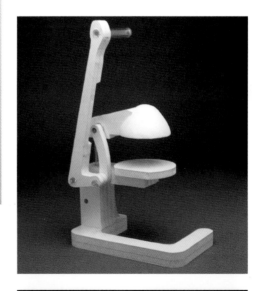

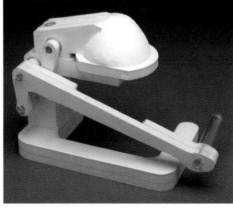

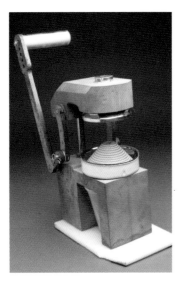

◁ Once the design team decided which direction to take with respect to the rocker crank mechanism, they used three-dimensional mechanical motion studies to analyze mechanical layouts.

▷ Smart Design tested these bread-board models with users of various sizes and strength to analyze and refine the mechanical motion of the juicer's rocker crank.

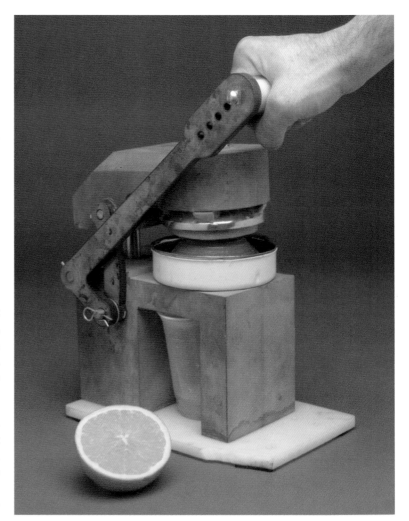

From the finalized mechanical breadboard, the team developed several three-dimensional foam designs, calculating the weight for each. The home juicers that performed well looked like drill presses in both size and shape. The challenge, says Di Bitonto, was, "How could we make a product with a complex mechanical function look friendly, inviting, and fun? We saw that there was an opportunity to make a sculptural object."

The team wanted the juicer to look unified rather than like an assembly of parts. The chosen design depends on a predominant swoop or C shape as defined by the base and head to create a sculptural statement. The handle and other elements contribute to this unified statement; all parts are in harmony. The design team presented three design concepts to the client with its recommendation. The client agreed with Smart's recommendation, and the product team incorporated and refined the required functional features.

The design was drawn up in CAD, where part and assembly engineering issues were resolved. OrangeX then used its foundry to cast four fully functioning cast-iron prototypes from CAD-generated stereolithograhies. OrangeX's foundry specialists and machinists found ways to make them more cost efficient. Smart's design team finalized drawings for production parts.

For a product to work on many levels, the design process must be multifaceted. The success of the OJex juicer resulted from integrating the client, assembly-line workers, a wide range of possible users, engineering, manufacturing, and industrial design in the product-development process.

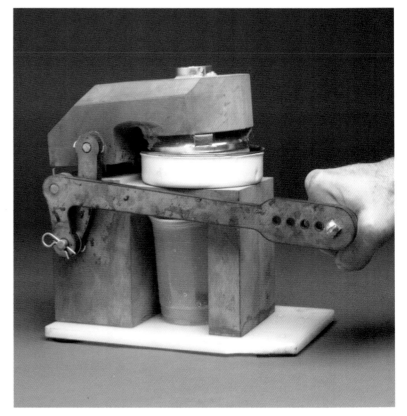

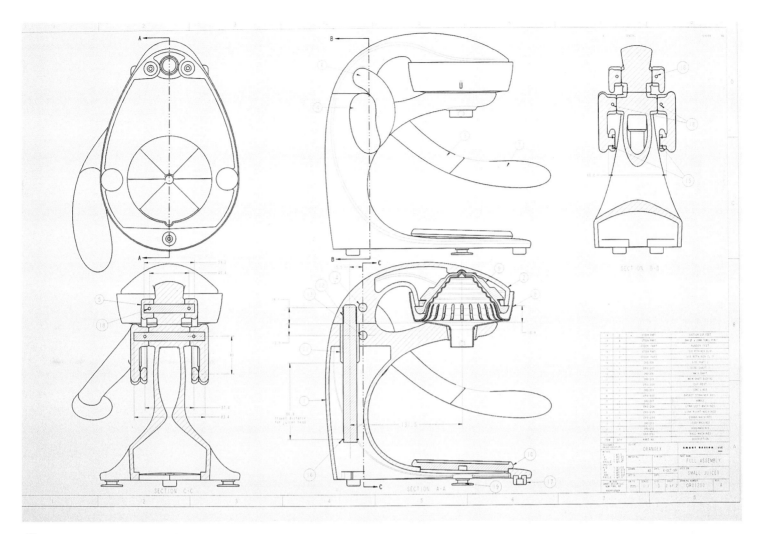

⬡ This engineering drawing shows the various parts of the juicer. Throughout the design process, the design team worked with OrangeX to find ways to accommodate the company's manufacturing processes and goals.

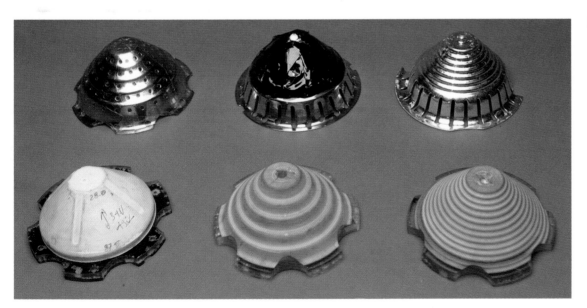

◇ User studies revealed that consumers do not like much pulp in their juice. Various prototypes of strainers were developed to determine the optimum profile for maximum juice extraction and the best perforations for holding back the pulp.

Quick 'N Easy Food Processor

Is it possible to initiate and implement a **creative idea** in just one week? Based on the **success** of the Black & Decker Quick 'N Easy food processor, the answer is **certainly yes.**

⬡ A quick timetable makes computer-aided design (CAD) a must. As details were refined, they were added to the AutoCAD file. This final control drawing was sent to the manufacturer to build the machine.

The Quick 'N Easy food processor was designed for Applica Consumer Products, Inc. Applica, an exclusive licensee of the Black & Decker trademark for household products, was transitioning its existing food processor from an external source to in-house manufacturing. Retooling plans were in progress, but Stuart Naft, Applica's manager of industrial design, recognized an opportunity to boost sales by introducing a food processor with a contemporary design. He sold the idea to management and asked Anderson Design to refresh the appliance's look.

Applica would consider a new design only if the proposal utilized the existing internal components and condensed the development cycle. They wanted tooling to start immediately so the product could be introduced on the timeline proposed for retooling the existing design. The development team agreed to a design development process of about a week. "Developing an exciting design direction in the condensed time schedule was a challenge," says David Kaiser, principal at Anderson Design. As a further complication, the program was initiated over the Christmas holiday.

The four designers got to work on sketches right away. The preliminary concept sketches were done on 8.5" x 11" (22cm x 28cm) pages for easy electronic transfer to the client's home. The team analyzed the internal components of the existing product to determine which would be used.

The design team and the Applica design manager then met to review twelve concept sketches and select the design direction. The group looked for a design that was not only fresh and exciting but also would fit with other products in the Applica line. These products had elliptical shapes with curved or flat ends. The team settled on a concept sketch showing a sculpted, elliptical form and agreed to emphasize this shape with details. The bowl and tower looked like an integrated piece. The top of the tower tapered from a larger base, giving the product stability while minimizing size.

Because the new food processor would use the internal components of the existing model, the next job was to ensure that the selected design could be integrated with them. The designers used AutoCAD to lay out an elevation drawing of the existing internal components and drew the exterior of the new design over it. Once the general shape was created on the computer, the dimensions were used to create a model in soft urethane foam that enabled fast sculpting by hand.

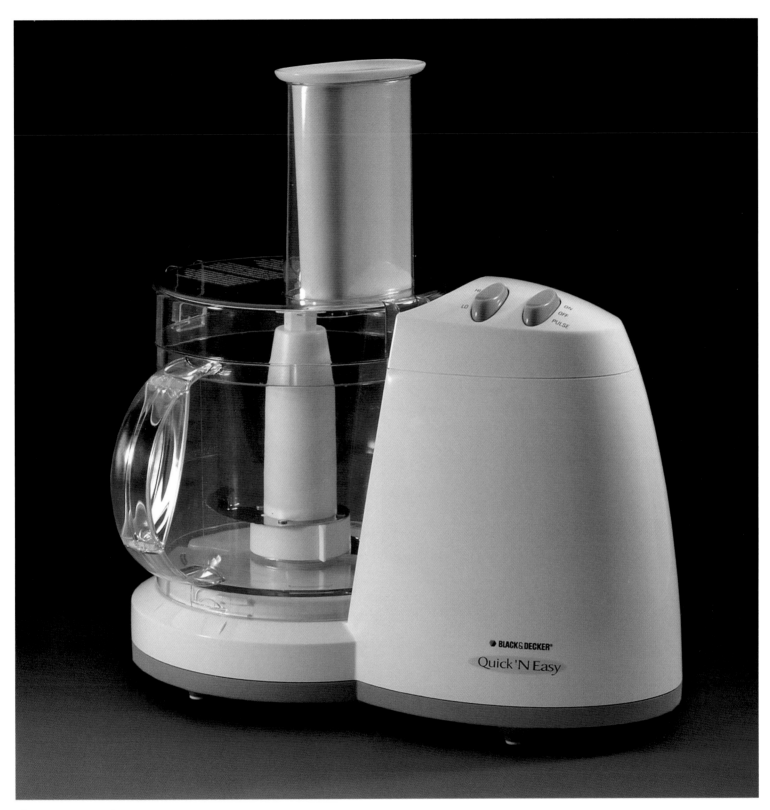

The designers used a sculpted form, clean surfaces, and small splashes of color to update the look of the Black & Decker food processor. Other changes, such as the tapered tower and un-complicated form, help minimize both the actual and the per-ceived size of the Quick 'N Easy food processor.

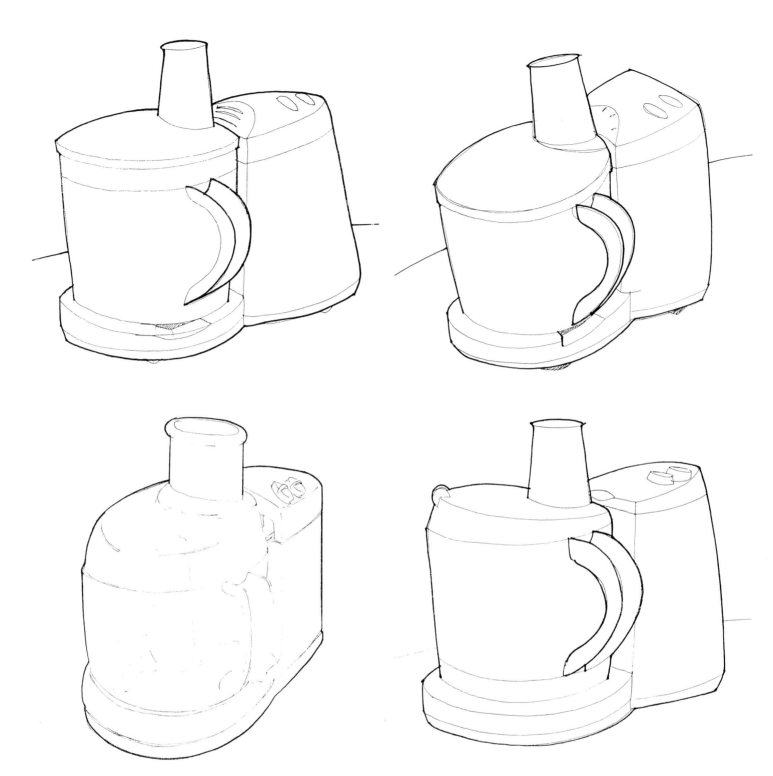

⬡ At the outset, the designers
hand-drew thumbnail sketches
to explore various forms for
the new food processor. In
making the decision about
which direction to take, the
team looked for a fresh, excit-
ing design that would also fit
in with the other products in
the Applica line. Concept 1,
shown top left, was selected.

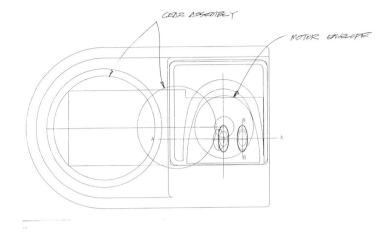

GEAR ASSEMBLY

MOTOR ENVELOPE

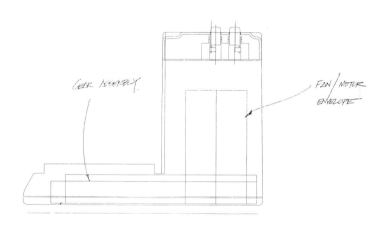

GEAR ASSEMBLY

FAN / MOTOR ENVELOPE

The design would use the same internal components as the existing food processor, so the design team used AutoCAD to lay out the internal components and drew the exterior of the selected design over them.

The designers revised the three-dimensional form to realize the original design intent. The soft foam accommodated rapid updating to the shape. Details such as the control knobs were modeled and added to the design. "There was little time to explore alternatives," explains Kaiser. "Smaller details were explored in quick foam models." The details were added to the AutoCAD documentation, which was sent, with the completed foam model, to the Far East for final documentation and tooling.

The entire design process, from initial concepts to delivery of a foam appearance model and AutoCAD control drawings, lasted just over a week. "The proposed schedule required an efficient, yet thoughtful, design process as well as clear and immediate feedback," says Kaiser. The designers saved time by making decisions quickly and conclusively. After the initial direction was agreed on, the team relied on fax and e-mail to share ideas with Applica.

"Sometimes design inspiration and unique design solutions come faster when a designer is under pressure," notes Kaiser. "In this program, everything came together smoothly without time for rethinking or changing the design."

The success of the Black & Decker Quick 'N Easy food processor demonstrates that good design need not take long. With minimal investment, the solution enabled the client to go to market with a fresh design that stood out against the competition. Clean surfaces combined with crisp intersections and splashes of color set the Quick 'N Easy food processor apart from other entry-level units in the same category. The uncomplicated form eliminated wasted space in the area beneath the controls by following the natural layout of the internal components. The team minimized details on the exterior, resulting in smooth, unobstructed surfaces for easy cleanup.

Kaiser is careful not to promise results. "This development process is not recommended for all programs. This project had defined components and had to fit into an existing product line, so there were fewer design variables to respond to." He adds modestly, "It is difficult to guarantee award-winning design in this condensed a development schedule." But the Black & Decker Quick 'N Easy food processor proves it is not impossible.

Ekco **Clip 'n Stay**

Previous to the design of the Clip 'n Stay, about the only **innovation** seen in the **category of clothespins** from year to year would be a new thirty six-pack—as opposed to the old twenty four pack—

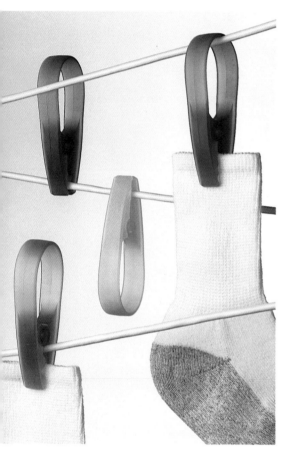

The beauty of the design of the Clip 'n Stay clothespin is not only in its untraditional appearance but also in its versatility. The device can be used as a clip or a ring, it doesn't rust, and it can be stored right on the clothesline.

or maybe a different color of plastic would be specified. But despite the product's well-known shortfalls, including a tendency to break at the hinge and that each pin required the assembly of three parts, no one reexamined this traditional consumer product.

That is, until Ekco Housewares asked Ancona 2 of New York City to rethink the clothespin's nature. "They were doing a new line of laundry products and asked us to take another look at clothespins," recalls principal Bruce Ancona. "They definitely needed new excitement, but [any new design] also had to be appropriate from a manufacturing point of view. Ekco asked us to bring color and style to the category."

Ancona 2 has developed hundreds of tools and gadgets over the years, and the designers are always brainstorming future projects. One idea that seemed sound but had not yet found a home was the design for a pair of salad tongs. The tong design was based on the principle that if a strip of plastic is curved in half, then pinched in a particular spot, a specific action is elicited from the tool—namely, its open ends part. In addition to its mechanical appeal, the design also had other benefits: The plastic used to create it could stand up to wetness, it was inexpensive, and it could be made almost any color. Furthermore, the design had an engaging look—particularly when applied to clothespins.

Ancona says his team is always on the lookout for ways to move smart designs and concepts from one product to another. "When you are doing these sorts of mechanical products, you are always exploring mechanisms. We might find a hinge on the back of a computer and say, 'Wouldn't it be neat if a garlic press opened that way?'"

The looping design has a self-contained spring, reducing the number of parts in the product from three to just one. When used to hang clothes, the clothespins can be used as their traditional brethren are—clipping clothing directly to the line—or used more like a curtain ring; attached clothes can be slid up or down the line as needed. The clips can also be threaded right onto the line for simple storage.

The designers knew the product would be made from some type of low-density polypropylene, but finding the right combination of give and stiffness was a long process of trial and error. In some experiments, when the clothespin was pinched several times, the plastic would fatigue. Some plastics were too hard to compress, and others wouldn't hold heavy, wet clothes on the line. Finally, the right mix was found.

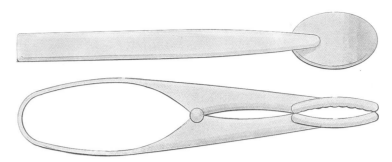

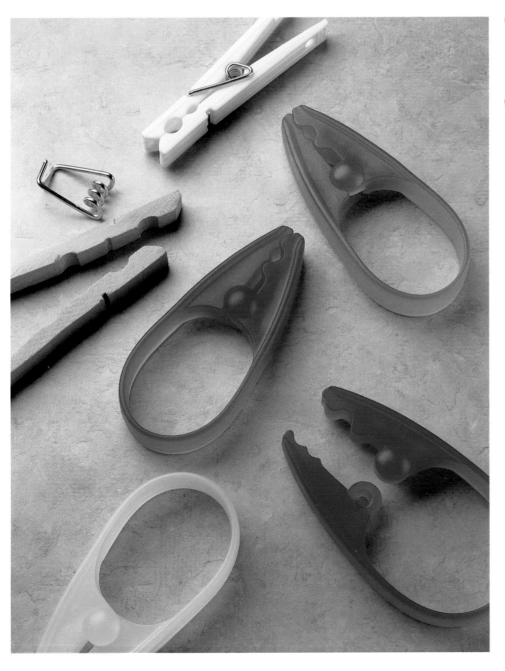

⊗ This is an original sketch of a concept for a pair of salad tongs Ancona 2 designers were working on for Ekco. The salad-tong mechanism inspired the clothespin design.

⊘ The design's built-in spring means that it can be molded as one piece; the traditional design requires the assembly of three pieces.

This early drawing had a notch at the end of the design's loop, allowing the user to lock the pin on the clothesline rather than letting it slide freely.

The device is molded in the open position, then snapped together. The tension in the looped plastic provides the pinch power for the design.

The result is a design that is so innovative that some consumers may not even recognize it for what it is, particularly in today's crowded retail environment, where there are few clerks to help buyers. But Bruce Ancona feels that packaging and point-of-purchase displays are already explaining the product well, while its design provides the necessary eye-catch. In fact, Ekco has already received calls from manufacturers in two unrelated industries—shower curtains and hair-care products—who are interested in licensing the technology behind the clothespin.

Success, Ancona says, comes from thinking about all the steps that a consumer goes through at the retail and consumer/home-use levels. What are the person's day-to-day experiences with the product? In this case, the new clothespin design is not only more useful and durable than traditional clips, it also helps make one of life's drab chores a bit more pleasant.

"It's the mousetrap conundrum," he says. "There is always the opportunity to do something unique. New influences and technologies come along. The market changes. The whole translucent plastic thing—that definitely influenced our thinking on this project. But if we were to be given this same project today, we would have designed something different."

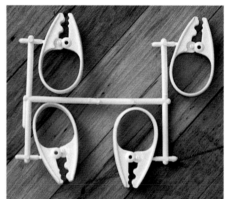

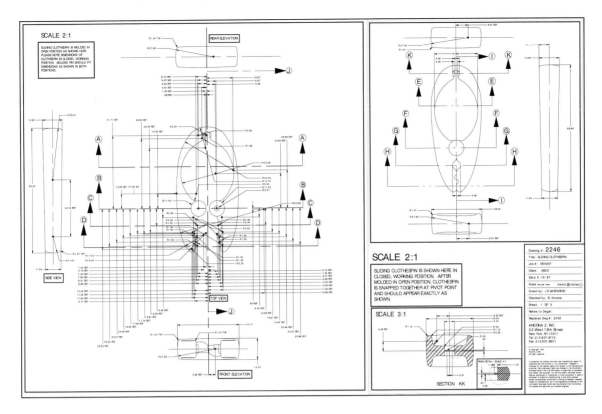

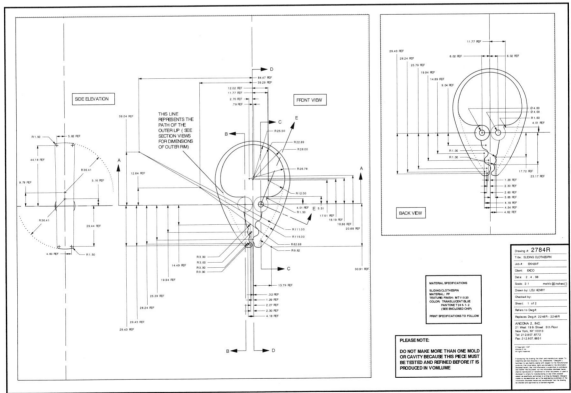

⬡ Above: This design shows variations in the notch as well as new teeth configurations. At each iteration of the design, Ancona 2 had samples made in different plastic resin mixtures in order to test resiliency, ultraviolet protection, and cost.

⬡ Below: This drawing shows the removal of the notch and a uniform loop. But this design had a weak point that put too much stress on one point, causing plastic failure.

Orca Mini Stapler

The success of some projects is the result of **true partnership** and an **open exchange of ideas** between a company and its industrial design firm.

UPSCALE MINI-STAPLER

add lever mechanism to prevent stapling while using hole punch

remove sharp edges and corners

add staple reservoir and hole collecting compartments

extend rubber to cover all four feet and wrap around the back (as shown in drafting)

⊘ Jeff Miller credits much of the success of the Orca Mini Stapler to the close collaboration between the design team and the manufacturer. Here, the design team comments on the first manufactured hand sample.

This was the case in the development of the Orca Mini Stapler.

Ecco Design has done a lot of work with the Hunt Corporation over the past few years and has a retainer with them. This enables the design firm to work with the company's marketing representative to explore ideas in general and to conduct less targeted market research. "The important part of what we do is to comb lifestyle trends, research existing products, and cross-fertilize our efforts with expertise from other markets and product categories in an effort to find market opportunities and help Hunt realize their marketing objectives," explains Jeff Miller, vice president of design at Ecco. "We are really part of their development team in a marketing sense and can help them choose what directions to take. Then, we put forth a marketing proposal."

When Ecco presented its proposal for a mini stapler, Hunt bit. The Boston brand staple division was seeking a way to reach high school and college markets as well as to increase their offerings to the small and home-office market. They were also interested in a new mechanism that would enable a stapler to punch holes as well. The challenge for Ecco Design was to create a product that would accommodate their patented hole puncher and have "a fun attitude."

Ethan Imboden, the lead designer on the project at Ecco, began with a series of concepts and sketchbook designs to find the right form. Some of the sketches were traditional and geometric; others took on a more organic, amorphic form. From these sketches, Imboden, Miller, and Eric Chan, design director of Ecco, selected concepts to share with Hunt, highlighting several they "felt good about." Because of their close relationship with the decision makers at Hunt, this was "not so much a formal presentation as a mutual discussion," says Miller.

⊘ The design team used CAD tools to refine the stapler's form and function. Computer-aided design had the additional advantage of allowing both the design team at Ecco and Hunt's overseas manufacturing group to work simultaneously, overcoming obstacles of distance and time zones.

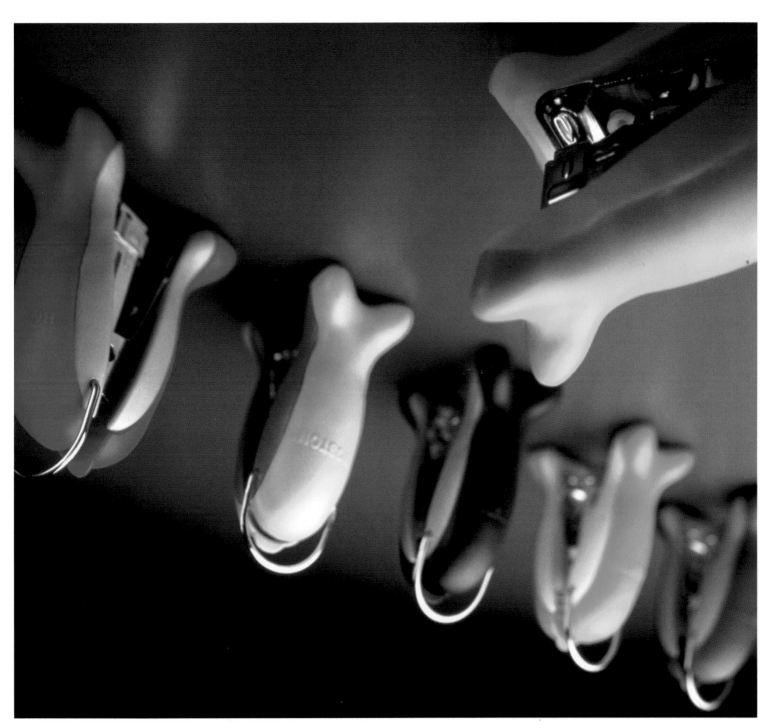

The Orca's friendly tropical-fish colors were based on trend research and designed to appeal to a young market and to reflect the aquatic theme. The colors most requested, however, are black and silver. "The humor and vitality of the form and color palette breathe life into the otherwise mundane task of paper organization," says Miller.

Once the client and designers agreed on the general direction to take, a number of foam models were created. The design team used the models to achieve several objectives. First, they were used to explore the stapler's basic sculpture and form. Second, they helped determine ergonomics; whatever form was chosen would have to fit comfortably in the hand. Third, the models were used to ensure that the product was suitably small but still accommodated the patented single-hole punch mechanism developed by Hunt's manufacturing team.

The next step was to develop three-dimensional models on the computer. The CAD models were instrumental as Ecco Design worked closely with Hunt's overseas manufacturing division to develop a product that met both design and manufacturing goals. Ecco also began to work on the color variations for the product.

The animated form of the stapler was inspired by the creatures of the sea. Even in the early sketches presented to Hunt, the aquatic feel of the stapler had taken hold, and the design team was careful to push this theme through the design process. The four feet resemble a whale's tail, while the bulbous head recalls the head of a whale. The name Orca reinforces this connection.

The stapler's unique appearance attracts attention on the store shelf and in the office. The organic shape not only gives the product a strong presence and friendly personality but also fits comfortably in the hand. The shape also allows the stapler to lie flat or to stand on its end like the other staplers in Boston's pioneering StandUP line. The design team also incorporated into the design a removable metal loop for attaching the stapler to a key chain, backpack, or tether—enhancing the mobility and utility of the tool.

In addition to Ecco's good relationship with the marketing team at Hunt, Jeff Miller credits the success of the Orca to the close interaction between Ecco Design and the overseas manufacturer. "Over the years, we've developed close ties with their processes," he explains, "having developed numerous staplers for Boston with them. We are keyed into their standard methods and capabilities, and we are constantly trying to push to develop pioneering solutions and features using their expertise and our innovation."

The Orca represents one facet of a focused strategic design collaboration in which Ecco is helping Hunt invigorate the Boston brand name and redefine the stapler market. If the Orca is any illustration, close teamwork is a whale of an idea.

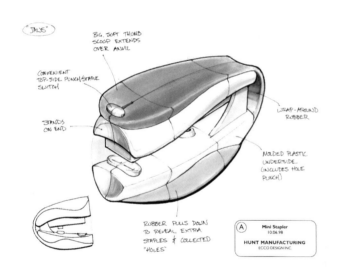

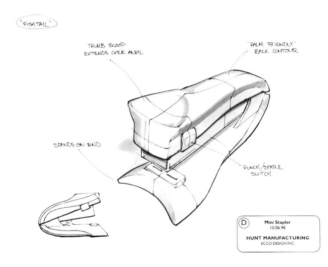

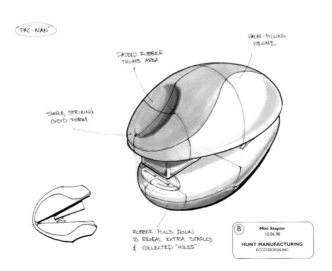

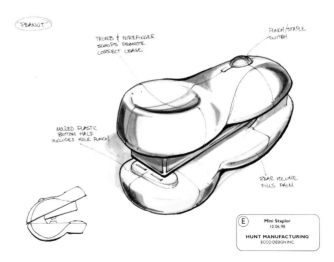

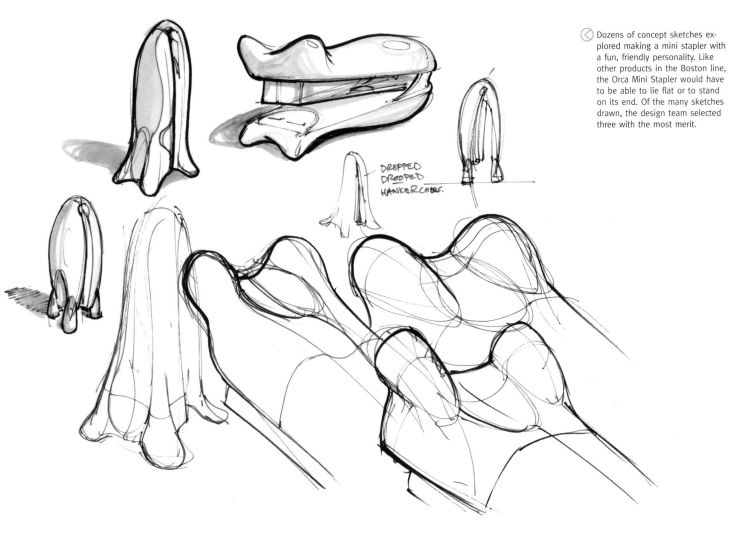

◁ Dozens of concept sketches explored making a mini stapler with a fun, friendly personality. Like other products in the Boston line, the Orca Mini Stapler would have to be able to lie flat or to stand on its end. Of the many sketches drawn, the design team selected three with the most merit.

DROPPED
DROPPED
HANKERCHIEF.

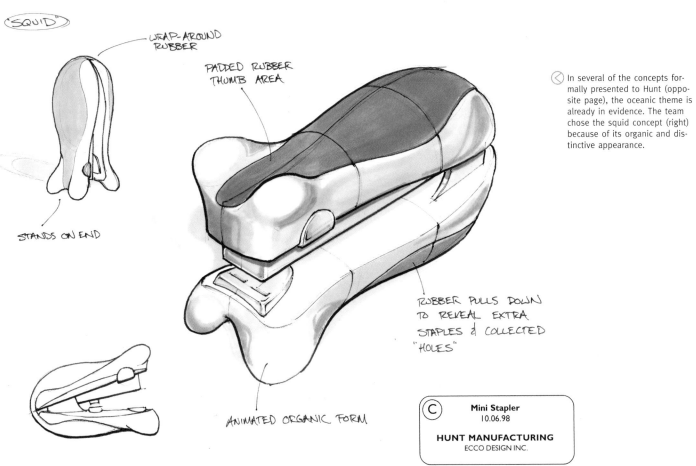

"SQUID"

WRAP-AROUND
RUBBER

PADDED RUBBER
THUMB AREA

STANDS ON END

◁ In several of the concepts formally presented to Hunt (opposite page), the oceanic theme is already in evidence. The team chose the squid concept (right) because of its organic and distinctive appearance.

RUBBER PULLS DOWN
TO REVEAL EXTRA
STAPLES & COLLECTED
"HOLES"

ANIMATED ORGANIC FORM

© **Mini Stapler**
10.06.98

HUNT MANUFACTURING
ECCO DESIGN INC.

The Royal-Olivetti ASF Paper Shredder

The paper-shredder market teems with brands and styles that pulverize **sensitive documents** for **giant corporations** or **slice credit cards** and receipts in the home.

From the outset, the team sought a design that emphasized the sheet-feed feature. Several design details achieve this, including a graphic indicator for maximum sheet amount and an obvious on/off switch. To make sure the feeding mechanism worked right every time, the designers soft-tooled it and tested it with first-round off-tool samples.

As seen here, each of the four design alternatives called attention to the automatic sheet-feed feature. The rendering at the top left was selected for refinement. The team liked its tapered stature and sculpted form and believed the design both called attention to the product's uniqueness and fit in any office environment.

Every company in the business uses design as a tool for gaining market share. As an industry leader, Royal-Olivetti welcomes and encourages new design solutions that will help them maintain or increase their presence. They approached Staubitz Design Associates with a question: "What features can we offer our buyers that cannot be compared on an apples-to-apples basis with our competition but that still satisfies the expectations of the consumer?" "That's all a designer needs to hear!" exclaims Tim Repp, the industrial designer for the project. "It was apparent that creating a real difference would involve more than just styling."

Royal-Olivetti works with at least five manufacturing vendors to whom Staubitz often proposes and discusses ideas about better ways to shred paper. One of these manufacturers supplied a breadboard prototype of a concept that had been under consideration months earlier: a product that could individually shred over fifty sheets of paper. The prototype was crude, but it worked.

However, Royal-Olivetti was concerned about cost. An automatic sheet feed would need to command a higher price at retail than what people were accustomed to paying. In Repp's words, this meant that the design would have "to visually communicate that the shredder included something new—something worth paying more for. The answers to this challenge sculpted a need for design originality."

After all parties agreed on the general direction of the program, a series of refined concept drawings were presented. The concepts ranged from whimsical to rugged in appearance. Each called attention to the paper entry tray and control area as well as the overall uniqueness of the product. "The chosen solution, dubbed the Tasmanian Devil for its tapered stature, seemed to please everyone," Repp explains. "What's more, its sculptural form would complement any office environment, including the typical office with rectilinear furniture and equipment."

As with many consumer products, there was a rush to get the ASF paper shredder to market. This meant time constraints for the design team. "To be honest," admits Repp, "our research was impromptu at best. Preliminary concepts were shown to a group of buyers, who loved the idea simply because it was new to mass market."

From preliminary CAD layouts of the design approach, an appearance model clarified details such as basket volume, switch orientation, and height. Adding appropriate weight to the model proved useful as well. Because it had a minimal footprint and 75 percent of its weight at its top quarter, it would tip over if accidentally bumped. The team remedied this by increasing the size

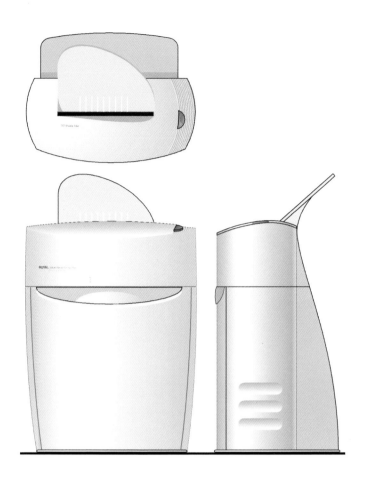

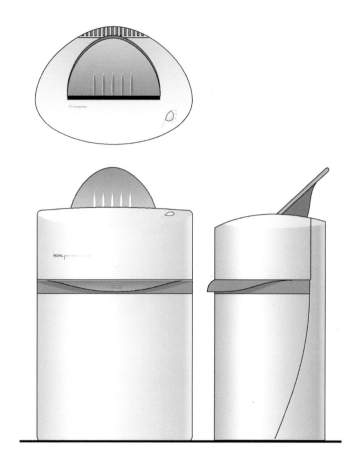

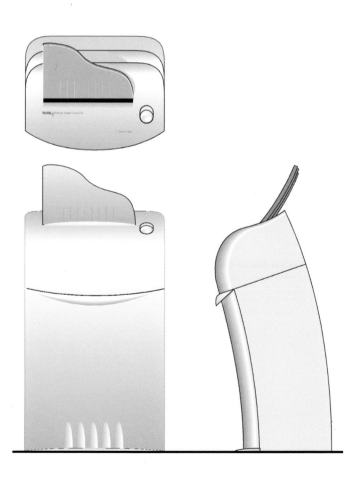

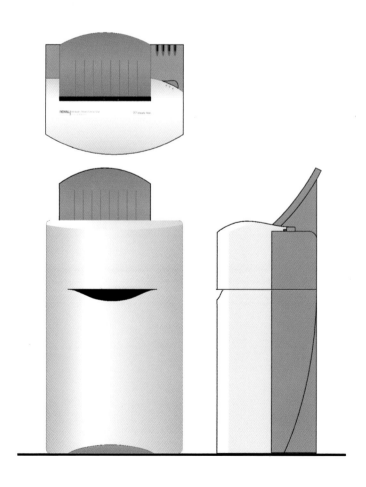

of the base plate. Throughout, the team looked for ways to communicate the product's unique features. "We needed to be sure that at a first glance the product said 'different,'" says Repp. "Certainly the feed tray drew attention to the sheet-feed feature. The overall form was stylish, yet serious where it needed to be, and the on/off switch was obvious and even a little playful."

Still pressed for time, these improvements were communicated to the manufacturer, who had been working concurrently on three-dimensional part files. The team decided to proceed directly to final tooling for everything but the feed tray, which would be soft-tooled and tested with first-round off-tool samples. This added time to the schedule but accommodated the sensitive nature of the feeding mechanism.

The first feed-tray sample had a graphic indicator for maximum sheet amount and simple bladelike guides on either side to align the paper as it was fed into the mechanism. This worked well unless the user tried to load additional sheets while the unit was running. If not inserted correctly, misaligned paper sometimes jammed the mechanism. A quick series of cardboard models led to the solution: a snap-on sleeve that covers the entire entry slot and allows only the maximum amount of paper. The sleeve also keeps foreign objects and debris from accidentally entering the unit. Translucent polycarbonate was selected as the material because it allowed the tray detailing to show through.

Repp credits the ASF paper shredder's success to the client's trust in the designers. "With this project, we were given full reign to explore what we felt was appropriate for the market. Surprisingly, we were not asked to compromise on anything. This almost never happens, and for good reason—designers don't know everything!"

"It's important to establish such a level of trust with your clients," Repp advises. "It allows the voice of design to be heard."

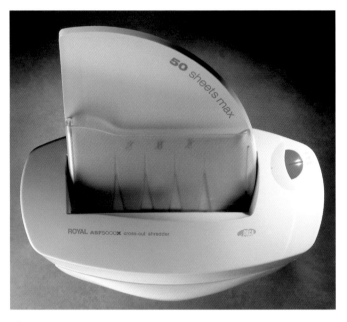

⬆ The bladelike guides used in the first feed-tray sample worked well unless the user tried to load additional sheets while the unit was running. The solution was a snap-on sleeve that covers the entire entry slot and allows only the maximum amount of paper. Translucent polycarbonate allows the original aggressive tray detailing to show through.

◁ The design team began with sketches that explored how to visually differentiate the paper shredder from its competitors. They drew early sketches from various angles, including a top-down view, to see how the product's unique features could be emphasized.

▷ Several refinements were needed as the design progressed. Early models risked tipping over if bumped because they were top heavy. The design team remedied this by increasing the size of the base plate. In addition, the designers emphasized the lifting handles on each side for easy assembly and, if needed, transportability.

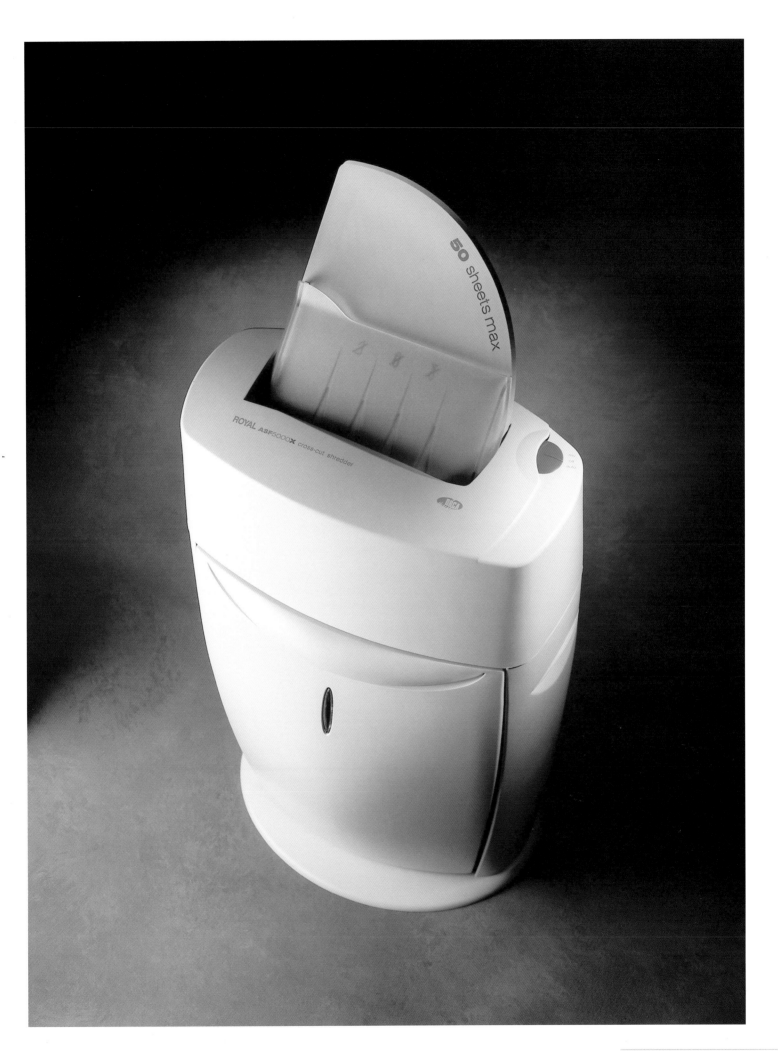

The MOUSE™ Sander

At the first team meeting to discuss **a new sander,** Black & Decker's **marketing** department **issued a challenge:**

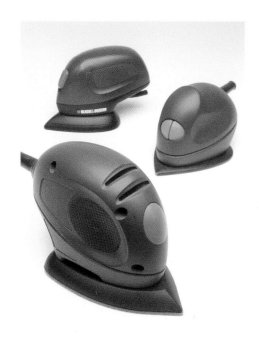

Clockwise from top: early, intermediary, and final MOUSE™ models. With each iteration, a rounder theme developed, with heavier sculpting and over-molded elliptical grips. The elliptical theme continued into the switch boot and air slots, which became softer. The cordset "tail" was raised to meet European dust extraction regulations and reduce visual weight at the rear.

"Design a detail sander that's as easy to use as a computer mouse." Some of the qualities of a computer mouse—its fit in the hand, the ease with which it moves across a surface—translated into the MOUSE™ sander.

Black & Decker's engineers used rough-workups—what they call Frankenstein concepts—to show that a miniature version of the company's sanders was possible. "Our new products group had a mechanical concept," explains Scott Evans, the lead designer on the team, "but it was up to Industrial Design to give the project life."

Evans made many, many sketches as he looked for a "viable and manufacturable" solution. Some of the sketches were conventional, others whimsical. All of them focused on making the sander as small as possible.

Evans was most interested in exploring the shape of the sanding pad, which "drives the function of the tool." The level of control needed to get into tight corners is impossible with the small triangular pad used for most detail sanders. Trying to keep the pad flat to the work surface is difficult, and its small surface area hinders performance.

From the sketches, several foam models were made to examine how the motor would work within the packaging. To keep the overall profile low, the motor was oriented horizontally. The study models featured an elongated pad, tapered at the front and widening to a teardrop at the rear, that gave the tool stability while allowing it access to tight corners. Because of its shape, the project team began to refer the sander as "the mouse."

Everyone loved the shape—until it was tested with users. The tool's low profile made it difficult to hold. It also was not long enough and was not weighted properly. The working mock-up told the tale: The motor stuck too far out in back for proper balance, and the necessary bevel gear proved both expensive and problematic.

Industrial Design went in search of a design that would better fit the hand. They revised the design direction in another series of sketches, adding height to obtain the minimum that was comfortable. This allowed an upright motor, better balance, and decreased mechanical complexity.

Several new models and a mechanical mock-up showed better results. With its higher stance, the new version had a nimbler appearance and was far easier to grip. The model that the team selected performed well functionally while retaining the mouse-

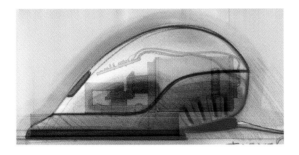

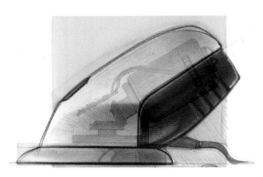

like character of the early model. Until now, the detail sander had been a "back-burner project," says Evans, "but when the MOUSE™ found its way into the hands of the company president at a global business meeting, the project was put on a fast track."

Now the real work began. Evans was paired with an engineering team in England and another designer, Mark Stratford, to make the concept a reality. The design had to take into account different consumer tastes in the United States and Europe, where wilder ideas are expected. It also had to adhere to the various regulatory requirements of the different markets.

The tool's grip still needed work. The MOUSE™ required concave sides to solve this, but part of its appeal was the color break afforded by the upper and lower clamshells, which didn't allow concavity. "Ergonomic sense won," says Evans. "We went to a conventional left-right clamshell with recessed sides."

The engineers also faced challenges in adapting to the design's small size. Many design iterations were required to fit the circuitry inside. By now, however, marketing insisted that the sander's mouselike character be maintained.

⊘ Early sketches were used to explore various shapes and orientations for the motor. The sander was given height to make the grip more comfortable, and these sketches proved that the new height would accommodate an upright motor, which offered better balance as well as less complexity and lower cost.

⊘ Once it was determined that an upright motor was possible, Scott Evans began to formulate what the sander would look like. This early sketch shows the direction taken.

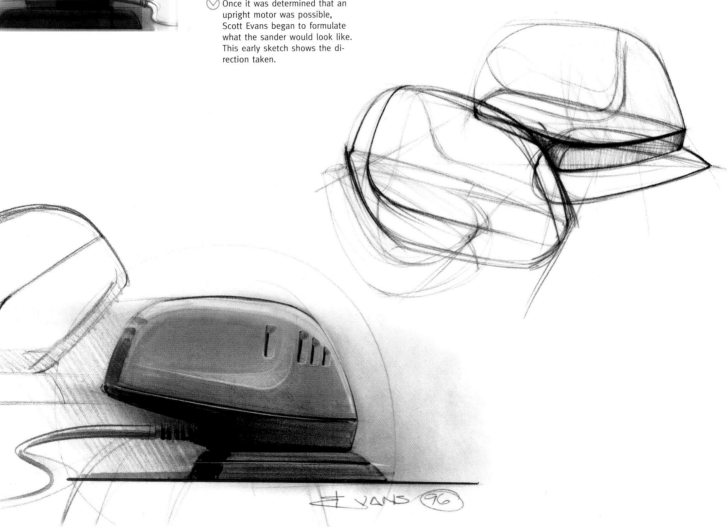

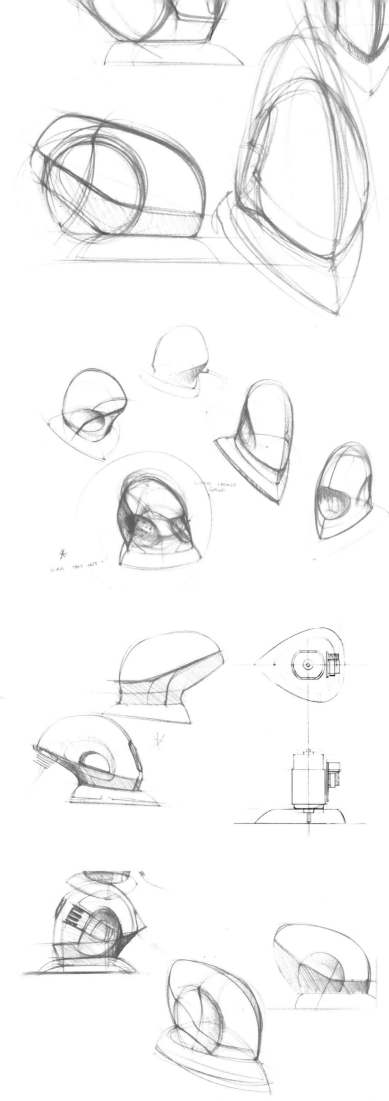

The MOUSE™ grew more refined with each iteration. It became softer and rounder, with heavier sculpting and overmolded elliptical grips. The switch boot and air slots also became softer and more consumer-friendly. The groove in the side was adopted to mimic the earlier clamshell proposal; it also produced a visually squatter stance. To meet European dust extraction regulations, the cord-set "tail" was raised, which reduced visual weight at the rear.

The evolution of the MOUSE™ was unusual in that its personality came first. "Everything we did played off that personality," says Evans. The sander has shelf appeal because the team was able to keep Industrial Design's vision so pure that, despite the search for a better alternative, the project name became the permanent name of the product.

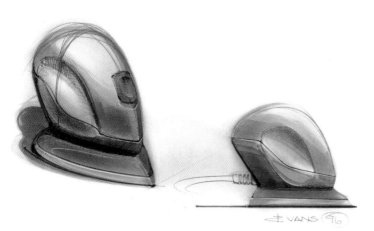

⊗ The sketches also helped determine the location and fit of the motor. This was the last color rendering before models were done. The sander's small size, triangular pad, different-colored upper and lower clamshells, and teardrop shape help give the MOUSE™ its unique personality.

⊗ "Everyone fell in love with the detail corded sander," says Evans. But there was still work to be done on the grip. As seen in these sketches, Evans hit on the idea of using concave sides to improve the grip.

The Frankenstein model of the upright motor, seen in the background, was used to ensure the sander would function as planned. But it was the hand-made model in the foreground that caught the attention of Black & Decker's president, giving the mouse its name and putting its development on the fast track.

The MOUSE™ compact sander is comfortable, offers good control, and doesn't fatigue the user. Says its designer, "Its appearance results from our desire to create a mouselike shape—a form that is nonthreatening, fun, and a bit lovable." The friendly form, bright colors, and design details contribute to the sander's distinctive shelf appeal.

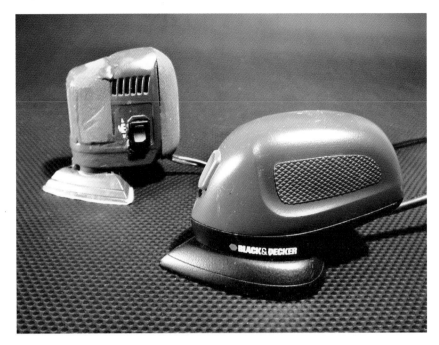

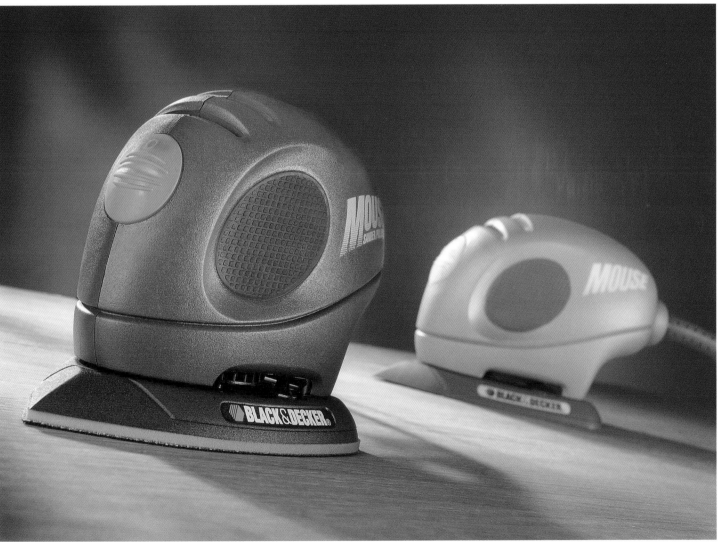

The HeadBlade

Run your fingers over the top of your head and **through your hair.** Go on, **give it a try.** In **one movement,** you've learned how to use the **HeadBlade,**

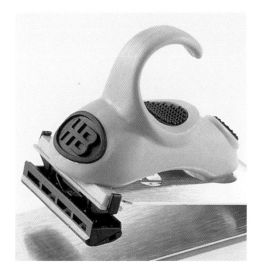

The HeadBlade not only looks great but also represents an enormous improvement in head-shaving technology. The user's hand, essentially, becomes the handle. Unlike conventional razors, the HeadBlade's natural position is at rest against the skin, and its back pad always touches the scalp. When driven across the head, the razor automatically pivots.

an ingenious razor handle designed for people who shave their heads. The device fits like a ring over the middle finger, with the blade facing the end of the digit. The user pushes—not pulls—the blade over the skin. Clearly, it's shaving anarchy.

Necessity was the mother and Todd M. Greene the father of the HeadBlade. Greene, a head shaver himself, was frustrated with conventional razors. He compares trying to shave with them to trying to ride a unicycle.

"An extended handle works against you. You try not to rock back and forth; you're always trying to find the right balance. Besides that, you tend to take short strokes, like when you rake leaves," Greene says. Each new stroke requires the shaver to establish balance anew, a problem complicated by the bumpiness of most heads. Greene's design allows the fingers to touch the skin at all times, guarding the head so the user need not constantly readjust and reorient that balance.

Another problem shaving the head with a conventional razor is handedness. A right-handed person might not have trouble shaving the right side of the head, but the left side is nearly impossible to do well or quickly. "When you shave your face, you don't need to convert from left to right or back. When you do the opposite side of your head, though, you can't take strokes down and to the side. Then, on the back of your head, you have to work in the mirror," Greene says.

The HeadBlade is made for use in either hand. In addition, with a simple flip of the blade cartridge, the device can be used for a conventional shave of the face or legs.

The idea for the design was born when Greene could not find a razor he liked. He discovered that large razor companies viewed head shavers as too narrow a market. With no product design experience, Greene began making sketches. "Gillette and Schick are in the blade business; they give the handles away," he says. "I needed to find a way to have people appreciate the handle."

His sketches soon gave birth to clay, Fimo polymer, then resin prototypes. At the outset, the device was round and was worn on the middle finger like a joy buzzer. But the razor in this design was stationary and did not adjust well to the irregular surface of the head when wet. His second and third prototypes, made with Fimo, were also round and had a flat top and bottom. Flanges were replaced by a 1-inch (3 cm) metal pipe clamp worn like a ring on the middle finger. These designs had a small extrusion on the underside that kept the razor from changing angles drastically while against the skin. More round designs followed; however, teardrop shapes soon emerged. These placed the razor at the front of the device and more readily suggested how it should be used.

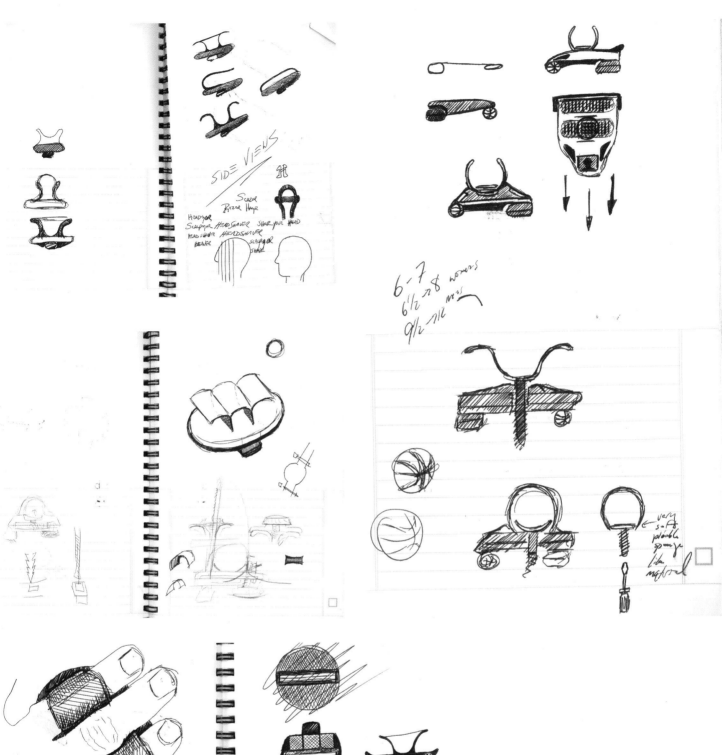

SIDE VIEWS

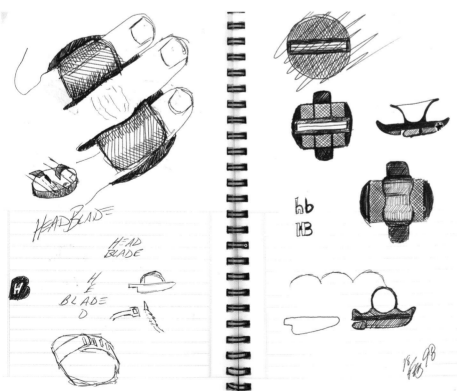

HEADBLADE

HEAD
BLADE

BLADE

hb
HB

Todd Greene began his design explorations on paper as he considered the ways the human hand could interact with the head.

Greene brought in Richard Jarel of Jarel Designs to perfect the design and make resin prototypes. Then, Roger Musser created the final model from which the product mold was made. "None of this was done using a print or three-dimensional model. [Musser] is a master moldmaker," Greene says.

One design challenge was the razor's pivot. Large razor companies had their own, but, of course, they were proprietary. Designing his own pivot, while a possibility, was too costly during the development stage. Finally, Greene discovered a German manufacturer that made an adapter that allowed German razor handles to be fitted with razors from major manufacturers. Greene's finished product was designed to hold the adapters.

Since its launch, the HeadBlade has met with almost unmatched consumer acclaim. It has been featured in the *Los Angeles Times, Inc.* magazine, *Sports Illustrated, Entertainment Weekly, Playboy,* and *I.D.* magazine, just to name a few diverse publications. Even better, being bald is fashionable today, thanks to Michael Jordan and other celebrity chrome-domes. Through his Web site and with virtually no paid advertising, Greene sold more than $25,000 of the $15 razors in one month.

"It's so simple, and it makes sense," says Greene. "There is something cool about its simplicity. By making the HeadBlade a piece of art worthy of display, we find more people inclined to shave and be proud of it. It validates the act of head shaving."

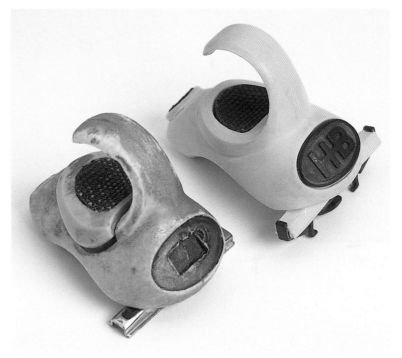

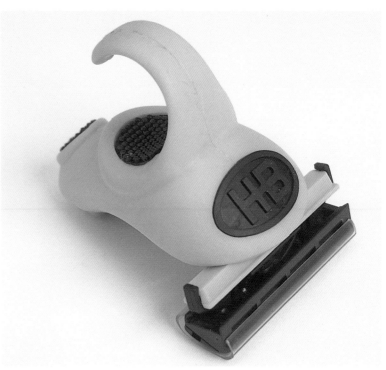

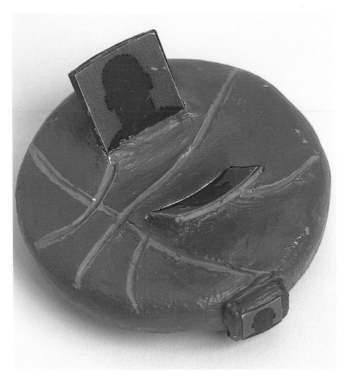

In 1998, Greene made the first HeadBlade prototype from clay. The original design was a round disk with 2.5" (6cm) flanges roughly 1" (3cm) apart protruding from the top. The disk slid around the middle finger and ran over the skin with the fingers touching. This design was not effective when wet.

Above: Later prototypes introduced an adjustable ring that fit more finger sizes. (Greene asked a jeweler for the highest and lowest ring sizes that should be accommodated.) The blade was also moved forward on the underside, and the extrusion was made larger to ensure the proper angle against the skin.

Below: Here, the body was elongated for a natural base on which to rest the index and fourth fingers. It became easier to sense the direction in which to push. The blade was moved to the front of the body, the extrusion to the back. The natural weight of the razor now yielded a clean shave with only a push.

Product packaging and promotion add to the HeadBlade's sense of style. The instructions on the back panel couldn't be simpler: "Lather head, slip middle finger through ring, shave."

Flexible Footwear
Imagine **support shoes** without arch supports, shanks, elevated heels, heel counters, or toe boxes! Are such things **really shoes?**

That was part of the challenge when designers set out to turn Jerry Gumbert's concept of footwear into reality. In addition to creating a superior product, the designers had to unlearn everything they knew about shoe construction.

Gumbert, president of Flexible Footwear Technologies Ltd., had a vision of footwear that works with the human body. He researched foot anatomy and shoes for years before concluding that he could develop something better and asked Design Central for help. The goal: to reinvent what we think of as shoes. Designers began by ignoring traditional shoemaking methods, nearly unchanged since the Industrial Revolution. Instead, they delved into Gumbert's research notes.

The designers did not realize, at first, that they were about to revolutionize footwear. They quickly discovered that shoes don't need their usual components to protect feet, absorb shock, and accommodate the elements. In fact, they found that these components could actually contribute to the foot ailments the shoe-wearing population complains about.

With the learning and unlearning process complete, the designers jumped into the conceptualization phase, hand-sketching various takes on flexible footwear and rejecting more than five hundred versions. They worked closely with vendors to create components and find flexible materials capable of absorbing shock and guarding against the elements. Next, they built three-dimensional models using a variety of materials over a last, the form on which shoes are built.

The result is a shoe that is flexible enough to wring out, literally. The old way of thinking is gone. Traditional shoes have an arch support, a rigid member that prevents the foot from flexing and expanding. If a foot doesn't expand, the shoe doesn't have to move and expand with it. Without the arch support in traditional shoes, your toes would run into the end of your shoes. Gumbert and Design Central based Flexible Footwear on how people walk barefoot on sand, where the foot naturally flexes and expands. They built the shoe to accommodate the foot's four arches, allowing for unlimited flexibility.

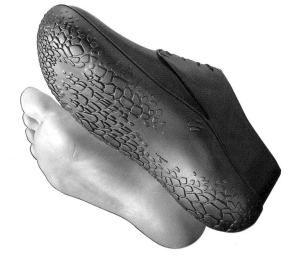

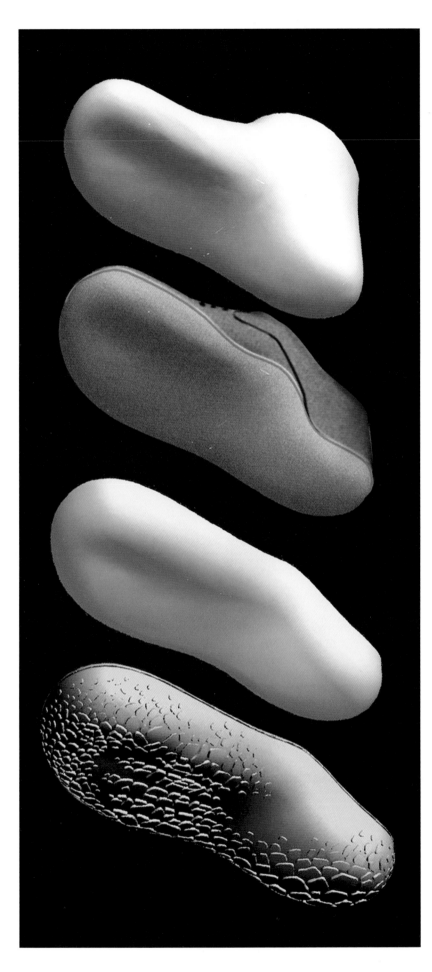

In fact, Flexible Footwear shoes allow a full range of motion and are designed to fit a foot like a glove or a sock, providing movement in every direction. Their tread pattern reflects the anatomy of a foot—bigger bones (treads) are located in the heel and smaller, more numerous bones in the front. The heel is designed in a neutral position. The shoes promote what designers call a barefoot gait.

Throughout most of the design process, few computer tools available to the designers allowed the creation of free-form, undulating shapes. "The shoe was complex, and some of the early computer tools had limitations that wouldn't allow us to do everything we needed," says Timothy A. Friar, vice president of Design Central. When the team was ready to turn the prototype into a mass-producible product, computers were finally integrated into the process. Friar estimates that the project was completed half by hand and half on the computer. If the project were started today, he thinks they'd probably still do a lot of the work by hand because the shoe's organic shape would be tough to achieve on the computer. Once they arrived at the computer stage, however, it proved an enormous time-saver; designers generated as many as forty shoe sizes from one part using a proprietary process created by Design Central that takes into account that foot dimensions do not change proportionally.

Next, Design Central went to its vendors to create the tooling—which involved a learning curve. The initial rollout went to small retailers, then podiatrists, chiropractors, and apothecaries. "We took the product to market in a small way, and we're having it grow from there," says Friar.

Market reaction has been positive, especially among consumers seeking comfortable footwear that is body-conscious and earth-friendly. Friar credits the successful design to Gumbert's philosophy of holistic integration. "Everything is connected to everything," says Friar. "Change one material here, and it affects something else."

As for the firm's partnership with Gumbert, Friar adds, "We've become a conduit for the concepts of a visionary. [Jerry is] singularly devoted to this product and this concept. [He's not] looking for a payoff but to make a difference to humankind, which is phenomenal. He has an expanding energy bubble around this concept. We use our professionalism without mandating [or] imposing style or fashion. If we were to do that, we'd ruin the product."

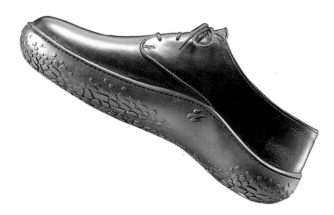

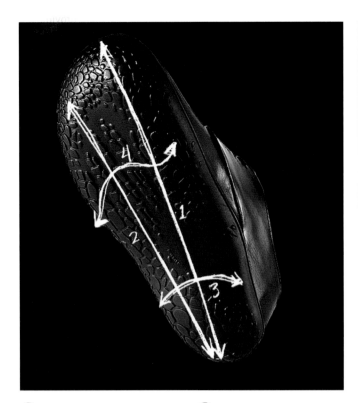

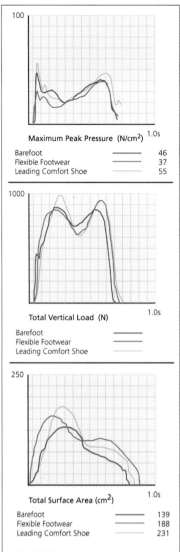

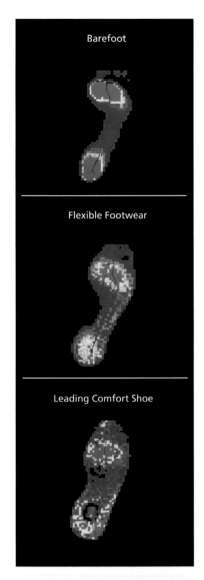

100

Maximum Peak Pressure (N/cm²) 1.0s

Barefoot		46
Flexible Footwear		37
Leading Comfort Shoe		55

1000

Total Vertical Load (N) 1.0s

Barefoot		
Flexible Footwear		
Leading Comfort Shoe		

250

Total Surface Area (cm²) 1.0s

Barefoot		139
Flexible Footwear		188
Leading Comfort Shoe		231

Barefoot

Flexible Footwear

Leading Comfort Shoe

⬙ Designers constructed the shoe based on the foot's four arches, each of which needs to be accommodated. However, they rejected the rigid arch support found in traditional shoes. Instead, they built a shoe with four nonrigid arch supports that allow for unlimited flexibility.

⬙ The heel is not raised; it is designed in a neutral position, as if standing barefoot. The idea is for the design to promote a natural gait—what designers call a barefoot gait.

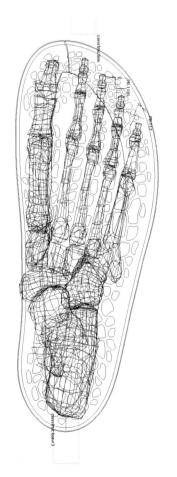

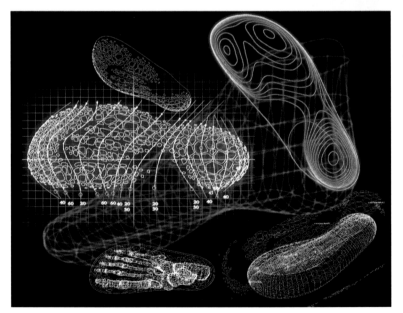

⬙ The shoes' treads pattern features larger treads at the back of the foot and smaller patterns at the front. This reflects the anatomy of a foot—bigger bones are located in the heel, where there is less motion than at the front, where bones are smaller and more numerous.

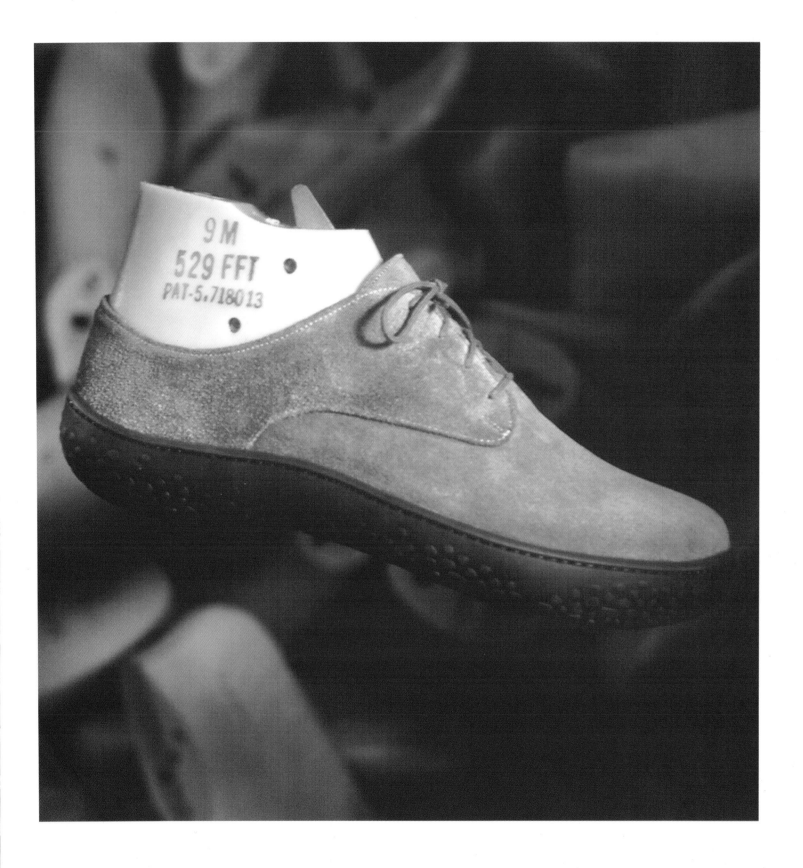

iax™ Running Watches Imagine running

ithon. You're still **inside the pack,** but you're

ide and are starting to pull ahead.

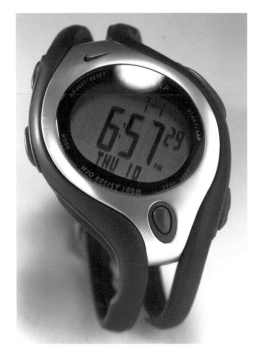

⟨⟩ The classic Triax™ 250 (above) is the first in the Nike line of innovative runner's watches. A huge award-winner and attention-getter, it spawned the Triax™ 300 (below). The 300 is more open and fluid around the wrist, improving on the ergonomics of the original.

You glance at your watch, which has been chafing your wrist for the past two miles, to check your time, but it has spun around to an awkward angle and its face is not visible. You look down again, breaking stride and accidentally elbowing your neighbor. Advantage lost.

That story, in a nutshell, is what's behind the design of the Nike Triax™ sport watch line. Already a leader in footwear for running enthusiasts, Nike decided to develop a watch especially for runners, one that was comfortable, secure, durable, and easy for the runner to read while moving. Further, it had to look great, so the watch could be a regular part of the runner's lifestyle, on the track or off.

With no in-house design department for watches at that time, Nike asked Astro Products of Palo Alto, California, to consider the problem. The watch's display was the firm's main consideration from the beginning, says design director Rob Bruce. "Prior to the Triax™, there were a handful of LCD watches that were not sport watches. They were styled for sport in terms of color and form, but they were not suited for reading during a sport," Bruce says.

That the watch would be used outdoors was another large consideration. Everything pointed toward the need for an unusually large display, even though this is contrary to ordinary watch design, in which the goal is to make the device small and sophisticated. Rather than positioning the display parallel with the arm, the designers wanted to cant the display 15 degrees so that wearers need only raise their arm slightly to view it.

Seiko was Nike's manufacturing partner for the project. To get the designers started, the watchmaker gave Astro an off-the-shelf unit with a larger-than-usual display. The first thing Astro designers noted about the sample watch was the symmetrical placement of buttons around the watch face. Bruce, a runner himself, knew that this would have to be changed for the Triax™.

"Priority number two was navigation," he says. "It needed what we called blind navigation. I don't want to stop running and have to look down at the buttons to see which one to push. It has to be intuitive."

The logical design was ergonomically sensible. First, place the start/lap button away from the stop/next button, then set the adjust/reset button on the opposite side. There's nothing worse than completing a race or run and then accidentally erasing one's time, says Bruce.

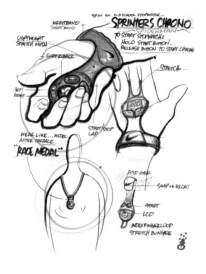

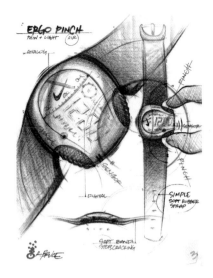

Opposite the start/lap button is a rubberized anchor for the runner's thumb. As the user grasps the watch to hit any button, his thumb is able to exert sufficient opposing force. Astro included nubs on the anchor so that it is easy for the runner in motion to place his or her hand in exactly the right spot. It's like the little nubs on the f and j keys of a keyboard, Rob says.

The thumb also held a lot of sway over the actual shape of the watch. The final design's distinctive S shape gave priority to the digit in the grip zone. The design is also simple and clean, which is important for a runner's watch, says Rob. "The styling cues I wanted to go after were all talking about the state of running and what the sport is all about. It's a minimal sport," the designer points out. "You don't have to have skis or a basketball or anything like that. When a runner is in his zone, the movement is fluid and stripped to the bare essence. That's why this watch had to be aerodynamic."

Another feature, crafted specially for the athlete, was a sweat management system. Not only is the watch sweat resistant, the designers included small ridges on its back that allow small currents of air to reach the skin of the wrist, a crucial cooling spot for the body.

From a fashion standpoint, the final design has been well accepted: Various models have appeared in publications from *Vogue* and *Playboy* to *Wired* and *Popular Science*. From a functional standpoint, both the watch and the very concept of a runner's watch have been a hit. Imitators are everywhere, Rob notes. "I find that flattering," he says. "It shows that the work we did has been validated, that it wasn't just a styling exercise."

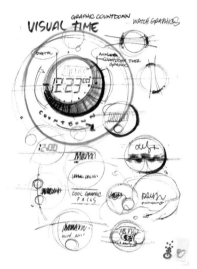

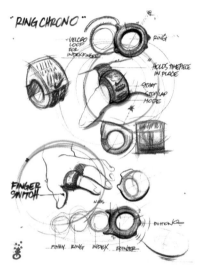

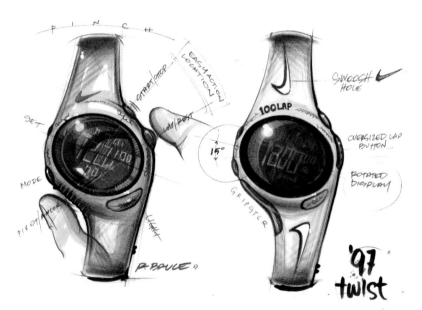

◁ These sketches explored the general concept of what a sports timing device could be. The Astro designers considered rings that needed only one hand for operation. They also looked into a palmlike handheld device—sort of a Spiderman design. The ergonomic features of the final design started to emerge at this stage.

◁ These sketches are more specific to the assignment of developing a runner's watch, says Bruce. The designers had learned earlier that an oversized display was a key distinguishing factor. These designs built on that feature while adding the ergonomic asymmetry.

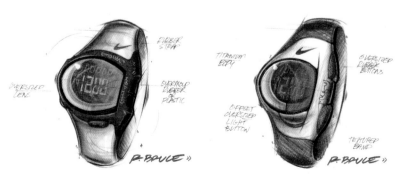

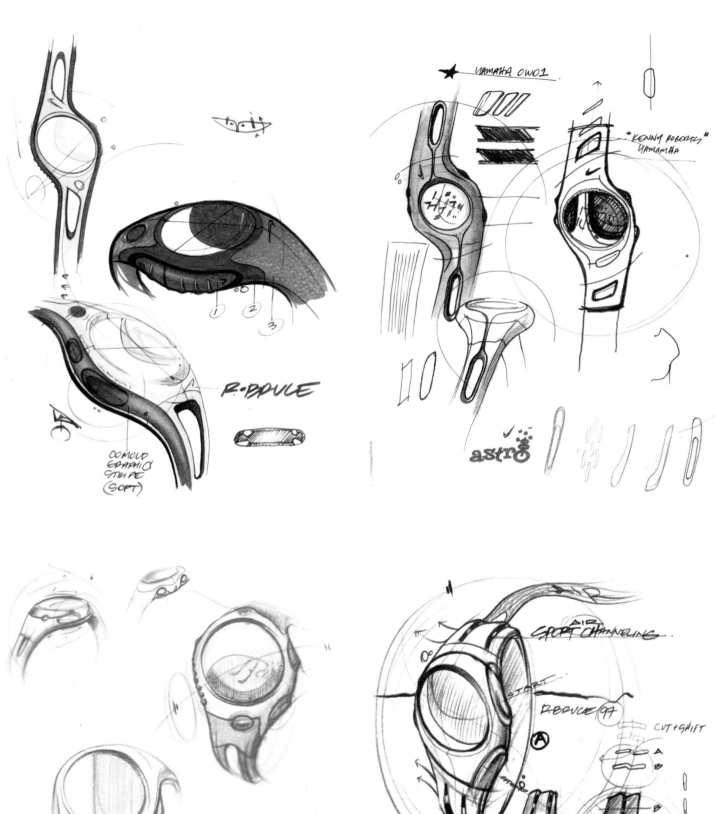

R·BRUCE

COMOLD
GRAPHIC
STRIPE
(SOFT)

★ YAMAHA OW01

"KENNY ROBERTS"
YAMAMHA

astro

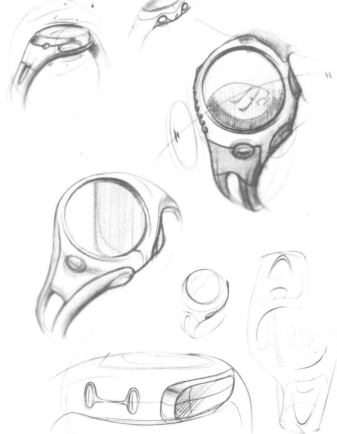

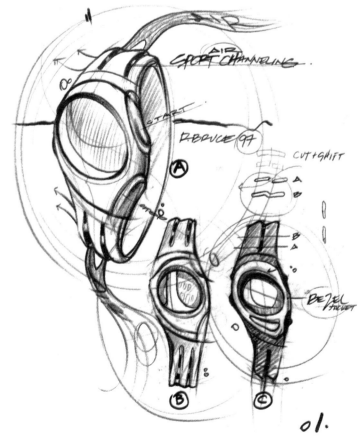

AIR
SPORT CHANNELING.

START

R·BRUCE 97

CUT + SHIFT

BEZEL
TICKET

01.

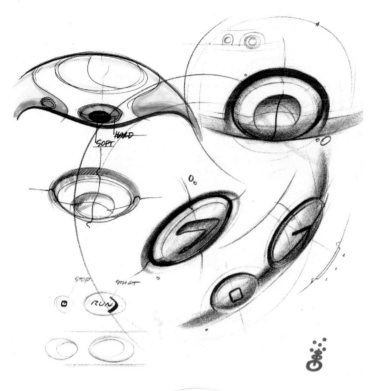

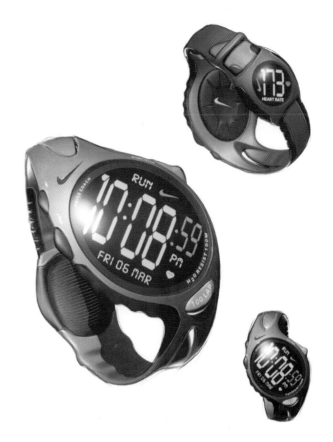

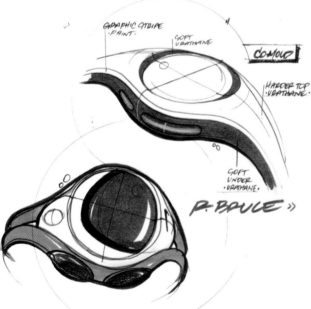

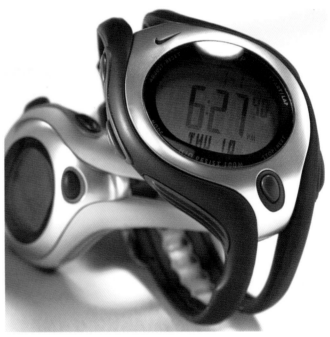

UNDERSIDE

"SWEAT MANAGEMENT"

FRONT

BACK

SIDE

FINS OF A MUSHROOM

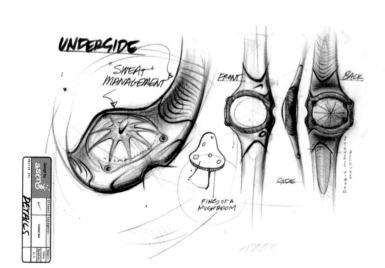

⟨ Left and opposite page: These drawings reveal exploration of the oversized display, ergonomics, grip zone, button navigation, air flow and sweat management, a one-piece integrated band and case, and more.

⟨ Above: This concept added a heart-rate monitor to the buckle area. Astro developed this to show Nike what could and perhaps should be incorporated in future products.

⟨ Below: The evolution of the Triax™ 300 line.

SnoWalkers
The inspiration for SnoWalkers **snowshoes** came at a **blow-molding** plant in Buffalo, New York, during a spring **blizzard** in 1996.

⊘ "We realized that we needed not just one snowshoe, but four: two children's snowshoes and two adult models," says designer Jim Bleck. CAD tools were used to modify the design for different shoe sizes. Keeping all fastening points identical for all four models helped keep production costs down.

"I was watching kids' sleds drop from a mold while the snow piled up outside, and the idea of a plastic snowshoe popped into my head," says James Bleck, president of Bleck Design Group in Chelmsford, Massachusetts. "A plastic snowshoe could be low cost, have a unique design, and possibly function even better than conventional snowshoes." He filled several notebook pages with ideas, but the notion sat dormant for months.

The next winter renewed Bleck's interest. To determine the feasibility of his idea, Bleck started with initial design concepts and production cost estimates. "Before spending significant time on development, I checked the current market," he explains. His research confirmed that the snowshoe market was growing fast. About 5000 pairs sold in 1990, but the market grew to 35,000 in 1993 and to nearly 250,000 units in 1996. Almost all the shoes on the market had aluminum frames with Hypalon decking or traditional wood frames. There were clear market leaders, especially at the higher-end price of $150 to $350, and the least expensive adult shoes cost about $130. Bleck felt that a shoe retailing for $59 to $89 would do well.

Bleck did a patent search and found that almost all of his initial concepts had been tested before. However, most of the ideas lacked real effort to reduce costs. During the patent search, the team also tested basic concepts for blow- and injection-molded designs. Vacuum-formed polyethylene prototypes were fabricated and tested for traction and control in a variety of snow conditions.

"Now that the concept was near definition," says Bleck, "I took the advice of several other designs firms that had attempted to develop products and brought in business partners." A new company, Outtaboundz Sports, Inc., was formed to develop the product. The new team did comparative testing with existing snowshoes and spoke with a few selected retailers. It also provided estimates of production costs, retail prices, and market volumes. Combining the design work with the business plan brought into focus the real design problem: cost.

Bleck elucidates the cost challenge: "We needed to minimize parts and labor in assembly while creating a secure binding attached to a snowshoe deck that had extremely good grip on ice and snow. We also realized that we needed two children's snowshoes and two adult models, with a focus on a the family market." Interviews with hikers indicated that reducing weight was crucial, so the team set out to develop the lightest snowshoes possible—3.5 pounds per adult pair, 1.5 pounds per child pair.

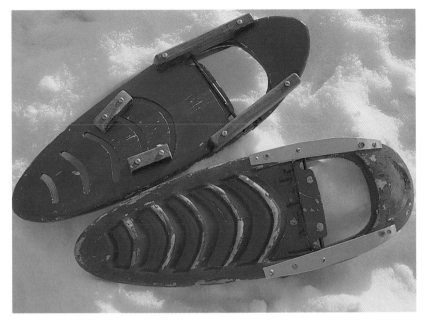

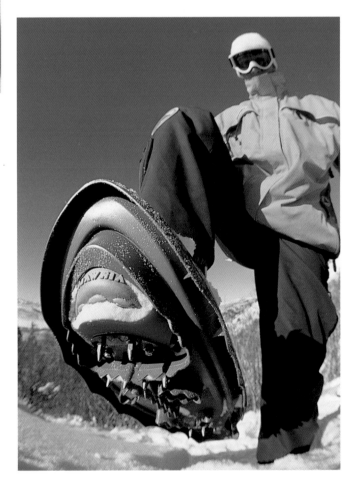

In late 1996, the final design effort advanced. Concepts for the form and different shoe sizes were developed and tested on children and adults. A binding system using a single continuous lacing system was perfected. The team checked costs continuously to assure low production costs.

The final design for the children's snowshoe, finished in December, comprised an injection-molded deck, one-piece binding, and riveted construction. The team applied for patents on the split deck, scalloped outer flange, and binding. Styling was critical during this phase. A beaver-tail design was preferred by "just about everyone" because it allowed for a more natural walking style."

Using advanced CAD tools, the design team completed a parametric design for the snowshoe, then slightly modified it for each shoe size. Production and assembly were simplified by keeping all fastening points identical, thus requiring just one setup for the rivet machine. The computer models were used to fabricate models in early prototypes. Testing the prototypes led to modifications. The binding was made easier to use. Parents wanted the snowshoe to be adjustable for their growing kids, so the U slots at the rear, which hold an elastic cord, were added.

The product line was finally available late in 1997, just making the Christmas sales season. Initial sales were brisk, especially during snowstorms. The designers continued looking for opportunities to improve the product. "After the season wrapped up," Bleck says, "and we attended several trade shows, we used what we learned to make design changes, including colors, hardware, and upgrading the plastic resins. We found that store buyers are more important than actual users. To meet their demands, we added a point-of-purchase display, and we changed much of the hardware to appeal to them."

⊘ Above: The first wooden prototype was based on the concept of blow molding the snowshoes. These were used for initial tests of shape and traction.

⊘ Below: The second prototype, also based on blow molding, was used to test the overall form for grip, the heel grips, which is the u shaped part on the deck, and to fabricate vacuum-formed models. Latter flanges were added to the wooden model to test flotation and a proposed size change.

⊘ Early research showed that a good grip was essential to a successful product. The design accomplishes superior grip with elliptical flanges and a scalloped edge that bites into a deeper layer of snow than a flat edge would.

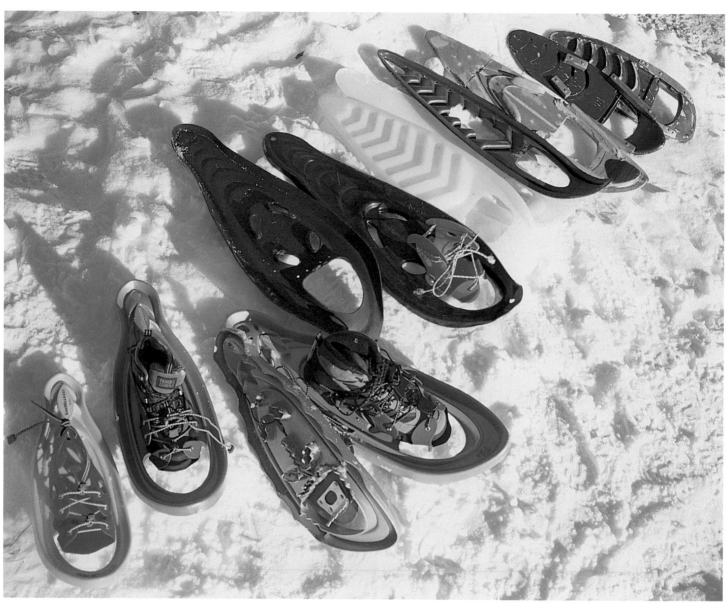

It's not often that designers answer warranty calls, but the SnoWalker's business model had the design team doing just that. "We had a few bugs to work out that first year," admits Bleck, "so, while we were apprehensive, hearing about problems was extremely enlightening. Customers always praised the SnoWalkers before asking for help. It was gratifying to hear how pleased they were with the product and its value."

Although functional design and cost minimizing were large parts of the design process, the aesthetic was likely the critical feature in the product's success. "Industrial design went a long way to sell the product," says Bleck. "We displaced the market leader in kids' snowshoes simply because our product looks like a cool, high-tech product." He continues, "In 1999, the product was featured in Wired magazine. It was amazing how many calls and sales we got from people simply because they liked the look of the product."

The prototypes represent the evolution of the product concept over a 2-year period, from initial concept through production.

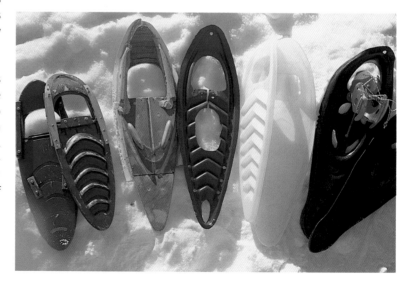

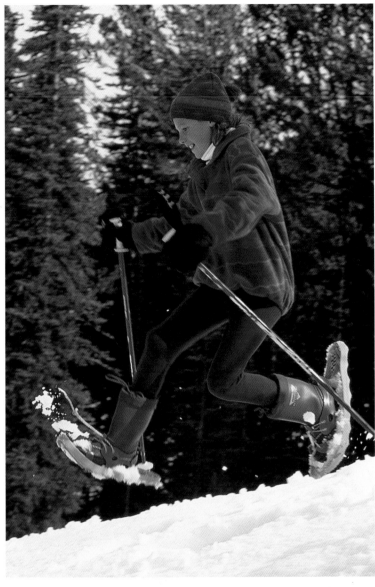

The patent-pending split deck allows the area under the foot to flex downward and outward, thus distributing stress and weight evenly. It is much simpler than traditional decks, has fewer parts, and is cheaper to manufacture. The designers also applied for a patent on the single-lacing binding system, which makes the snowshoe easy for kids to use.

Feedback from experienced snowshoers and novices to the sport is an important part of the SnoWalker story. Prototypes were tested with adults and children of all ages to improve the product.

Opposite page: The white plastic snowshoes are vacuum-formed models used to test the blow-molded concept. These were very light but not very durable and tended to take in water. Later they used the same wooden patterns to mold several single-sheet vacuum-formed Kydex prototypes. These proved to be very effective and led to next prototype. The dark blue and the black snowshoes are prototypes made on a prototype thermoforming tool. These were much larger (11" x 34") and were used to test the final traction design and perfect the binding concept. Approximately 25 sets of these were built to test bindings, traction, and materials and to show the concept to consumers.

Sportscope **Flex-Fit Bicycle Helmet** Consumers love a **perfect fit.** When they find it, they treasure it—witness the many threadbare pairs of jeans that **can't be parted with.**

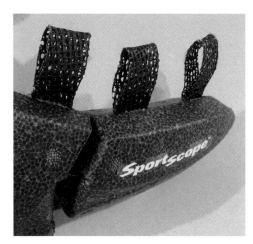

⊘ A close-up of the interlinked panels.

When Design Workshop, in concert with Biokinetics Ltd. and product inventor Rick Obadiah, president of Sportscope, Inc., developed a bicycle helmet that fits perfectly, it was clear the product was a winner.

A snug fit is an ongoing problem with bicycle helmets. Bicyclists don't bother wearing uncomfortable helmets, which compromises their safety. But offering helmets in many sizes and versions is a headache for retailers. Consequently, the market tends to offer five or six helmet sizes, from toddler to adult. They typically come with shim pads that allow individual sizing. Consumers fortunate enough to buy from a knowledgeable salesperson who can shim the helmet perfectly are guaranteed a good fit—at least until their head grows, as children's do. However, helmets often are purchased from mass-market retailers lacking skilled personnel, so buyers must shim the helmets to size themselves. As a result, they do it once—often improperly—and don't bother installing the shims correctly; sometimes they lose the small parts. Either way, the result is a helmet that fits poorly. Fitting problems are compounded when helmets are purchased through mail-order catalogs or Internet e-tailers, who typically experience a high rate of return.

The Sportscope Flex-Fit helmet, originally intended as a retailer's salvation only, solves these headaches for users and retailers alike. Obadiah patented an idea for a collapsible bicycle helmet that would save valuable shelf space and be easier to display and warehouse, then asked Biokinetics to develop the product. Biokinetics, in turn, retained Design Workshop to manage the industrial design. After researching the market, the team decided that mass-market consumers would deem a collapsible helmet unsafe and, while the helmet did change shape, it really didn't collapse enough to benefit the retailer.

However, all was not lost. "We were able to track the benefits and the inventor's technology to address market needs," says John Tutton, Design Workshop's principal. Research indicated that 95 percent of the population could be fitted with three sizes—toddler, child, and adult. "Biokinetics' sizing data told us we could cover the market with just these three sizes—and that these could result in a fit that was better than conventional helmets."

The idea was to modify Obadiah's collapsible helmet with segmented parts that could conform to the user's head. The design was limited to six parts—one main component and five peripheral panels—and retained the appearance of a traditional bike helmet. "If it looked too far out or different, people were not going to buy it," says Tutton. "People aren't going to spend the time to educate themselves on this. When you're in Sears, Wal-Mart, or Toys 'R' Us, you'll go to the product you know. So we had to keep this in familiar territory."

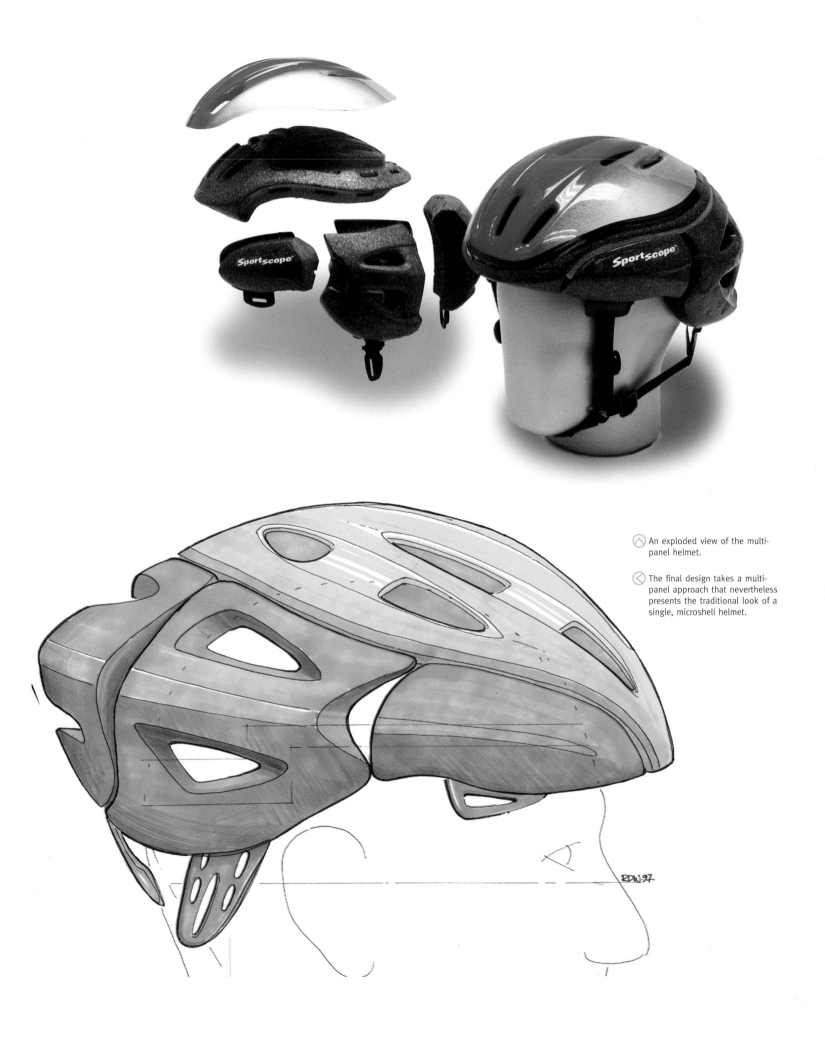

⊗ An exploded view of the multi-panel helmet.

⊗ The final design takes a multi-panel approach that nevertheless presents the traditional look of a single, microshell helmet.

Designers launched the design process by reviewing the inventor's original ideas. "We quickly saw how hard it would be to make the user comfortable with this product. The segmentation was both our biggest benefit and our biggest potential problem," says Rob Watters of Design Workshop. Designers sketched ways to make the segmentation look appropriate, interesting, and valuable but jumped into making three-dimensional models by cutting existing helmets with a bandsaw and reassembling them with duct-tape hinges. Concurrently, Biokinetics tested various materials and provided designers with valuable data on the amount of material needed for impact testing, how large vents could be while maintaining safety standards, and more—a communication that continued throughout the design process.

Once designers had a feel for how the helmet would look, they created visual models, sized them, and cast them onto head shapes. These models looked realistic but were very heavy. Test consumers were confused, so designers created lightweight visual models to improve consumer feedback accuracy.

As designers got safety standard results from lab testing, specific areas of the product were changed. Says Watters, "We were continually going back to the drawing board, sketching, figuring out solutions, and modeling solutions as this real-world information was coming in." Consequently, the helmet went through numerous iterations during its eighteen-month design process.

The manufacturing process imposed another layer of constraints. "We have a complex helmet here, just in terms of the number of parts. How were we going to mold this? How were we going to make this at a mass-market price?" says Watters. To contain costs, designers linked the five peripheral panels so they could be manufactured from one mold—in essence, five products were preassembled. Designers made increasingly small changes based on information from testing and feedback until they arrived at the final product.

The result is the Sportscope Flex-Fit helmet, in three sizes, which adjusts with straps to make it snug under the chin—a simple process that has made it a winner with consumers and retailers. Moreover, its simplicity has opened new sales avenues among mail-order, and e-tailers, who offer the product knowing it provides a perfect fit.

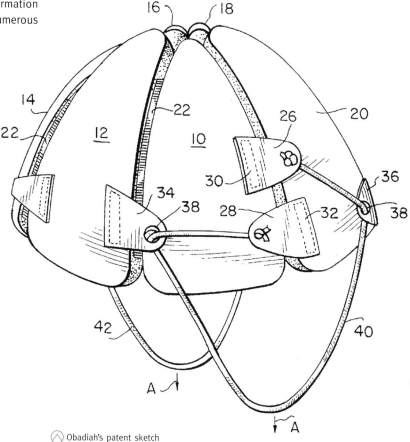

Obadiah's patent sketch for his original invention.

⬡ Above: Designers' early renderings sketched concepts that tackled the dominant issue: how to manage the segmentation so that it looked appropriate, interesting, and of value.

⬡ Below: Designers addressed issues of incorporating smaller vents and extended coverage into the toddler-size helmet in this series of sketches.

TR5 Stationary Bike

Think of a stationary exercise bike and a vision of a **clothes rack** typically comes to mind. Why do **stationary bikes** meet this fate so often?

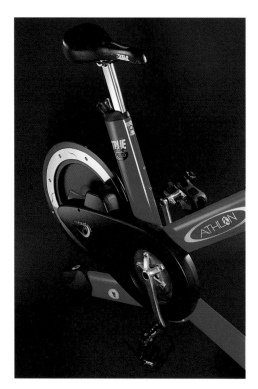

Side view of the TR5 showing the eddy current brake system, seat-adjustment system, rear suspension, and monostay.

They don't have cadence, the rhythmic flow or movement that one feels when riding outdoors, according to designers at Strategix I.D., Inc. When the firm set out to create the TR5 exercise bike, they built in cadence, which is just one of many features that make the TR5 workout far from static and boring.

Initially, avid bicyclist and part-time inventor Pete Schenk of Park City Entertainment approached Strategix to create a bicycle platform that would allow side-to-side motion. Because creating a platform that would work with any bike was a complex proposition, designers suggested a more efficient approach—and more practical, in terms of marketing to the fitness industry: Start from scratch and create a stationary bike that moves as Schenk envisioned.

The design team, all enthusiastic bikers, instinctively knew what Schenk was after. Stationary bicycling gets boring because the bicycle doesn't respond to the rider. The designers set out to simulate the actual riding experience. They measured bike riders to determine power, resistance, and balance minimums, and observed people riding indoors and out. The result was a wish list. They wanted the TR5 to be open and quickly adjustable. "It had to allow cyclists to maneuver the way they do outside—standing, sitting, sprinting, cruising, and just riding," remembers Bill Clem of Strategix. "It had to be quiet. It had to be real. Bikes don't sit still; they react to the cyclist." Further, "serious riders wanted to be able to stand on the pedals as if they were racing up a mountain. They wanted to find the same resistance every time they got on the bike," adds Clem.

The team created rough sketches based on a configuration, suggested by the research, that addressed fit, resistance, forces, and feel. Next, they made a full-size model by welding new parts on an existing bicycle frame and eliminating others. They quickly realized that this approach wouldn't work because the existing bicycle frame's geometry couldn't be adapted to an indoor application, nor did it have the ergonomics they wanted.

They used CAD throughout the process to build a rectangular model and to refine the design. As soon as the design was close to their original definition of the bike, designers created a prototype and took it to experienced mountain-bike enthusiasts, novice bikers, and stationary-bike users for testing. "It was crude, but it got us what we wanted," says Clem. "People got really excited about the ergonomics." With their feedback, Strategix made more modifications and built the final prototype eight weeks later. After completing a minor prototype run of six bikes, conducting more testing, and working on the fixtures and tooling, the bike was ready for its first pilot run, consisting of 1200 hours of

⊗ Initial CAD layout of the TR5, with red marks indicating the measurements of riders of different sizes.

⊗ Internal CAD view of the seat-adjustment system.

life testing completed in two weeks. The results were good. They produced a second pilot run of 160 bikes for sales and marketing; from there, the bike went into production. From start to finish, the process took approximately ten months.

If you think the bold red bike looks good standing still, wait until it's in motion. To maximize movement while making the bike feel safe and stable, Strategix created a three-point pivoting suspension system with a central balance point that causes side-to-side motion, and a rear balance point that absorbs forces for a smooth ride. The resistance system is an eddy current magnetic braking (ECB) system within a flywheel that is smooth, quiet, and consistent. However, "neither the fitness industry nor the physics department understood how ECB worked in practice, so implementing it took significant experimentation and off-the-wall thinking," remembers Clem. "The result is a system that performs consistently from the outset and resists a load of almost 2 1/4 horsepower" as compared to a normal experience bike, which resists about 1/2 horsepower. Finally, the bike has an eccentric belt-tensioning system that allows for easy access and accurate control of the belt length.

The bike is constructed of extruded aluminum for utmost flexibility—flexibility that extends to the user, who can easily customize the bike—for instance, a higher seat. "The pedals, seat, handlebars, and stem can be found in any bike shop, so you can change the feel of the bike in ten minutes with the components you prefer," says Clem. "This makes the TR5 more than just a stationary bike; it makes it your bike."

Clem clearly enjoys his work, which is one of his secrets to successful design. "You have to love what you're doing and want to solve someone's problem," says the man who loves mountain biking as much as his work, which added to his enthusiasm for the TR5 project. "We all bike and understand the process of riding a bike. We know exactly what an individual goes through when experiencing these motions—how they feel, what they react to, what they like. It's amazing to look at a product from the standpoint of the person who is going to use it. Probably the biggest secret to making great products is understanding the users more than you do the product. You can always design a new product, but understanding what people do with it or how they use it is far more important."

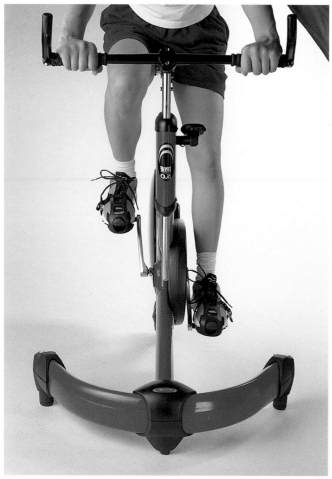

⟨⟩ Above: CAD image of the rear view of the TR5.

⟨⟩ Below: A detailed view of the production-eddy current brake system.

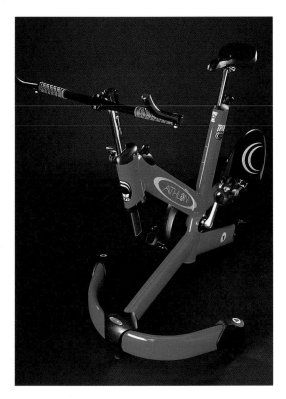

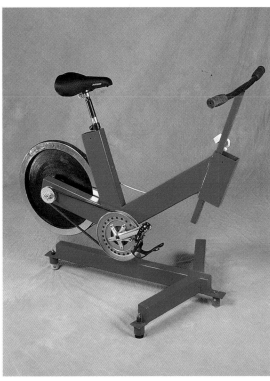

The finished TR5 production model (left). Note how it changed from the first-generation steel prototype ergonomic frame with prototype flywheel (right).

Exploded view of the TR5.

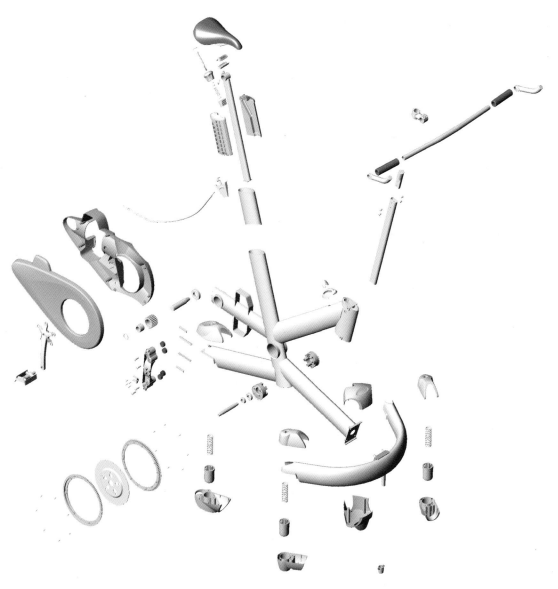

Hobie Mirage Kayak As enjoyable as **kayaking** is, designer Greg Ketterman of Hobie Cat can point out plenty of ways to make it **even better:**

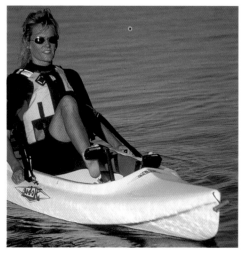

The Mirage is offered in a number of colors and provides an excellent alternate boating experience.

The weaker muscles of the upper body are used for propulsion, and the hands are used for paddling and so are not free for other tasks. The paddle constantly drips water on the user and is a less-than-effective steering tool. Finally, the lower body gets no exercise.

All of these points led Ketterman to a kayak design so innovative that it opened an entirely new category of boating. In his design, the kayak is powered by the legs and feet, which push a pair of pedals back and forth. Through an ingenious mechanism, this motion is transferred into the side-to-side motion of a pair of fins underneath the kayak that swing in opposite directions. The fins are flexible. When water pressure hits them, they twist and flex and take on the shape of a propeller blade. Ketterman compares the process to the way a penguin propels itself through the water.

"The Mirage is smooth, quiet, and compact," he says. "You will be amazed at how close you can get to wildlife because you are not making splashing noises with a paddle. You will be amazed at how easy and pleasant it is to cruise along with someone and have a conversation, because the boats can touch without the paddles getting in the way. You can take pictures, fish, or just relax."

The penguin's feet are probably the most like those on the Mirage, as they essentially rotate, but other sea creatures move using the same concept of a fin shifting from side to side. The movement is extremely energy efficient.

The key to efficient boat propulsion is to create as little turbulence as possible. Turbulence equals wasted energy, but in order to create a driving force, some water must be pushed backward. A small amount of water can be pushed back quickly, or a large amount of water can be pushed back slowly. The latter is much more efficient. The way to maximize this efficiency is to maximize the size of the propeller, because then it will turn slowly and act on the largest amount of water.

The fins on the Mirage mechanism are analogous to a large, slow-turning propeller. One stroke of the fin, or one half-cycle of the Mirage mechanism, acts on about 10 cubic feet of water. By comparison, a paddle works on a much smaller volume of water—and the paddle creates turbulence. "The water after the Mirage passes," Ketterman says, "is much less turbulent than after a paddle kayak goes by."

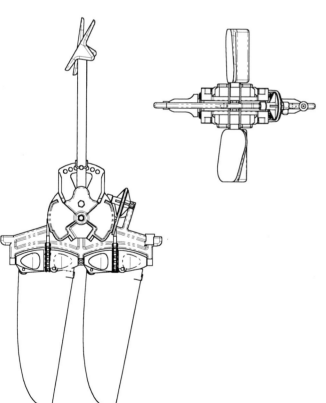

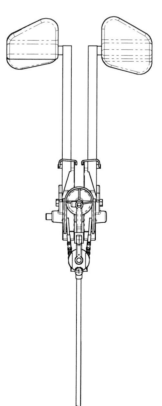

⬦ Above left: This original concept sketch illustrates the initial idea of building the mechanism into the hull of a boat so there was no structure holding the two shafts in place. The plan was to use cables to drive the two drums that the fins were attached to.

⬦ Above right: This computer drawing is the final version of the design that is now in production. The design evolved to include the chain drive on the bottom, adjustable pedals positions for different size people, and a fifth pulley, which dramatically reduces the stress on the mechanism.

⬦ This computer generated 2D orthogonal drawing shows a side, front and, top view of the mechanism. The drawing depicts an injection molded spine (currently cast in aluminum) and sprocket (currently cast in stainless steel), both of which are features the company aims to make a standard over the next year.

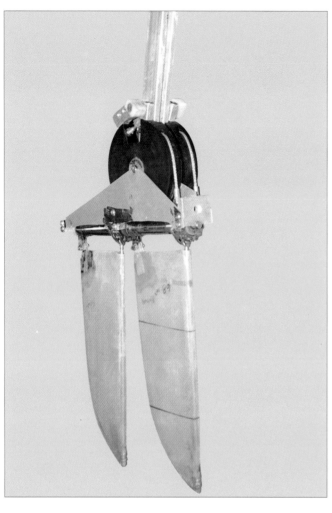

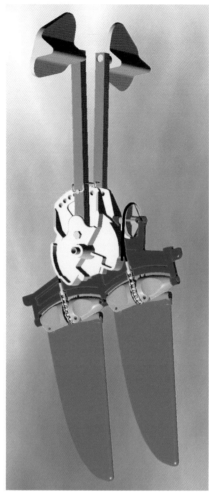

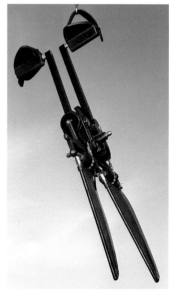
Far left: The second prototype of the mechanism with the fins attached. This differed from the first model in that it could be pulled in and out of the hull for transportation or maintenance.

Near left: Soon, the cable drive was replaced by a chain-and-sprocket drive, similar to those on bicycles. This was the system that was eventually built into the final production model.

Several views of the current mechanism.

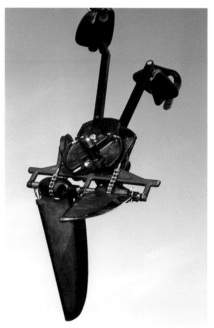

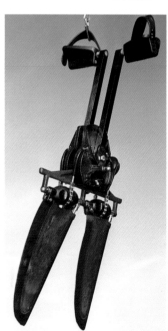

The fins work like the wings of an airplane, developing force or lift in a direction perpendicular to the motion of the fin; this drives the boat forward. To do this efficiently, the fins' design is crucial; it was a major portion of the Mirage's development process.

The other main part of the design process was the development of the unique Mirage mechanism. "I have always known the benefit of the additional strength in the lower body and felt it was natural to figure a way to propel a kayak with the legs," Ketterman says. "I had seen attempts at converting the back-and-forth motion of the feet into a rotary motion of a propeller shaft with a clutch bearing. Clutch bearings are clever things that turn only one way on a shaft." From this, he got the idea to attach a propeller with flexible fins that provide forward thrust from a shaft oscillating its direction of rotation. Two counter-rotating, flexible propellers offset torque from each other. "I calculated that one stroke of the pedal ought to be about the right amount of motion to turn a shaft 180 degrees," he says.

Because the human body is designed to propel itself with the muscles of the lower body—through walking, running, biking, rollerblading, skiing, and so on—the natural question is, Why aren't there more pedal-powered boats? Up to now, the answer was that they were just too complicated to produce. The Mirage design, however, simply converts the linear motion of the feet into forward thrust.

"The real challenge was to make the fins durable and affordable, but the concept has always worked well," Ketterman says.

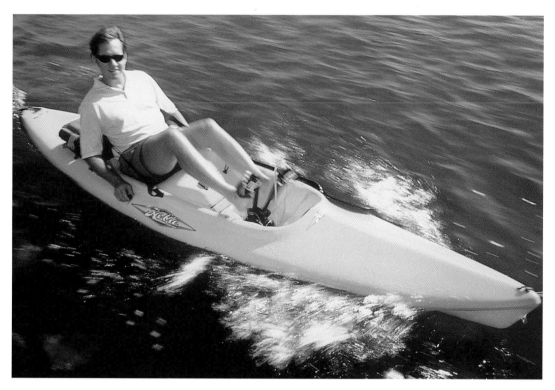

Designer of the Hobie Mirage and kayak enthusiast Greg Ketterman enjoys a spin in his new creation.

Given the popularity of the original model, a tandem Hobie was created next. Unlike on a tandem bicycle, which requires both riders to pedal in unison, this tandem's drive chains operate independently. The person in back steers using two handles on the right side of the boat.

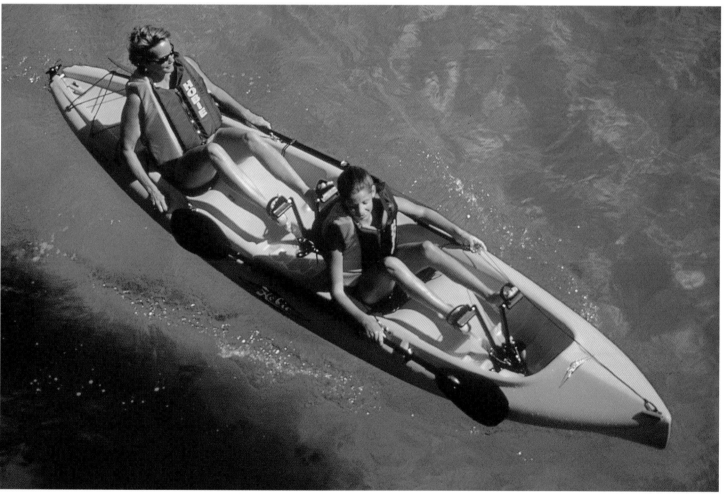

Sea-Doo Challenger 1800

"We are always looking for **new ventures** for **recreational watercraft**," says Denys Lapointe, vice president for **product design** of Bombardier's Recreational Products division.

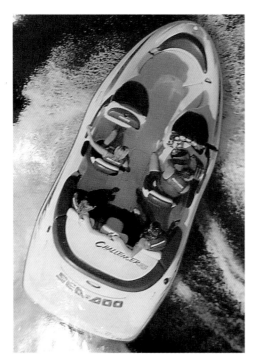

With jet-propelled twin engines and contemporary styling, the 18-foot (5.5 m) Challenger 1800 is in a class all its own. Its versatility is key to its success—it is strong and nimble enough for a day of water sports and safe and comfortable enough for a leisurely cruise with the whole family.

"We reintroduced our personal watercraft concept to the public in 1988. As the market grew, we looked for new opportunities to expand on its success, moving to bigger boats."

The calculated risk paid off promptly. The 14-foot (4.3 m) version was a commercial success and won a Gold Award from the Industrial Designers Society of America in 1996. Having overcome this product's challenges, Lapointe and his team of designers, Pierre Rondeau and Greg Martin, designed an 18-foot (5.5 m) recreational jet boat large enough for a family, yet retaining the sporty image usually associated with smaller vessels. Lapointe likens the Challenger 1800 to a family sportscar—strong and speedy enough for waterskiing or towing, with precise handling for easy maneuverability, yet safe and comfortable for a family picnic or leisurely cruise.

"The Challenger 1800 is designed to be radically different," explains Lapointe. "Our challenge was to reinvent the 18-foot (5.5 m) recreational boating segment with a jet boat that offered the styling, features, performance, and safety available only on much more expensive boats. The intended user was a first-time boater or someone moving up from a smaller boat."

The first step was to develop an image of the customer and his or her needs. Lifestyle boards were compiled to generate information about the intended audience. A preliminary product definition outlined the project scope with respect to both performance and design. The design team then visited boat shows to learn more about their target market and competition. "We placed ourselves in our customers' shoes," says Lapointe. "What are customers looking for? What are the turn-offs? What do they want that doesn't yet exist?"

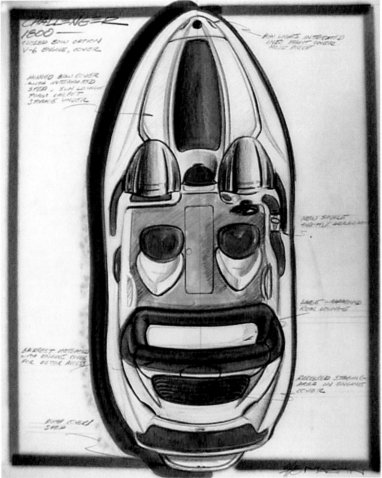

With a strong grasp of the overall objectives, the designers generated around fifty sketches representing various alternatives. These first sketches were monochromatic, using simple markers and pastels to illustrate the ideas. Lapointe explains that this not only saves time but also enables each concept to be evaluated at the same weight, without the influence of color.

The team developed mechanical and ergonomic packages of the four or five sketches they liked best. They presented these proposals and industrial renderings, as well as two clay models, at a product review meeting with the division president and representatives of marketing and engineering. As with most products, the Sea-Doo Challenger 1800 blended concepts from several proposals, taking the bow of one, the seating arrangement of another, and the overall styling of a third, for example.

The next step was to develop what Lapointe calls a "three-dimensional, full-size master plug to validate hypotheses and explore different things." Three generations of working prototypes were used to verify and refine such basic elements as the seating arrangement, ergonomics, functional layout, mechanical layout, and hull behavior. Next, the designers considered the visual design, adding color and fabrics to complete the dynamic look.

The result is a jet boat uniquely positioned to satisfy the family sports market, bridging the gap between safety and sportiness. The introduction of twin pumps rather than propellers make the boat safe for recreational activities. In addition, the boat's unique layout accommodates five well-seated passengers and two more at the open bow. Using bucket seats rather than benches fosters a strong feeling of safety as well as comfort. The stylish and functional grab arms are positioned for safety and enhance the boat's profile. The twin windshields offer wind protection and good visibility, and accent the sporty styling and performance feel. Quick acceleration for waterskiing or toy pulling is made possible by the twin 800 cc engines and formula jet pumps. The design team also enhanced the boat's versatility with amenities such as ample storage; there is a footlocker for water skis and space under the windshields and at the bow for the other gear needed for a day on the water.

Using the preliminary description of the product's basic performance and design objectives and information about the desired clientele, the design team made monochrome ideation sketches. Each concept thus could be evaluated at the same weight. Different features from the sketches seen here were incorporated into the final product.

The appearance of the Challenger 1800 speaks clearly about the boat's function. Through the use of blended muscular forms that flow through an hourglass shape and integrated rear wing, the Challenger 1800 conveys a sense of motion and performance. The deep green color and careful use of interior materials and textures adds sophistication and elegance. "We broke the paradigm, from a styling perspective," remarks Lapointe. "It was risky. We felt we were on the right track, but we weren't sure how the market would receive it."

"We have a saying," adds Lapointe, "'La chance sourit a ceux qui osent,' which translates loosely as 'Luck smiles on those who dare.'" Luck has. The Sea-Doo Challenger 1800 has not only won design awards but also, in just two years, became one of the best-selling boats in North America. For Bombardier, the Challenger now serves as a platform for other products, including the Sportster 1800, a 20-foot (6.1 m) family-oriented version introduced in 2000.

This clay model, produced at a scale of 1:2.5, helped the team look at the proposed form of the design before investing in a functional mule. Two such models were created and included in the presentation of ideas.

This full-size functional mule was created to look at and refine ergonomics, the seating arrangement, and the functional and mechanical layouts. The team went through two generations of working prototypes before combining these aspects with the desired aesthetics.

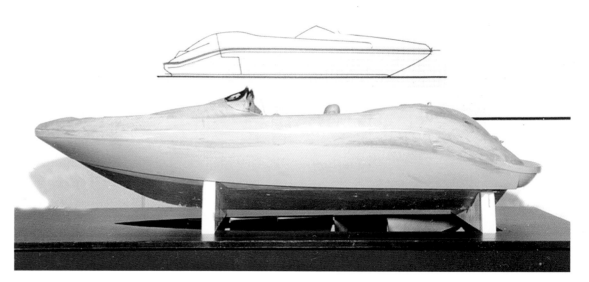

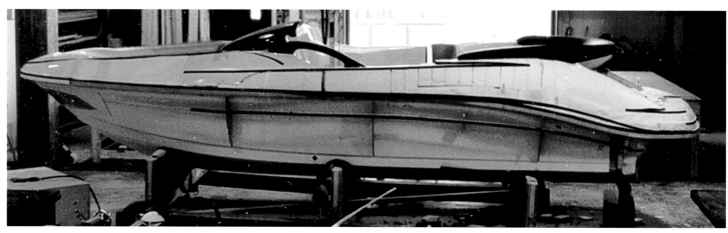

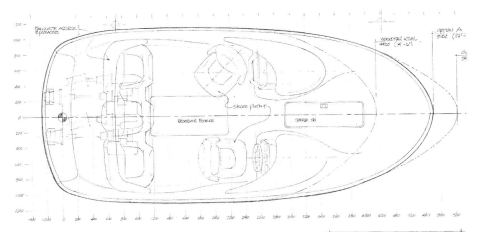

DESSIN PRÉLIMINAIRE
ERGONOMIQUE & MÉCANIQUE
OPTION A & B vs SPEEDSTER
P. ROUDEU MAI 94 ÉCH 1:10

Euclid was used to create mechanical and ergonomic packages of the designs the team liked most. The team presented these packages, as well as industrial renderings, to the division president and representatives from marketing and engineering, who determined the direction to be taken.

Specific aspects of the Challenger 1800, such as the ergonomics of the controls (left) and the comfort of the bucket seats (right) were explored in the full-size mock-ups. The bucket seats, unique to this type of watercraft, were designed to give passengers a sense of comfort and security.

Xootr Scooter

The Xootr is a **grown-up** interpretation of a **child's push scooter,** but it's **no toy.** It targets adults and college students

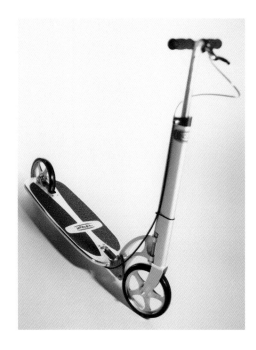

seeking a practical, healthy relatively inexpensive way to get around urban spaces and campuses at 10 to 12 miles per hour. The Xootr folds in seconds into a compact, easily carried configuration, perfect for carrying into a building, bus, train, or cab. It goes where the owner goes. Also important: When collapsed, the Xootr fits into the standard-sized school locker.

The Xootr was the brainchild of college professor Karl Ulrich, who visualized the scooter's potential as an efficient, simple form of urban transport. He was certain that if he could keep parts costs down and the aesthetic turned way up, he would have a hit. After his brother Nathan developed a prototype, they formed Nova Cruz and brought in Lunar Design to partner in the development and design of the product.

Scooters had been around for decades and, in fact, become more popular than ever with the release of low-cost kid versions like the Razor. Lunar's job was to turn them into an exciting new category through a design that appealed to adults.

Quality was the measuring stick throughout the design process. Was the product durable enough? It had to be lightweight so that people could carry it around, yet strong enough to support the weight of an adult.

Another issue was what Lunar Design designer Jeffrey Salazar calls "the ease of push." "What do you get for pushing this thing? How far can you coast? How good does it feel?" he asks.

Other design considerations: Because the product was meant for adults, it necessarily had to be adult-sized, with a large, wide deck that comfortably accommodated grown-up feet. Customization was also considered a real plus for the Xootr, at least in the future. Wouldn't it be great if Xootrers could change the deck or even design their own? Maybe the grips, tires, and so forth could come in different colors. The design had to accommodate these plans.

Nova Cruz and Lunar began by gaining an understanding of general manufacturing concerns in order to utilize production processes that would achieve the desired price point, yet yield a hot design. The team built rough prototypes and purchased existing products to experience scootering firsthand. Then Lunar began committing sketches to paper.

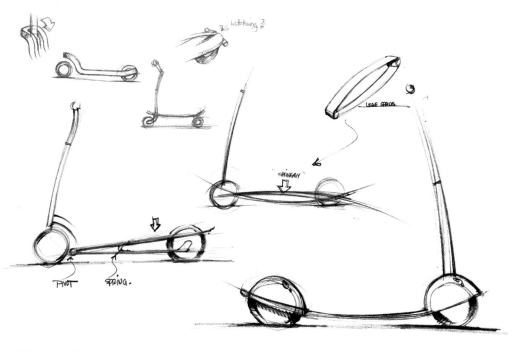

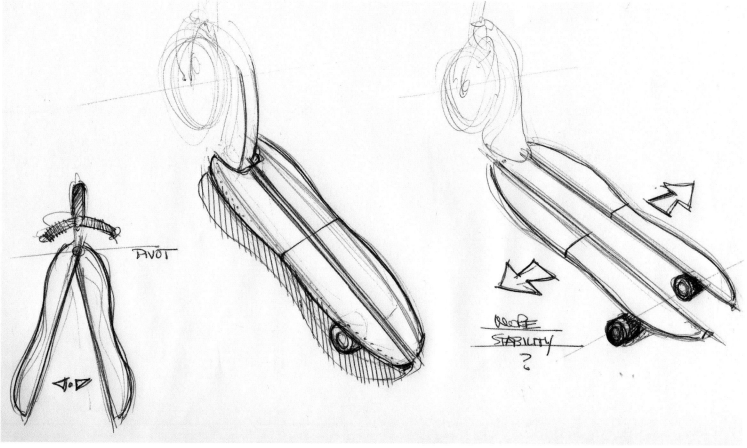

After trying competing scooters and exploring manufacturing processes, the designers created gestural sketch studies that began to capture the true essence of scootering.

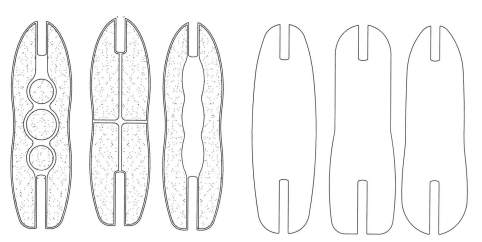

Above and left: Other studies looked at the overall scooter as well as its components, like the shape of the deck.

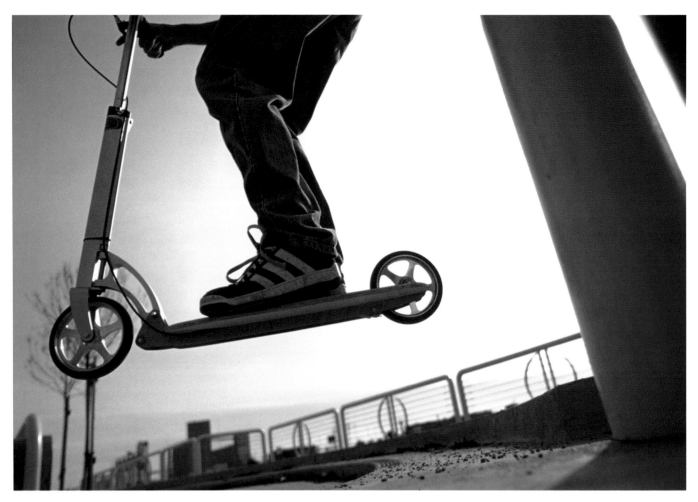

"Our initial design approaches were mainly gestural, just to capture the feel. What should the Xootr say as it slides past you? You want people to say, 'Wow!' and then remember it," Salazar says. Some early sketches had a retro feel, complete with fenders on the front and back of the design. Other trials were ultradynamic, communicating speed and performance.

"We weren't concerned about the price point of the Razor and other brands. The Razor is for kids. It's an impulse buy at $99. But this was for grown-ups. If they were going to pay a certain amount of money for it, the Xootr had to feel like quality. The initial wow factor does say quality," he adds. Today, Xootr models range from $249 to $489.

The final design is modular. Users can tear the scooter apart and customize or repair as necessary. To make it easily configurable for a wide range of tastes, budgets, and performance needs, the deck options are Baltic birch plywood, machined aluminum, and carbon fiber. The Cruz version (birch) evokes visions of beach cruisers and skateboards, while the Street (aluminum) version connotes a more rugged, techie feel. The Comp was designed to reflect the ultimate vision of extreme performance.

Wheel options include a standard polyurethane on die-cast aluminum centers and a race-grade polyurethane on machined aluminum centers. The stucture of the Xootr is entirely aluminum and features one extrusion for the steer support; the remaining parts are machined. Lunar Studio, Lunar Design's graphic design arm, created the graphics for the scooter and its Web site.

From initial business concept to sales of the first Xootrs, only six months passed. Rapid product development and attention to tooling costs enabled startup Nova Cruz to generate needed revenues quickly. The Xootr is, indeed, a popular choice of transport: Available through the Sharper Image catalog and the Xootr Web site, the developers are faced with contracting out assembly work for the first time.

The design of the device and its components continues to develop as Nova Cruz and Lunar discover that enthusiastic Xootrers are using the scooter in ways they hadn't anticipated. "Now we're looking at the needs of extreme scootering and trick scootering," Salazar says.

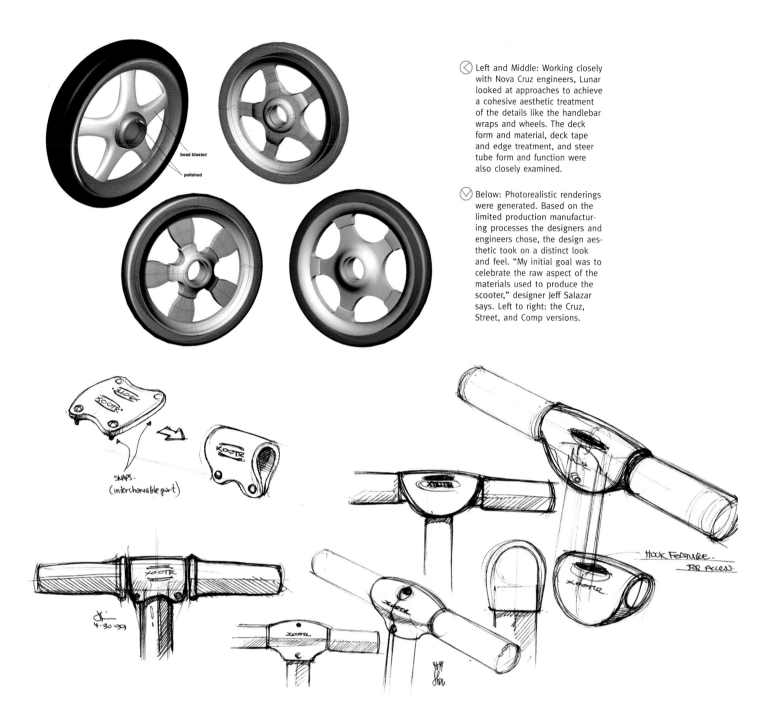

bead blasted

polished

◁ Left and Middle: Working closely with Nova Cruz engineers, Lunar looked at approaches to achieve a cohesive aesthetic treatment of the details like the handlebar wraps and wheels. The deck form and material, deck tape and edge treatment, and steer tube form and function were also closely examined.

▽ Below: Photorealistic renderings were generated. Based on the limited production manufacturing processes the designers and engineers chose, the design aesthetic took on a distinct look and feel. "My initial goal was to celebrate the raw aspect of the materials used to produce the scooter," designer Jeff Salazar says. Left to right: the Cruz, Street, and Comp versions.

SNAPS.
(interchangeable part)

HOOK FEATURE.
FOR ACCESS.

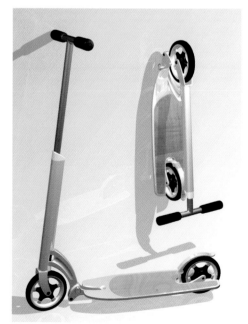

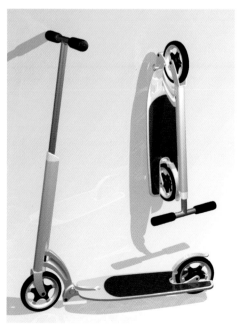

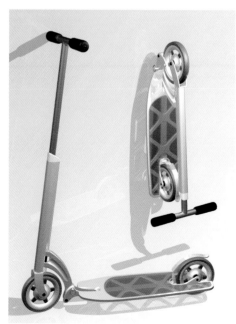

The **BMW K 1200 LT** motorcycle is loosely **based on** its predecessor, the K 1100 LT (luxury tour), which debuted in 1983. Whereas the K 1100 LT became **increasingly luxurious** over time, the BMW K 1200 LT was designed with **luxury as its priority**

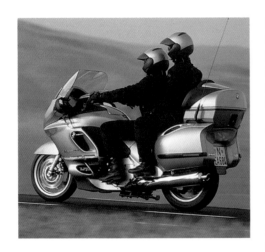

from the outset. The result is the two-wheeled equivalent of a luxury sport sedan. It features an electrically adjustable windscreen, a sound system with a radio and tape and CD player, heated seats, reverse gear, lots of storage space, and a lighted vanity mirror—none of which are the norm for a motorcycle, but which comprise today's definition of luxury for the motorcycle enthusiast.

The design team, all active riders, spent a lot of time considering what the driver and the passenger wanted in luxury. David Robb, design chief, BMW Motorcycles, spent days on the back of an LT asking basic questions. Is there vibration somewhere? Can you talk with your driver on the intercom? How comfortable is the ride? With their firsthand insight, designers created tape drawings, technical drawings with a translucent overlay. Then they developed a clay model, which they took into a wind tunnel for testing. They gathered feedback, and the model entered what BMW calls a competition phase, where two clay models compete. Technically, each model was the same bike, but they had different looks and attributes—one sporty, the other elegant—that made them appear different. The winner possessed design styling and characteristics that predominate the U.S. market; it was large and substantial, yet elegant and understated. "You can see the strength in the bike," says Robb. "It has an individual poise, its own stance."

Designers refined the clay model, then added fiberglass parts before testing it in the wind tunnel again; simultaneously, they refined the prototype's ergonomics. They tweaked the suspension, among other features, and continued tweaking until they optimized a package that they confidently claimed was well balanced. All the adjustments occurred in parallel. These refinements were incorporated into the final clay model and digitized into the CAD system—from which, eventually, they emerged as finished parts. The entire process took more than four years (three is typical) because the designers felt they had to invest heavily to get the innovative luxury features right.

Among their biggest challenges was getting the details to fit together. "Everything has to harmonize. They should all be part of the same symphony," says Robb. "A luxury motorcycle needs to have balance and harmony without becoming boring. You need to get music from every corner. Striking the balance was tough. We had to continually ask, 'Is this working?' As the director, I had to listen to all the voices and look for balance."

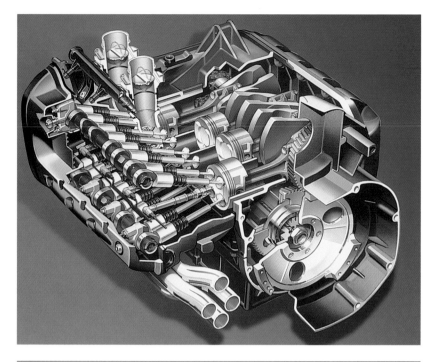

The balance between high-performance engineering and luxury can be elusive, but Robb thinks BMW has an edge because the car and motorcycle design departments share information and insight. "I think we're the only company with the car and motorcycle design studios under the same roof. We try to learn from each other, prod each other, inspire each other. You see a lot of the elegance we have in our cars in the K 1200 LT. There is no contradiction; this is a high-performance vehicle."

Judging from the market response—overwhelmingly positive—it looks like Robb and the BMW design team achieved the balance they sought. The BMW K 1200 LT is a consistent best-seller. "The press and critics alike say we knocked it out of the park," says Jeff Ehoodin, motorcycle and motorsport specialist, BMW. "I would consider it our most successful motorcycle—and it rides pretty nice, too."

This bike is not for the faint of heart. "It's for someone with a lot of experience," says Robb. The typical buyer is over forty and has the experience to handle its mass and power. "The class is generally ridden by two people as a long-distance motorcycle. The ceremony of buying this type of motorcycle is different from a 20- or 30-something buying a sport bike for personal use. It has a different wooing process. This is something you share."

What is BMW Motorcycles' secret to design success? "The motorcycle designer must have an emotional appeal. Compared to cars or home products, motorcycles generate an emotional or binding relationship with the rider. They provide a freedom you don't get in the office or your living room. You develop a hands-on, intimate relationship with a motorcycle." Robbs notes that, as designers, they must communicate the attributes for which BMW is known.

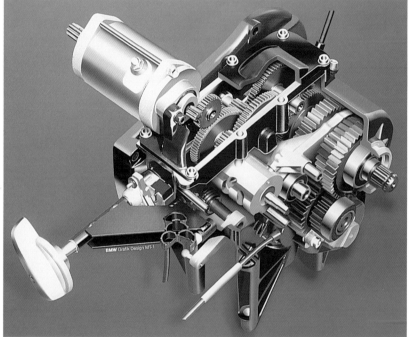

"BMW is a technical motorcycle. It is precision. It is durability. It's something you can trust. Hopefully, what we do in all of our motorcycles, including this one, is communicate the excitement of motorcycling, the freedom. It's a precision product you can trust. The BMW values are in there and so is its heritage. The bike has to say, 'This is BMW. It is a big company.'"

⊘ Above: A cutaway display of the BMW K 1200 LT engine.

⊘ Illustration of the reverse gear mechanism.

⊘ Illustration of the chassis and suspension.

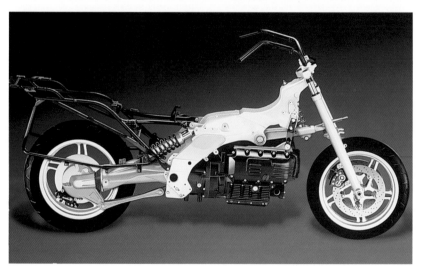

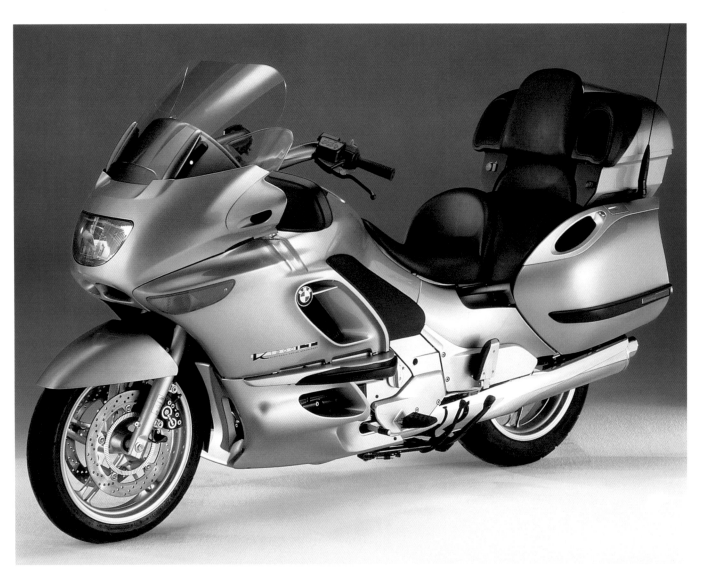

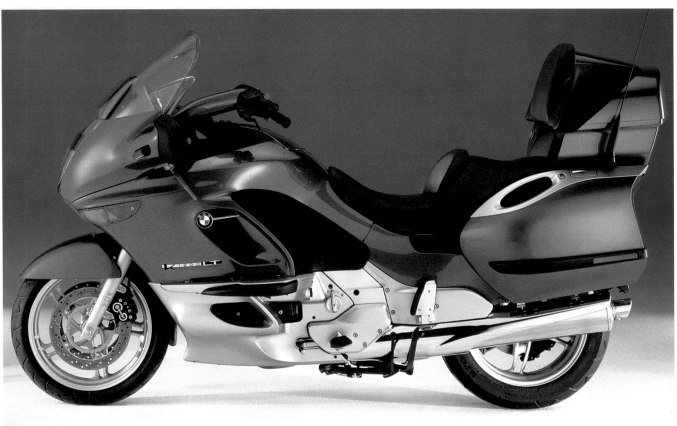

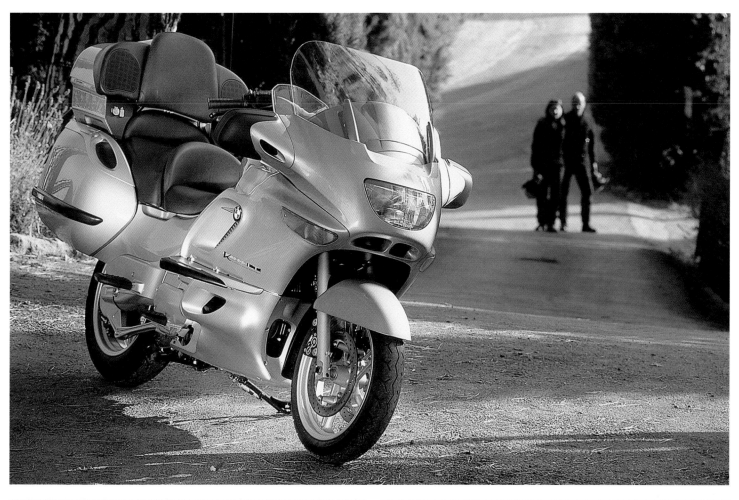

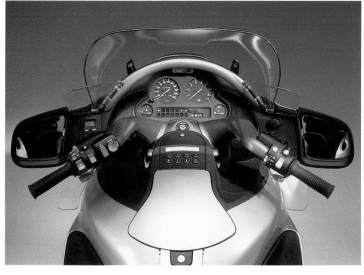

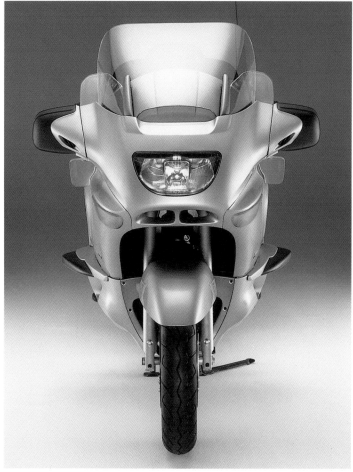

⊙ Opposite page: The fully integrated body design, with a new vehicle architecture, accentuates the length, passenger space, and luxury offered. The panel breakup and use of different materials emphasize the purpose of each area and relieve otherwise large surfaces. The K 1200 LT is shown here in champagne and basalt gray, but also comes in other colors.

⊙ Above: The interface between pilot or passenger and vehicle is through soft-touch surfaces in the leg area and the seat and back.

⊙ Below: The pilot sits amid comfortable surroundings, as evidenced by this clear, functional cockpit area reminiscent of BMW's luxury sedans. The cockpit area is closed off from road noise through a newly developed interior cover.

⊙ A body bumper system divides the upper and lower halves of the vehicle, protecting the bodywork in the event of an accidental parking lot tip-over.

Scorpio 270

Imagine a product with these parameters: It must be **extremely lightweight** but **sturdy.** It must **safely contain a flammable liquid,** and it must be able to support heavy pots full of **hot food** or liquid.

⊘ The Scorpio 270 is stable, safe, compact, and affordable—everything the casual hiker or camper looks for in a portable stove.

It must be easy to operate outdoors, sometimes in dim light and less-than-ideal conditions. Finally, the occasional or even first-time user must be able to understand its operation almost inherently.

Those are the requirements that the French company Campingaz asked Design Continuum Italia to build into a new camping stove for camping and trekking enthusiasts. Several competing products were on the market already, but these were top-of-the-line mountaineering tools geared to the professional or extreme user prepared to pay a high price for materials such as titanium. In addition, the existing stoves were not equipped with safety features like an overflow regulator that shuts off the gas if the stove tips over.

Campingaz wanted a collapsible, horizontal stove that was better suited for the general consumer, priced at about $50. One of the most prevalent consumer concerns for such a product was safety. On competitors' stoves, a rubber hose connection between the gas cartridge and the burner was not perceived as safe by the average camper and hiker.

Design Continuum began to search for ways to fulfill all of the client's wishes. "Campingaz has always offered reliable, sturdy, universal vertical stoves geared at light hiking, camping, and emergency use, such as in refugee camps," explains Paolo Rovida of Design Continuum in Milan. "A horizontal stove was a logical extension to their line. It is more stable, thus more safe."

Early designs centered on minimal, skeletal configurations. Only essential elements were included. Alternate designs included products with a rigid body, more like catering products; this design also offered grilling and broiling possibilities.

All the design experiments used the gas canister as part of the stove's support system. Some had flip-out legs; another had wing-like legs. But after seeing the collapsible horizontal idea, Campingaz decided to go with the more compact design. The result was the 557-gram Scorpio 270—Scorpio for the stove's scorpion or spiderlike appearance when unfolded, and 270 for the size of the gas cartridge it uses.

COMPACT HORIZONTAL STOVE. A.

HORIZONTAL STOVE B. - Compact.

Compact HORIZONTAL STOVE C.

The stove is extremely stable, yet compact. Absolute stability was achieved by utilizing the fuel cartridge itself for solid support; also, the stove's center of gravity is low. Further stability is achieved with height-adjustable legs for proper balance on uneven ground and an unusually large surface for pan support. Folding legs, made of rustproof stainless steel, guarantee a flat and compact position for storage. When the device is folded, it is very small, only 9.5" by 2.5" by 2.5" (24 cm X 6 cm X 6 cm) without the fuel canister.

To address the gas connection worries of consumers, Design Continuum designed the Easy-Clic connection system. With this system, the device is pressed into the gas cartridge valve, then rotated to align its body with the control knob.

"The Easy-Clic feature reduces the possibility of overtightening the appliance or damaging the valve, and, in the event of a violent impact, the grips on the locking collar allow the cartridge to come off without damaging the valve casing," Rovida says. Competitors' models offer no feedback to the user when he or she reaches the point where the connection is made. The Easy-Clic design actually clicks into position.

Even the knobs on the product were specially designed. "The control knobs are chunky but ergonomic because they house a regulator, another safety feature developed by Campingaz," explains Rovida. "A minute assembly of diaphragms and valves allows for steady gas pressure for the burner and prevents a spill-out if the stove is tipped over." The main body of the stove is made of die-cast Zamac metal, which resists heat well. The legs and body cover are made from stainless steel to prevent rust. The knob is plastic.

The Scorpio 270 has been a huge success: Campingaz can't keep up with consumer demand. The design's striking profile draws consumers to the product, the unit's unique safety features convince them to make the purchase.

Camp and trek stoves used to have two separate pieces: the stove and the gas canister. A rubber hose connected the pair. Design Continuum's trials used the canister itself as part of the stove. This proved a much more stable—and safe—configuration

Designed by Design Continuum Italia, the Scorpio 270 folds down to a compact, lightweight shape.

When they used competitors'
models, consumers felt uneasy
about connecting the gas car-
tridge to the stove unit. So
Design Continuum designed the
Easy-Clic system. The user hears
an actual click when the two
pieces are connected properly.
In fact, it is impossible to
tighten the connection further.

Adjustable legs allow the user to
make the stove—and the full, hot
pots it is bound to be holding—
stable, even on uneven ground.

ViewMaster Discovery Channel™ Viewer

Everyone remembers the **ViewMaster.** For sixty years, it enjoyed **virtually 100 percent (unaided) brand awareness.**

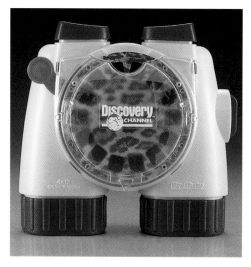

The design team maintained an unintimidating, whimsical feel while drawing styling cues from professional binoculars and optical equipment. The result is a "fun-techy" look with inviting bright colors and sensual forms—an up-to-date version of the classic ViewMaster.

But when Fisher-Price acquired the ViewMaster brand in 1998, toy buyers were concerned that this classic toy was dated and had dwindling appeal for today's children.

Fisher-Price wanted to reestablish ViewMaster as a premier visual product in the toy industry. "We also wanted to bring Fisher-Price quality to the brand," says Jeffrey Miller, a senior product designer at the toy company. The first new ViewMaster viewer in over a decade was planned. To be successful, the team needed to update the product's image by improving its performance and adding new features. They also wanted to extend the play pattern so that children would be engaged for a longer period. Fisher-Price looked at adding video, telescopes, sound, and a host of other features. They enlisted the Discovery Channel as a licensing partner to help contemporize the educational and visual aspects of the ViewMaster line.

The result of much brainstorming was the decision to create a three-dimensional stereo viewer and binoculars. "The binoculars seemed a natural fit for the Discovery Channel content," explains Miller. "They allow children to role-play while looking at the three-dimensional images. They can go into their backyard and pretend they are seeing in real life what is depicted on the ViewMaster reel."

With the basic approach decided, the team needed to create a contemporary look for the ViewMaster, make it more durable, and emphasize its high quality. Hundreds of thumbnail sketches and sketch explorations followed. Fisher-Price used the creative talent of its own people as well as the fresh perspective of outside consultants. Meetings with designers and marketing representatives helped define the direction the product took and brought desired attributes into a coherent whole.

Preliminary foam models were shared with children at Fisher-Price's in-house play facility for human factors testing to determine ease of use, hand fit, ease in holding the product to the eyes, and so forth. Children were also given binoculars to see how they played with them. Miller credits the success of the ViewMaster Discovery Channel™ Viewer and other Fisher-Price products to this interaction with children and mothers during the development process.

The main challenge was to design the product around its optical requirements. Dr. Stephen Fantone, an expert on lenses and optical design (he helped fix the Hubble space telescope lens), was brought in to develop the lensing system and define the light paths needed to operate the binoculars.

Miller and Pete Reile, the lead engineer on the project, created a form that accommodated the complex optical system. "The optical system required a lot of physical space for both mirrors

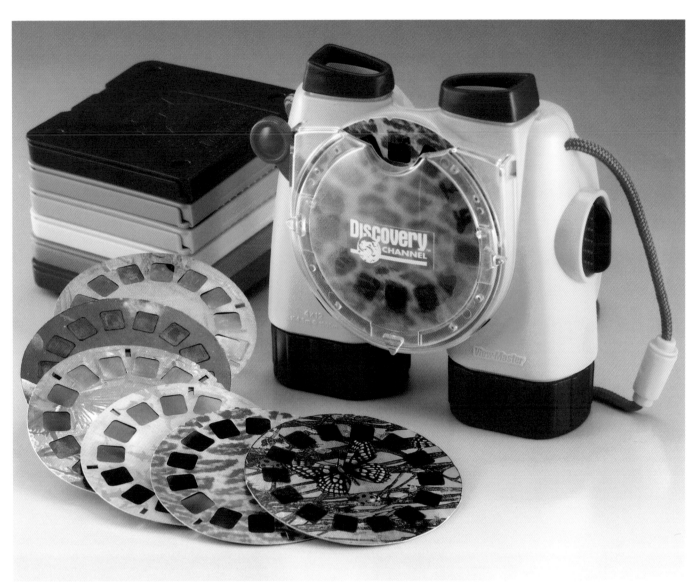

and sliding lenses," explains Miller. "It was challenging to design an aesthetically pleasing form that still had room for the internal mechanism."

From this point, the team worked almost exclusively in Solid-Works, a popular computer software three-dimensional modeling program. "The time to market was aggressive," says Miller, "and working digitally allowed us to explore ideas quickly. A number of iterations were done virtually. We made needed changes, had an SLA model made overnight, and met again the next day." This enabled the team to move from concept approval in sketch form to pro-engineering geometry in just five to six weeks, cutting weeks out of the development schedule.

But the benefits of CAD go beyond shortening the time frame; it enables design exploration that might not occur otherwise. "CAD tools enabled us to meet marketing launch dates and explore and refine aesthetic aspects of the design," Miller continues. "Without them, we never would have produced a product of this quality so quickly."

The result is a product that captures the energy and adventure of visual exploration. Full-color printed reel graphics, a larger three-dimensional viewing area, and an enhanced graphic approach to

◇ Fisher-Price's partnership with Discovery resulted in high-quality, contemporary content for the ViewMaster reels. Colorful, full-bleed artwork lets you know what to expect when you insert the reels into the viewer. The reels have a decorative, collectible feel.

the stereo imagery bring ViewMaster viewing to an entirely new level. Styling cues were drawn from professional binoculars and optical equipment, but the toy has an unintimidating, whimsical feel. Bright colors and sensual forms invite children and adults alike to use the product. Among the ViewMaster Discovery Channel™ Viewer's innovative aspects is horizontal reel-loading, which allows the user to light the film frame with overhead ambient light—no need, any longer, to point the viewer toward the sky.

Hardware innovations paralleled the updating and enhancement of the reel content. Contemporary support visuals provide double and triple the visual information of earlier ViewMaster reels. In addition, Fisher-Price redesigned the ViewMaster logo, updated its packaging, included full-color printing of the white Lamilux reel stock material (a technical first, led by Fisher-Price senior engineer Tim O'Connell), and added colorful labels to the reels, enhancing their collectible and content-specific nature.

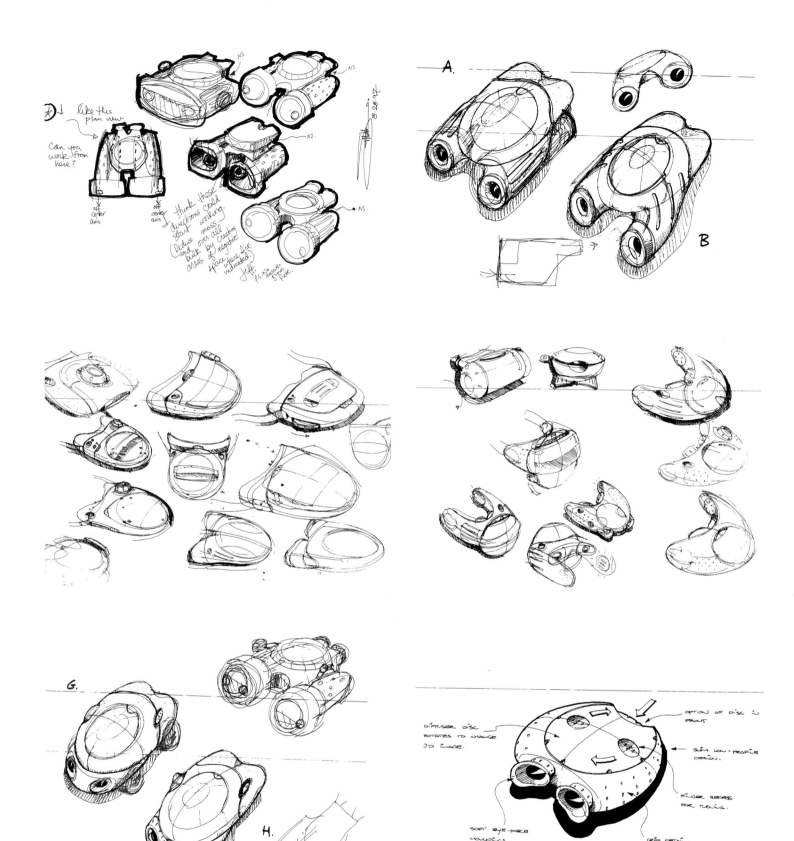

A.

B

G.

H.

After Fisher-Price decided to update the ViewMaster by adding a three-dimensional stereo viewer and binoculars, hundreds of thumbnail sketches were completed by outside consultants and in-house designers to explore various directions the design could take. Some forms were amorphic and whimsical, while others were much more traditional.

⬡ Fisher-Price brought in an expert to define the light paths needed to operate the binoculars. The team designed the Discovery Channel™ Viewer around the lensing system and light paths shown here. "It was a real challenge to design a form that was aesthetically pleasing and still provided enough room for the internal mechanism," notes Jeff Miller.

◁ The designers also explored how to improve the other items in the ViewMaster product line, including the reels and their storage. Various storage options are explored in these sketches.

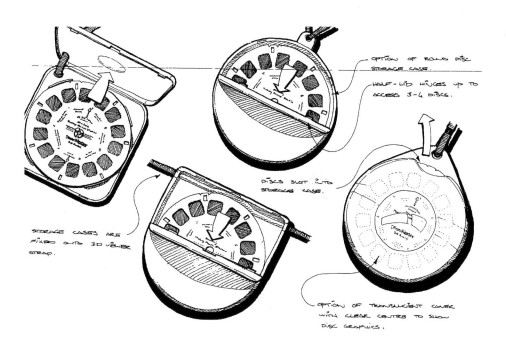

OPTION OF ROUND DISC STORAGE CASE.

HALF-LID HINGES UP TO ACCESS 3-4 DISCS.

DISCS SLOT INTO STORAGE CASE.

STORAGE CASES ARE FIXED ONTO 3D VIEWER STRAP.

OPTION OF TRANSLUCENT COVER WITH CLEAR CENTRE TO SHOW DISC GRAPHICS.

Worm Light
What the **flashlight** was to comic books, the Worm Light is to the **Game Boy.** The tiny, War-of-the-Worlds-like device **snaps directly** into the handheld game's connector port,

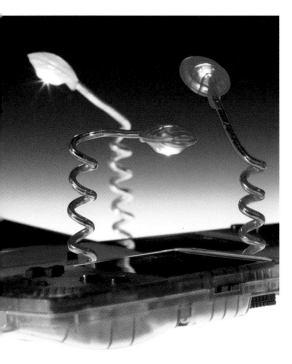

Produced in colors to match the popular handheld Game Boy game device, the Worm Light looks like a natural—and fun—extension of the product, not an add-on.

unobtrusively borrows from its power supply, and allows the user to keep his or her thumbs busy late into the night. More than three million lights were sold in its first year of availability.

The device was designed to be uncomplicated, says Hauser, Inc. designer Kevin Hayes, who worked on the project. "One of the things that makes it so great is its simplicity," he notes. But the project's turnaround also made simplicity a necessity: only two weeks from start to finish.

Client Nyko wanted a fun and exciting lighting device that was appealing to all but that was targeted at adolescents and teenage boys, the primary users of the Game Boy. The company had discovered that the connector port—the same port that two players can use to connect their Game Boys for competitive play—produced enough power to light a small LED. Nyko asked Hauser first to explore the functional aspects of the light, then to find a design that really stood out. Just as important was durability: Even though the Worm Light is an accessory to a toy, it had to stand up to being carried in a pocket or even being dropped onto the floor.

Hauser designers began by studying the properties of the white LED. Would a reflector, lens, diffuser, or another mechanism improve the light source? Many mock-ups were created to test various concepts. "I spent plenty of time figuring out the optical diffusion or refraction of the light. But we came to the conclusion that if you put anything in front of the LED, like a lens, the light is diminished. The LED shining directly on the display was the best way to do it," Hayes says.

Another issue was figuring out the optimal height of the light. The display area on the Game Boy is reflective, so the light had to be placed so as not to create glare.

Once the shape and design of the light and its shade were determined, the designers decided to make the housing of clear but tinted plastic. They also developed an internal rib structure that could be seen through the glowing plastic. Hayes says the ribs were important in creating the shade's organic shape. "It gives the light a science fiction look," he adds.

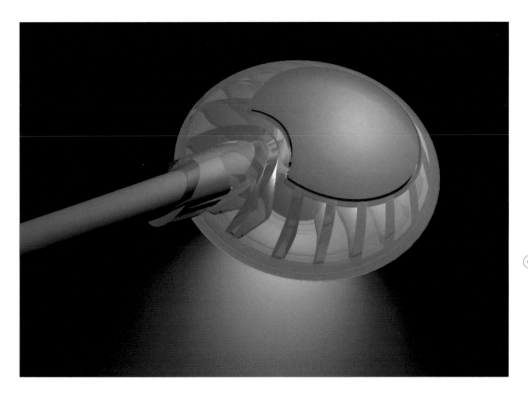

When the final shade design was complete, it was rendered in Alias for viewing in three dimensions. Translucent amber resin prototypes, colored with store-bought Rit dyes, were also made using the computer data. These working prototypes had electronics installed and were demonstrated at an electronics show.

BONE LINE .

Preliminary sketches of the shade design were made to resolve how the light source would be hooded as well as how people would hold and interact with the device. For instance, one design had rubber nubs, meant to give users a better grip on the light shade while adjusting it.

The sketch/view shows another early component and housing design.

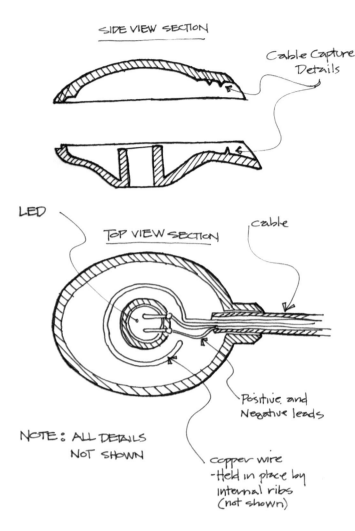

SIDE VIEW SECTION

Cable Capture Details

LED

TOP VIEW SECTION

cable

Positive and Negative leads

NOTE: ALL DETAILS NOT SHOWN

copper wire
-Held in place by Internal ribs (not shown)

Another striking design element is the inexpensive, durable, flexible coil of copper wire that holds the light in position; users can easily adjust the coil to suit their individual situations. A clear, tinted plastic coating accentuates the coil's playful nature.

The welding process allows the housing to capture the rigid copper wire and cable. The Nyko logo is pad-printed on the housing.

The Worm Light was a hit even before it hit the market. Nyko presented models and renderings at the 1999 E3 trade show, and buyers responded overwhelmingly. Released to stores in September, 1999, the design has been such a phenomenal success that no fewer than seven companies have "borrowed" the concept and design. Nyko has had to enter litigation to force these companies to cease production.

The original Worm Light has such strong visual appeal that it attracts the attention of not only the target group but a broad range of others. The translucent neon colors were matched to the Game Boy color for coordination or contrast at the whim of the user. In fact, the aesthetic is so strong and the price point so low (approximately $9.99) that it is not uncommon for players to own more than one Worm Light.

"This was definitely a playful project, and Nyko had no constraints on it," says Hayes. "We always want to improve the effectiveness of whatever we are working on, and the Worm Light is no exception."

◁ This drawing helped Hauser and the manufacturer resolve assembly questions the designers had about the engineering of the housing.

◁ Created in Pro/Engineer, this rendering helped communicate the part breakup and assembly of the light to Nyko.

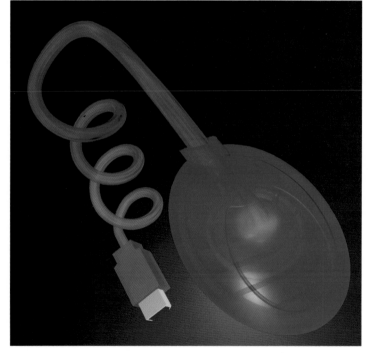

The engineering information gathered in Pro/Engineer was imported into Alias to visualize the final design, complete with multiple colors and finishes.

Logitech **Wingman Formula Force** Although Logitech is one of the **largest manufacturers** of electronic **game unit controllers** in the world, it did not have a **driving** game controller,

⊗ These studies, with triangular hubs and thickened grips, are similar to the finished design.

so when the time came to release such a unit, the company wanted to be certain that the product would immediately emerge as a leader, surpassing all competitors in terms of performance, design, and quality.

IDEO San Francisco took on the challenge of designing the Logitech Wingman Formula Force. The new product was constrained by price target points, so parts costs and assembly needs had to be kept minimal. The product also had to be tough and durable to withstand the rough handling that users, caught up in the fun of the game, often inflict on such controllers.

Checking out the competition immediately helped the design team establish their direction. IDEO's Scott Underwood says, "The big thing we noticed was that competitors' product felt cheap. Their finishes were cheap. They felt light and fragile. We knew that these games get a lot of abuse from the young men who play them." They also noticed that the pedal portion of the units tended to slide forward when pressed, which definitely detracted from the realism of today's driving games.

Several IDEO designers who worked on the project are car enthusiasts, so they brought their knowledge of Formula One racing cars to the project. Sketching began with console designs. All trials looked like real dashboards in real cars. Many had a natural downward and forward swoop that not only looked like the design found in a racecar but also insinuated speed and sleekness.

A major part of the dash design was the clamping mechanism that held the device snugly to a tabletop. The obvious design—and one used on many competing designs—was a standard C-clamp, such as those commonly used for desk lamps. However, as Underwood points out, lamps secured by C-clamps are prone to falling over. The Wingman needed to feel stable, even when jostled.

"We created a modified C-clamp. As you close the clamp, you also close a cam. The shape we gave it worked well going around the edge of a table with a lip or with a flat edge," he says. A quick-release mechanism makes the design easy to remove as well.

The Wingman Formula Force is a driving game controller consisting of a steering wheel that clamps onto a tabletop and a foot pedal unit that sits on the ground. Designed by IDEO San Francisco, it has the look and feel of a real racing car console.

The realism of the steering wheel was another crucial design element. Some design trials were radical; others explored variations of simple rounded designs. All had the definite touch of realism: Some, including the final, looked as though they came out of an actual racecar.

The sliding pedals were also addressed in the new design. IDEO designers created a pedal on a pivot rather than a hinge. With the hinge design, as the user pushes on the pedal, he pushes forward and away. With the pivot design, the pushing force moves toward the ground, so the user actually holds the device in place just by using it.

"We're very happy with the final design," Underwood says. "It's one thing to design a medical instrument or something more esoteric. But it's another to design a toothbrush or a TV or a game unit that will actually end up in someone's home and be enjoyed. The Wingman Formula Force definitely is something that will be enjoyed."

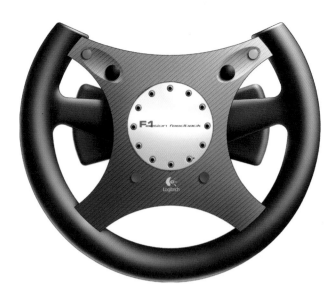

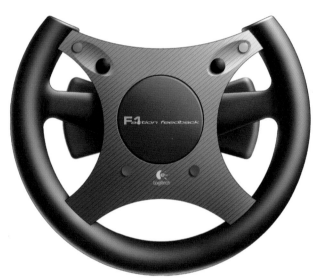

The designers explored button locations on the spokes, wheels, and ears off the hub.

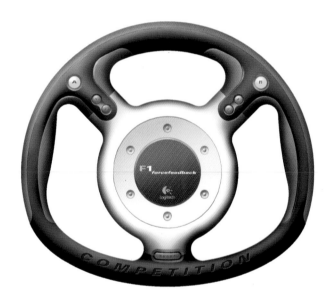

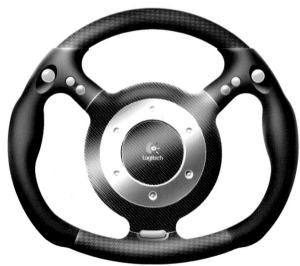

Studies of the wheel, the part of the game with which users physically interact, were many. These three show portions of the top of the wheel removed, with rear paddles and different hub variations.

These radical shapes have their buttons at the top of the spokes.

IDEO created many sketches of possible console designs. The console had to be structurally strong to accommodate the game's clamping mechanism but still look smart.

Rocket eBook
A digital reader—probably more commonly known as an **electronic book**—can be a curious sell. Its **goal** is to marry two disparate ideas—

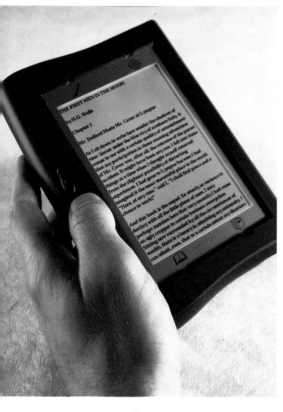

The Rocket eBook is a versatile product. It can be held in the left or right hand and read in landscape or portrait mode. It is lightweight, yet holds the equivalent of ten books or almost 4000 pages.

Palo Alto Products International (now Flextronics) searched, through thumbnail drawings, for what a digital reader or electronic book should look like.

cool, efficient technology and the warm comfort of a good book. For the time being, a digital reader does not need to replace conventional books. In fact, a conversion may never occur, given readers' devotion to ink on paper. But in order for consumers to embrace the concept of reading a book on screen at all, digital readers must offer the paper version's pluses, then add advantages of its own.

The trickiest thing about designing the Rocket eBook for client NuvoMedia, says Palo Alto Products International (now Flextronics) director of industrial design Dallas Grove, was not so much the computer or technical aspect of the project. Instead, it was the fact that a book is ink on paper. "It is pages that you turn. The user interface is completely tactile and very low tech. How can we design something that is not a parody of a book? How can we create a new form that embraces the technology and the parts of history that are important?" he and his team asked.

The device had to be small, ambidextrous, comfortable to hold in all orientations, and easy to use. In short, the design solution had to prevent technology from getting between the reader and the text.

Functionality was a major concern. The client was confident of its core technology, which enabled a CPU to store and retrieve text using minimal power. Keeping power use down was important

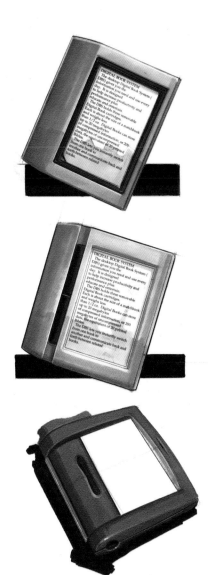

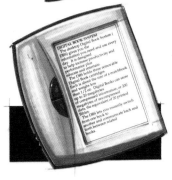

⊗ These sketched concepts begin to zero in on the final design. It was evident that, by placing the battery on the side of the product, a natural handhold was produced. The swell is much like the one produced on the side of a paperback book when the pages are folded back.

because batteries are heavy. Lower power needs means lower battery size, which means lower battery weight and, therefore, lower eBook weight. With a workable technology in hand, the designers could concentrate on creating a unique aesthetic.

Grove and his designers first considered the question of what a digital book should look like. A direct metaphor—wrapping the device in leather, like a fine leatherbound book—was quickly abandoned. But the idea of a paperback, especially one that folds back on itself, held promise.

"We thought of serious readers curled up in a chair, doing what they love. They may have those leatherbound volumes in their libraries, but a paperback is more casual. The eBook should be more casual," Grove says. "The trick with a paperback—or a digital reader—is in how you hold it."

Readers change position as they read, the designers knew. Their hand and body positions change. So the device had to be comfortable no matter what posture the reader curled or stretched himself into.

Sketched experiments included trials that looked like paper notebooks, laptop computers, electronic game panels, and devices like picture frames. The eBook needed a stylus for highlighting text on screen, so that element had to be worked into the design as well. "If you are in a body of text and find a word you don't know, you can highlight it and look it up in the on-board dictionary," Grove says.

The final design took elements from all of the experiments. By positioning the battery as the spine, the designers created a natural handhold for the product, like the folded-back swell of a paperback. The battery placement also centered the weight of the product in the palm. Navigation buttons were kept to a minimum, ensuring less visual clutter for the user. There are only two page-turning buttons. The only additional controls are touch-screen icons used for basic navigation and a power button recessed in the side of the product. A stylus located on the back of the viewer is available for detailed annotating or highlighting.

The Rocket eBook weighs only 1.5 pounds (.68 kg), and it holds up to 4000 pages—the equivalent of about ten books. By placing the device in its cradle, users can log onto the internet via a PC and download new titles at any time. Being digital, books read on the eBook can be browsed, searched, annotated, highlighted, bookmarked, linked, and referenced in ways that are impossible with a conventional book—but the device still looks and feels familiar and friendly.

"The paperback metaphor is really subtle," says Grove. "The essence of a book is there. Form was a big part of the function."

One of the best things about the eBook, he adds, is that it is comfortable no matter how it is used and no matter who uses it. Set on a table, it has a natural tilt that makes reading comfortable. It can be used in landscape or portrait mode, and it can be flipped for right- or left-handed users.

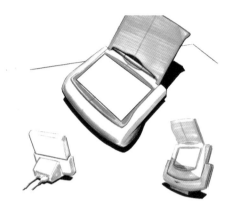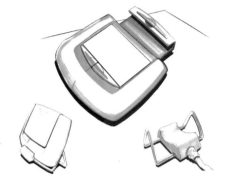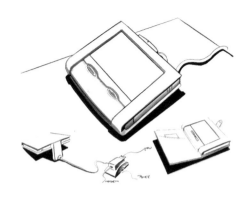

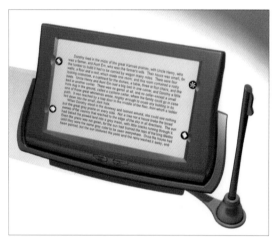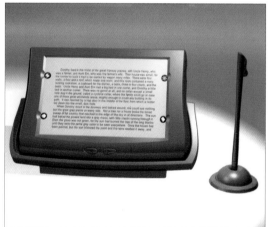

The eBook design had to work with the device's cradle, which recharges it and connects it to a PC. This complicated considerations of screen angle, weight, shape, and so forth.

The stylus represented another consideration for the designers. While these trial designs show the stylus seated in a separate cradle, in the final design, the eBook stylus is placed on the back of the device.

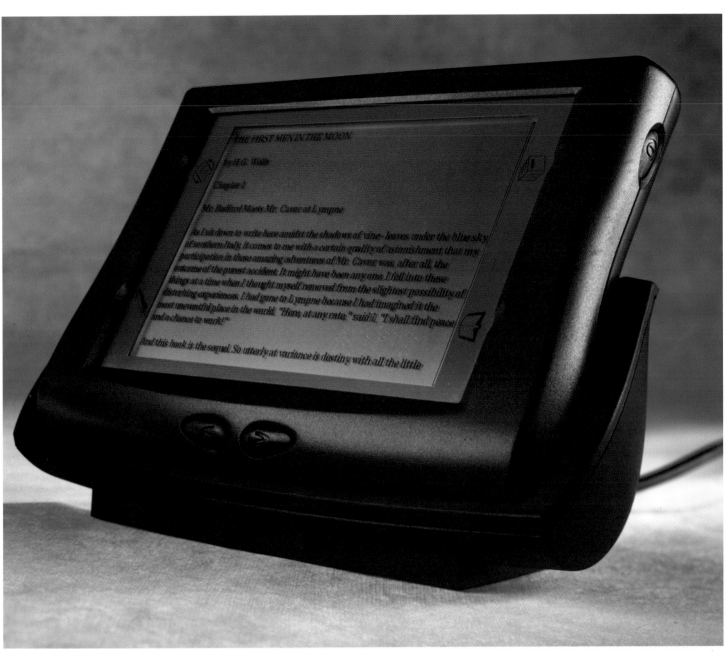

THE FIRST MEN IN THE MOON

by H.G. Wells

Chapter 1

Mr. Bedford Meets Mr. Cavor at Lympne

As I sit down to write here amidst the shadows of vine-leaves under the blue sky of southern Italy, it comes to me with a certain quality of astonishment that my participation in these amazing adventures of Mr. Cavor was, after all, the outcome of the purest accident. It might have been any one. I fell into these things at a time when I thought myself removed from the slightest possibility of disturbing experiences. I had gone to Lympne because I had imagined it the most uneventful place in the world. "Here, at any rate," said I, "I shall find peace and a chance to work!"

And this book is the sequel. So utterly at variance is destiny with all the little

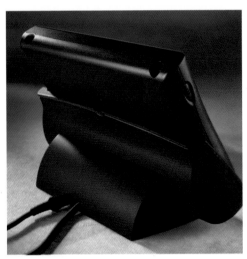

Above and right: Various views of the eBook seated in its cradle with its stylus. Minimizing the interface was essential to the product's success; it could not get between the reader and the text. Some early designs actually had only a single power button. Navigation was done by touching the edge of the screen.

New Vision TV Due to heavy price erosion, many television manufacturers have been forced to eliminate enhancements that allow them to differentiate their products.

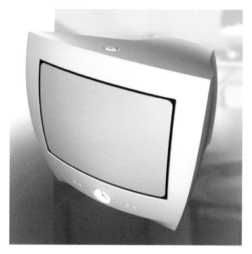

⊘ Details were defined in Alias and models. The clock was established as the most visible innovative element of the bedroom TV.

Although Philips was relatively successful in this highly competitive market, in 1997, the company initiated the New Vision Television project. The goal was to explore how to give added value to the 14-inch (36 cm) television set. The team wanted to address what Stefan Marzano, chief executive officer of Philips Design, calls "higher-level consumer needs" by adding "benefits that are emotional rather than purely rational." Philips believed this was key to differentiating the brand in the marketplace. "Innovative design is arguably the only way that new value can be given to such a ubiquitous product as the small-screen TV," says Marzano.

"We first identified our target group and then, using focus groups, investigated their needs and tried to translate them into product/market concepts," says Piet Coelewij, global program manager at Philips. In internal workshops, the team identified the target market as "design-oriented people and their children."

Focus groups revealed that consumers want a variety of returns from their television viewing experience, including relaxation, excitement, privacy, companionship at home, and being cool. Using this input, multifunctional teams took part in brainstorming sessions that resulted in thirty product concepts. Workshop participants then selected the seven concepts that best matched Philips' objectives: emotional TV, CD-TV/super sound, TV clock, message TV, pullover TV, invisible TV, and cuddle TV. Each of these was visualized through animations the designers generated in Alias.

The core team refined the selections based on information gathered from postworkshop analyses. With the help of the video animations, Philips verified the attractiveness of the concepts in face-value tests around the world. Each location held, on average, six sessions with eight and ten participants in each. On the basis of participants' reactions, Philips decided to focus on proposals for a bedroom TV and a mini-CD/TV system.

Assisted by input from the Visual Trends Analysis and Visual Communication groups, the four product designers developed these concepts. Philips had previously developed small televisions shaped like football helmets and other novelty items. This time, they planned a more holistic approach that addressed a range of elements—color, form, shape, ease of use, and functionality. "The project team went beyond simply creating a new styling; they integrated colors, materials, and functions in a way more in line with recent innovations in top-end products," says Marzano.

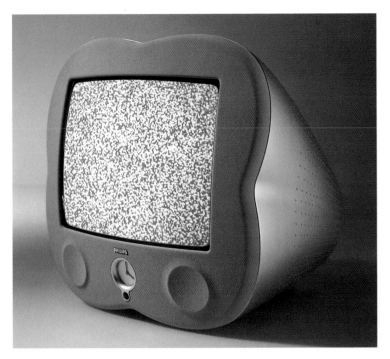

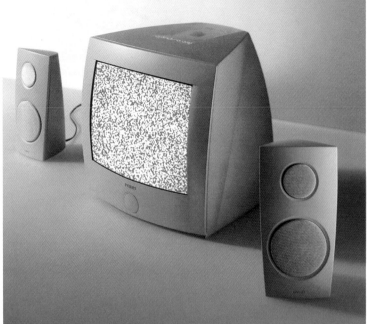

⊗ Above: *Hana* is Japanese for flower. This model features a splash of color and curves. The light emanating from the rear gives a warm glow, while the holes in the enclosure are "like droplets of water on a flower." Hana can be positioned on a surface or on supporting legs.

⊗ Below: Cubi's name was derived from Cubism, a 20th century art movement or style that uses predominantly angular shapes and stresses abstract form.

⊗ Above: *Kiku,* which means "to listen" in Japanese, was the concept explored for the combination sound system and television. Kiku features an integrated CD player and accessible controls at the top of the mini-TV. The large rotary volume control hints at Kiku's powerful audio performance.

⊗ Below: Ulie, derived from the letter U which is "the 21st letter for the 21st century", includes a spot-lit clock and luminescent feet and aerials.

The team developed full working models for three designs of the bedroom television (Cubi, Ulie, and Hana), and one design of the minisystem TV (Kiku). The bedroom TVs were designed to blend into an intimate environment. For added value, the TVs have radio reception, an elegant analog clock, and lighting elements that warmly glow on or around the set. The fourth concept, Kiku, gives consumers the convenience of a small-screen TV combined with the sound quality of a hi-fi system. Kiku features a subtly integrated CD player with a large rotary volume control that emphasizes its powerful audio performance. Bringing the qualities of a full-scale entertainment system into the privacy of the bedroom, Kiku is a perfect response to the desire for personalization.

The greatest challenge in the New Vision Television project turned out to be not in the design itself but rather in the corporate culture. "Designing these products was a lot of fun," says Marzano. "However, the usual codesign phase took longer than normal. The real challenge was keeping commitment levels high long enough to allow the design to find its full potential. We had to instill enthusiasm for a relatively risky concept."

Marzano credits the success of the product to the "commitment and enthusiasm of the project team." He also emphasizes the importance of management commitment. "Design has come to be an important theme within the company," he explains. "More than ever, management is recognizing the value of design as a key element in making business exciting and, therefore, more profitable."

Marzano predicts that the New Vision Television project will affect how future products are developed. "The approach has proved it can enhance the Philips brand and has confirmed the company's commitment to continue design work that pushes the envelope. New Vision Television has provided Philips with more than just new TVs; it's shown the company a new way of seeing and working with their products."

"We realize that we still have a long way to go," adds Coelewij. "At the same time, we are convinced we have found a template that will allow us to create and market products that consumers will be passionate about, helping us avoid the commodity trap and strengthen the Philips brand image."

⊘ Once it was determined that a bedroom TV with added features was the right direction, sketches were used to define the basic form and elements. This sketch is of Cubi, one of the three concepts explored in face-value tests. With its angular shapes and abstract form, Cubi takes its cue from the Cubist movement.

new vision
focus group sessions

Profile	Paris	Los Angeles	Hong Kong
Teenagers	CD Mini	Message	CD Mini
	Clock/radio	CD Boombox	Message
	Pullover	CD Mini	CD Boombox
Young adults	CD Mini	CD Mini	Message
	CD Boombox	Clock/radio	Cuddle
	Emotional	CD Boombox	Emotional
Established adults	CD Mini	CD Mini	CD Mini
	Clock/radio	CD Boombox	CD Boombox
	CD Boombox	Clock/radio	Clock/radio
Overall	CD Mini	CD Mini	CD Mini
	Clock/radio	CD Boombox	Message
	CD Boombox	Message	CD Boombox

⊗ The strength of the New Vision program is its emphasis on gathering information from consumers to guide design decisions. Focus groups with participants of various ages were conducted in Paris, Los Angeles, and Hong Kong. The results were compiled to learn about the needs and desires of the target market.

⊘ The three sketches shown here were used to explore the dimensions and details of Ulie, the concept that became one of the three eventual designs.

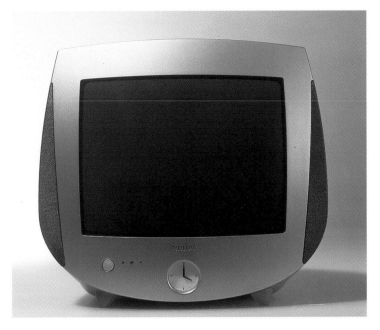

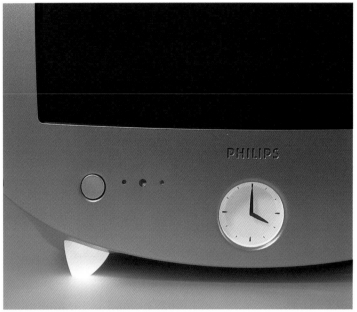

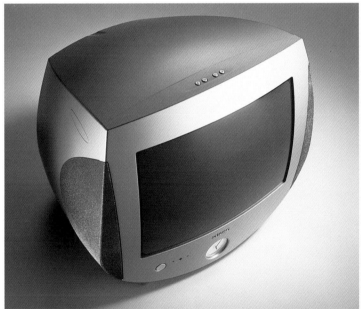

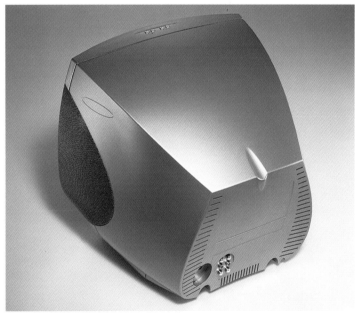

⊗ All three bedroom TV concepts include radio reception, an analog clock, and lighting elements. The user can combine these functions to awaken to music, light, or a favorite program. The Ulie model shows the clock at the front center (top right), controls at the top (bottom left), and cloth speaker panels that hint at the sound quality and refer to the bedroom environment (bottom right).

ANT-500 Digital Antenna

Rabbit ears. The words conjure images of an **awkward home eyesore** that rarely delivers on its **promised performance.**

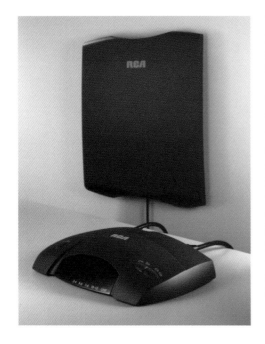

These antennas are the only way to receive off-air television signals when cable or a satellite aren't available, but that doesn't stop consumers from describing them as ugly and embarrassing in market research conducted by Thomson Consumer Electronics.

The accessory division of RCA, the company's major brand, initially proposed development of a revolutionary new antenna system. The design team at Thomson ran with the idea, investigating antenna programs to find a solution that addressed the problem of receiving off-air television signals, could be accurately tuned to receive specific channels, and could become part of the home entertainment scene, replacing the dreaded rabbit ears. The team delved into concept sketches, producing myriad ideas, but the job wasn't easy without a predecessor. Rabbit ears had been the mainstay antenna since the 1950s, and the design was relatively unchanged after forty years. "So we kept asking ourselves, 'What can this sort of product be? What should it be? How should it relate to the user and the environment?'" remembers Christopher Frost, one of two designers on the project.

Initial concept sketches showed an antenna that stacked on a shelf, much like a VCR or audio component; designers curved the top to prevent people setting things on it, which would interfere with the signal. They placed the LCD channel display, along with the frequency range controls, on the front. On review, the product management team urged designers to break out of the box and discussed how the antenna might work equally well as a horizontal unit or mounted vertically on a wall, which would occupy less space. But overriding questions remained. "People were used to mounting art or photographs on their walls, not electronic components. How were they going to relate to this?" says Frost. "The other question was, should the control panel and the antenna be separate so that the antenna could be placed behind the TV or a piece of furniture while leaving access the controller?" Because some people would want to separate the antenna while others would prefer to keep it as a single unit in their component rack, designers pursued the idea of a docking panel.

Product management gave the idea the green light; then it became a matter of working out the aesthetics. The first well-developed passes at rendering the docking design as three-dimensional Alias models placed the control buttons on the front of the panel. Because the control panel had so few components, however, it was too light to provide resistance when the buttons were pushed. To remedy the problem, designers reoriented the buttons atop the unit while maintaining its compact size.

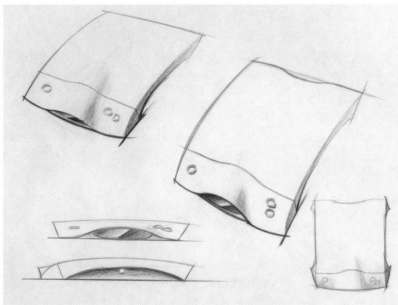

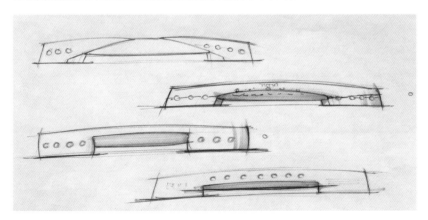

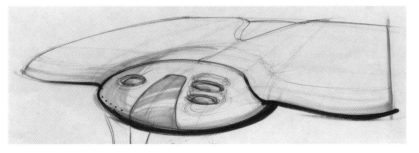

Next, the product went out for market research to gain insight about consumers' comfort level with accepting something new. Two groups of potential consumers were interviewed—satellite users who wanted to pick up off-air local stations and people without satellite or cable. The response was uniformly enthusiastic. "People wanted to try almost anything to solve their antenna problems, which combined the invasiveness of current antennas and their often weak performance," says Frost.

Although results were favorable, product management urged designers to modify the control panel again. "I think we pushed the envelope a little further than our product management liked and, even though it tested well in market research, there wasn't enough component space in the control panel area and we had to enlarge it," says Frost. They resized the control panel and, in so doing, had to move away from the curved form; it worked well at the smaller scale but failed aesthetically when made larger. Next, designers completed two rounds of color testing, ultimately choosing a dark neutral gray when metallic gold and deep purple were ruled out. In all, from concept through production, the project took twelve months.

The ANT-500 transforms the television antenna from a gawky, unpleasant eyesore to an attractive, fully integrated component of the home entertainment system, providing unparalleled versatility. When docked, the antenna and controller blend with other components. When separated, the antenna stands on its own as a sculpted form or can be hidden, while the controller is stylish, yet minimalist and unobtrusive in its presence.

"This project resisted a solution that all parties could live with," remembers Frost. "We found a lot of solutions one group liked that another couldn't stand, solutions that met some program goals but not others. We had to stick with it, stay detached from previous concepts, and remain free to come up with ideas in completely new directions."

What is Frost's secret to sound product design? He doesn't hesitate: "Tenacity."

⊘ Initial concept sketches showed an antenna that stacked on a shelf, much like a VCR or audio component; designers curved the top to prevent people setting things on it, which would interfere with the signal.

⊘ Designers placed the LCD channel display, along with the frequency range controls, on the front.

⊘ The product management team urged designers to consider how the antenna might work as a horizontal unit or mounted vertically on a wall. Because some people would want to separate the antenna while others would prefer to keep it as a single unit in their component rack, designers pursued the idea of a docking panel.

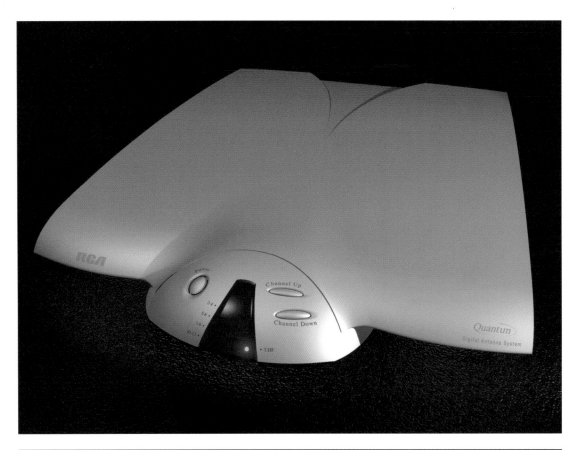

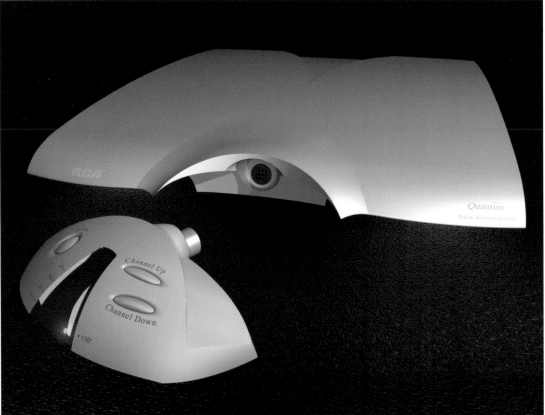

Designers modified the control
panel for ease of use by reorient-
ing the buttons atop the unit
while maintaining its compact size.

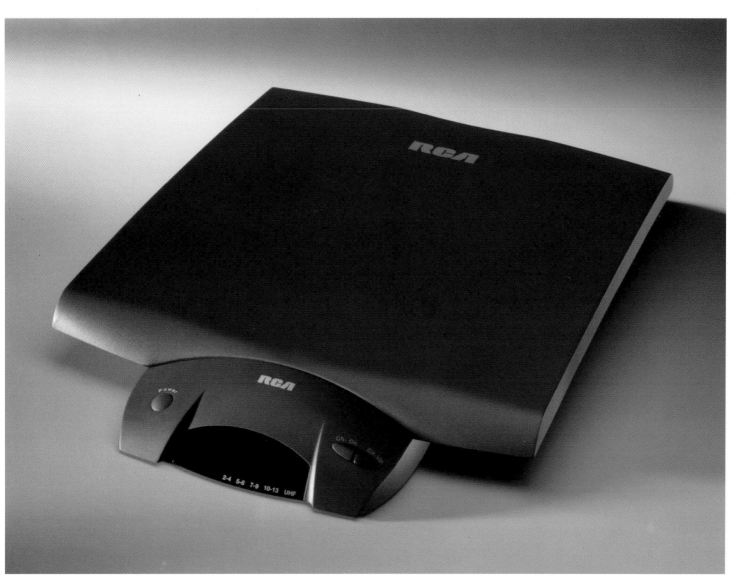

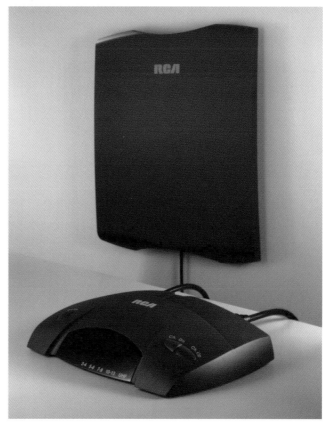

When docked, the antenna and controller blend with other components. When separated, the antenna stands on its own as a sculpted form or can be hidden, while the controller is stylish, yet minimalist and unobtrusive in its presence.

Motorola i1000™ Wireless Communicator

The **challenge** before the **designers** at Motorola was to make existing technology **accessible to a broad population.**

○ "The challenge of creating a handheld two-way radio and a face-fitting phone in one device presented a design paradox," says designer Scott Richards. Overcoming this challenge led to the i1000's most attractive features. For example, a window in the clamshell door allows users to access information without answering the phone, while maintaining the desired phone form.

○ Opposite top: Mind-mapping was among the creative problem-solving methods used to create a profile of the target market and the product and its features. Predesign mind-maps incorporated diverse requirements and wish-list elements into the product's design objectives.

○ Opposite bottom: Several concepts were evaluated as the development of the i1000 Wireless Communicator progressed. The industrial design team used solid modeling software and stereolitography tools to create forms and to incorporate different folding schemes into the design, as shown here. Interviews with users helped determine which form to go with.

Motorola wanted to integrate paging, cellular, two-way radio, and data technologies into a product with a less commercial feel than most business communication products. By restating the traditional rectangular box product in a less threatening, more intuitive package, Motorola's design team hoped to generate universal appeal and attract first-time wireless users.

One reason the team succeeded in accomplishing this goal was interdisciplinary teamwork. "The program succeeded because disciplines got together way up front," explains Scott Richards, the industrial designer assigned to the project. Regular meetings and product reviews provided a system of checks and balances for the various disciplines.

The project team spent six months researching user needs and narrowing the concepts before embarking on a yearlong product development process. "In any project, capturing preresearch data is essential in preventing the loss of early breakthrough ideas," emphasizes Richards. The team held mind-mapping and brainstorming sessions to identify the problem and create a profile of the user, the product, and its features. Marketing, engineering, human factors, and design team members then analyzed the results and devised a wish list of features: a hands-free speakerphone, extended battery life, and preferred product emotion targets. They also identified as a goal reaching beyond Motorola's traditional commercial base to attract white-collar professionals and consumers.

The industrial design team used solid modeling software and stereolithography tools to create forms—from crisp to soft—and to incorporate different folding schemes into the design. Nine form factor solutions were presented to three hundred users to gauge preferences in wearability, fit when in use, folding scheme, and general appeal.

The testing yielded important data that helped determine the direction. The clamshell top-hinged format, which affords users a high level of portability as well as a degree of privacy during use, emerged as the preferred form.

One-on-one interviews further clarified the research data and contributed to the design team's understanding of the issues and conflicting demands. "The data were ambiguous," says Richards. "Observing the users enabled us to read between the lines. For example, a designer can learn from the intensity and nuance with which a user discounts one feature, embraces another, or casually suggests a third."

Many users voiced a need to access display information on their communication device at all times. This conflicted with the high percentage of users who wanted a hinged clamshell door that provided a face-fitting form when opened and protected the device

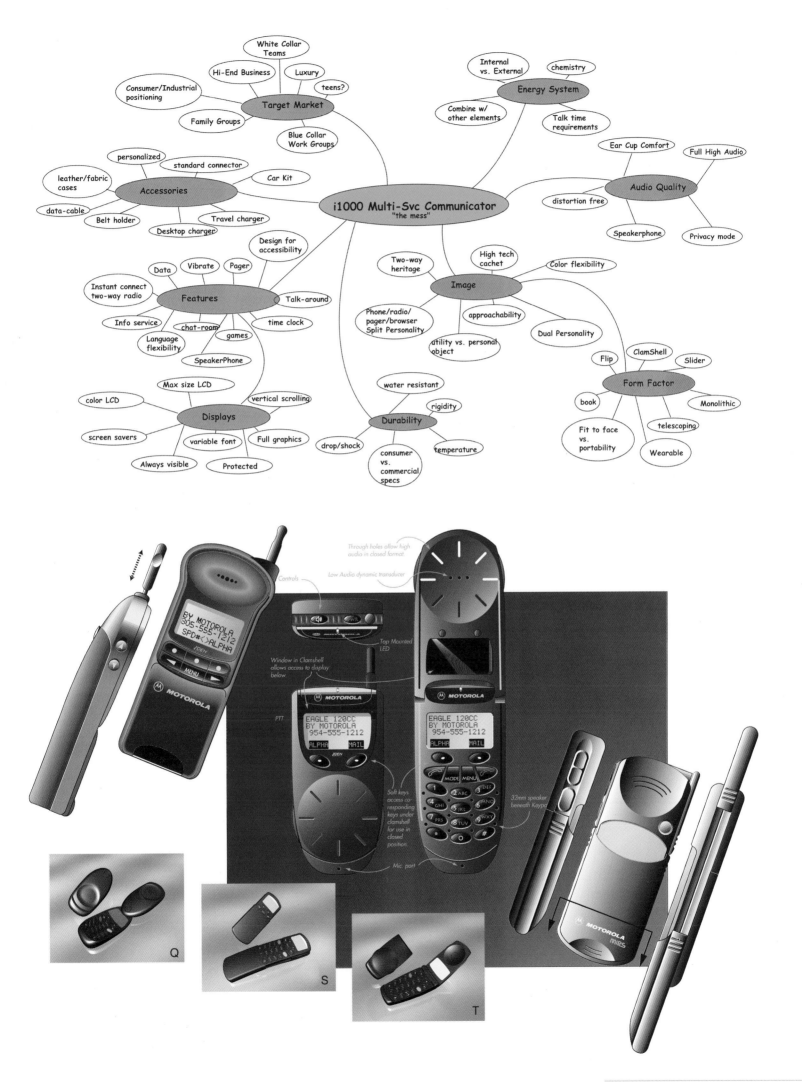

Target Market
- White Collar Teams
- Hi-End Business
- Luxury
- teens?
- Consumer/Industrial positioning
- Family Groups
- Blue Collar Work Groups

Energy System
- Internal vs. External
- chemistry
- Combine w/ other elements
- Talk time requirements

Audio Quality
- Ear Cup Comfort
- Full High Audio
- distortion free
- Speakerphone
- Privacy mode

Accessories
- personalized
- standard connector
- Car Kit
- leather/fabric cases
- data-cable
- Belt holder
- Travel charger
- Desktop charger

i1000 Multi-Svc Communicator
"the mess"

Features
- Design for accessibility
- Data
- Vibrate
- Pager
- Instant connect two-way radio
- Talk-around
- Info service
- chat-room
- time clock
- Language flexibility
- games
- SpeakerPhone

Image
- Two-way heritage
- High tech cachet
- Color flexibility
- Phone/radio/pager/browser Split Personality
- approachability
- Dual Personality
- utility vs. personal object

Displays
- Max size LCD
- vertical scrolling
- color LCD
- screen savers
- variable font
- Full graphics
- Always visible
- Protected

Durability
- water resistant
- rigidity
- drop/shock
- consumer vs. commercial specs
- temperature

Form Factor
- Flip
- ClamShell
- Slider
- book
- Monolithic
- Fit to face vs. portability
- telescoping
- Wearable

Through holes allow high audio in closed format.

Controls

Low Audio dynamic transducer

Top Mounted LED

Window in Clamshell allows access to display below.

PTT

Soft keys access corresponding keys under clamshell for use in closed position.

32mm speaker beneath Keypad

Mic port

BY MOTOROLA
305-555-1212
SPD#< >ALPHA

MOTOROLA

EAGLE 120CC
BY MOTOROLA
954-555-1212
ALPHA MAIL

MOTOROLA

EAGLE 120CC
BY MOTOROLA
954-555-1212
ALPHA MAIL

MOTOROLA

Q

S

T

when closed. These users also wanted to access caller ID information without answering the phone. A grasp of the issues underlying these seemingly conflicting requirements enabled the designers to solve the problem with a window in the clamshell door. The solution protects the device while allowing access to many functions.

An important aspect of the i1000 program—as with any high-volume product development program—was keeping within the goals Motorola set regarding cost, time, and manufacturability. Once the initial solution was agreed on, a vision rendering was archived by Motorola's division general manager. The team referred to this master drawing throughout the program to ensure that they stayed on course.

The handheld nature of the i1000 demanded three-dimensional modeling and evaluation. The industrial design team generated the external form of the product in its entirety using the same modeling software as the engineering development group. Motorola's internal rapid prototyping center created numerous wax-deposition, stereolithography, and machined models, which enabled the team to put a number of iterations before users for prompt feedback. The iterative nature of design was facilitated by all designers using the same CAD language. Using a common tool platform allowed data to be transferred with the design intent intact.

While industrial designers played a key role in the product's excitement, they give ample credit to the other disciplines. The success of this product begins with brilliant technology; solid industrial design conveys this power to the user. "Industrial design succeeds only when combined with similar success stories in acoustics, human factors, manufacturing, software, mechanical, engineering, and other areas," says Richards. "The ability of various product teams to work together is central to the success of complex products." He adds that while the disciplines do not always agree, constructive conflict often results in the best products. The i1000 clearly benefited from the early identification of users' needs and each discipline's understanding of them.

What inspires the industrial designers at a company like Motorola? Some people believe that designing for an existing company is frustrating, but Richards says that Motorola's heritage and design tradition creates a "nice framework to build on. To take products and add a new twist—to draw on the language of the past and interpret it for the future—is what makes industrial design exciting."

"The need to embed ever-advancing technologies into increasingly intuitive products will continue to challenge and inspire designers," predicts Richards. "We are witnessing, and effecting, the fulfillment of many communication ideas once thought unattainable. This convergence of dream and possibility is an incredible design inspiration."

The design team began with thumbnail sketches to explore how they might be able to restate the traditional "rectangular box" product in a less threatening and more intuitive package. Simple thumbnail sketches such as these were used to rapidly communicate early ideas among designers at Motorola. The need for immediate renderings and 3D models drove a quick migration to computer-based tools after this point.

Once the design team had determined the form factor for the i1000, they began the process of analyzing the impact and placement of internal components, including batteries, as shown here.

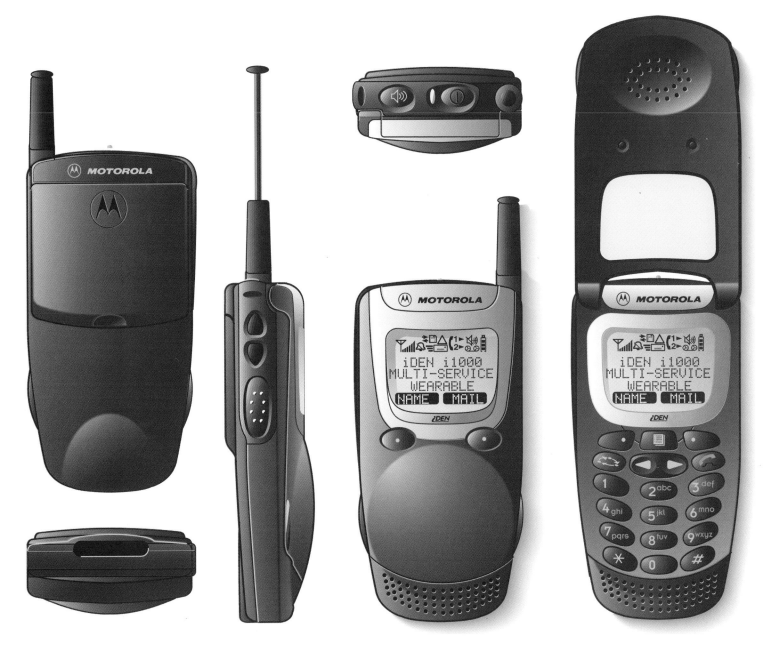

This rendering was created at the end of the design process. Looking at all angles of the i1000 in both open and closed positions helped the design team assess whether or not it achieved the program's objectives.

Infinity Prelude **MTS Loudspeaker**

With a price tag of **$8000 a pair** and their singularly **elegant presence,** the **Infinity Prelude MTS loudspeakers** are definitely not for the weekend **audio enthusiast.**

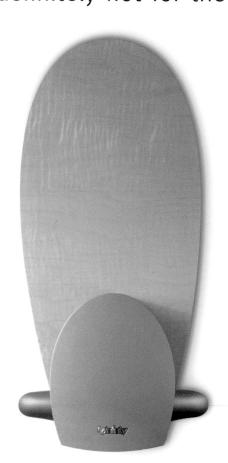

These are speakers for the affluent fan who demands a superior audio and visual performance in a home theater.

"This was not a project in which the designer just wraps a pretty box around the technology," explains Dan Ashcraft, president of Ashcraft Design (Los Angeles), a firm that has been designing speakers for about fifteen years. "We had to marry the look with how the product works for the customer. The speakers had to work closely with the context of their enviroment. They represent a technology and design statement."

The design and subsequent success of the product is even more remarkable considering that the Infinity brand was in trouble. Once a premier brand name, Infinity has been struggling for several years. Considerable competition, the laissez-faire attitude of enormous consumer electronics retailers, and a flood of similar products spelled smaller price margins and a greatly reduced presence in the market. Somehow, the brand had slipped into a category where consumers were more concerned with price than with superior quality and unique features. Certainly, industrial design was a non-issue, despite the fact that audio industry research shows that 50 percent of the customer's purchasing decision is based on a loudspeaker's appearance.

Harman International, Infinity's parent company, knew it was time to revitalize the brand by creating the most distinctive products in the category. Ashcraft Design was brought in to make the vision real. The firm identified nine key factors that would help the brand regain the attention of its prime customer, the serious audio enthusiast. This list became the Infinity brand framework: image among audio enthusiasts, musical accuracy, advanced materials application, innovative technology, a profitable brand, selective distribution, utilization of trickle-down technology, relatively high price, and distinctive and interesting industrial design.

At the start of the project, most of the industrial design from competition on the market was predictable—primarily, rectangular wooden boxes—so upping the aesthetic values of the product held plenty of potential. The box was seen as a necessary evil; in order to amplify sound, speakers must contain a large volume of air, at least several cubic feet worth. Infinity's designers used a different technology—an amplifier in the subwoofer—to better drive the woofer. "The oval subwoofer enclosure provides more internal volume and reduces standing waves to improve the bass performance in a visually smaller cabinet," Dan Ashcraft explains.

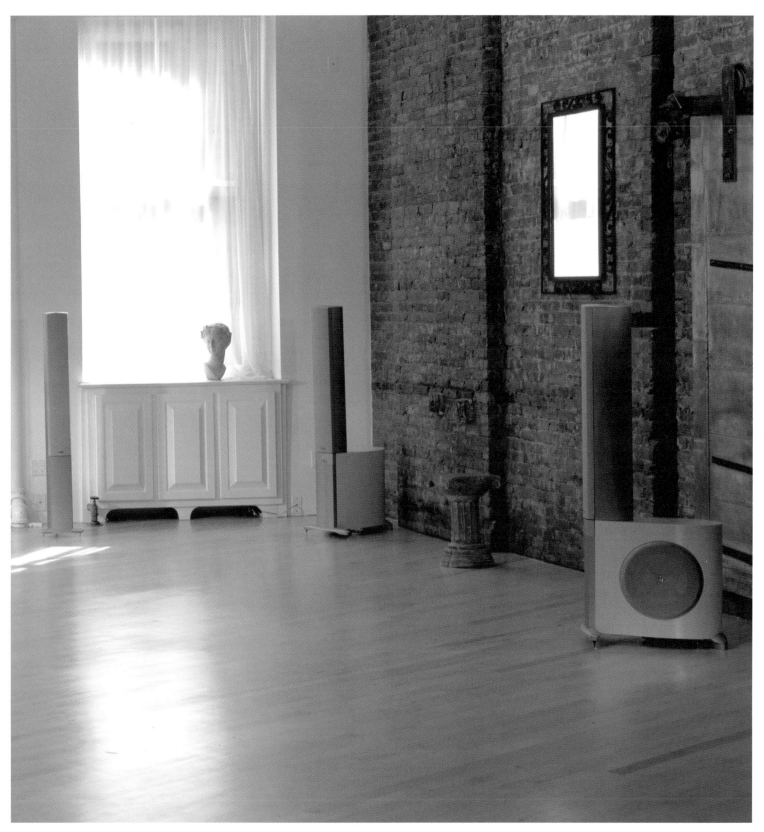

⬨ Tall, thin columns of high-quality,
die-cast aluminum and a choice
of wood finishes give the buyer
of the Infinity Prelude MTS loud-
speaker system an opportunity
to create a design statement in
a home theater system.

This change in technology allowed Ashcraft to consider an entirely new shape for the speakers. The new tower's modular design and wall brackets allow the customer to use the speaker tower and subwoofer together for a dramatic architectural statement or to separate the tower and wall mount it or set it on a stand. In any configuration, the Prelude's thin aspect ratios made the product more compatible with the high-end customer's interior environment. Another aesthetic plus: The buyer has a selection of figured maple, cherry, or black anigre wood finishes.

The Prelude MTS tower column is fabricated from a brushed, anodized aluminum extrusion with titanium powder-coated, diecast aluminum end raps and a fabric grille. The subwoofer is made from wood veneer placed over bent, steam-formed plywood.

"Materials, colors, and finishes account for 50 percent of a buyer's purchasing decision," Dan Ashcraft says. Matching the high-quality audio experience with an equally wonderful visual experience creates a real emotional connection to the brand.

Among audio enthusists and critics, the new system met with immediate acceptance. "Visually as well as sonically," wrote Corey Greenberg of *Audio* magazine, "these speakers make as bold a statement as I've seen high-end audios produce in quite a few years. The Prelude MTS is far and away the finest-sounding loudspeaker system ever to wear the Infinity badge." Margins have increased from zero on the previous product to 30 percent, and Harmon International's stock increased from $44 a share at its introduction to $60 a share as of February 2000.

 This page: The speakers can be split, with the top portion hung on the wall with a bracket.

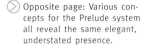 Opposite page: Various concepts for the Prelude system all reveal the same elegant, understated presence.

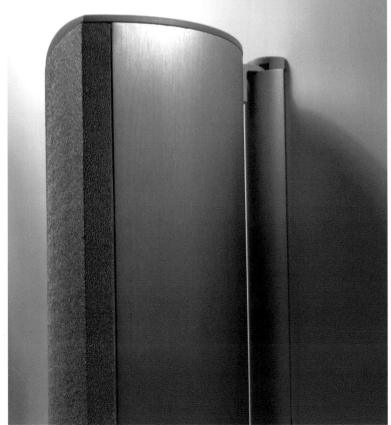

Benwin Executive Speakers

Flat-panel technology **completely changed** what is possible in **speaker design** for Benwin, a **new brand** in the United States.

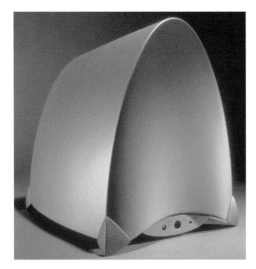

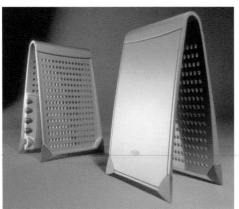

⌃ Above: The Executive.

⌄ Opposite page: The Gamer (above) and the Soho (below).

The final designs are sculptural and beautiful enough to be displayed prominently in the office or home, yet they clearly show off the flat panel technology in a dramatic way.

The company seized an opportunity to exclusively license a new flat-panel-driven technology that uniformly spreads vibrations over a flat surface and does not require the traditional volumetric speaker enclosure—that is, the familiar box shape. But the exciting technology needed a home that was just as intriguing. For that, Benwin turned to RKS Design of Thousand Oaks, California.

Benwin asked RKS to create three levels of multimedia speaker systems for three kinds of users—executives, gamers, and multimedia computer users. In addition, they wanted the speakers to communicate at first sight the new technology they housed. The technology also had to be made affordable. Designers Ravi Sawhney, Hiro Teranishi, Cary Chow, Lance Hussey, Kurt Botsai, Christopher Glupker, and Juan Cilia say they created three hundred to four hundred different gestural drawings, just to explore how a flat surface could be manipulated as well as how the thinness of the device could be highlighted. Many experiments were highly sculptural. The challenge was to intrigue the consumer with the thinness of the speakers while conveying the quality of the sound they produced.

Favorite shapes—those that could become visual keys for the Benwin brand, not just look cool—soon began to emerge. For what would become the Executive, a speaker system destined for the office, an arch shape for the speakers and subwoofer created an elegant, decidedly unspeakerlike presence, but the shape was nevertheless stable and strong.

The design for the multimedia speakers—often for homes and small offices—turned the arch shape upside down. Sweeping upward, the speaker shape for the Soho is a visual representation of sound emerging and boldly expanding in a space. An elegant half oval, or what the designers called an acorn shape, was slightly contoured to give its panels dimension and shape. The speaker base is a distorted mirror version of its top, and the subwoofer reflects the same form factor.

"The Soho speakers are created for people who want just a little change," explains RKS president Ravi Sawhney, noting that seating the speakers on adjustable arms immediately communicates to the consumer that they are adjustable. The speakers also look light, as if they might float away unless the arms were not tethering them. "They have a bit of edginess but with balance. Something that gets wider as it gets taller is not something we are used to seeing," he adds.

The design for what became the Gamer took the upward swoop even further. Both the speakers and the subwoofer are decidedly whimsical but still look powerful. The designers liked the way the shape of the subwoofer, reminiscent of the Mad Hatter's unusual topper, implied sound welling up and bursting through the speaker they placed at its top.

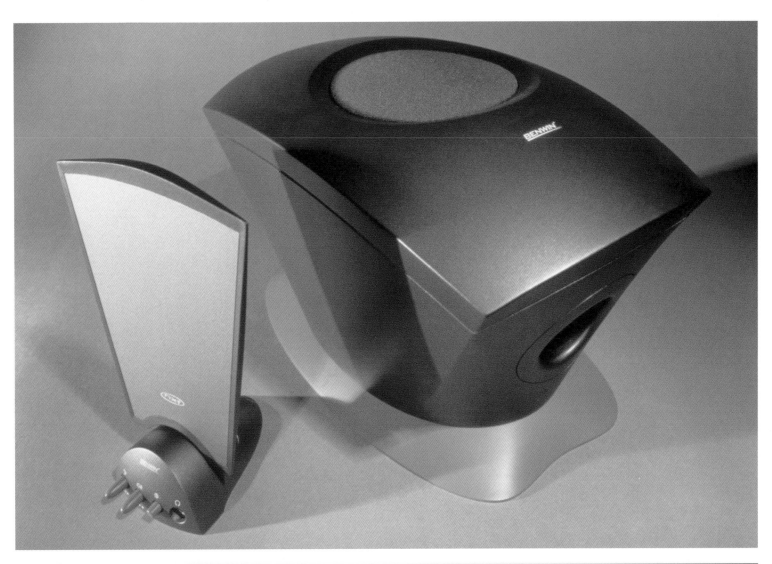

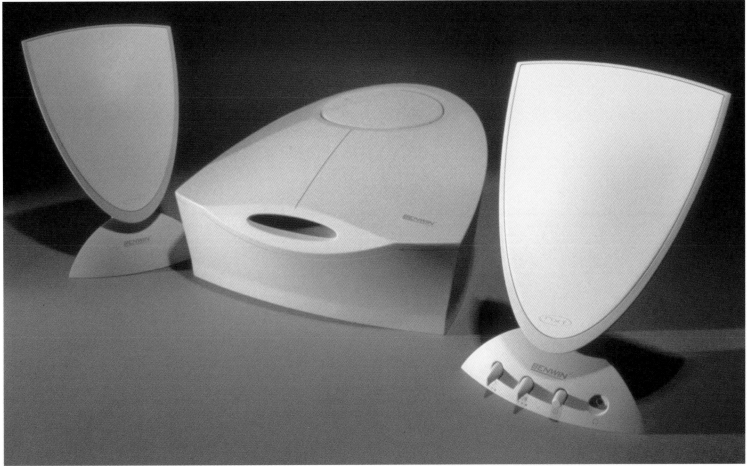

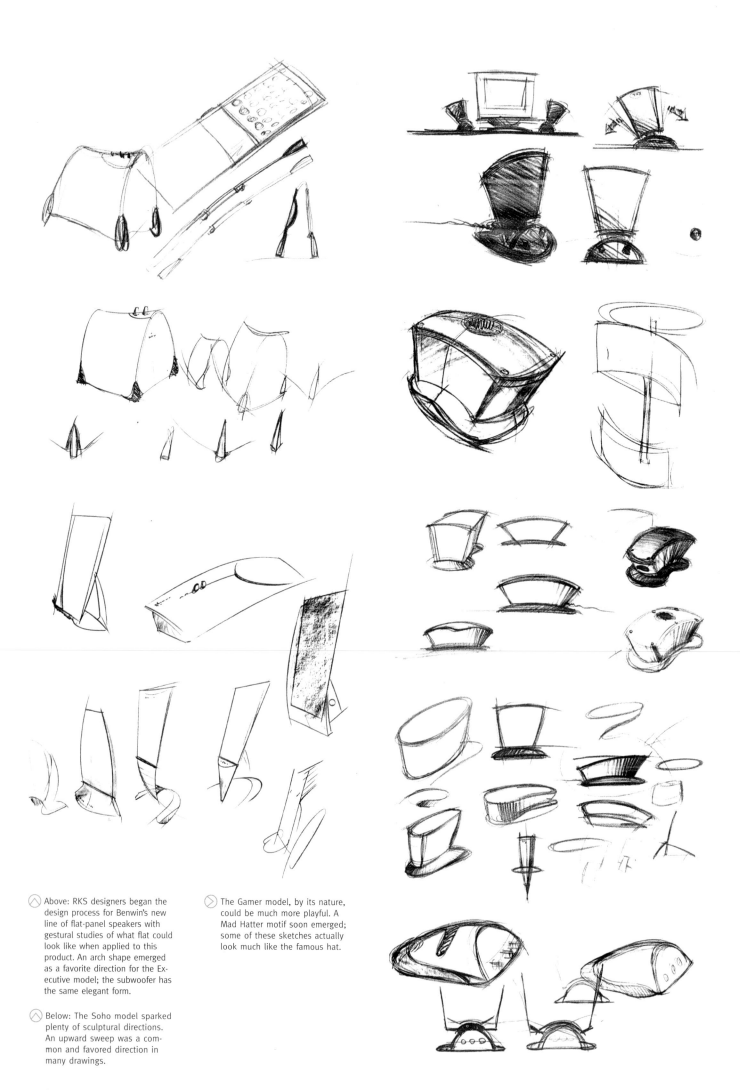

⌃ Above: RKS designers began the design process for Benwin's new line of flat-panel speakers with gestural studies of what flat could look like when applied to this product. An arch shape emerged as a favorite direction for the Executive model; the subwoofer has the same elegant form.

⌃ Below: The Soho model sparked plenty of sculptural directions. An upward sweep was a common and favored direction in many drawings.

⌄ The Gamer model, by its nature, could be much more playful. A Mad Hatter motif soon emerged; some of these sketches actually look much like the famous hat.

The Gamer's speakers are also seated on adjustable arms. "The Soho arms actually pivot. The flat-panel technology is so lightweight that you can articulate the design easily," explains Hiro Teranishi, RKS vice president and design director. "The design suggests motion, and they do actually move."

While most subwoofers are meant to be hidden under a table, all three Benwin designs are meant to be displayed like sculpture. The Executive's subwoofer, in particular, looks modern and iconic, yet it subtly refers to a much earlier audio technology: the old-fashioned-single-speaker radio of the mid-twentieth century.

Details like knobs and feet were crucial to the design of the line. They are metaphoric, referring to high-end audiophile equipment. "We will push and pull the detail to imply the genre of the industry. These are wild shapes that people may not immediately recognize as speaker systems, and in any design, it's easy to be a shock jock. But these designs also offer relevance," says Teranishi.

In the end, RKS created designs that were so remarkable that they have become identifiers for the Benwin brand: The company has become well known for its design, which definitely breaks out of the box conventional speakers embraced. "Benwin defines itself now as a provider of designed technology, not just technology," says Sawhney. Even better for the consumer, all this wonderful-looking technology is affordable. The Executive's suggested retail price is only $250.

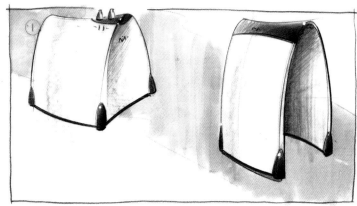

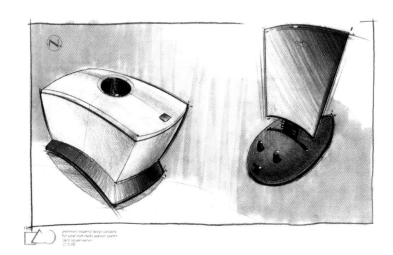

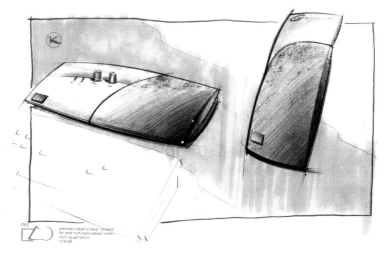

⌃ Even knobs and plugs got special attention. The designers relied on these elements to refer the consumer to previous, more familiar speaker aesthetics. After all, this range of speakers is so radical in appearance that the buyer may not immediately understand what the product is.

⌄ From sketch studies, the designers created more refined drawings that worked out knob, logo, and accessory placement, among other details. These Soho rejects show that the designs were still under consideration, even at this point in the design process.

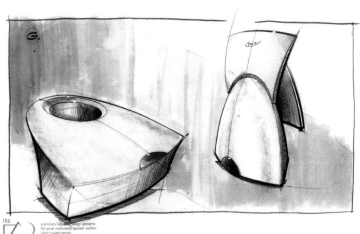

KSM32 Studio Microphone

Cesaroni Design's goal was a **new product** for Shure Incorporated—a studio microphone that **appealed to consumers** with **home studios** as well as small to midsize **professional studios**—

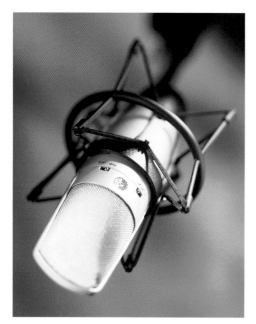

⬡ Here, mounted inside the uniquely designed shock mount, one can see the retro logo and retro chrome switches on the reverse side of the microphone.

but never did they envision that their creation would turn up on Jay Leno's *Tonight Show* desk. The Shure KSM32 microphone was suddenly in full view; not surprisingly, Shure has revisited the KSM32's market appeal and is targeting much bigger studios.

Shure Incorporated originally came to Cesaroni Design wanting a microphone for professional studio recording and live productions. The company was established, known for the quality of its professional audio equipment, but, at the time, did not stock a microphone exclusively for professional studio recording. Shure executives were confident that their technology could surpass the competition's offering, especially by combining its high-quality performance with a midrange cost.

Shure provided Cesaroni with the parameters and dimensions for the microphone, along with their objectives—which were somewhat contradictory: Design a microphone that looks timeless, yet retro, while also appearing high tech. Shure also wanted the microphone to look and feel expensive, despite its lower price.

Curt Cruver, principal designer of the project at Cesaroni, set out to integrate these seemingly divergent characteristics. To achieve a timeless appearance, he used Shure's corporate product color scheme—charcoal gray and champagne—which the company had relied on for years. He avoided trendy design details, such as the large radii used frequently in the late 1980s and early 1990s to give edges and corners a softer look, so the design would not seem dated in just a few years. "I had to strike a balance between trendy and contemporary," says Cruver. "That was the trick."

For a retro feel, Cruver placed an old Shure logo on the side of the microphone opposite to where the current mark appeared. Finally, while the electronics themselves demonstrated the product's high-tech nature, Cruver decided to apply contemporary styling so that the microphone would not be a straight cylinder.

With these elements in mind, the design team created rough concepts and sketches, took those to the three-dimensional computer geometry stage, and presented color renderings of six concepts that ranged from conservative to daring. The selected design was one concept away from the most radical idea presented despite Shure's tendency toward conservative design.

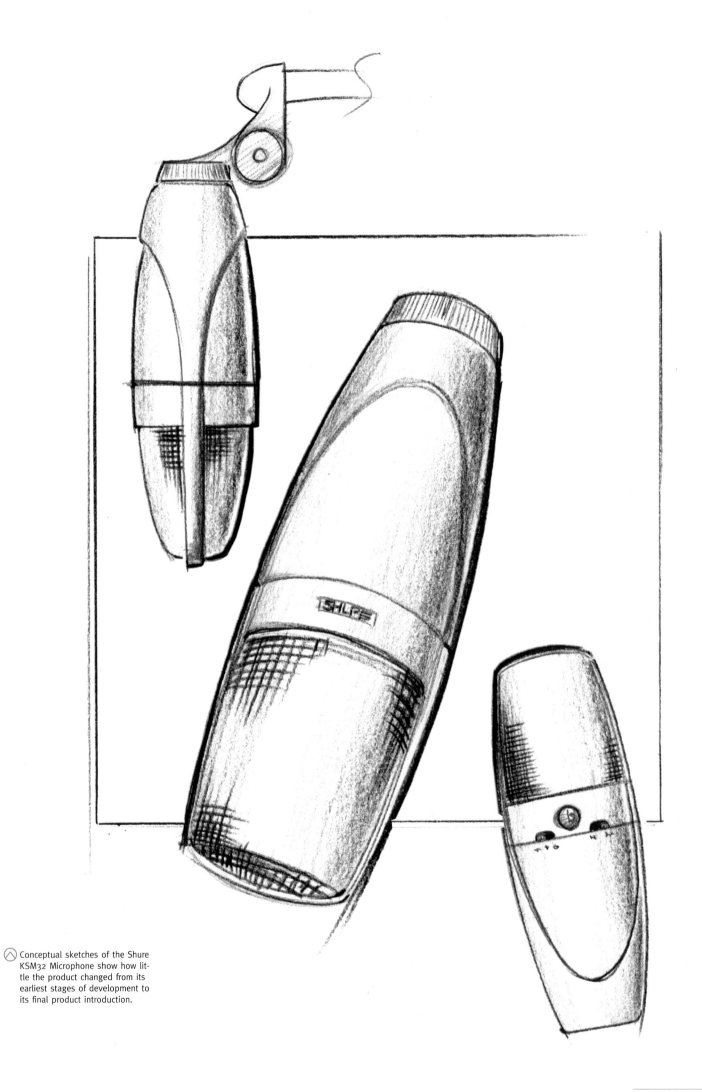

Conceptual sketches of the Shure KSM32 Microphone show how little the product changed from its earliest stages of development to its final product introduction.

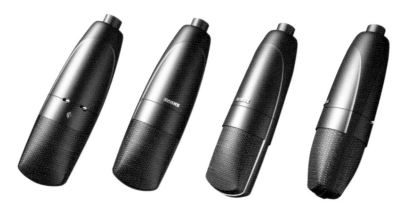

"The project was stereotypical with respect to the procedure and how we got from point A to point B," Cruver says. Less common was the computer work. The project was the perfect candidate for breaking in Cesaroni's new three-dimensional computer software, but a learning curve was involved. Typically, the design team used Adobe Photoshop, a popular photographic and graphic design program, as an illustration tool to create two-dimensional layouts. Designers created a sketch, scanned it in, then colored it; this saved time because they could scan in a drawing without worrying about the actual dimensions. Photoshop was a good tool for complex products because it was fast.

However, because the KSM32 Microphone has only three major parts—the lower half main housing, the midsection ring, which sports the two logos, and the grill assembly—the three-dimensional software program was most efficient because it gave the designers a head start on the tooling geometry. They could take the geometry to the finished industrial design geometry level and hand it off to an engineer, who could bring it into his system, refine it, and pass it on to the toolmaker.

By far, the microphone's most innovative design feature is its shock mount accessory. While all studio microphones have this feature, the Shure Incorporated mount is unique in that it suspends the microphone in a web of elastic bands. Studio microphones are mounted to a boom; users do not touch them. If they do hit a microphone by accident, the shock mount helps absorb the noise.

The final product met all of Shure's expectations and looked and felt expensive, just as requested. "There's a line in Jurassic Park that we like to joke about," says Cruver, quoting from a scene where one character acknowledges that a pair of night-vision goggles is heavy and adds, "They are also expensive, so put them down!" Cruver says the use of cast zinc, which was used for all the enclosures, contributes to the product's weight and helps it feel expensive, despite its price point.

Cruver says the biggest challenge was motivating a conservative company like Shure Incorporated to push the design envelope. "They took a chance and it paid off," he says. His secret to good product design: "Understand the client and address all their concerns and goals. Show them concepts that address exactly what they want. Then, show them exactly what they want plus more."

⊗ With the help of two software applications, ProEngineer and CRDS, designers were able to show Shure Incorporated the microphone from multiple angles using a computer rendering of its three-dimensional geometry.

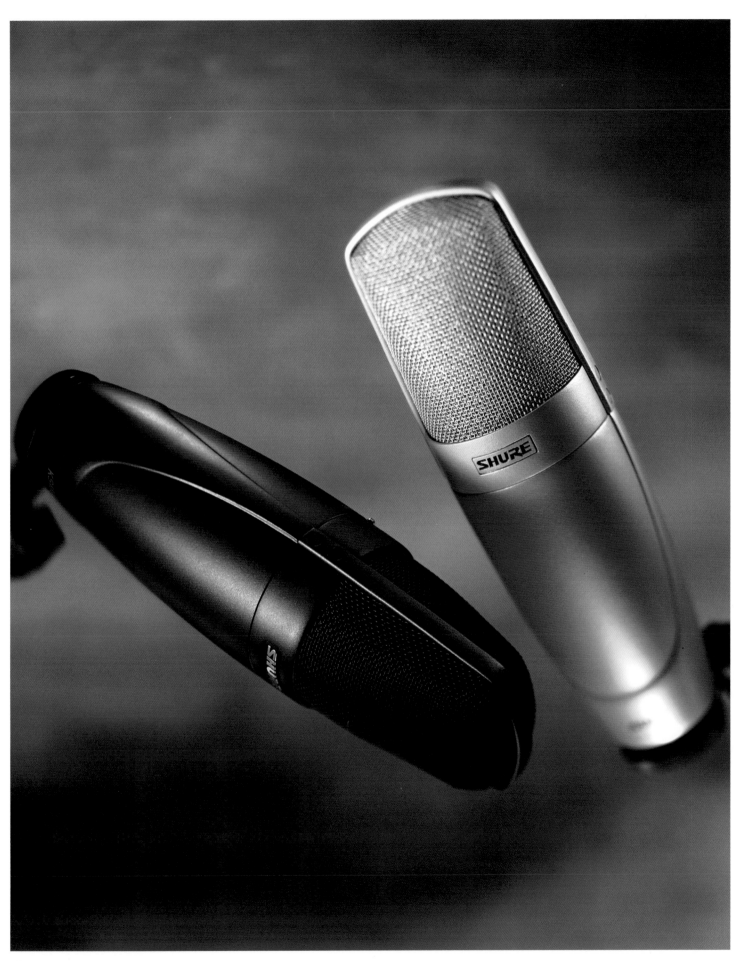

The Shure KSM32 microphone.

DeWalt Worksite Radio/Charger When Martin Gierke, Black & Decker's **director of industrial design,** met with Brian Matt, principal of **Altitude,**

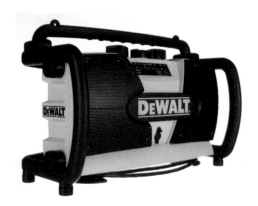

The overall form of the radio and its details, such as its oversized control knobs, carrying handle, and roll cage, convey an air of ruggedness, durability, and ease of use. The DeWalt name is advertised through its signature black and yellow and the large logo printed front and center.

a small design firm in the Boston area, to discuss potential products, he outlined several and said, "Pick what you can do quickly and effectively."

Matt was immediately intrigued with the brief for a commercial construction site radio. Black & Decker wanted a radio for use at a commercial construction site as part of its DeWalt line. "You might rethink that choice," responded Gierke. He saw the product as a minor DeWalt influence, loaded with political concerns and difficult implementation. Black & Decker makes tools, not radios! But Matt saw the project's potential and pushed on.

The technology wasn't new, so the focus was on design. "After all," explains Matt, "a radio is a radio. The excitement lies in the execution of the product. Our traditional design process would work perfectly well." Matt believes this enabled more creativity in designing the product. "To be successful with mature category products like radios, you have to be twice as creative as with a product that dazzles with new technology," he says. "This project didn't need a unique process; it needed extensive design creativity."

The biggest challenge proved not to be within the product but the way the product was positioned within Black & Decker. "Because it was an insignificant program for them, with only moderate volumes projected, the marketing team didn't provide as much information and insight as they usually do," laments Matt. "There were also chain-of-command problems. At one point, we had to completely redo one of the phases."

Matt and Dan Cuffaro, Altitude's design manager and the leader of the DeWalt radio program, visited job sites and applied their knowledge of construction to the radio's use, form, and features. "We treated the product as if it were a tool rather than an electronic device," asserts Cuffaro. To avoid building a mere boom box, they made product architecture and design decisions by determining what was best for the environment—destructive, corrosive, dirty, wet construction sites.

A team of five began developing sketches, continuing to visit construction sites to consider and reconsider their ideas. In all, the team generated more than one hundred sketches—some whimsical, others practical. The ideas included a knapsack radio, a radio that drove into the ground like a giant tent peg, a soft toolbag, and a radio in a five-gallon pail.

To whittle down the options, the team used an evaluation matrix with criteria—durability, manufacturing costs, ease of use—weighted according to their importance. In addition, the sketches were shared with DeWalt's best customers to learn what appealed to them.

Early concept sketches explored a number of directions, including a ground stake (top left), tool box configurations (bottom left), and various tools (center right and bottom right). Designer Brian Matt liked the concept of a radio built as the lid of a five-gallon pail (top right). The direction chosen—a tool box merged with a generator (center left)—was more conservative.

SPIKE END

BATTERIES

SPEAKERS

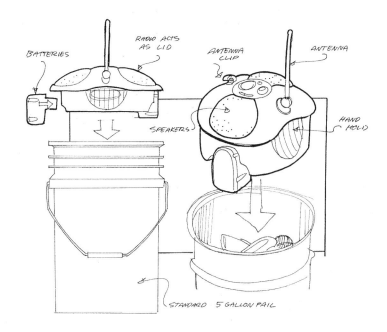

BATTERIES

RADIO ACTS AS LID

ANTENNA CLIP

ANTENNA

SPEAKERS

HAND HOLD

STANDARD 5 GALLON PAIL

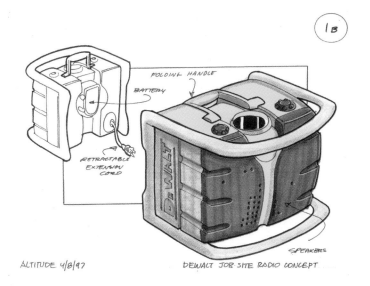

1B

FOLDING HANDLE

BATTERY

RETRACTABLE EXTENSION CORD

SPEAKERS

ALTITUDE 4/8/97

DEWALT JOB-SITE RADIO CONCEPT

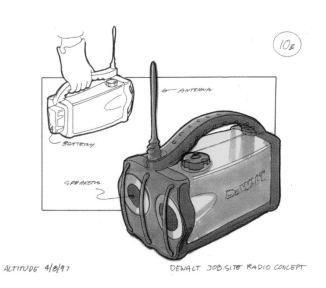

10B

ANTENNA

BATTERY

SPEAKERS

ALTITUDE 4/8/97

DEWALT JOB-SITE RADIO CONCEPT

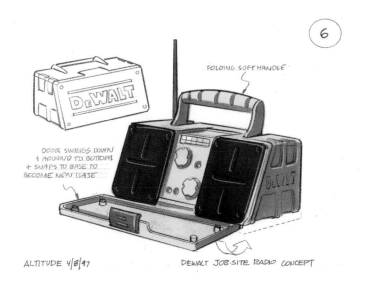

6

FOLDING SOFT HANDLE

DOOR SWINGS DOWN + AROUND TO BOTTOM + SNAPS TO BASE TO BECOME NEW BASE

ALTITUDE 4/8/97

DEWALT JOB-SITE RADIO CONCEPT

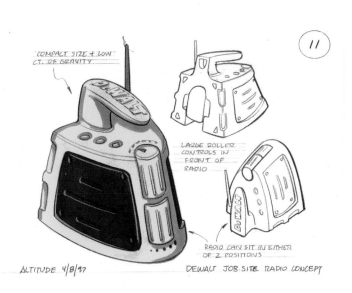

11

COMPACT SIZE + LOW CT. OF GRAVITY

LARGE ROLLER CONTROLS IN FRONT OF RADIO

RADIO CAN SIT IN EITHER OF 2 POSITIONS

ALTITUDE 4/8/97

DEWALT JOB-SITE RADIO CONCEPT

Armed with the recommendations suggested by the decision matrix, the Altitude team met with a team from DeWalt—a senior design manager, marketing manager, project engineer, and sourcing director. The direction they selected—a toolbox merged with a generator—was relatively conservative, but it emphasized the nature of the radio as a job tool.

Matt stresses that the charger is a key ingredient of the product's success. Conversations with construction workers reinforced his opinion that users did not want to waste electricity needed for power tools on a radio. "I kept pushing this idea despite initial reluctance," Matt says. "Our conversations with users were helpful in convincing Black & Decker that it was worth the added expense and technology hurdles."

During the next design phase, the team experimented with the look to develop a radio that fit in with the job site and spoke to its function. They built four three-dimensional foam models to explore variations on the design theme and developed full-color illustrations to show moving parts. In addition, they used two mechanical engineering bucks to show how the battery fit into the back of the radio—perhaps the greatest engineering challenge. The team shared early mechanical models with users to make sure they could easily insert the batteries. The team also used the models to investigate various types of roll cages, which not only protect the radio but also speak to its durability and ruggedness.

Once they clarified these basic issues, the team refined the details. A series of rapid prototypes helped determine the placement of the rubber feet and antenna, the form of the knobs, and so forth. Black & Decker conducted focus groups with customers to share appearance models. Assembly issues were also hammered out during this stage.

Finally, the team sent the specifications to Black & Decker to manufacture an EB-1 (first engineering build) using real plastic forms with real components. Most of the creative work was done, but the team continued to tweak details, graphics, and color.

The result is a radio whose appearance speaks to its function. The large grill covers scream "big sound." Oversized buttons and a cord wrap area under the radio address ease of use. The rubberized antenna shows that it is made to withstand rain, mud, and worse. The roll cage visually indicates the product's strength.

The radio also serves as a billboard for the DeWalt name; Matt got this idea during a meeting. The design team placed an oversized logo between the speaker grills; it is clearly visible as the radio hangs from a nail on the construction site or sits on top of a truck. In 1999, DeWalt produced 1.5 million units—a tad more than their original prediction of 30,000 to 60,000 units.

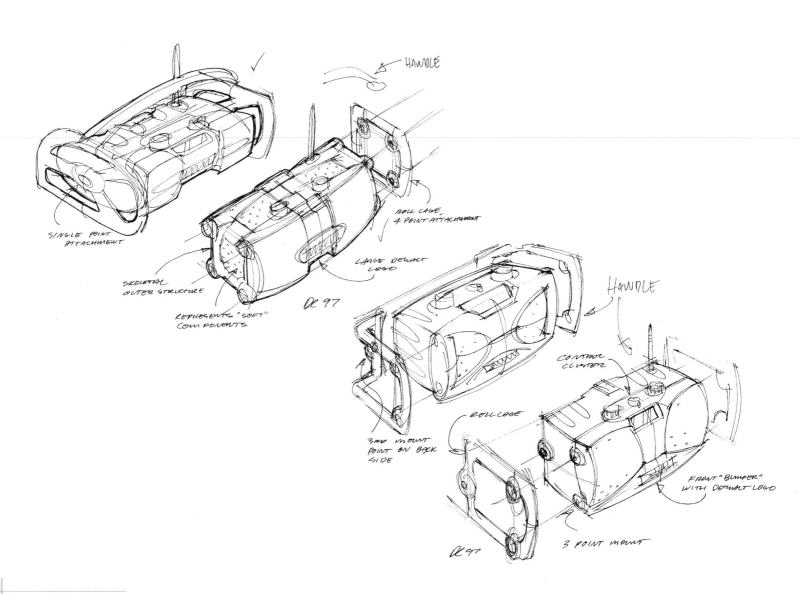

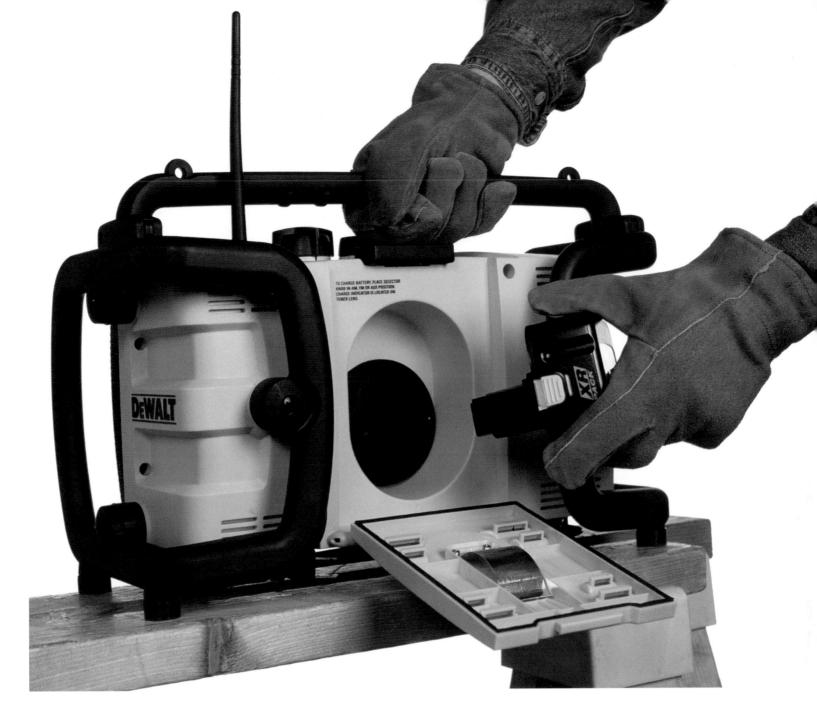

On the radio photo: "TO CHARGE BATTERY PLACE SELECTOR KNOB IN AM, FM OR AUX POSITION. CHARGE INDICATOR IS LOCATED ON TUNER LENS."

The initial project brief was simply for a radio; it was designer Brian Matt's idea to add the battery-charging function, a feature that contributed greatly to the product's appeal in the marketplace. Mechanical models were used to make sure the charging function was easy and intuitive.

Once the basic architecture of the radio was defined, the group sketched refinements to the design and to explore the form of the radio, the roll cage, the speakers, and a host of other details, including how to advertise the DeWalt name. This refinement sketch closely resembles the final direction.

Yamaha Compact **Silent Electric Cello—SVC 200**

Can a cello be given the **silent treatment?** It can if it is part of Yamaha's **line of silent instruments,**

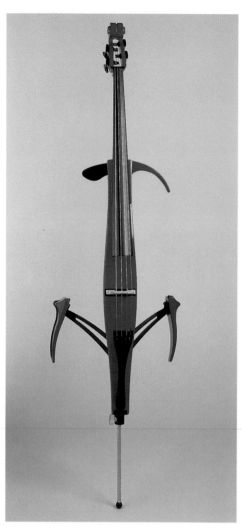

The Yamaha SVC 200 Compact Silent Electric Cello, open and ready for play.

created to give musicians the option to practice silently in places or at times that their music might not be appropriate or allowed. Surprisingly, most musical instruments can be made silent or least very quiet, according to Yamaha Corporation. First, they are made electric; then, added headphones render them virtually silent. At that point, Yamaha can add numerous features that enhance the player's experience and make practice more meaningful and fun.

The concept of silent instruments is popular, especially among musicians in countries where living and working spaces are limited. Even in the United States, where such space is comparatively expansive, situations still exist where silent practice is practical, if not necessary. Musicians who live in apartments or dormitories, stay in hotels, or practice late at night are among the likely consumers of silent instruments. Schools and educators also use these instruments, in both private and group instruction, as do adults just learning to play who are inhibited by the reaction of others.

Yamaha began developing its silent technology for drums, piano/keyboard, and brass before embarking on classical stringed instruments. "As the offering widened to include several families of instruments, consumers continued to request that other instruments be given the silent treatment,'" says Michael Schaner, product manager, Yamaha Corporation of America. Yamaha's first silent stringed instrument was the successful Silent Violin; the Silent Cello was the next logical development.

Yamaha designers created the compact Silent Cello for use in amplified situations, such as performing outdoors or within a band. Because it is a solid-body wood instrument, it is not susceptible to variables, such as changes in weather and humidity, that affect acoustic cellos. It is also not as fragile.

But the ability to practice virtually anytime, anywhere, and durability aren't its only advantages; the Silent Cello is also compact, a big plus among cellists who travel. "Most traveling cellists buy an extra seat for their instrument on an airplane, to avoid the hazards of checking their cello as baggage. The compact Silent Cello can be placed in the overhead bin of most planes, saving the cellist money and grief," Schaner explains. In addition, designers included reverb, which lets players choose the environment in which to hear the sound they produce—that is, in a concert hall, a small room, outdoors. Finally, designers added an auxiliary input to allow for practice with recorded accompaniment. They worked to make the instrument feel as much as possible like a typical acoustic cello to enhance player comfort and limit the need for relearning when switching between instruments.

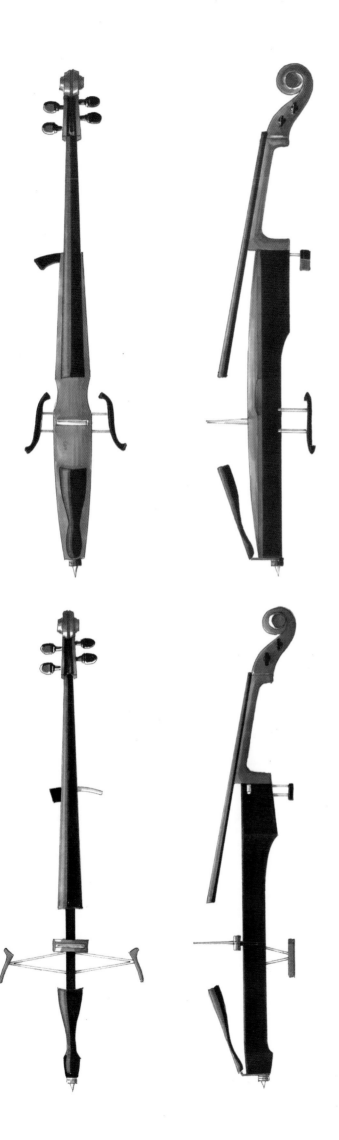

Though the Silent Cello is an atypical product, the design process followed a traditional route. Designers began with rough sketches in which they streamlined the size of the cello, removing as much extra material as possible while maintaining the identifiable shape of the instrument. Next, they created several 1:5 mock-ups before making a 1:1 mock-up to check the ergonomics and playability of the instrument. At that point, they brought the final drawing into CAD, where they simulated an innovative folding system. Next, they built a prototype to refine the folding feature and gather design feedback. Cellists were invited to evaluate the instrument and, based on their suggestions, designers modified the size of the armrest and the shape of the chest support. After that, the cello required only fine-tuning of color and finish before it was ready for production.

Making the instrument compact while maintaining the image, playability, and elegance of an acoustic cello was the design team's biggest challenge, according to Mazahito Ikuma, manager of the string design section, Yamaha Corporation of Japan. To overcome this hurdle, the team minimized the components but kept many other attributes of the acoustic cello intact. "We were

ⓐ When designing the Silent Cello's knee support, designers were not sure if the position would be comfortable for the player, so they tweaked the design in CAD. Engineers then eliminated extra parts to minimize the body. However, with this change, the product did not resemble a musical instrument.

ⓥ Working in CAD, designers were able to recover the shape of the cello, although it needed more support for playing.

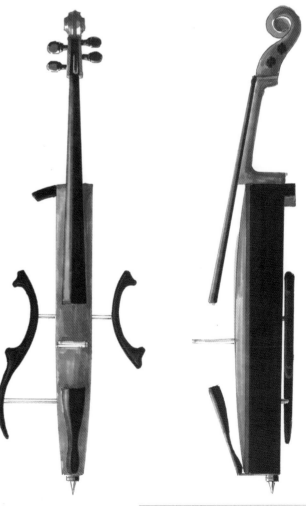

particular about the material, shape, and finish of the parts for keeping the elegant and rich atmosphere of the cello," Ikuma says. The instrument is sleek, compact, and portable. Designers created a detachable arm support and folding knee support but maintained traditional construction and size in the neck and centerpiece of the body to enhance the instrument's playability.

To date, consumer reaction has been positive, especially among professional cellists. "They needed an instrument to practice at a hotel or at midnight, and they also saw great potential for big-stage use with other electric instruments," says Shigeto Nomura, general manager of strings, guitar, and percussion exports, Yamaha Corporation of Japan.

What is Yamaha's secret to silent success? "Acoustically, we used natural woods, spruce—the same as an acoustic cello—as the centerpiece. The instrument's slim body made the natural sound harsher, but we successfully adjusted the sound warmer by modifying an electrical circuit," says Nomura.

"Our wide experience with designing and producing many acoustic and electric instruments helps make such hybrid products. Another factor is our relationship with musicians. Many of our employees are musicians, and sharing ideas and passions with world-class artists is the major driving power in developing these instruments."

⊗ Below left: As designers closed in on the final design, Yamaha engineers decided to make the chest and arm supports detachable so the cello would be portable.

⊗ Below right: Engineers were happy with the basic model but wanted to reduce the parts to yield a sleeker design.

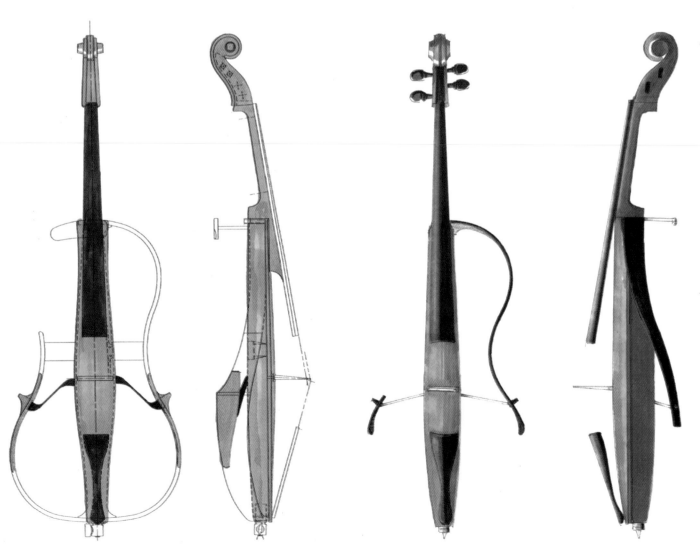

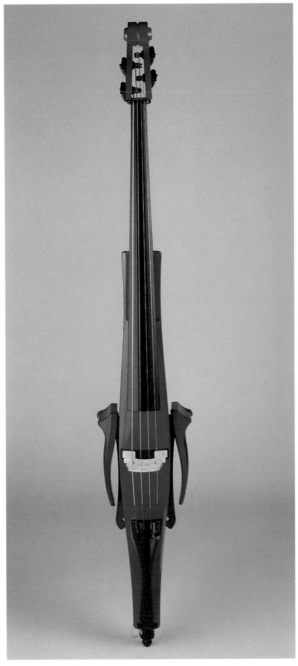

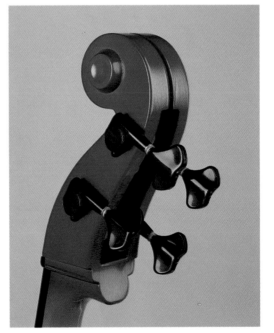

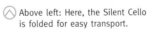 Above left: Here, the Silent Cello is folded for easy transport.

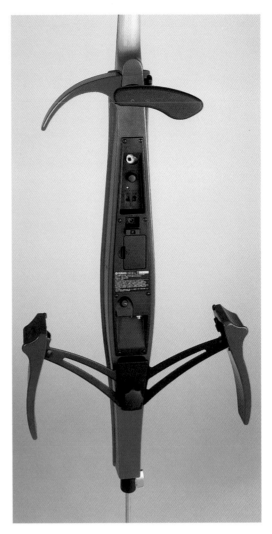 Above right: Rear view reveals electronics panel and retractable lower bout in fully extended position.

Machine heads make tuning more precise and keep the cello in tune longer than traditional tuning heads.

NEC Z1 Personal Computer Despite the significant **advantages** a computer can bring to **the home,** consumers think of a **thousand reasons** not to have one.

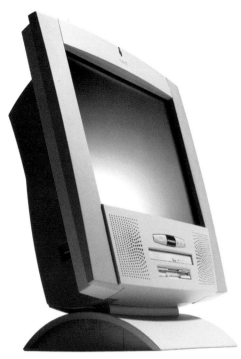

They are expensive. They're hard to master. They look clunky. There's no room. You can get a great-looking computer, but it costs a fortune. You can get the price you want, but you have to wrestle with a large machine with multiple components.

It was time for a smartly designed all-in-one computer with an attractive price point, NEC believed, and the manufacturer brought the puzzle to designers at Hauser, Inc. The client wanted an elegant product to serve as a flagship for a larger product family. The design had to establish NEC's brand image in the American market. Hauser's answer, the NEC Z1, not only answered technical concerns but also represented groundbreaking design. Amazingly, it was delivered, from white paper to working prototypes, in only four months.

"The client stated that if the design did not break the rules, the project would not move forward," says Hauser designer Kevin Clay. "We looked at it like a sculptor looks at a stone and takes away everything that doesn't belong there. That's how the shape emerged."

Initial criteria included creating an elegant design, as opposed to the iMac's playful design. The Z1 was meant to feel like furniture, a natural part of any room, rather than a colorful toy or accessory. The design also needed to comprise modular components and be easy to set up and update. Perhaps most important, it needed a minimal footprint so as to occupy as little space as possible on a cluttered desk.

NEC already had an all-in-one laptop variation whose screen sat vertically on a post. It was based on space-efficient but expensive laptop components. The company asked that the Z1 design involve more desktop computer components, which are larger but cost less. Specifically, the motherboard needed to be easily replaceable.

"One complaint with all-in-one computers is that they are not easy to update," says Clay. "Also, when the screen and CPU [central processing unit] are stuck together, they can't be replaced separately. The LCD screens are expensive; if you want to update the CPU only, you don't want to pay for a new screen too."

The tight deadline meant a twenty-four-hour-a-day schedule. Hauser received engineering files from the manufacturer in Taiwan, and, at the end of the day, sent design files back for comments. While the Hauser designers worked, the Taiwan engineers slept, and vice versa.

Early trials were based on NEC's original all-in-one product. The designers looked for ways to make the design more angular. Of course, the computer's interior components dictated the basic

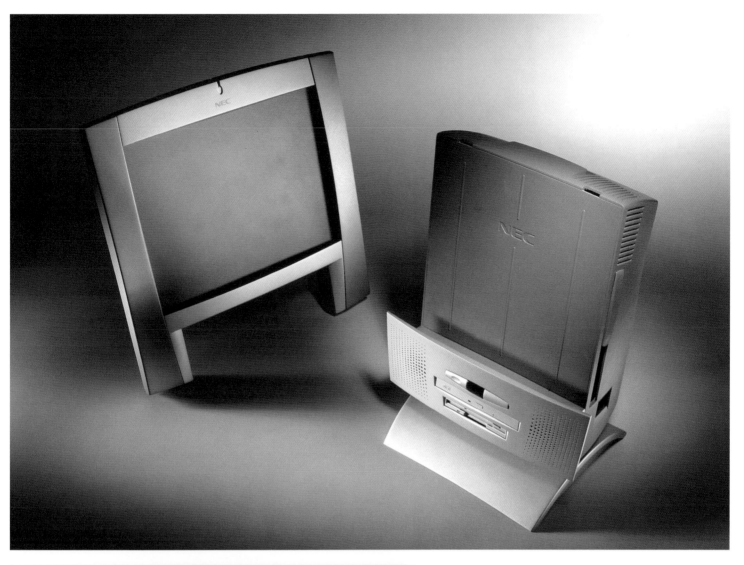

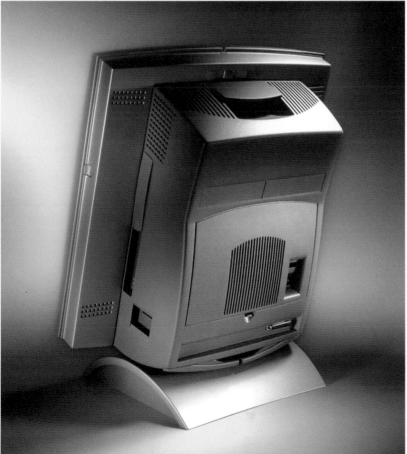

Another design plus: The LED flat screen and stand—which holds the hard drive, CD-ROM drive, speakers, and other hardware—can be easily separated. The modular approach allows the device to be updated in pieces—an attractively inexpensive option.

A back view of the NEC Z1.

shape. The designers stacked and restacked foam models of the components in different configurations, searching for the best way to minimize the device's footprint.

They found that most of the computer components could be placed behind the screen. Rather than attaching to the screen, however, the components were housed, together with the speakers, in a separate stand into which the screen slid.

"It was 'form follows function' with the internal components," Clay says. "The drives have depth that the case had to accommodate. Also, the back is where the CPU is. In the middle, we had inside space to work with, so an hourglass shape emerged. Sometimes, that's how good shapes happen; instead of fighting the shape, you go with it."

Another challenge was how to deal with the input and output cables. The motherboard's cables came out the side, which was unattractive, so the designers developed a soft rubber cord management device that pulls the cables back gently, and they simply flow unobtrusively to the back of the computer. Cord clutter, a common complaint about home computers, is eliminated.

In the end, Hauser designers used a combination of desktop and laptop components. The hard drive is a desktop device of lower cost and higher capacity. But the screen is a thin laptop device whose flat surface is appropriate to the design. The CD-ROM and floppy drives are also laptop devices because of their thin profile.

Concentrating on the human factors influencing potential purchasers of the Z1 led to a design that is both space- and user-friendly. Even the colored panels on the front of the computer are tooled for easy removal and replacement with wood, textured, or even cloth panels—a definite nod to the owners' home decor concerns.

"We feel this is an elegant solution," says Clay. "We created a unique aesthetic for the Z1 that sets it apart in the highly competitive PC market."

△ This early concept was based on an existing NEC design that used a post to suspend a flat screen above the computer.

▽ These diagramatics show how the components might be organized with the piggyback concept as well as what the body of the computer might look like.

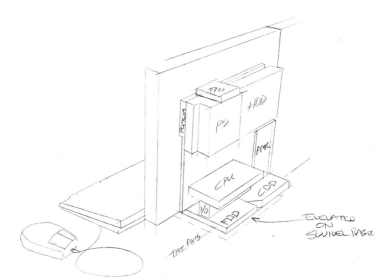

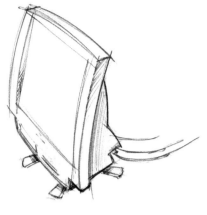

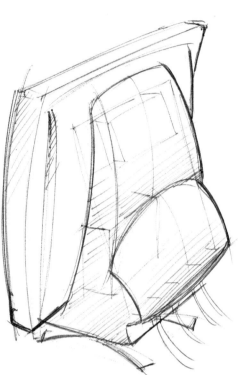

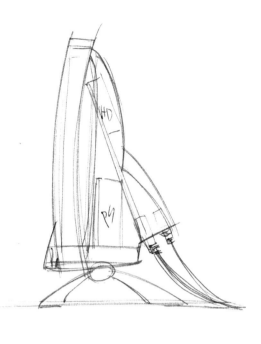

POSSIBLE PACKAGE
ALLOWING I/O
CONNECTORS TO
REMAIN "AS IS"
WITH VERT. BOARD

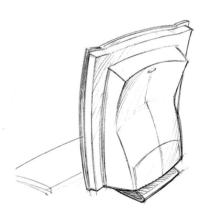

'ORGANIC' Bo.

⊘ The chassis at left has a soft
form the designers liked, but it
lacked the modular quality they
wanted; removing the screen
would ruin the form. The design
at center was a frontrunner. The
defined seams made it easier to
break into smooth shapes. The
view at right is the front of the
same design.

SmartGlas Flat Panel Display System Being all things to all people isn't easy, but that is exactly the feat Product Insight, Inc., **pulled off** when they designed the PixelVision SmartGlas Flat Panel Display System for use on **financial trading** floors,

which are typically populated with fifty to one hundred traders amid a lot of commotion. The goal: a high-resolution, flat-panel display that communicates information to the trading floor in a flexible, robust, manageable, easily configured, low-maintenance, fault-tolerant, and cost-efficient system. If the designers could simplify the visual clutter and minimize the physical mass created by many adjacent displays, so much the better.

They also had to meet the needs of three core markets, each with different priorities. The product had to satisfy traders, who require massive amounts of information and want to retain as much desk space as possible; information technology managers, who want a system that is easily installed, configured, and maintained; and facilities managers, who require tools and systems that allow control of the operation and maintenance of the trading floor environment.

Further, architects who design financial trading floors want displays with a simple mounting scheme. Other flat-panel displays on the market didn't offer this flexibility. In fact, some required users to remove the back of the housing to expose the mounting point. Remedying this situation became a primary focus, so designers developed a flexible mounting system that accommodated two or more of PixelVision's existing flat-panel displays. This approach was dropped, however, in favoring of a system or "whole-floor" perspective.

The team compiled data from PixelVision's previous success in developing flat-panel displays for the New York Stock Exchange with new research into trading environments in the United States and Europe, plus data from a United Kingdom architectural firm specializing in financial trading floors. Clearly, a simpler mounting scheme would eliminated clutter and allow an unobstructed view of the displays. Product Insight designers worked closely with PixelVision's president and director of design throughout the process. Their easy relationship allowed the design team to gauge the initial design direction with thumbnail sketches, from which they developed rough foam mock-ups. From the outset, the goal was a display that minimized the product's perceived visual thickness.

Next, they went to the CAD system, where the process was complicated by the LCD vendors. "We had an interesting time keeping up on the components," remembers Jon Rossman, vice president, Product Insight, Inc. "The LCD was provided by a variety of manufacturers, and they didn't have definitive specs on the

⊘ From the earliest sketches, designers attacked the goal of making a display that minimized the product's perceived visual thickness.

⊘ Middle and Below: Initially, designers set out to develop a flexible mounting system that accommodated two or more of PixelVision's existing flat panel displays. Soon, this approach was dropped in favor of approaching the design problem from a system or "whole-floor" perspective.

parts through most of the project. They had 'tentative' or 'preliminary' stamps on everything. So we engineered the internal details to allow three different vendors' LCDs to be mounted in this housing without having to change any of the details." This approach gave PixelVision the flexibility to change vendors on the fly and to respond to market fluctuations in LCD prices without interrupting the assembly process or requiring tooling modifications.

To verify their work, designers created a prototype of urethane casting with stereolithography. The initial production release did not require heat ventilation holes on the rear housing, so these were not included in the prototype; they were later added in anticipation of future cooling needs. The final prototype and CAD drawings went to manufacturing for tooling while designers worked with vendors to conduct color and texture studies, all the while taking into account how the product would be manufactured so as not to exceed PixelVision's capabilities.

The result of their efforts is the SmartGlas Flat Panel Display System, a 15-inch (38 cm), flat-panel display system that partitions an image across tiles. Each system has a hub serving up to eight display tiles with one mouse and keyboard. The tiles are thin and easily configure to create walls or cockpits of information tailored to the fluid needs of the trading floor while occupying little space—replacing CRTs, which are often more than 20 inches (51 cm) deep. Designers spent considerable time exploring ways to expand the visual borders of the display's active area to minimize the "grout" space between each tile, hoping that the information would appear to be floating on glass. Their time was well spent. When several displays are mounted together, they look like a glass wall of information; their backs are unobtrusive, aesthetically appealing, and provide a means of easy mounting.

"You must try to meet or exceed the user's expectation of the product," says Rossman, citing the successful market reaction to the SmartGlas Flat Panel Display System. "This product went to the core of the needs of the various users in the market segment they were addressing and solved their problems. Many LCD displays are meant for any application. Trading floors install them, but they don't solve any particular needs."

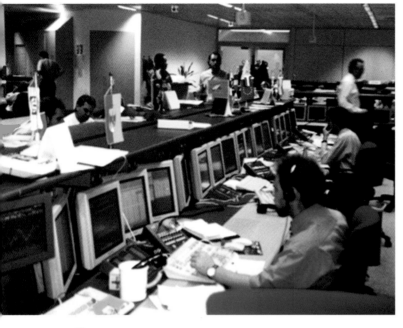

⊗ The team compiled data from PixelVision's previous success in developing flat-panel displays for the New York Stock Exchange with new research into trading environments in the United States and Europe.

⊗ Product Insight developed a chassis with mounting features for three different LCD manufacturers' components, giving PixelVision the flexibility to change vendors on the fly and respond to market fluctuations in LCD prices without interrupting the assembly process or requiring tooling modifications.

 Product Insight designers worked closely with PixelVision's president and director of design throughout the process. Their easy relationship allowed the design team to gauge the initial design direction with thumbnail sketches, from which they developed rough foam mock-ups.

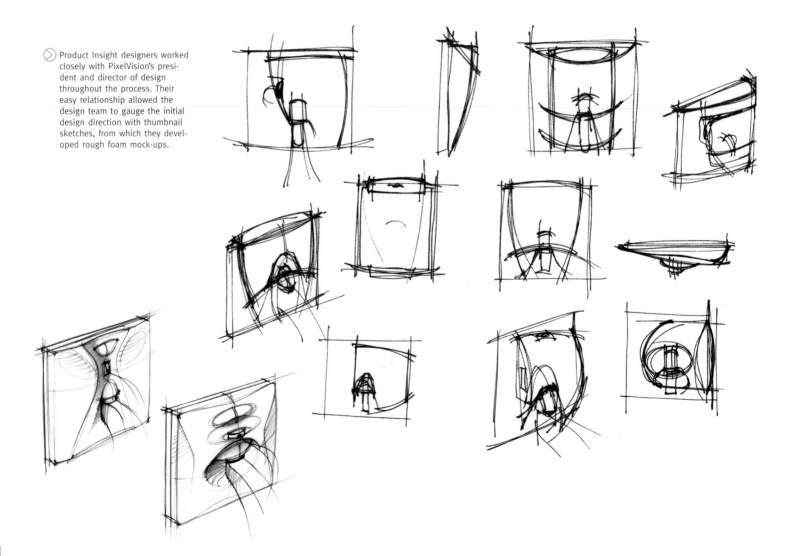

To verify their work to date, designers created a prototype of urethane casting with stereolithography. Because the initial production release did not require heat ventilation holes on the rear housing, these were not included in the original prototype; they were later added in anticipation of future cooling needs.

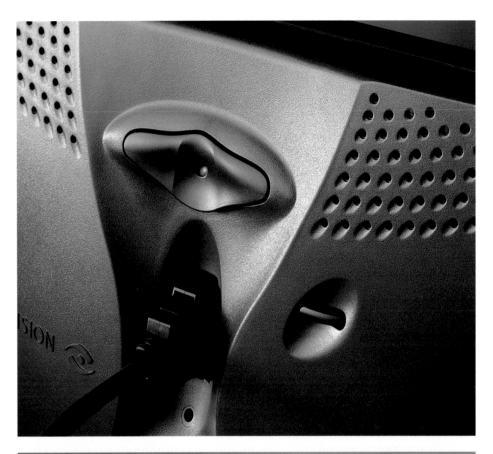

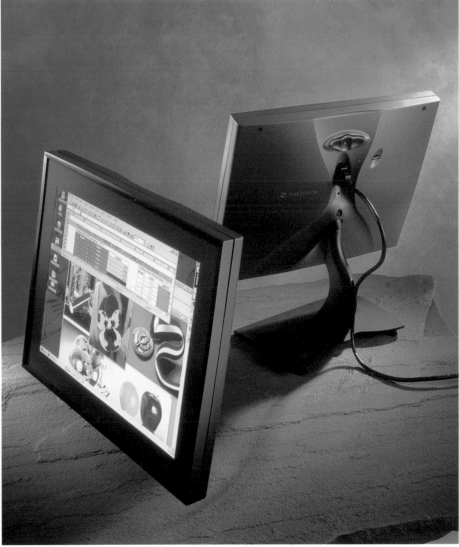

Stowaway Portable Keyboard

As time goes on, **personal digital assistants** (PDAs) get smaller and smaller. That's good. But during the same passage of time, people's eyes get **older and older,**

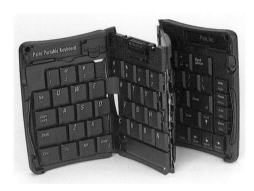

The Stowaway keyboard, designed by Pentagram, Inc., for Think Outside, is a portable, foldable keyboard that allows users of certain Palm and Handspring personal digital assistants to input type through conventional typing.

and their patience in learning new skills—like the graffiti screen writing some PDAs require—grows shorter and shorter. That's bad. So for many, the Stowaway Keyboard, sold by Think Outside and designed by Pentagram, Inc., is a welcome invention. When folded, it is slightly larger than a Palm or Handspring device (the two brands that currently accommodate the Stowaway). Unfolded, it is a surprisingly stable, full-size keyboard that is kinder to less nimble fingers and tired eyes.

Think Outside asked Pentagram to develop an alphanumeric input device that stored as compactly as possible and that unfolded to a full-size keyboard. They also wanted it to dock with a handheld computer. The goal was to help users input large amounts of text as well as retrieve and send e-mail. Predecessors were almost unheard of. One competing keyboard folded in half, says design director Robert Brunner, but it didn't really fold small enough for most users and so didn't make much of a splash.

The client came to Pentagram with preliminary design ideas in mind. The shape Think Outside presented was bricklike and unfolded in a number of segments; an accordion mechanism held everything together. It had an interesting, skeletal look, but once Pentagram engineering began to create prototypes, problems emerged. Keys popped off, the keyboard wouldn't sit in the user's lap, and the board itself felt fragile, among other difficulties.

So the designers began to explore another folding scheme, one in which the keyboard opened like a book to reveal a Z-fold with one additional panel (four panels total). Once flat, the two outside panels slide in toward the middle to form a complete keyboard. Sections are connected with flex circuits. When folded together, the keys compress to make the smallest package possible.

The cradle for the handheld computer slides out and folds upward to hold the device in place. "The angle for the computer needs to be decent," Brunner says. "It has to be angled in the same way a laptop computer screen is." Another nod to laptop design: The device uses scissor-type activators for the keys rather than center post plungers. Of course, every component was kept as minimal as possible to keep weight down.

With the folding mechanism determined, the Pentagram designers concentrated on the device's form. A number of similar shapes, colors, and textures were explored at this stage, but the focus was on small details-a rounded corner, a small indent, or a textured panel. At the same time, they studied the exterior shape of the hinges and closing mechanisms. The Palm devices were smooth and rounded in shape, and Pentagram designers followed that lead in their work.

"I think we showed a lot of restraint in the detailing of the Stowaway. We let the form of the device speak for itself," says Brunner. He adds that, at one point, the client asked that the curved edges Pentagram created be changed back to square edges, more like the brick shape first envisioned. But once Think Outside representatives saw the square and rounded designs side by side, they preferred the rounded design, too.

The design of the 7.9-ounce, 3.6" x 5.1" x .8" (9 cm x 13 cm x 3 cm) Stowaway was a great example of back and forth cooperation. "We had excellent collaboration between engineering and design. It was a nice hand-in-hand project," Brunner says.

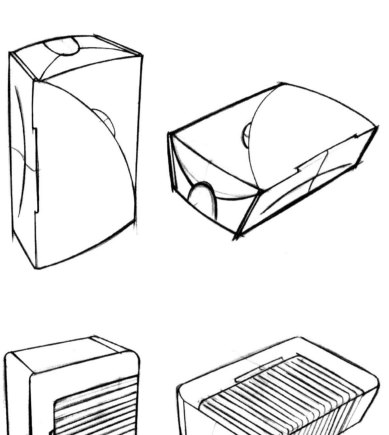

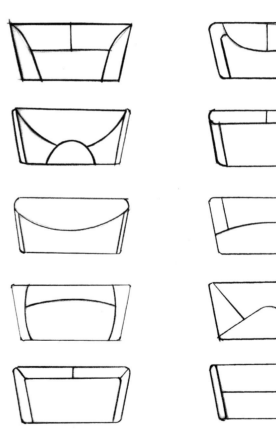

 When the Stowaway design process began, client Think Outside envisioned a bricklike design, one held together with an accordion mechanism. Pentagram explored various chassis shapes that opened in different ways.

 These sketches reveal the results of some of the experiments shown in the previous figure.

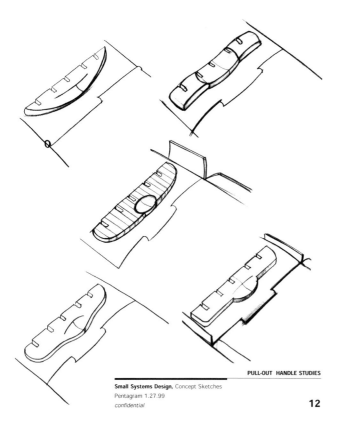

Small Systems Design, Concept Sketches
Pentagram 1.27.99
confidential

12

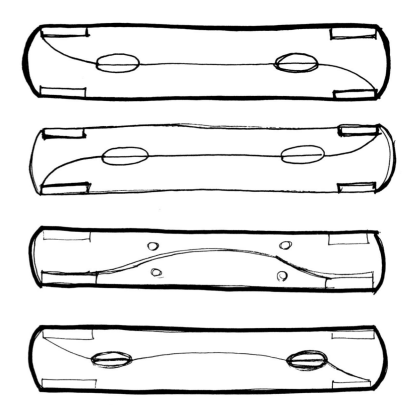

To turn the unit into a unified board, the user unfolds it and pushes the segments of the board together toward the center. To refold it, the user must pull the segments outward into articulated segments again, using pull-out handles. These studies demonstrate different ergonomic and style approaches.

As they worked, Pentagram designers figured out details for the most minimal, yet most elegant, design possible.

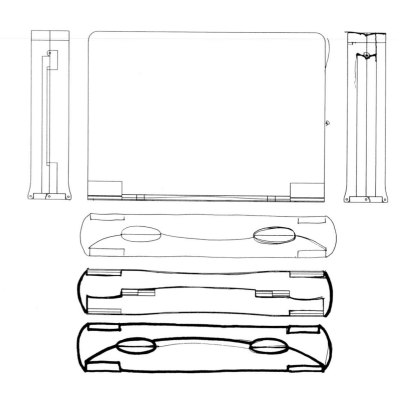

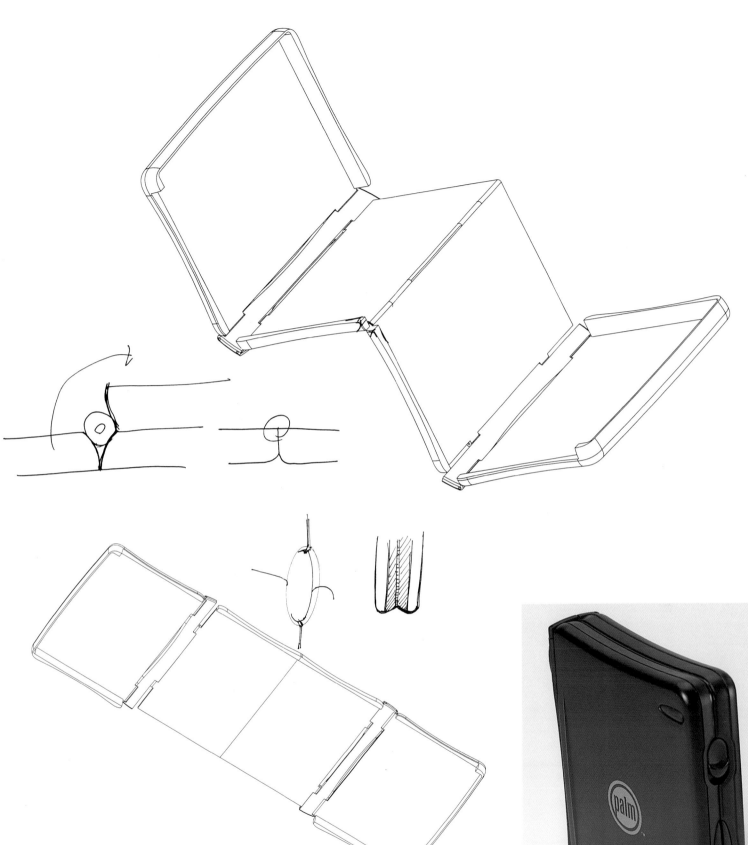

△ These drawings demonstrate how the unit unfolds and how its hinges work.

▷ When folded, it is slightly larger than a Palm or Handspring device (the two brands that currently accommodate the Stowaway).

IntelliMouse Explorer

Microsoft's IntelliMouse Explorer, from its **launch in September 1999,** has quickly become the **world's best-selling mouse,**

Microsoft's IntelliMouse Explorer uses a red LED light rather than a rubber ball to help Internet surfers move about faster and more accurately. The product's design is ergonomically satisfying and aesthetically pleasing. Its taillight is a delightful aspect of the user's experience.

according to Microsoft. Designed especially for navigating within a graphical user interface environment, the device has no rubber ball underneath, like a typical mouse. Instead, a scroll wheel on top of the product allows the user to intuitively scroll up, down, and sideways on a page.

Despite the device's sales and design success, however, the question is raised: Why is a software company designing hardware? It's simple, says Carl Ledbetter, industrial design manager for the Microsoft hardware group: to provide the most direct, most functional bridge possible to the software. "A good input device helps customers get to the Microsoft experience," he says.

When Ledbetter and his design team began working on the IntelliMouse Explorer, they had two goals: first, give the mouse a completely new look, and second, have the design somehow tell the story of the new LED tracking technology. He says, "We wanted people to see it and want to pick it up."

And this certainly would not be an ordinary mouse. Mouse tracking mechanisms had remained unchanged since the basic device's invention three decades ago: a plastic housing covering a rubber ball is steered by the hand, and the movement of the ball steers the on-screen cursor. The IntelliMouse uses a new optical sensor, a red LED light source, which reads the surface passing under the mouse. The result is better and more reliable performance, as there is no mechanism to get dirty.

At the start of the project, though, the designers didn't know if the technology would work, given the mouse's design. Eager to visually express the technology through design, they first created models with a distinctive swoop shape. The base of these models was hollow and open, which clearly displayed the red LED light in operation. The design team liked these seashell-like concepts but felt the idea was becoming forced. In addition, by that time they had discovered that the light was so sensitive—it creates microshadows and picks up contrasts between distinct light and dark areas—that the base would have to be closed.

"It was then that we decided that if we couldn't express the technology in a new form, let's try to make the mouse itself look like new technology," says Ledbetter. The designers started to explore new materials and surfaces as well as new forms.

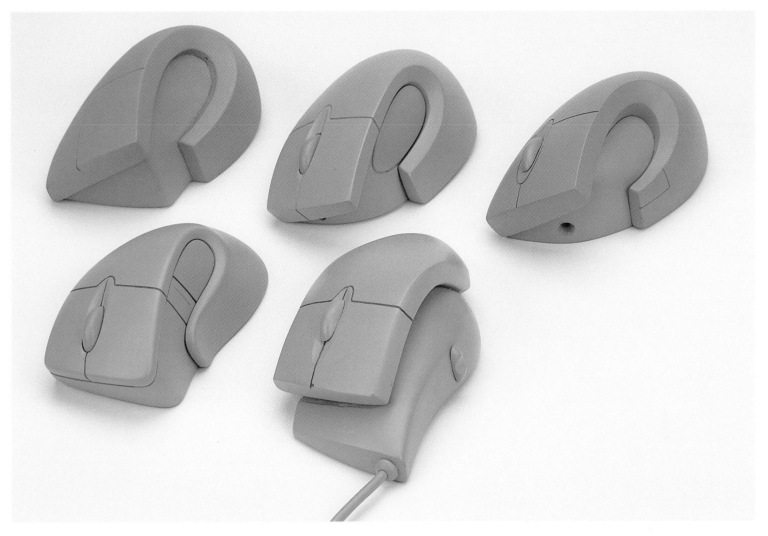

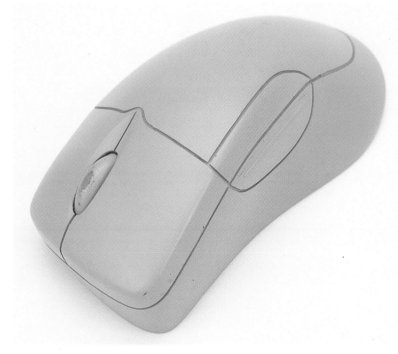

The original seashell design was not based solely on aesthetics; it was also the results of extensive ergonomic studies. Its humped shape provided contact and support for the metacarpophalangeal ridge—the pad under the knuckles—to allow the whole hand to rest comfortably. In other words, the shape encouraged a relaxed wrist posture by angling to one side, like the natural state of the hand on a table. So the Microsoft designers reduced the extreme swoop of the original design and worked it back into a shape that was comfortable, yet enclosed the light effectively.

To allow the product to exhibit the new technology, transparent red plastic was used on the entire bottom case and wrapped around the top surface nearest the user. The new bottom case and taillight treatment allows for the red LED tracking light to illuminate the product and be visible to the user.

The resulting mouse is recognizable as a desktop input device, but it definitely sparks interest with its unusual shape. Through the use of a wheel on its top and two buttons on its side, the mouse allows users to move quickly and easily as they surf the Web. The device's shape and glowing base create a distinctive brand statement—in fact, Ledbetter says IntelliMouse has become the moniker of an entirely new line of products.

⊘ Above: Early designs had a swooping or seashell-like nature. While distinctive, the idea was eventually seen as forced by the design team. Technology also had to be considered; the LED light had to be better sheltered.

⊘ Below: Less dramatic but still distinctive, this modified design emerged. Optimized for the right-handed user, the shape comfortably accommodates the hand in a resting position, taking stress off the wrist. Buttons on the side combined with a wheel on top allow the user to intuitively move about a page.

As the shape of the IntelliMouse was developed, a range of colors and surfaces were also explored. The designers sought the right visual cues that would convey the new LED technology while providing surfaces that were pleasing and responsive to the touch.

Subtle details are an important part of the IntelliMouse's success. The most dramatic detail is the transparent red plastic on the entire bottom case; it wraps around the top surface nearest the user. The new bottom case and taillight treatment allows the red LED tracking light to illuminate the product and be visible to the user.

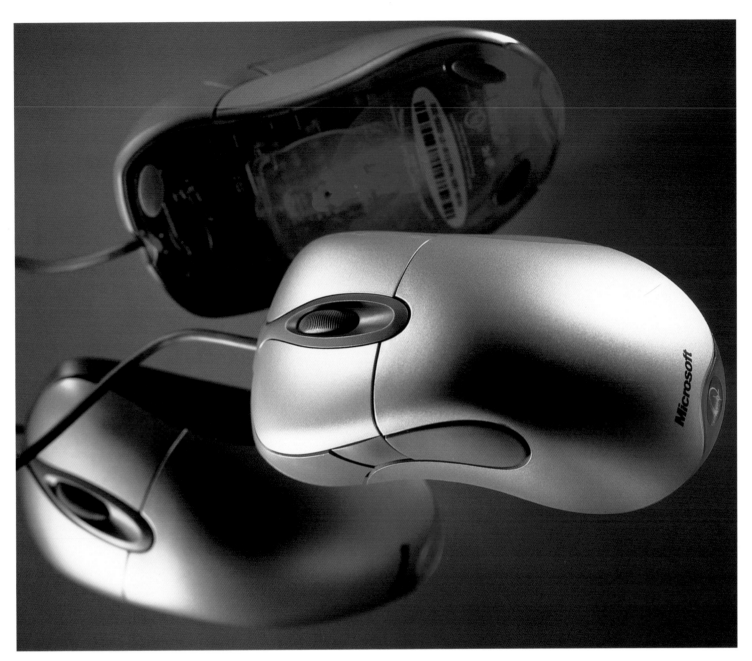

The device's shape and glowing base create a distinctive brand statement—in fact, Ledbetter says IntelliMouse has become the moniker of an entirely new line of products.

Bandit™

Anyone who has ever carried **more than two Zip disks** or **CD jewel cases** between meetings or classes knows how **bulky and fragile** they are.

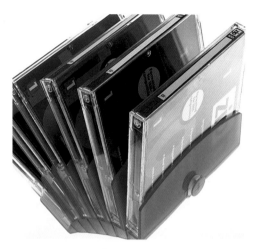

The Bandit™ fulfills a practical need while being far from boring. When splayed, the Bandit™ adds dynamic movement and interest to an otherwise mundane product category.

Sure, they stack neatly into desktop storage trays, but these racks are hardly portable. When Josh Ferguson, a designer at Speck Product Design, was in college, he regularly toted six or eight disks in his backpack and bundled them together with an industrial rubber band. His theory: "Why lug it when you can band it?"

From such an inauspicious beginning arose what is known today as the Bandit™, a deceptively simple device for storing and transporting computer media. Closed tight with its elastomeric band, the product secures disks for easy transport. Release the band, and the disks are splayed open for easy viewing and access. If that isn't good enough, it is free to consumers—that is, manufacturers of disks and CDs can afford to offer it as a bundled item, offering value-added packaging to their product at no extra cost to the buyer. Moreover, because the disks stored in a Bandit™ typically include archival information, the product is assured a long life cycle, remaining in use and on the desktop indefinitely, unlike most packaging.

The project was the first speculative idea to make its way into production at Speck Product Design. The goal was to develop a device for storing and transporting media disks that was comfortable, secure, and convenient at such a low cost that it could be produced in high volume and bundled as packaging. A business partner provided the firm with an introduction to Iomega, and the team decided to develop the as-yet unnamed product as an accessory for the company's 100-megabyte Zip disk. Speck's Josh Ferguson was given substantial responsibility for moving the project from concept to final production.

After a brainstorming session and some sleepless nights, Ferguson formulated a concept that combined mobility and accessibility in a single form. "The device had to be compact for secure and easy transport, but what if it could spring open, allowing the user to select the desired disk? Polypropylene could provide the living hinge, and a good elastomeric band could provide the necessary tension."

Ferguson's early drawings show how close he was to the final Bandit design from the beginning. He had the first prototype, featuring a plain rubber band and two pieces of wood to simulate an arched base, machined off quickly. He refined the display angle by printing a CAD file of the Bandit splayed open and laying disks atop the diagrams.

Throughout the design process, it was a given that the product would be bundled with the sale of disks, so it had to be manufactured as inexpensively as possible. To that end, initial plans called for a stock industrial rubber band to secure the device. But after reviewing the first shot, the design team found they could afford to spend a little more and saw enough benefits to replace

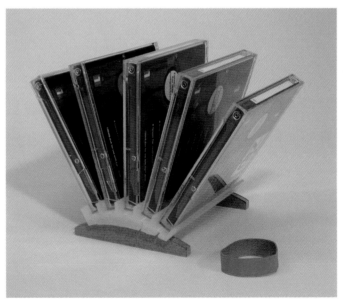

⌃ Ferguson's early drawings show how close he was to the final Bandit™ design from the beginning.

⌃ Ferguson's first prototype included a plain rubber band and two pieces of wood simulating an arched base.

the rubber band with an elastomeric version, which meant changing the tool. Ferguson found his colleagues' input invaluable to the design process; it generated more creative solutions than if cross-fertilization didn't take place. "It is interesting how, when you think outside the box, even wacky ideas might seed a clever solution. Very seldom is the first solution the best."

The addition of an elastomeric band that stretched across the disks necessitated a catch for the band to latch onto. While making this change, Ferguson added a feature on the sides of the disk slots to keep disks from sliding out of the device. Using stereolithography, he was able to see how the revisions worked and to review an accurate prototype that was the same dimensionally as if the product were injection molded. Ferguson also played with different versions of the band to find a material that would not creep, yield, or lose its tension over time.

When the time came to present the Bandit™ to Iomega, bad timing and unforeseen circumstances forced Speck to shop the product around. They found an interested taker in Maxwell, where enthusiasm for the product required that more tools be made to keep pace with the volume of orders.

"I'm delighted by the toylike quality of the Bandit,™ and it gives me the greatest satisfaction to imagine that it might spread a few smiles throughout the Dilbert cubicles of America," says Ferguson of the Bandit,™ who hopes to position the line of CD, Zip, and SuperDisk cases in a suitable retail or e-tail environment when Speck Product Design's arrangement with Maxwell ends.

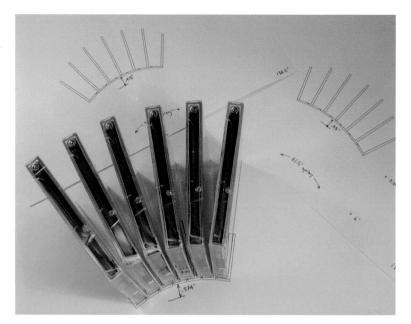

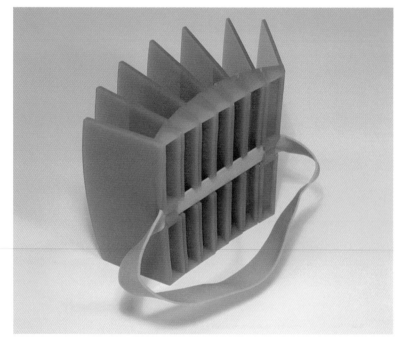

Above: Ferguson refined the angle at which the media are displayed by printing a CAD file of the Bandit™ splayed open and laying disks atop the diagrams.

Below: After reviewing the first shot, the designers found they could afford to replace the rubber band with an elastomeric version, which meant changing the tool. Ferguson found his colleagues' input invaluable to the design process; it generated more creative solutions than he could alone.

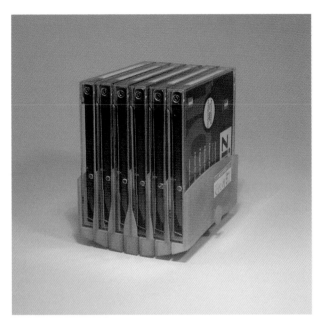

Using stereolithography, Ferguson was able to see how the revisions worked and to review an accurate prototype that was the same dimensionally as if the product were injection molded.

Ferguson played with different versions of the band to find a material that would not creep, yield, or lose its tension over time.

"C" Shell Compact Disc Holder
If simplicity is key to **sound product design,** the "C" Shell compact disc holder is the **epitome of expert design.** Its **minimalism** makes it **eye-catching.**

Its size and light weight make it ideal for transporting and storing compact discs. Above all, it is thin, allowing users to store two CDs in two C Shells in the space of one traditional CD jewel case.

The C Shell didn't start out as a project where the result was a foregone conclusion. In fact, Bob Lakoski, founder of BobInvention, came to Design Edge with ideas for a CD holder that provided an alternative to traditional jewel cases, along with names of prospective customers. "This was definitely a nonstandard way for this to come about, but he convinced the necessary people for us to do some ideas in our spare time," says Daniel Tagtow, director of Design Edge. The first sketches were boxy concepts that held about six compact discs. Designers assembled the ideas into a presentation so that Lakoski could show them to his prospects.

After a few months, Lakoski revisited Design Edge with an entirely new concept. "He showed up with, literally, two pieces of cardboard with a piece of tape between them," remembers Tagtow, who ultimately headed the project—doing whatever he could in odd hours and his spare time. "Bob said, 'This CD is so small and so thin, let's package it in as tiny a package as we possibly can.'"

Tagtow's early pencil sketches playfully focused on the idea of a shell-shaped box. The first concept was close to the final product-in fact, very close. "We had prototypes made, made modifications, and tweaked here and there, but, for the most part, that cardboard idea turned this into a totally different project.

"I think the toughest part was to understand the hundreds of types of products in this category and to come up with something unique, creative, and innovative through color, simplicity, design, and materials as an alternative to the jewel box," says Tagtow. Why replace the jewel case in the first place? "It met an initial need, but it takes a lot of material and isn't rugged enough for mail and shipping. It needed to evolve and to face alternatives."

As the new thin concept was polished, engineering concerns arose along with questions about how many pieces the product should comprise. "Can we get it down to one or two pieces? One would certainly be ideal. Polypropylene can be used for living hinges, plus it had other advantages," says Tagtow, pointing out that a live hinge, where the material bends on itself, was perfect for the application. One of the alternatives was a three-piece concept with a real hinge, which was still relatively simple but definitely more complex to make. "We just put all the ideas out there," says Tagtow, glad that, ultimately, the live hinge was determined to be the most effective option.

The next step was to decide how the shell would snap together. Original thinking called for a button, but designers wondered if there was enough room and whether a button made sense. Tests showed that outside snap closures were flimsy, but the center retention button proved a solid, reliable way to hold the two sides of the shell together while preserving the product's thinness. Finally, the design team tweaked the product footprint, opting to scale back the size of the shell until it perfectly mirrored the size of a compact disc. The shells were colored in a rainbow of hues, making them ideally suited to organizing information, and while targeted at both software makers and consumers, are being marketed for the time being solely through a Web site, www.buycshell.com.

Throughout the project, flexibility was absolutely essential to allowing the product to evolve. "We started off going in one direction and, based on findings and input, we ended up in a very, very different direction. That is not unique to Design Edge or the process. The product definitely needs to be able to evolve so that we can get to the right answer, not necessarily the answer we think is right in the beginning," says Tagtow.

To ensure that each project has the flexibility to evolve, he suggests structuring the creative process so that the designer can choose the best among dozens of concepts and take those to the next step. "Maybe that narrows the options down to five, but you constantly give yourself many choices and by taking the best of each, you end up with something meaningful and important, and, ultimately, the best product."

⊘ Early concepts took on a boxy presentation and were designed to contain multiple compact discs.

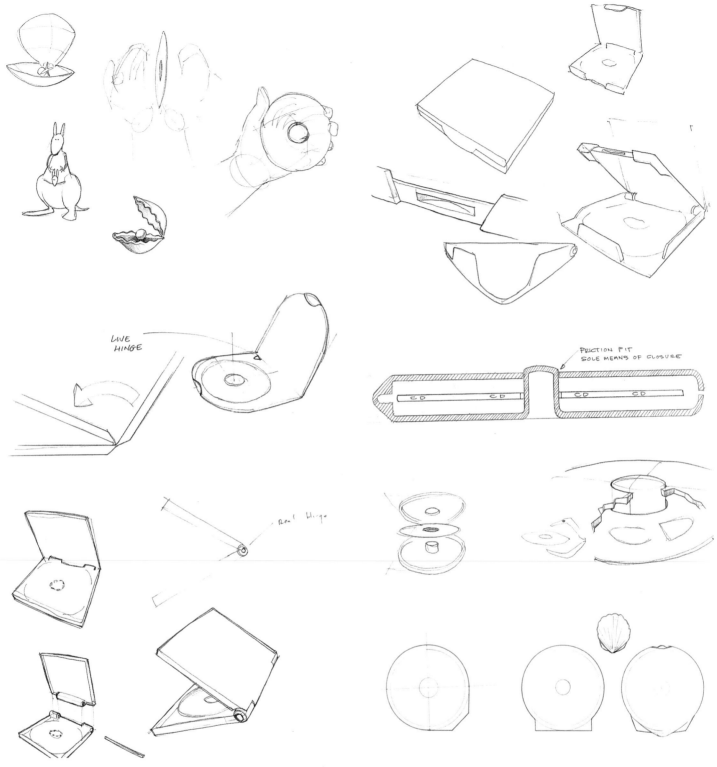

LIVE HINGE

FRICTION FIT
SOLE MEANS OF CLOSURE

CD CD CD CD

Real Hinge

⌃ Above: Tagtow's early pencil sketches playfully focused on the idea of a shell-shaped box. The first concept was close to the final product—in fact, very close. "We had prototypes made, made modifications, and tweaked here and there, but, for the most part, the cardboard idea was the thing that turned this into a totally different project."

⌃ Middle: "Can we get it down to one or two pieces? One would certainly be ideal. Polypropylene can be used for living hinges, plus it has other advantages," says Tagtow, pointing out that a live hinge, where the material bends on itself, was perfect for the application.

⌃ Below: One of the alternatives was a three-piece concept with a real hinge, which was still relatively simple but definitely more complex to make. "We just put all the ideas out there," says Tagtow, glad that, ultimately, the live hinge was determined to be the most effective option.

⌃ Above and middle: Original thinking called for a button, but designers wondered if there was enough room and whether a button made sense. Tests showed that outside snap closures were flimsy, but the center retention button proved a solid, reliable way to hold the two sides of the shell together while preserving the product's thinness.

⌃ Below: The design team tweaked the product footprint, opting to scale back the size of the shell until it perfectly mirrored the size of a compact disc.

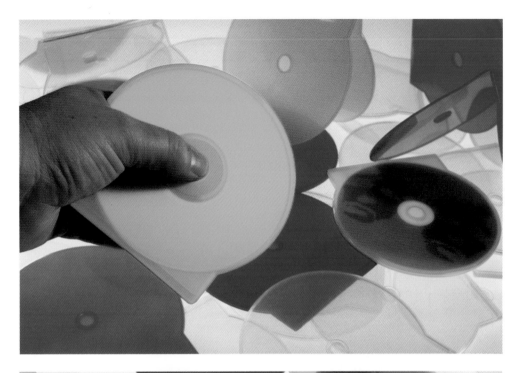

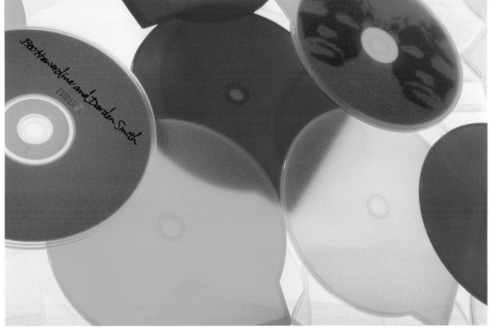

Hot Plug SCA Hard-Drive Tray Anyone who has **lost data** to a **hard drive crash** knows the awful feeling one gets as one **considers the ramifications.**

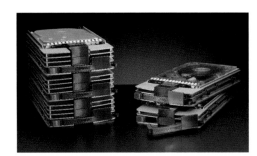

No one likes to think about it. Fortunately, insurance is available against the worst possible scenario—Compaq Computer's Hot Plug SCA Hard-Drive Tray, which allows users to add or remove hard drives without shutting down their system or losing stored data. The product can also be used when replacing failed hard drives, moving data from one server to another, and upgrading equipment.

Such hard drives are nothing new. When Compaq set out to design the Hot Plug, they were improving the company's existing product. The design team's objectives were to develop a hard-drive tray that is easy, comfortable, and intuitive to use, and that provides maximum airflow to cool the drive. The current tray design didn't afford the airflow required by today's hot new technologies. Moreover, it required two-handed operation, was clumsy to use, and pinched the user's fingers. Designers also hoped to improve its aesthetics, and, above all, design a tray less expensive to produce.

Because the design team had a clear set of objectives, going from concept to final production took just four months; the design itself was accomplished in one. This was possible because there was a predecessor product whose function and ergonomics needed fixing. Says George Daniels, manager of Compaq's Enterprise Solutions and Services Group Design Center, the project "gave us the chance to take the lead in the marketplace, which we now have. To do it, we had to go through the steps in a very short period. We didn't get to go back to the users and test it the way we wanted. Instead, we had to use our design experience and knowledge from working with customers."

"We knew what the market group was—who we were trying to solve for. We had all the previous research and feedback from our customers, so we knew what the problems were with the old drive tray," adds Keith Kuehn, senior industrial designer. The team was less sure about how to solve the problems.

They began by brainstorming with mechanical engineers to review the problems. In a short time, designers produced sketches, which they brought back to mechanical engineering to put in CAD. From there, the two groups worked closely to resolve issues and polish any details that arose getting the product to final production.

The designers' priority was addressing the airflow and heat-dissipation problem while keeping the design intent. The answer was found in exposed die-cast aluminum fins that dissipate heat and help convey the nature of the technology. "It would be like exposing your car's engine in the design," explains Daniels. "We pulled the technology out from the inside. Normally, it is hidden away. We made it part of the design—an honest solution done in a clean, aesthetic way." As Kuehn puts it, "We showcased the technologies."

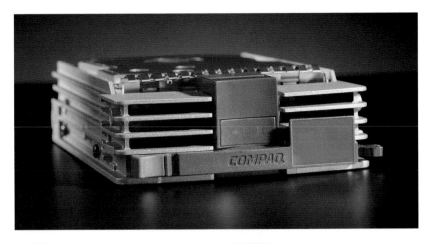

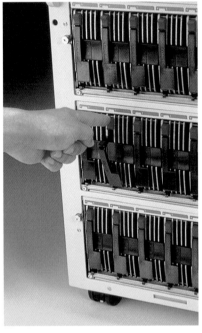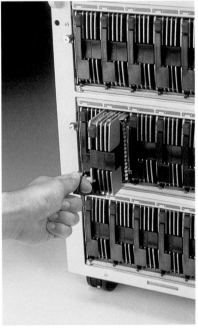

Next, they worked on the handle, used both to eject the drive and to carry it. They opted for a double-shot, injection-molded, hooked design with a urethane inner surface. The shape of the single-point ejector button and handle, as well as the use of Santoprene, make the design comfortable for one-handed operation, with inviting touch points. The color of the ejector button is purple, used by Compaq to signify hot pluggability for all such devices.

Finally, the designers opted used fiber optics to move the light from the typical surfaced-mounted LEDs in the unit's rear to back-lit icons on the front surface, effectively presenting the information where it is easier for users to see.

"The basic design language—the fins, the single-handed ejector—now have been used on other components, like hot plug tape drive trays. We have evolved the design into a design language that goes beyond hard drives. Any component that is hot plug-gable has a similar feel and look, so the customer automatically recognizes it," explains Daniels, pointing out that the Hot Plug SCA Hard-Drive Tray has become not only a pivotal design for Compaq but also has made the company the industry leader in server storage.

Despite its turn-and-burn timetable, the product has more than delivered on its objectives. Production costs of the new product are half of the original due to its simpler design. Moreover, be-cause of the product's built-in cooling efficiency, Compaq will not have to redesign it for many years. Similarly, users will be able to continually upgrade their trade drives for years to come.

For the design team, the most challenging aspect of the job was creating a design that is aesthetically pleasing and ergonomically and functionally appropriate. Often, in design, trade-offs must be made; in this case, none were. "That is what separates this design from most others. We were able to stay true to the most impor-tant objectives—to provide an excellent ergonomic solution, to allow the technology to live for a long time, and to generate a sim-ple, honest design that reflected the technology," says Daniels.

So what is Compaq's secret to great product design? "Simplicity, honesty, a focus on the user's need, and a multidisciplinary prod-uct development team," says Kuehn.

"I would say that great design must be user focused," echoes Daniels. "Second, it must reflect function. Third, it must reflect the values and attributes of the manufacturer—in this case, the Compaq brand. If you're able to do those three things, you have got the secret to good design, no matter what the product."

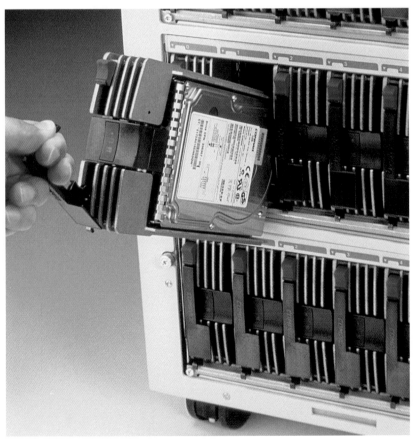

Above: To facilitate cooling of the device, designers exposed die-cast aluminum fins that dissi-pate heat and help convey the nature of the technology.

Designers opted for a multipur-pose handle, used to eject the drive and to carry the drive. The shape of the single-point ejector button and handle, as well as the use of Santoprene, make the design comfortable for one-handed operation, with inviting touch points. The color of the ejector button is purple, used by Compaq to signify hot pluggabil-ity in any device.

The CS 2000, a palm-sized bar code scanner, may revolutionize the way we shop. At the press of the thumb, the CS 2000 can record as many as 350 bar codes from physical goods.

The CS 2000's small teardrop shape is ergonomically designed to be easy to hold and intuitive to operate. Lightweight (2.7 ounces) and biomorphic, the CS 2000 houses the smallest laser-scan engine available in an elegant design. The organic form is molded with gloss and matte textures for a subtle color change.

The user can then transfer this information via a serial cable connection to a personal computer. By taking the tedium out of shopping on the Internet, the CS 2000 links the efficiencies of e-commerce to the sensuality of real-world retailing.

"The CS 2000 was definitely a market-driven product," says Alistair Hamilton, senior director of industrial design and human factors at Symbol Technologies. "User scenarios guided decisions as we went."

Specifically, the CS 2000 was designed to address problems experienced by cybershoppers, thus making Internet shopping more appealing. "Customers are intrigued, but also vexed, by the advantages of e-commerce," says Hamilton. "With frustrating download speeds and long lists to scroll through on grocery Web sites, Internet shopping can be tedious. The design problem was to create a mobile, handheld scanning device that appealed to consumers of all ages, smoothing the transition from physical to digital—from home or mall to the Web."

He explains, "Most people build shopping lists in their kitchen, but their PC is almost always somewhere else—in the den, in an office. How do you manage that?" The team quickly hit on the idea of a refrigerator magnet. "Everyone is familiar with the idea of a shopping list attached to the fridge by a magnet. When you're ready to shop, you simply take it to the PC."

With this concept in mind, the designers began extensive sketching of a broad array of ideas in a variety of forms—pens, pancakes, hanging clips. Because the marketing department wanted to launch the product in just nine months, the exploration phase was condensed, and foam models were in the hands of users within a few weeks.

At this point, the design team sought feedback about the way the product looked and felt. Like many designers—particularly those in a hurry—they turned first to colleagues and friends, but they got better feedback from focus groups targeting people already grocery shopping on-line. "The technology got in the way of good feedback from people who were new to the concept," explains Hamilton. "They were too blown away by the idea." Pressures on the schedule also meant that the development team had to rely heavily on users' experience with previous generations of bar code scanners.

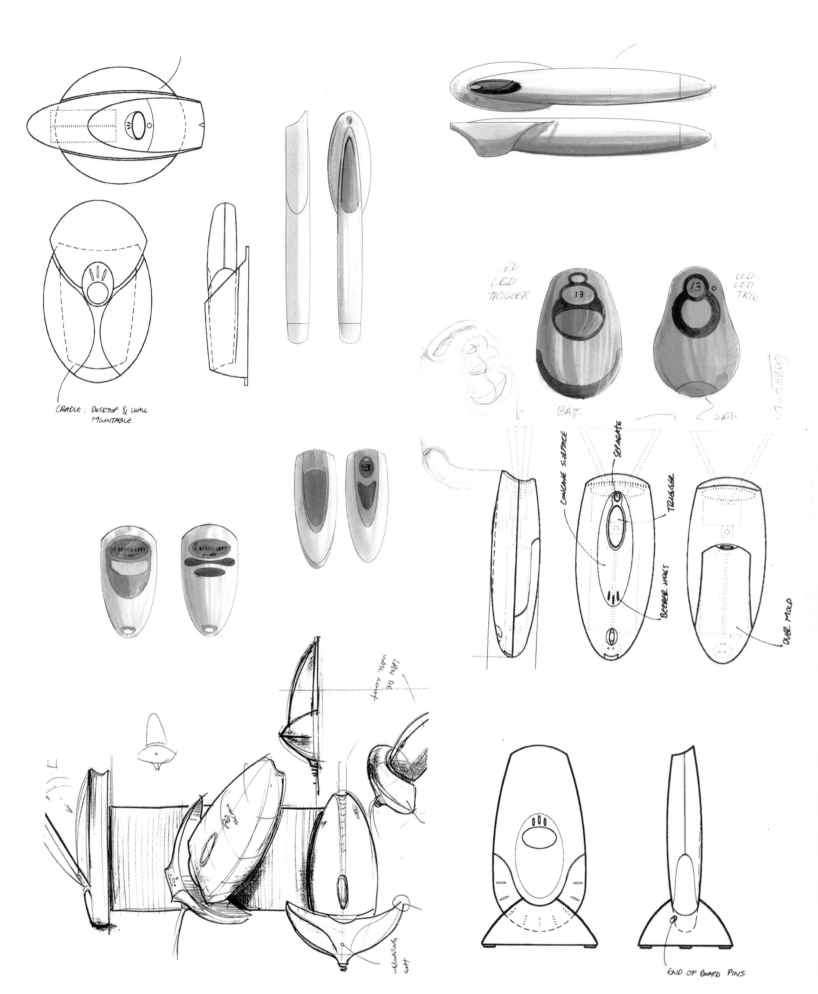

CRADLE : DESKTOP & WALL
MOUNTABLE

LED
LED
TRIGGER

LCD
LED
TRIG

BATT.

BATT.

CONCAVE SURFACE

SEPARATE

TRIGGER

BEEPER HOLES

DBL MOLD

END OF BOARD PINS

⬡ Early sketches explored a number
of forms and investigated what a
consumer scanner should look
like, how it should dock, how
much space it should take up,
and where it should be located.

What the designers learned surprised them. Because the CS 2000 was meant to scan grocery items, they planned to fit the feel of a kitchen, with soft tones that would match appliances. Users confirmed that they planned to store and use the device in the kitchen, but they wanted a high-tech gadget with an electronics look and feel.

As the team refined their concept accordingly, the CS 2000 morphed into a small, smooth object inspired by the water-worn pebble—a shape simple and serene. A meandering line with polished areas was added to help convey the look of a high-quality tool. The team then built mechanical models in Alias, which allowed engineers to work concurrently with designers and helped accommodate the tight schedule. Working models were built to explore ideas about the trigger location, the beam of the scanner, and other details.

Equally important and, perhaps, more challenging was the need to provide an intuitive interface. Because the product was a consumer giveaway, its cost had to be low. Some original designs had a display and other features that made the product highly usable, but were too costly to manufacture. Essentially, a single LED and two controls had to communicate everything the user needed to know—when the battery was getting low, when the memory was full, and so forth.

In the end, says Hamilton, "what appears to be a simple product has a lot of complex features." The LED uses color to signal the unit's status: Green means the scan was successful, orange signals the scan is deleted, and red means the battery is running low. A child lockout function can be activated by depressing both the scan and delete keys simultaneously for one second.

The CS 2000 is easy and intuitive to use. Its gently dished interface area tells immediately which way is up and fits comfortably in the hand, while the concave scan button provides a natural landing area for the thumb. The organic form is molded with gloss and matte textures for a subtle color change. A flowing demarcation line between areas of texture allows the CS 2000 to be customized with colors and graphics for specific companies without losing the integrity of the basic product.

By focusing on the user and soliciting feedback throughout the design process, Symbol Technologies made a product that accommodates the current and future needs of shoppers. Postproduction testing illustrates the CS 2000's broad appeal—more people participate in making shopping lists than ever before. Companies also have picked up on the advantages of the CS 2000 for gift registry. Customers can simply scan in the items they want to add to their registry and then download them to a computer.

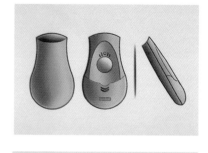

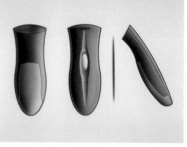

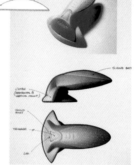

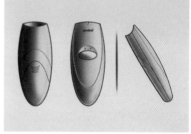

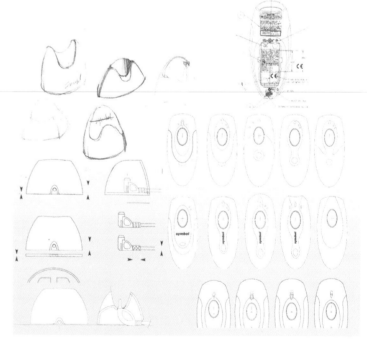

⬡ Above: The industrial design team and marketing group reviewed several concepts to determine which would have the most appeal to the widest audience.

⬡ Below: Once industrial design and marketing had settled on the teardrop shape, the design team used the computer to refine the details of both the scanner and its holder.

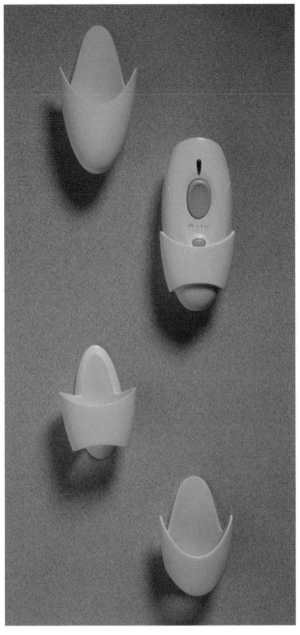

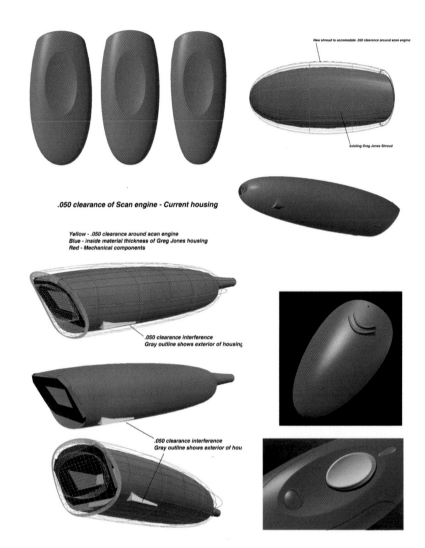

.050 clearance of Scan engine - Current housing

Yellow - .050 clearance around scan engine
Blue - inside material thickness of Greg Jones housing
Red - Mechanical components

New shroud to accomodate .050 clearance around scan engine

existing Greg Jones Shroud

.050 clearance interference
Gray outline shows exterior of housing

.050 clearance interference
Gray outline shows exterior of hou

⊗ After designers realized that the scanner needed a home base in the kitchen, the team designed four wall-mounted holder concepts. The design had to be easy to mold and look good when it was empty as in use.

⊗ Alias was used to sculpt the teardrop form in three dimensions around the internal components. Using Alias enabled the industrial design team and engineers to work on the CS 2000 simultaneously.

⊘ Color combinations were explored first on the computer and then on Ren Shape™ models. The design group had expected to use kitchen appliance colors, but the color palette was revised after consumers told them they wanted the CS 2000 to look like a high-tech gadget.

Virtual Ink mimio™

While graduate students at MIT, the **designers** who became Virtual Ink had an **idea** for a **portable pen-tracking technology** that used a combination of **infrared and ultrasound** transmitters

⊘ One design challenge was packaging the technology within the pen. The infrared sensors in the capture bar identify the color of the pen being used, so the designers developed color-coded jackets for each of the markers. As seen here, the jackets fit around standard markers and accommodate hands of all sizes.

to record handwritten notes on a standard whiteboard. High-frequency pulses emitted from an electronic stylus were transmitted to a receiving device for downloading to a PC. Armed with limited venture capital and primitive working prototypes of both hardware and software, the four creators looked for a company to help bring their idea to fruition.

Virtual Ink settled on Fitch, a large industrial design firm that offered help with not only product development but also branding, naming, manufacturing, and sourcing. Fitch signed on as an equity partner—an increasingly common option. "Working with startups is becoming more frequent at companies like ours," explains Richard Watson, Fitch's lead designer on the project. "It's an exciting relationship."

Fitch assembled an interdisciplinary team of product designers, engineers, and manufacturing specialists and a team of brand strategists and communication designers. The teams needed to convert the technology into a viable and desirable consumer product, a goal Virtual Ink sometimes overlooked in their enthusiasm.

The industrial design and mechanical and electrical engineering teams began by examining the product's predetermined objectives—to be small, easy to assemble, portable, lightweight, and low-cost. Semifunctioning models were used to explore issues related to assembling and dismantling the product. At the same time, information designers within Fitch's communications group worked on issues related to commercialization—name, descriptive language, packaging, and so forth.

Fitch routinely met with Virtual Ink and shared ideas via fax. At a more formal meeting, the Fitch team presented models and renderings of three concepts, plus the advantages and disadvantages of each. Virtual Ink agreed with Fitch's recommendation about the design direction—that the overall design should be intuitive and simple for users to understand. In addition, the design had to lend itself to efficient, cost-effective manufacturing. The cost savings resulting from streamlined manufacturing could be reflected in price. The team also decided on the name Mimio™, which communicates the product's high-tech capabilities as well as its approachability and ease of use.

To ensure that the mimio™ delivered on its portability promise, the industrial design team designed housing for the pen-tracking technology in the form of a collapsible 24-inch (61 cm) capture bar that attaches to any conventional whiteboard. A major question was the orientation of the bar; should it be attached to the top of the whiteboard or at the side? The team experimented with both scenarios before settling on the latter. Placing the bar on the

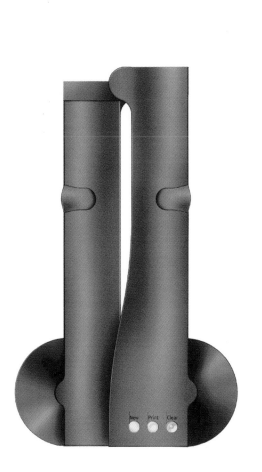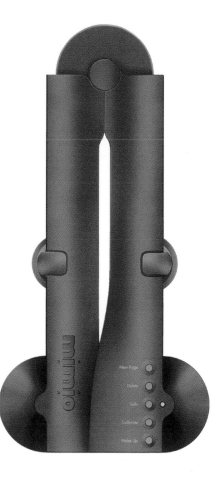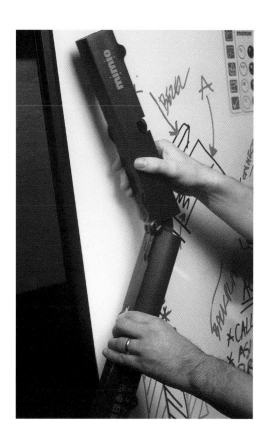

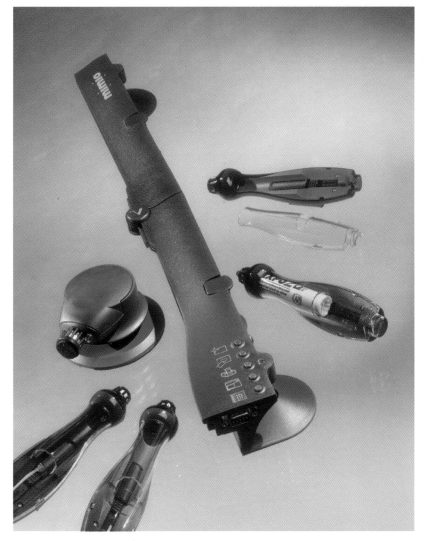

side of the whiteboard minimizes potential interference from cables and helps ensure that smaller users can reach the bar during setup. The side orientation also offers the capture bar a greater receptivity range for signals emitted from the pens.

Over the next several months, Fitch's industrial designers and engineers worked with Virtual Ink to refine the selected concept. During this phase, the tasks were split, with different people working on the pen, eraser, and capture bar. The team used both physical and CAD models to communicate ideas and to explore the function of components.

Once these matters were decided, the engineers made functional prototypes of the pen, eraser, and bar. The pen proved particularly difficult—up to ten prototypes were needed to figure out how to package the technology within the pen.

◇ A differentiating feature of the mimio™ is its portability, enabled by the folding capture bar. A set of interface icons was added to activate often-used functions. The resulting design (right) attaches to the side of any conventional whiteboard with a simple suction cup.

◇ The mimio™ had several components that needed to be designed. To accomplish this in a short time frame, the team assigned different people to work on the four pens, the eraser, and the capture bar. The team used both physical and CAD models to explore the function of the components.

As the designers and engineers grappled with final issues regarding the design and functionality of mimio, Virtual Ink contracted with the GE/Fitch joint venture team to have Fitch take control of sourcing, tooling, and delivery logistics. "This represents a significant trend in consulting firms," says Watson. "Large industrial design firms are taking a lot of responsibility and control all the way through to manufacturing and deeper and deeper into the product development process."

Working with a startup has advantages. Virtual Ink brought a great deal of passion to the project. The industrial design team worked directly with the people at the top of the organization, so decisions were made quickly. This enabled Virtual Ink to meet a tight schedule; mimio™ moved from concept phase to complete product and brand in less than fourteen months.

For an industrial designer, it is rewarding to have so much control over the product and the brand—but it is also risky. Startup companies rely heavily on the consultants they hire for advice at all phases of the product development process. "The stakes are high," says Watson. "Success or failure means everything to the founders of a startup." In the case of the mimio™, the close collaboration of the interdisciplinary team was vital to success.

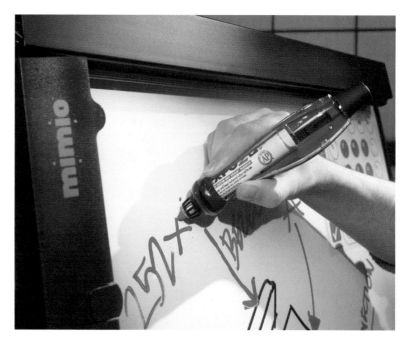

⬡ As information is written on a whiteboard, signals are passed from the stylus to the capture bar. Specialized software downloads the signals to a PC in real time and real color, freeing meeting participants to engage in true discussion even when they are not in the same room.

⬡ mimio™ was born as a new technology, but its success results from the marraige of its innovative stylus tracking technology with the needs of users. Placing the capture bar at the side, for example, enables anyone to easily set up and use mimio™.

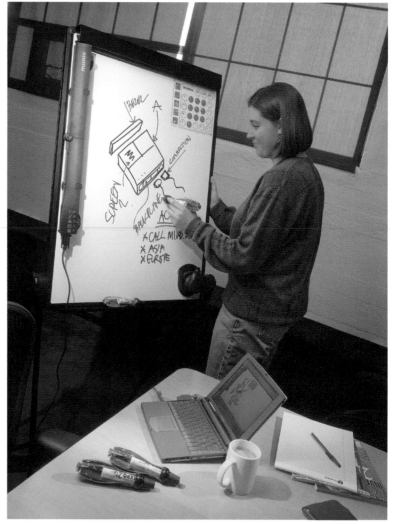

⬦ Above: To facilitate on-the-fly editing, the design team developed an eraser capable of both precision and large-area erasing. Like the marker jackets, the eraser transmits signals to the capture bar for instant recording.

⬦ Below: One of the goals for mimio™, established at an early project meeting, was portability. The design team accomplished this by reducing the size of the components and folding them to fit comfortably in a laptop case or briefcase. At just 2.5 pounds, the Mimio™ weighs far less than competing technologies.

Eclipse Gasoline Dispenser When you're filling your gas tank, **what do you do** once you've **cleaned** your windshield? Consider ordering take-out from the gasoline pump or **checking your e-mail.**

You can do this if you're filling up at an Eclipse gasoline dispenser featuring an Internet interface.

Welcome the next generation of gasoline dispensers. Yes, service is back. Not since the 1950s has this ideal been so important. Service disappeared during the 1970s gasoline shortage, and, when the crisis was over, it didn't come back. In 1986, the big innovation was the ability to pay at the pump. The next generation of pumps takes that concept another step. "What was primarily a gasoline pump is now a kiosk that still focuses on gasoline dispensing but also reflects the necessity of merchandising other products," says Charles Keane, senior vice president and design director at Herbst Lazar Bell's Boston office.

The Eclipse appeals to today's desire for convenience. The new dispenser allows filling up on either side of the vehicle, thanks to an overhead hose 24-inches (61 cm) longer than standard. Several dispensers in a row don't form a wall between fueling lanes but instead are narrow pillars that permit greater visibility and provide an open atmosphere that feels safer and more secure.

Before fueling, consumers' smart card transmits data to the dispenser, including gasoline preference and preset payment amounts. The lower portion of the touch screen, the design of the graphic screens, and the entire keypad are configured to comply with the Americans with Disabilities Act (ADA). Users can take advantage of the Eclipse's Internet-access interface for travel directions, weather reports, and stock quotes. A touch screen presents menu icons from local eateries; customers can order take-out, pay right at the pump, and pick up their meal at leisure.

How did this revolutionary gasoline dispenser come about? Slowly and with meticulous attention to user feedback, according to designers at Herbst Lazar Bell, which worked in tandem with Marconi Commerce Systems to create the system. "This is a conservative industry," says Keane, noting that the overhead hose took eight years to achieve acceptance.

Discovery, conceptual development, and confirmation were the three phases of the product development process. Herbst and client Marconi, formerly known as Gilbarco, started with a brainstorming session that resulted in a list of ideas and rough sketches, which they distilled to a manageable wish list. From there, designers developed and built crude models that illus-

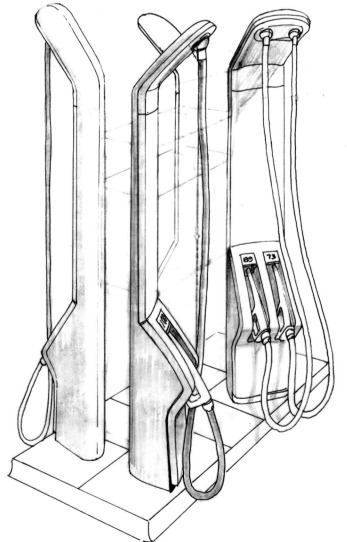

trated the basic shape of the new kiosk. They organized seven U.S. test sites and sought feedback from typical consumers on three options: a conservative dispensing system, a middle-of-the-road version, and a radical kiosk. Consumers surprised everyone and chose the most radical design—which became the Eclipse.

"They directed us to push the art much further than we envisioned," remembers Keane. At each feedback site, consumers were given parts—much like Mr. Potato Head—and invited to place them on the kiosk based on convenience and frequency of use. Testers wanted to know how the average consumer preferred to interface with the kiosk in what designers termed the approach zone. "It helped us come to grips with how to display a lot of information," says Keane. Much more was involved than positioning gasoline grades and posting prices. "We had to get a feel for the consumer's intuition because we used the research to convince the major oil companies, jobbers, and convenience stores that this would be advantageous. The market research was important in communicating the value of this radically new piece of equipment to the industry."

The kiosk took on a tree-shaped design that reflects the requirements of users, whose SUVs require extra hose when fueling on the far side. Because of the dispenser's pillar structure, thorough testing was done to ensure it couldn't be pulled over. Designers integrated consumer feedback and soon had a full-scale model, which they took to a focus group to confirm their hypotheses.

Marconi worked with designers to bring the software to the interface. A functional prototype was developed to test safety. The design was tweaked and, finally, a working prototype was delivered to Marconi, along with final computer drawings for production.

According to Keane, the toughest aspect of the project was satisfying the requirements of all parties—consumers, oil companies, convenience stores—with a piece of equipment that could be manufactured for a reasonable cost. In hindsight, Keane attributes the designers' success to the integration of research early in the development process and to the active involvement of the client.

He also gives high marks to the use of three-dimensional models at the outset. "The Eclipse is so far out that it was essential to allow users to interact with a three-dimensional object. That's essential when the product is completely new."

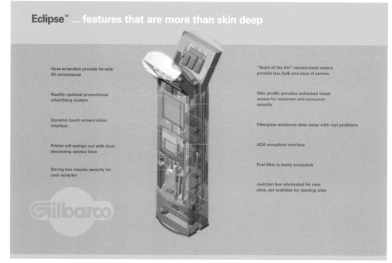

Eclipse™ ... features that are more than skin deep

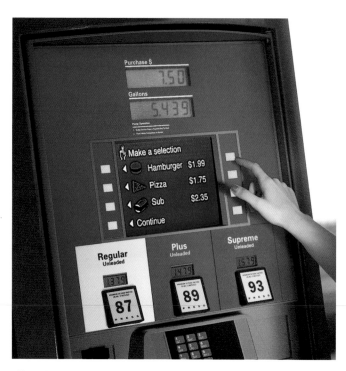

⌂ A touch screen presents menu icons from local eateries; customers can order take-out, pay right at the pump, and pick up their meal at leisure.

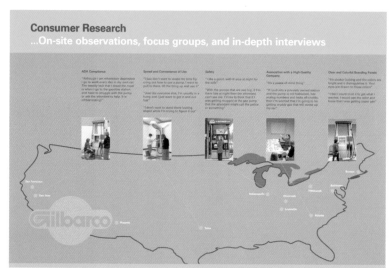

Consumer Research
...On-site observations, focus groups, and in-depth interviews

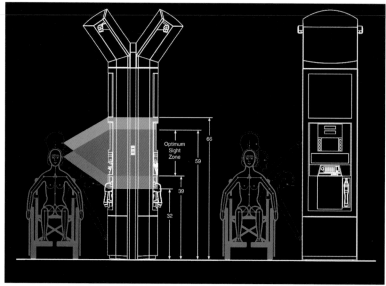

⌂ Above and Middle: Herbst and client Marconi, formerly known as Gilbarco, organized several U.S. test sites to get feedback from typical consumers.

⌂ Below: The lower portion of touch screen, the design of the graphic screens, and the entire keypad are configured to comply with the Americans with Disabilities Act (ADA).

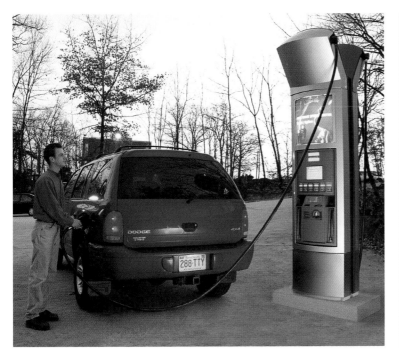

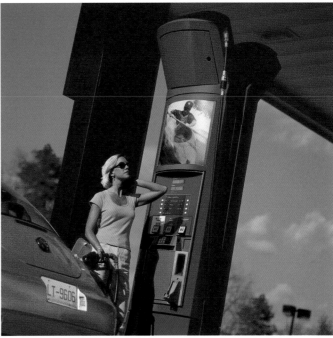

⬨ Above left: The kiosk took on a tree-shaped design that reflects the requirements of users, whose SUVs require extra hose when fueling on the far side.

⬨ Above right: Testers wanted to know how the average consumer preferred to interface with the kiosk in what designers termed the approach zone.

⬨ Below: The new dispenser allows filling up on either side of the vehicle, thanks to an overhead hose 24-inches (61 cm) longer than standard. Several dispensers in a row don't form a wall between fueling lanes but instead are narrow pillars that permit greater visibility and provide an open atmosphere that feels safer and more secure.

IR2080 **Fleet Air Impact Wrench** Industrial designers rarely **start work** on a project before they move in to a new office, but that's what happened to **Scott Price.** His first week at Ingersoll-Rand was spent **on the road**

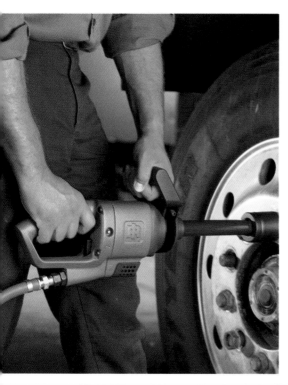

The IR2080 is designed specifically for use by tire-maintenance workers. Lightweight and easy to operate, the tool's innovative grip enables workers to maintain a natural wrist and body position.

with a design team, conducting end-user studies with people in factories and tire shops to discover their needs. Mike Loomis, the program manager for the IR2080 fleet air impact wrench, credits the success of the product to the fresh perspective Price brought to the team. "This was the first project that Ingersoll-Rand did with an internal industrial designer," he explains. "Before, we always used consultants. Usually, we brought in industrial design after the product architecture was determined." Price adds, "Industrial design in this project went beyond aesthetics. It allowed us to design for the user."

The task was to come up with a 1-inch (3 cm) impact wrench—a power tool that would withstand daily pounding in a variety of settings. Impact tools are designed for broad applications found in heavy industry—petrochemicals, bridge-building, steel erection, industrial maintenance and repair. Ingersoll-Rand wanted a wrench that could be used for two different markets: industrial and automotive. The two markets are very different, however. Whereas the industrial market has a relatively long sales cycle and can afford a high-end tool, the automotive market is essentially a commodity market with narrow profit margins. In the past, Ingersoll-Rand and other suppliers accommodated the automotive market by defeaturing the tool designed for the industrial market and selling it for less. Not only did this result in narrow profit margins, it meant that the automotive workers were using a tool designed for other purposes.

For years, Ingersoll-Rand and other suppliers of impact tools struggled with this quandary. How do you make essentially the same tool for two very different markets with very different price points? As Ingersoll-Rand's team talked to users, they realized that, whereas industrial users applied the tool to a variety of situations, automotive users used it in just one way. As Loomis puts it, "In the tire-changing world, nothing else mattered. It's a 3-foot (91 cm) world—it's identical from one place to the next." For tire-maintenance workers, what happens in the immediate area where they're working is the only thing that matters.

The tedious task of changing truck tires involves the repetitive removal and installation of tires in a high-volume environment, operating impact guns held below the waist at 10 to 30 inches (25 cm to 76 cm) from the floor and impacting as many as ten wheel nuts per tire or two hundred per truck. Removing stiff nuts requires a powerful tool to deliver significant torque, often in awkward, back-bending positions. Focusing on the needs of these users would enable Ingersoll-Rand to capture a market niche. The product could be a true innovation.

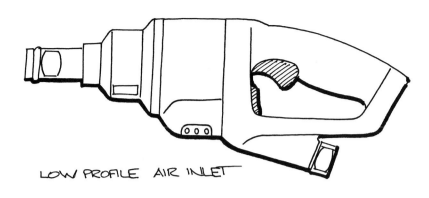

LOW PROFILE AIR INLET

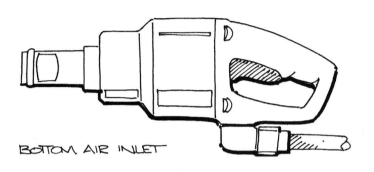

BOTTOM AIR INLET

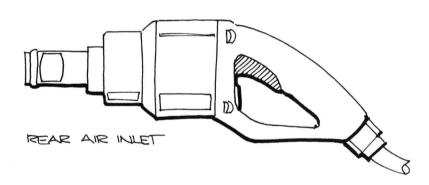

REAR AIR INLET

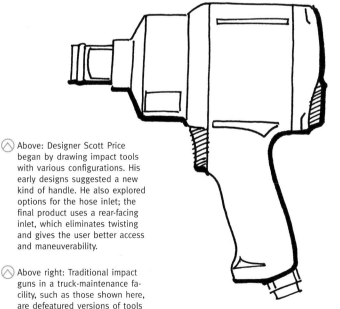

⊘ Above: Designer Scott Price began by drawing impact tools with various configurations. His early designs suggested a new kind of handle. He also explored options for the hose inlet; the final product uses a rear-facing inlet, which eliminates twisting and gives the user better access and maneuverability.

⊘ Above right: Traditional impact guns in a truck-maintenance facility, such as those shown here, are defeatured versions of tools designed for broad applications in heavy industry. The design team looked at ways to reduce the usual 30-pound weight and to improve comfort of use.

Price began to sketch ideas and came up with a new approach within a couple of hours. "The first time Scott put pen to paper, he came up with a handle that looked like a chainsaw's," says Loomis. Because this was a departure from the norm, the team went directly to models to determine whether the concept had merit. They bought a chainsaw, attached its handle to an existing impact tool model, and took it to a local tire shop. The response was instant—users loved it!

From there, the design team used foam models of the handle to get the right size and shape. The rest of the design process was straightforward. The design team worked to develop a product that was fast, durable, manufacturable, and marketable. "All these elements are part of industrial design," emphasizes Loomis. "It's more than just making something look good. This product could be the poster boy for putting 'industrial' back in industrial design."

Within ten months, the IR2080 fleet air impact wrench was born and the market embraced its new baby. When the team left a working prototype in a tire shop to get user feedback, they returned to find it had been kidnapped. "The manager liked it so much, he took it home," says Price. "Despite it's being a prototype, he didn't want to part with it!"

The form and function of the IR2080 addresses the specific needs of tire-service technicians. It is 40 percent lighter than competitors' tools, but it delivers the power and speed needed for wheelbolt applications. The form and orientation of the chainsaw handle significantly improve user comfort and control.

What inspired the solution? The design team knew they could dramatically improve the lives of tire-shop workers. "The team got excited because customers were screaming for a solution to the awkwardness of existing products," explains Loomis. People complained again and again of backaches and fatigue resulting from carrying around a 30-pound piece of equipment with an uncomfortable grip.

In the past, the only way to capture a piece of the market was to increase the tool's power, but the design team for the IR2080 fleet air impact wrench proved that the road not taken may be the road to success. They focused instead on ergonomics and weight. "We broke some paradigms with our customer base, as well as with Ingersoll-Rand," says Loomis. "The target market is known to be conservative—usually, these guys don't like anything new. But we've shown that the market will welcome a new product if it will make their lives easier."

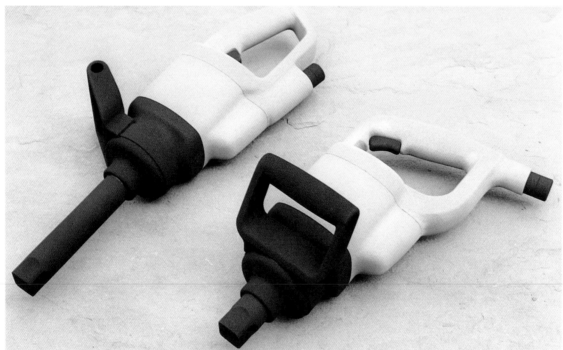

Above and left: Once the designers thought to develop different handles to accommodate different markets, they used the hand-drawn concept layout sketch above to create foam models of two impact wrenches. The model with the chainsaw handle (left) addressed the needs of the automotive market, the more traditional handle (right) the variety of tasks performed by users in the industrial market.

The first step in designing the impact wrench was visiting truck and fleet maintenance shops to learn more about what Mike Loomis calls "the 3-foot (91 cm) tire-changing world." The design team translated what they learned about how workers used existing tools and problems they encountered into the IR2080.

3' World

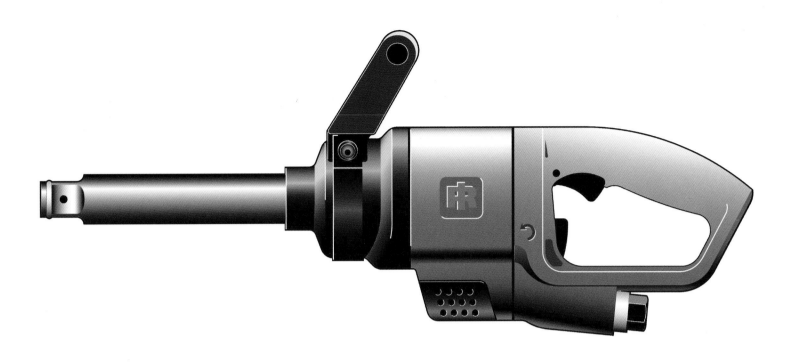

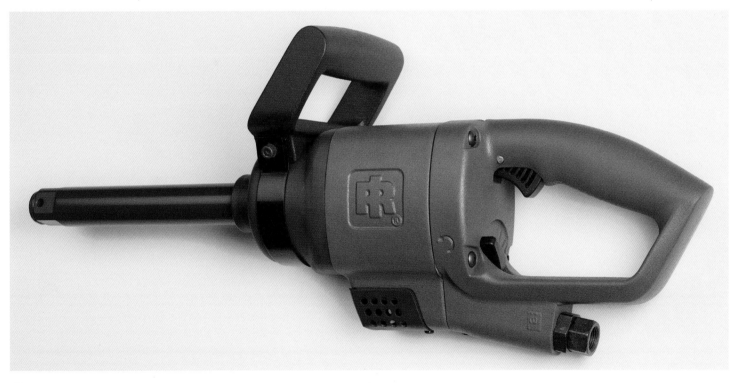

⬦ Above: Moving from concept to this final design rendering took less than four months. Once the general design direction was determined, most of the work was tweaking the form and feel of the handle to get it just right. Ten months later, the IR2080 was ready for market.

⬦ Below: The clean, no-nonsense design with sturdy controls conveys the tool's workhorse nature. The orientation of the handle sets it apart from the competition, and the product's early success proves that even conservative markets are willing to accept exceptional design.

SC4000 Series Sit-Down **Counterbalanced Electric Lift Truck** For twenty five years, Crown Equipment Corporation **supplied the market** with a **forklift truck**

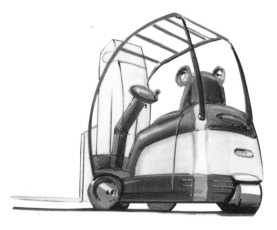

An early sketch of the operator-forward concept.

that more than satisfied the needs of its customers, but, as market demands shifted, it became obvious that the time had come to develop a replacement. Crown's new SC4000 Series Sit-Down Counterbalanced Electric Lift Truck took the industry by storm. Here was a lift truck so small and maneuverable that it could load and unload pallets almost everywhere—from shipping docks to tractor-trailers and long warehouse aisles. For Crown and the company's busy customers, this innovation came just in time.

"These trucks operate in tough environments that place incredible demands on the operator and the product. Operators in this environment work fast in order to meet their tight deadlines, and they need a workhorse truck that's comfortable and easy to use," says Jim Kraimer, design manager at Crown Design Center.

In addition to the truck's lift capacity, speed, and maneuverability, its innovative operator compartment, which allows users to be more comfortable and productive, distinguishes it from a pack of lookalikes. One of Crown's industrial designers conceived the concept of an operator-forward vehicle when he noticed that operators had difficulty getting on and off the truck from the right side because there wasn't much room between the overhead guard and the control levers. To increase accessibility, he designed a huge doorway into the operator compartment by replacing the traditional straight rectangular overhead guard tube with a round tube with a large front radius. "The idea seems simple, but this was a major paradigm shift in forklift design," says Kraimer.

"Accessibility and fork visibility are the best in the industry. The operator compartment has an automotive feel, with such features as a fully adjustable steering column and soft-touch levers," adds Kraimer. Many of its other features are major changes for the industry as well, including its smooth handling, comfortable ride, refined ergonomics, reliability, performance, and easy serviceability, which, when combined with the truck's unique design, communicate to buyers a sense of quality.

The route from concept to reality was typical. The Crown Design Center began by thoroughly investigating all the product issues to determine what the market needed. The project team was multidisciplinary, including industrial design, engineering, and manufacturing, along with a mix of marketing, sales, service, and outside consultants. The team performed competitive analyses

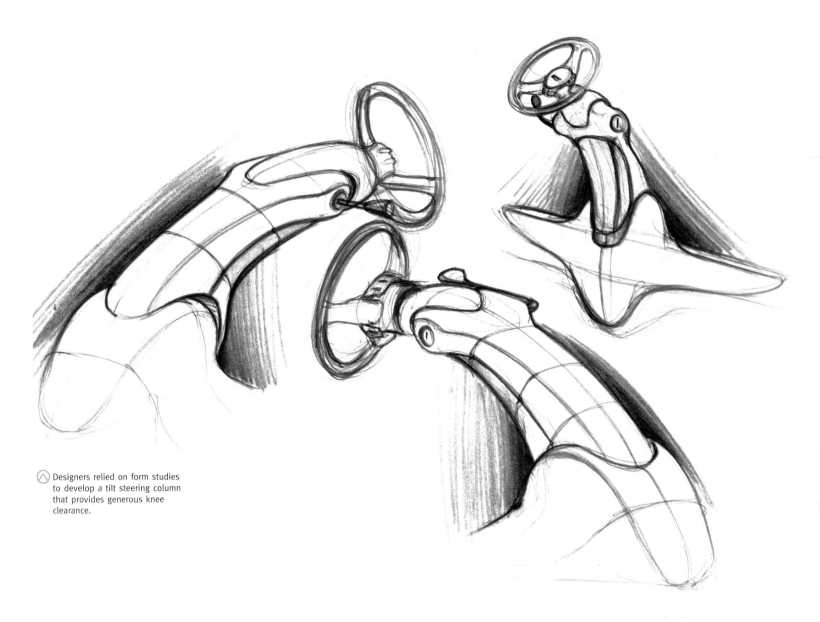

⬡ Designers relied on form studies to develop a tilt steering column that provides generous knee clearance.

and test-drove competitive trucks while researching market trends. Concurrently, they initiated research into ergonomics, which played an important role in the final design. Research results in hand, the team created design alternatives as sketches, scale models, and even an initial full-scale mock-up. "We also built ergonomic testing bucks in order to understand operator interface issues, especially with the operator-forward concept. We continued to research our operators and their applications in order to discover ways to create value for them in our product," says Kraimer.

To ensure that the design stayed within cost parameters and remained manufacturable, designers worked closely with engineering. They tested to refine the controls while getting down to the detail work of selecting colors and materials, all of which were presented in a final mock-up that communicated the design intent. Next, they created three-dimensional CAD models of all the appearance parts and resolved remaining details regarding appearance, texture, color, logo, and material and process selection. Designers tweaked outstanding issues, refined the models, and sent field test trucks out for feedback; specifically, they wanted to know how users regarded design and ergonomics. The results were excellent.

Throughout the process, the overriding challenge was to maintain the operator-forward concept while optimizing the truck's ergonomics and establishing a new precedent in three-wheel truck design. "The truck, generically, wants to be a short box on wheels that you sit on. But this is not to say that it has to be that way; so we set out to differentiate ourselves from the competition—not for the sake of differentiation but for the sake of the operator. The challenge was to first create a unique appearance that invited operators to take a closer look and then to reward them by giving them the best working office we could, considering the tight functional space requirements of the truck," explains Michael Gallagher, Crown Design Center's director.

"I attribute the design success of the SC4000 to the fact that we did all of the fundamentals right. One catalyst was the way we organized, isolated, and empowered the development team, giving design, engineering, and manufacturing common goals that they had to meet, and frankly did so superbly." Gallagher says. "This common effort led to a truck that has great drivability and fits like a glove. Let there be no mistake, though; it fits because everybody dove into the details and made them all happen to plan."

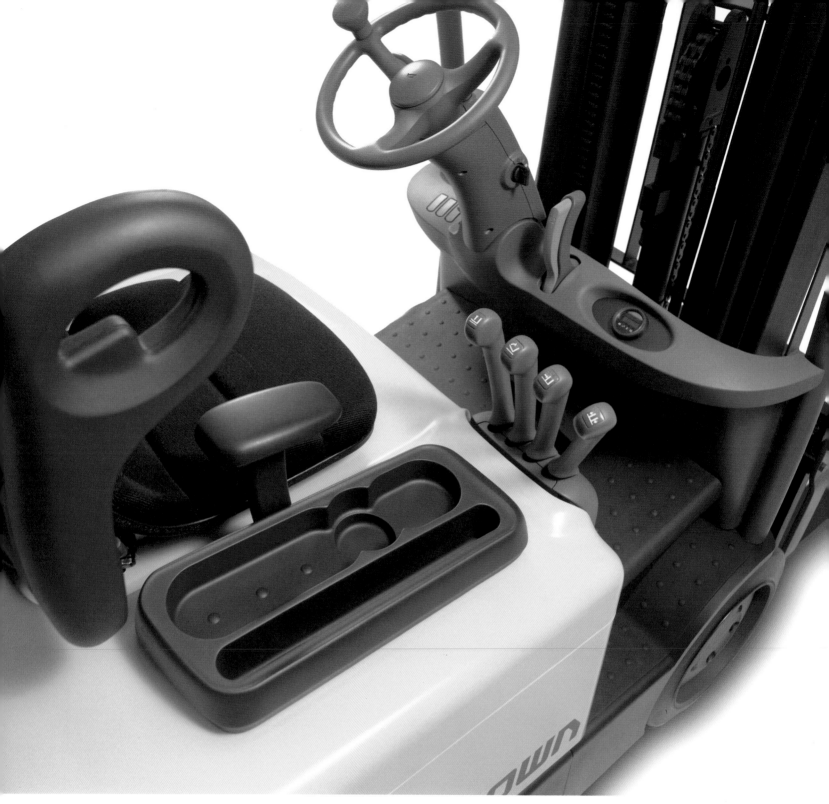

Crown opened the overhead guard for better ingress/egress while keeping the front cowl as thin as possible in the foot area and making the steering column as narrow and ergonomically friendly as possible.

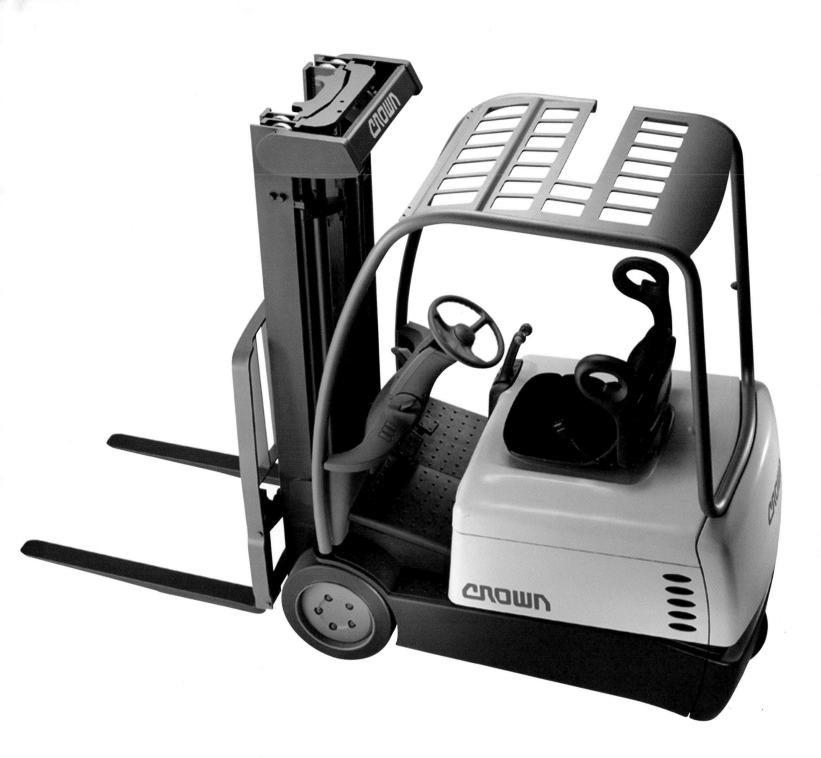

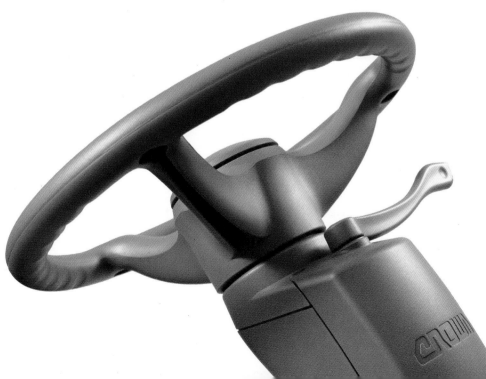

"In terms of design, this product is beyond what the market expected. People connect emotionally with this new truck. They tell us they want to buy it because it has better quality, yet they've never turned the key. They associate good design with quality, value, and a strong company that stands behind its products," says designer Jim Kraimer.

HiSonic Head Gear

Few products elicit a **true cry of joy** from the **user,** but that's exactly what the HiSonic Head Gear **causes,** reports Designology, the firm that **designed** the **amazing device.**

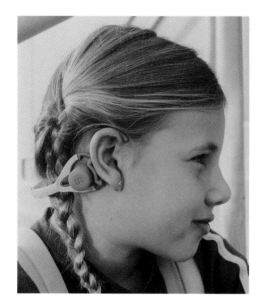

The HiSonic is an ultrasonic bone-conduction hearing device for the profoundly deaf. A potential additional application is the treatment of severe tinnitus (ringing in the ears). The profoundly deaf derive little or no benefit from conventional hearing aids. For some, surgery is an expensive and painful option. For others, even medical intervention will not help. So the HiSonic Head Gear, an effective, affordable, noninvasive solution, often brings forth tears of happiness, especially from people who hear for the very first time.

The Head Gear holds a transducer to the "hearing spot" of the mastoid bone, the bone that protrudes behind the ear. Behind the bone lies the saccule, an unused sensory organ that can detect vibrations. After proper fitting by an audiologist, the Head Gear delivers ultrasonic vibration to the mastoid bone and saccule. The vibrations begin as normal sound that is picked up by a lapel microphone. They are converted by a battery-operated digital signal-processing unit, transmitted by the transducer, and perceived by the brain as sound.

Hearing Innovations, Inc., the developer of the device, had designed a similar device previously, but it was somewhat uncomfortable, clinical-looking, and difficult to adjust. Designology made the technology easy to live with. The design problem was to locate the relatively large and heavy (36-gram) traducer comfortably, accurately, and securely. The flat head of the transducer had to seat as flush as possible to the mastoid bone, the surface of which is different on each user.

This led the designers to the necessity of a floating fit, which accommodates varying contours while applying the proper pressure to hold the transducer flush with the skin's surface. Elastomer material was the right choice for comfort, durability, and flexibility. Designology's Randsom Brown notes that the elastomer not only provided a good grip, it also protected the transducer and shielded the ear from the stainless-steel device should the metal become hot or cold.

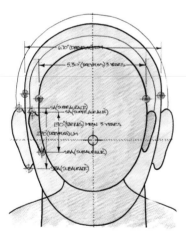

Above: The HiSonic Head Gear, designed by Designology, looks more like a personal radio than a prosthetic device.

Below: Composite anthropometric diagram showing head and ear size range (three-year-old to adult) needed to be accommodated with the head gear system.

After working through a number of design trials, Designology developed a C-shaped arm that wraps unobtrusively behind the head. A rotating and indexing boom was designed with an elastomer ear hook, which positions the assembly on the ear like glasses. An internal boom provides vertical adjustment so that the transducer can be precisely located. The only adjustments requiring tools are the locking of the boom rotation with a small screw and the trimming of excess length to the boom once the transducer/jacket assembly is positioned. The device can be switched from ear to ear as desired.

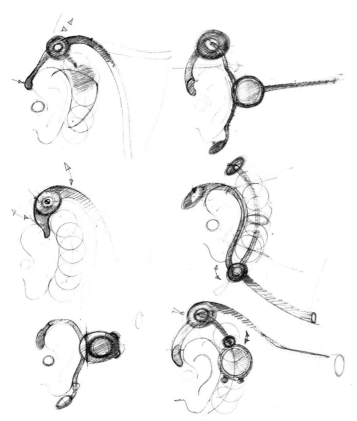

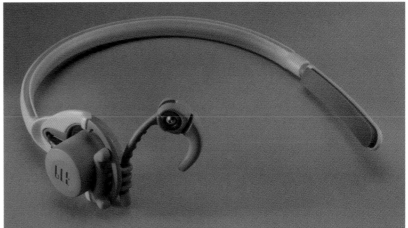

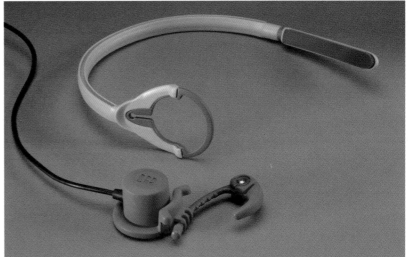

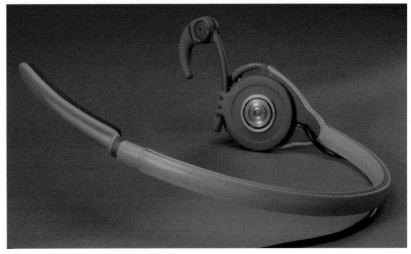

"Considerable anthropomorphic data related to the head and ears was used as a foundation for sketch and development models," says Brown. When people tried on models of the device, their comments boiled down to comfort and fit. The data they provided was invaluable in helping Designology achieve both.

The result is an extremely satisfactory combination of customer comfort and product function. The low-profile, minimal design fits without straining the ear lobe. It looks friendly and sporty, like a personal radio. The overall design has a ruggedness that dispels the usual stigma of wearing a prosthesis.

Another plus: Designology was able to reduce the parts count from the original design by more than 50 percent, which reduced tooling and parts costs.

The ultimate benefit, of course, is for the profoundly deaf person—one in a population of approximately 2 million in the United States alone—whose only choice prior to the HiSonic was an invasive $50,000 cochlear implant surgery—certainly not within most people's budgets. The cochlear implant is permanent, whereas the HiSonic allows the user to remove the device at will. Severe tinnitus sufferers, of whom there are 12 million in the United States—will potentially benefit from the HiSonic Head Gear as well; its ultrasonic bone conduction masks ringing in the ears, which can be severe enough to interrupt daily life, even sleep.

Randsom Brown says that the experience of designing the consumer interface has been gratifying. "We get e-mails from people who are excited about the opportunity of perceiving sound without having to experience a surgical procedure," he says.

⬡ Above left: Early thumbnail sketches of design options.

⬡ Above: The final production version of the HiSonic Head Gear reveals its nonclinical personality. Soft but sturdy materials make the device sporty, not invasive.

⬡ Middle: The two prime subassemblies of the production version. The ear clip (bottom) adjusts and keeps the transducer in the best position. The head clip (above) fits around the back of the head and applies the required pressure to the transducer.

⬡ Below: This view of the production version shows the stainless-steel transducer head.

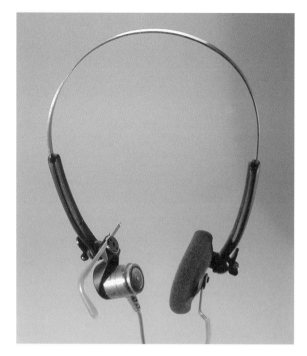

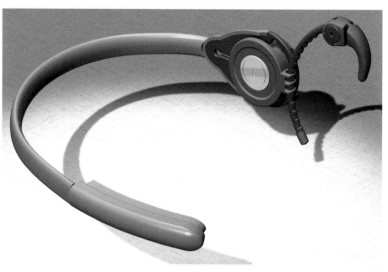

◁ Prior HiSonic head set. The middle image shows the stainless steel transducer.

△ Above: Early sketch models of the ear clip assembly show variation in contouring and dimension to accommodate a wide range of ears and heads.

△ Middle: Computer-generated proposal rendering typically used to convey design options.

△ Below: Selection of prototypes generated from computer solid modeling.

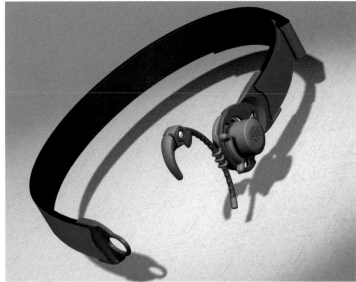

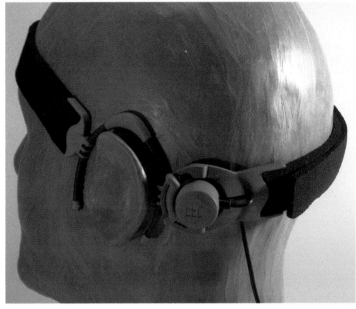

⬡ Above: Three of the development models used in the establishment of head size ranges.

⬡ Below: A sensitive force gauge was used to determine the force being applied to the head by the transducer.

⬡ Above: A headband version of the HiSonic was designed for children younger than three and persons involved in strenuous activities, like sports.

⬡ Below: The headband version uses pressure applied by the band to keep the traducer in place. Again, the device has a sporty, not clinical, appearance.

SIGNA **OpenSpeed MRI** According to studies by GE Medical Systems, 7 percent of **patients** who require a magnetic resonance image (MRI) scan for **aid in diagnosing** a medical problem **refuse** the procedure;

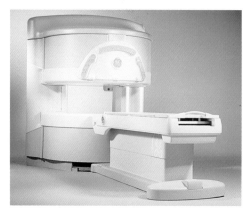

the thought of lying in a closed tube for thirty to forty-five minutes (the length of a typical exam) is unbearable. Moreover, a growing number of obese patients go unscanned because they cannot physically fit into the 60-cm (23.5") opening of the traditional cylinder magnet. GE Medical Systems knew it was time to seek new ideas.

Designers came up with a rough idea of the ideal MRI. They outlined the basic configuration, explained how it would work, and took the idea globally to gather feedback. "We did a lot of research and testing before we welded a single part," remembers Doug Dietz, global design process manager.

Global feedback on the design criteria clearly ranked openness as a priority. With this in mind, parameters were established from the outset. It was agreed that the distance between the two structural posts would be no less than 85 cm (33.5") and the distance between the two magnets a minimum of 44.7 cm (almost 18"). "These numbers were sacrosanct," says Lawrence Murphy, chief industrial designer. "It took serious invention and work by physicists and mechanical engineers to meet these numbers. They pushed back quite a bit, but we had photographic, dimensional, and user testing to prove that you can't get smaller than these measurements and fit this size population and do this anatomical set of scans."

The next step was a competitive profile, followed by a market trend analysis that included far-flung sources like the industrial equipment and automotive industries to see what design innovations might aid in the project. The team visited customer sites and reviewed existing equipment, environment, and efficiency performing tasks involving scanners. Next, they had a global brainstorming session where participants were asked to choose the top three workable configurations. With the design objectives becoming more specific, designers implemented a commonality plan to find similar ideas and parts from existing products that could be borrowed to minimize costs. Then they created a foam core mock-up, which they used to solicit customer feedback.

From there, designers went to CAD drawings to ensure the design would work with engineering. Despite necessary trade-offs, soon they had a master model built to scale that validated the design and allowed them to perform color studies. They machined molds right off the CAD data and added fiberglass covers. From this, they were able to start preproduction tooling and test the fit and the finish. They documented the entire process for the benefit of subsequent designers.

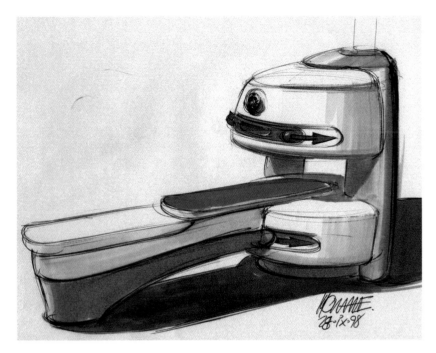

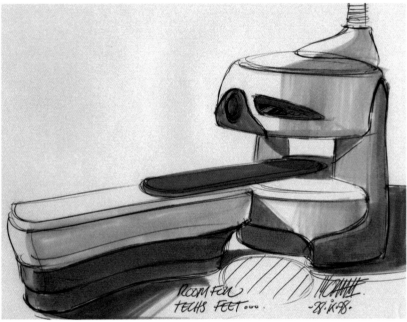

⊘ Original brainstorming
sketches of the ideal open
scanner from France.

The resulting scanner is completely new. Whereas a traditional closed superconductive magnet is tubular, the SIGNA OpenSpeed MRI looks like two hamburger buns suspended on two pillars. The configuration gives both patient and provider more room. "This magnet is open because of its configuration, but its success also has to do with how open it looks and feels," says Murphy. Other open systems exist but are not superconductive like the SIGNA and most tube scanners. These permanent scanners, while more open than cylindrical tube scanners, have weaker magnets and significantly longer scan times. The SIGNA combines the best of both worlds. It is open, superconductive, up to three times faster than other open MRIs, and provides the same quality image as the cylindrical magnet.

In addition, the scanner can accommodate patients weighing up to 500 pounds, and the bed can be extended to 6.5 feet (2 m) so that patients don't lie precariously on a narrow palette during the procedure. The scanner's swing table can enter the magnet from three locations and allows technicians to position patients for extremity exams, including scans of elbows, knees, and shoulders, that are difficult to image in a cylindrical magnet.

The technician can always move the patient laterally while in the magnet; other scanners require the technician to back the patient out of the magnet for each adjustment. "If you look at that first image and realize you should be 1 or 2 cm (.5 or .75 inches) to the left, you can make that as a real-time adjustment in the magnet," says Murphy. To save time in just such a situation, designers built in a small pinpointing laser that indicates the centerline of the scan with a red dot on the patient's gown.

"The line that we walked between patient comfort and access versus the laws of physics was probably our biggest challenge," says Murphy. "This magnet is just a pile of inventions. There was a reason why there hadn't been a superconductive open magnet before—the challenges of physics. Creating a superconductive magnet of this configuration was daunting. How can I work with physicists and mechanical engineers to create as open a design as humanly possible? A lot of material science went into this, a lot of in-depth research by people way smarter than I am. But the interesting part is, the industrial design and the focus on provider and patient needs drove all that analysis."

"[To be successful] in medical product design, we put ourselves into the position of the patient or the user. We decided to be responsible for compassionate quality. We wanted to make sure that while technology is important, the experience is just as important for the patient and the user. That's the way I approached the design," adds Murphy.

"As designers, we need to really look at balance of product," adds Dietz. "We represent the folks who don't go to the design meetings. The patients aren't there. We need to stick up for them."

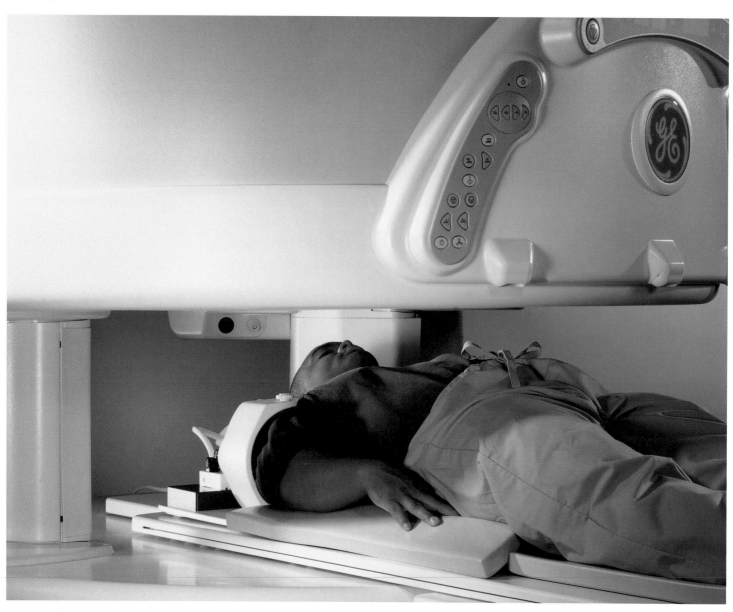

The scanner can accommodate patients weighing up to 500 pounds, and the bed can be extended to 6.5 feet (2 m) so that patients don't lie precariously on a narrow palette during the procedure.

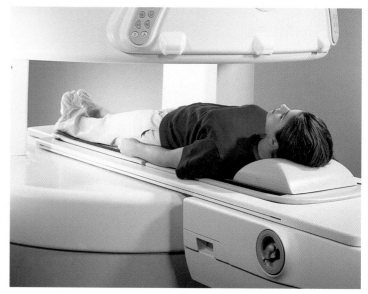

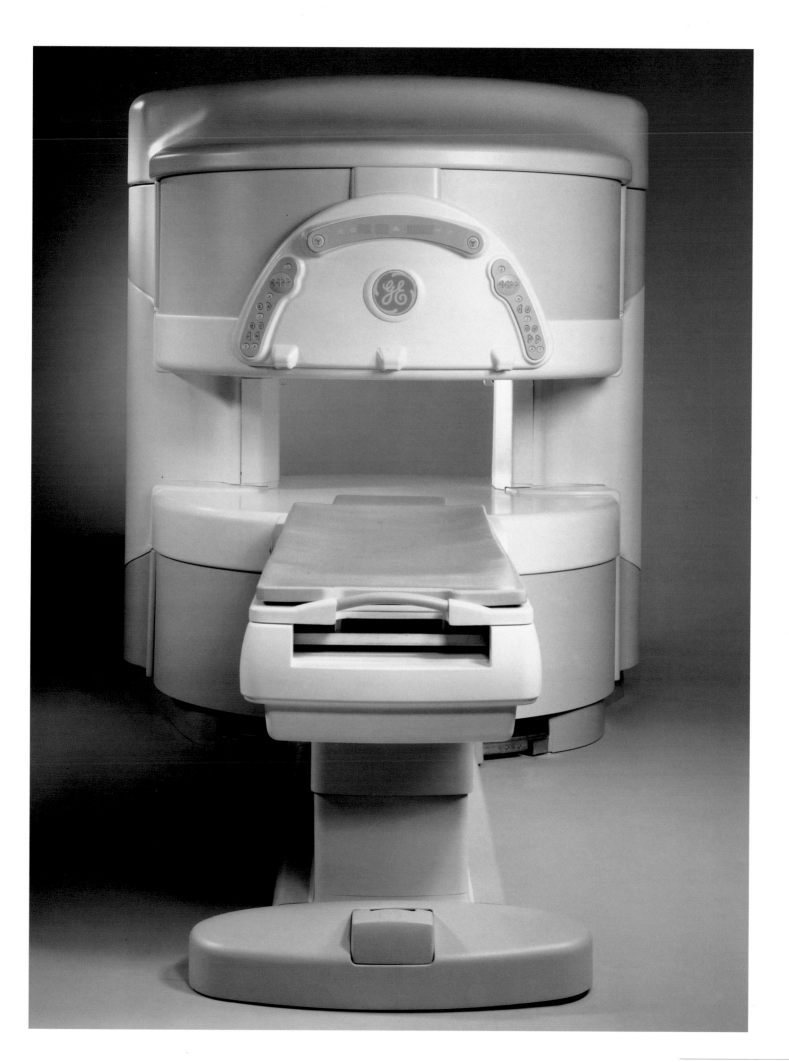

NeuroMetrix NC-stat™ Carpal tunnel syndrome

(CTS), which affects the **hand and fingers,** is an increasingly frequent **problem.** CTS is the result of compression of the **median nerve,** which runs through the carpal tunnel in the wrist.

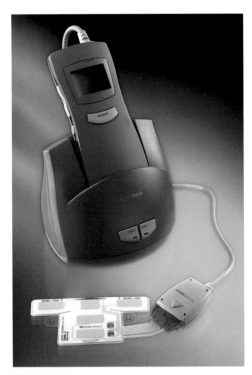

The NeuroMetrix NC-stat™ system allows clinicians to diagnose and monitor patient progress during treatment at the point of care, be it an office, factory, or doctor's office. It is completely noninvasive. Previous test methods required that a sterile wire be inserted into the patient's wrist.

It can be caused by repetitive motion of the fingers and hands, pregnancy, or diabetes. The result is pain, numbness, weakness, and, eventually, atrophy of the muscles in the hand.

People make 2.4 million physician office visits because of CTS every year. Obviously, it is a significant cause of lost productivity in the workplace. In fact, the average cost per workers' compensation claim is $12,370, the third most expensive. It is also the cause of the highest median number of days lost from work.

As unpleasant and inconvenient as the syndrome is, the traditional diagnosis, electromyography, is no better. A fine sterile wire electrode is inserted briefly into the muscle in the wrist, and the electrical activity is displayed on a viewing screen. The process, which is done in a doctor's office or other clinical setting, is invasive and painful.

Engineers at NeuroMetrix, Inc., of Cambridge, Massachusetts, believed they could find a better way. Based on their research and advances in neuroscience, the company began developing a new class of noninvasive products for testing neuromuscular disorders—including CTS—right in the workplace, if necessary. The first product, the NC-stat,™ is used primarily to evaluate disorders of the median nerve.

NeuroMetrix asked Product Genesis, a product development firm also located in Cambridge, to develop the new product design for the NC-stat.™ "The client had developed the core technology, which yielded results, but had no idea what the embodiment should be, nor how it would integrate into the physician environment," explains Product Genesis vice president of design development Luis Pedraza.

From a designer's standpoint, NeuroMetrix was an ideal client. The company was visionary in its technology but had no preconceptions of how the product should be designed. To understand the problem and design an appropriate solution, the Product Genesis design team examined the entire diagnostic procedure. A series of questions emerged. Where would the unit be stored? Who would the users be, and how would they interact with the device? Should the unit be handheld or a desktop device? How would the information be recorded? How would a patient's progress be tracked? Should the product have a carrying case? Should the output for the device be a built-in printer or modem? How could NeuroMetrix best serve its clients?

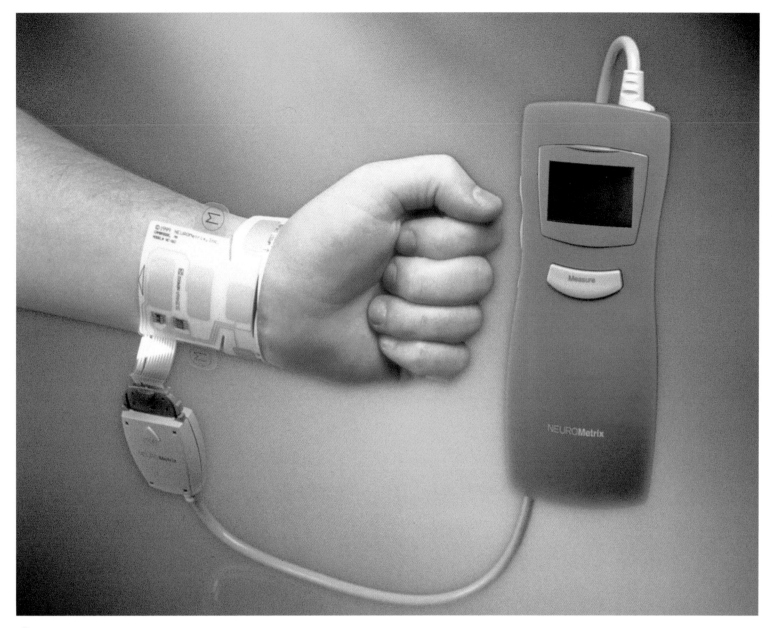

A biosensor adheres to the patient's wrist and delivers a controlled electrical stimulus that causes the patient's thumb to twitch.

Through focus groups, Product Genesis designers searched for the answers to these questions. The findings were clear. A simple device—handheld, with a docking cradle and internal modem—was preferred. The device had to have a soft, friendly form, and be comfortable for both the diagnostician and the patient. It had to deliver accurate information quickly and clearly.

The device's cradle needed to have a minimal footprint, as it would likely be placed in a cluttered administrative area, maybe next to a fax or printer. As with all electronic devices, cabling problems had to be addressed. Finally, users asked that the display be visible from seated and standing positions.

Various models focused on maintaining a friendly presence, both aesthetically and from a user standpoint. One trial had a computer mouselike appearance: It nestled flat into its cradle and so had a low profile. Another prototype looked like a cordless phone sitting upright in a charger. In the end, the higher-profile model, with its smaller footprint, was deemed to have a more commanding presence.

The designers visualized the product in use. In one scenario, the diagnostician is in the room with the patient and the device. He or she reads the display screen and prints out the results. In another scene, the results are modemed to another location.

The final design looks like a cordless phone, a device most people are already comfortable with. It is decidedly nonthreatening: A biosensor pad is fastened on the patient's wrist, the device is clipped to the wristband, and the test is performed. The roundness of the handpiece allows the NC-stat™ to fit comfortably in the user's palm. Both the handpiece and the cradle look elegant on their own; together, they form a harmonious unit.

The crisp outline of the handpiece gives the product a more distinctive look than softer-edged consumer handheld products like phones and communicators. Even though the product has consumer appeal, its designers wanted to make clear that it is a medical device. It has only three buttons, making it extremely simple to use, even if only occasionally.

"The overall aesthetic presence of the product is unique. It captures the curiosity of everybody who sees it," says Pedraza. "Its unique blend of medical/consumer-looking features makes the product appear friendly. The soft, inviting curves of the handpiece encourage people to pick up the device and interact with it."

Procedure

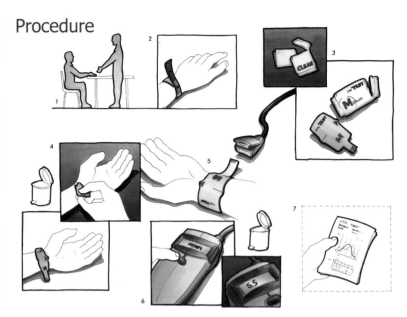

⊗ Product Genesis helped Neuro-Metrix develop the entire testing procedure from setup to tracking a patient's progress.

⊙ The transmission of information was another crucial component. The user had to be able to view the screen directly and print out information or modem data.

⊘ As well as developing the product's design, Product Genesis laid out a variety of situations that explored various aesthetics, control locations, and cradling methods.

Information Tracking

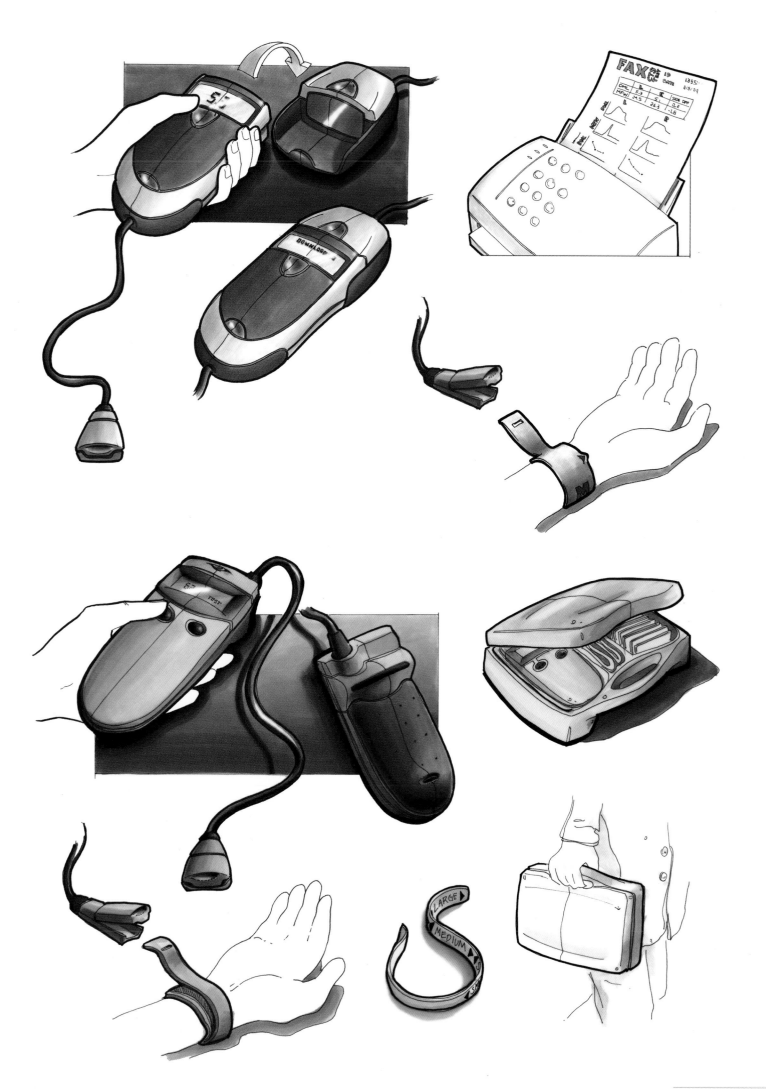

Mixing Station and Syringe Components

Pharmaceutical manufacturer Immunex created a new powdered drug to treat **rheumatoid arthritis;** patients reconstituted the drug by **mixing it with a liquid**

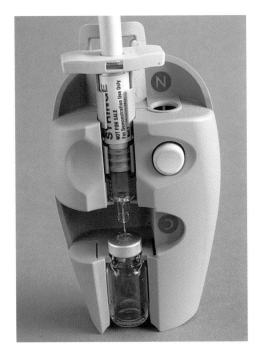

and self-injecting twice a week. It sounded simple enough on paper, but while medically helpful, the new drug brought about a classic dilemma. Reconstitution requires manual dexterity—something patients with rheumatoid arthritis typically don't possess. How could this process be simplified so patients could use the drug with ease?

Immunex sought a solution from Will Zolentrou, president of Coleman Product Design, who wrestled with the objectives: (1) Design a mixing station and syringe that accommodate a variety of hand shapes and positions; (2) Create an alignment mechanism to line up the syringe with the vial stopper; (3) Create a device that heightens a patient's comfort factor with self-injecting the drug; (4) Make the device visually appealing, intuitive, and confidence-inspiring.

The design process was fairly typical, with Zolentrou starting by developing rough ideas from which he selected and refined the best. "The most significant thing I did was put ergonomics and functionality first. Some people put aesthetics first and hope the device works," says Zolentrou. "Because this was for people with arthritis, the functionality absolutely had to come first. I made something that physically achieved good, and I didn't care what it looked like. Once I knew it worked, I came back and worked on the aesthetics."

The obvious hurdles were figuring out how to avoid needle contamination and designing the syringe plunger for ease of use. When inserting a needle into a vial, "your chances of hitting the needle on the tube are pretty high. However, when you solve the needle contamination problem, the device also becomes more complicated," says Zolentrou. For patients to hit a small vial target with the needle without oversteering and contaminating the needle, he needed an alignment mechanism that was open on top; the patient could lay the syringe down from the top, then slide it into the vial, which would provide the control needed to guide the needle's entrance into the tube of liquid.

The second challenge came with the syringe plunger. Originally, Zolentrou thought he would enlarge the existing plunger handle, but early feedback did not rank this design as high as expected. In fact, it tied in testing with a very stubby plunger, Zolentrou remembers. With only three days to develop a new plunger, Zolentrou set to work. On Monday, he developed a new design with a thick, stubby T-shaped handle, put the design into the CAD system, and, although it was rough, sent it to Immunex, which approved it. He refined the details and added a series of horizontal

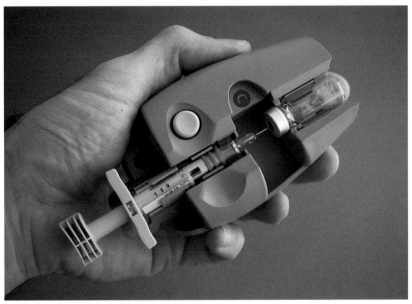

⊘ Above: From the earliest prototype, the product was fairly refined, though not necessarily aesthetically pleasing. "At this point, I wasn't even thinking about the manufacturing process," says Zolentrou, pointing out that the first model was a single piece.

⊘ Below: Ergonomic functionality came first, so Zolentrou designed the mixing station and syringe components to accommodate a variety of hand shapes and grasp positions. Later, he focused on the aesthetic, engineering, and manufacturing concerns. The result: a mixing station with a soft, organic shape that invites touch and easy handling while being functional and practical.

fins to increase the thickness of the handle and provide a better grip from several directions. "I could have used a regular glass syringe, but I made these changes because patients suffering from rheumatoid arthritis must be able to grasp things differently." (In fact, Zolentrou designed every component to be held in more than one way, and all the steps, save one, can be done with the mixing station on a surface or in one's hands.) Thanks to rapid prototyping, a plunger model was delivered to Immunex on Wednesday. By Thursday, new tests confirmed that this was the winner.

Throughout the process, Zolentrou relied on the CAD system and rapid prototyping to test and get feedback about the design of the mixing station, the syringe plunger, and the syringe flange. Rapid prototyping was indispensable and kept the project ahead of schedule. Moreover, the product design "worked first time out of the tool," says Zolentrou. "No rework!"

The final product operates in seven steps. (1) The patient removes the vial cap and syringe needle cover with the help of the device. Patients uncap the syringe cover by removing the rubber piece that protects the needle. Ordinarily, this cap is difficult to pull off or users nick themselves with the needle, but, with the new device, the needle sticks into a little hole, a button clamps down on the cap, and the syringe pulls away easily. (2) The patient places the vial in the back section of the mixing station. (3) The patient fits the syringe onto the mixing station. Its needle is guided through the vial's rubber stopper with guaranteed perfect alignment and enters the vial at the correct distance—far enough in to puncture the rubber stopper but not so far that it withdraws air bubbles. (4) The patient locks the syringe onto the mixing station with a 90-degree twist. (5) The patient inserts the syringe plunger and reconstituting liquid is injected into the vial. (6) The patient swirls the mixture, reconstituting it. (7) The patient withdraws the medication into the syringe and self-injects.

How did Zolentrou manage to meet the product's objectives while keeping the process simple and user-friendly? "I start with the user's problem and work from here. Form follows function—for me, that's critical," he says. "Products speak a language. If a door has a flat panel, push it; a handle, pull. If you walk up to a door and push instead of pull, the door isn't communicating properly.

"The first goal should be to make the product work ergonomically and cognitively, and to communicate clearly. If it doesn't work, it comes up short."

ALIGNMENT MECHANISM

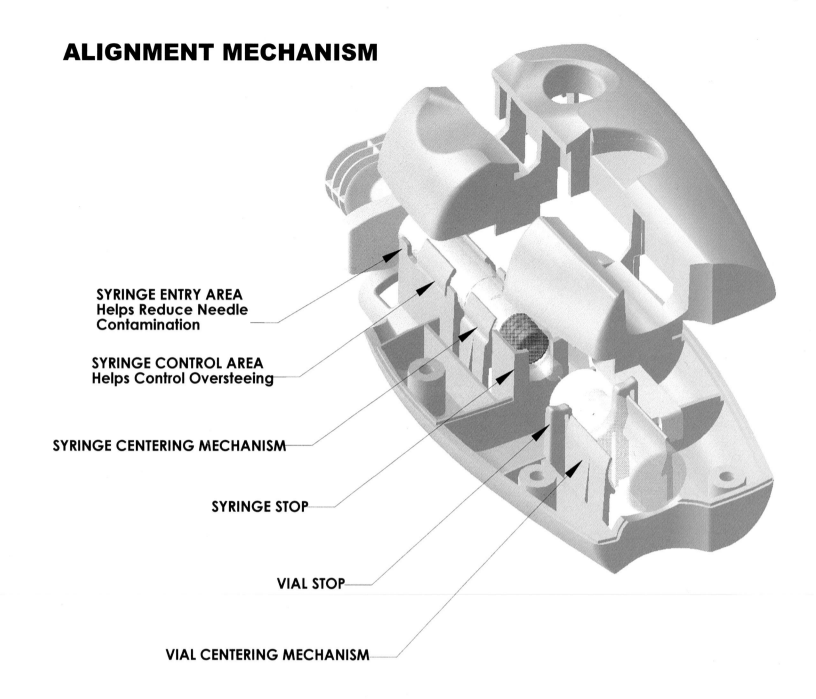

SYRINGE ENTRY AREA
Helps Reduce Needle
Contamination

SYRINGE CONTROL AREA
Helps Control Oversteeing

SYRINGE CENTERING MECHANISM

SYRINGE STOP

VIAL STOP

VIAL CENTERING MECHANISM

The built-in alignment mecha-
nism guarantees perfect needle
alignment in the vial every time.

Opposite left: The mixing station
and syringe components oper-
ates in seven basic steps.

Opposite right: Syringe flange
and syringe plunger shown
separately and on syringe.

MIXING STATION: EXPLODED VIEW

Entry 0498

MIXING STATION COVER

"Carved in" Bevel

Vial Cap Removal Mechanism

Finger Indentation Area

SYRINGE

VIAL

Attachment Boss

Syringe Flange

Syringe Plunger

MIXING STATION BASE

BUTTON for Syringe Needle Cover Removal Mechanism

BLADE for Syringe Needle Cover Removal Mechanism

Syringe Lock Mechanism

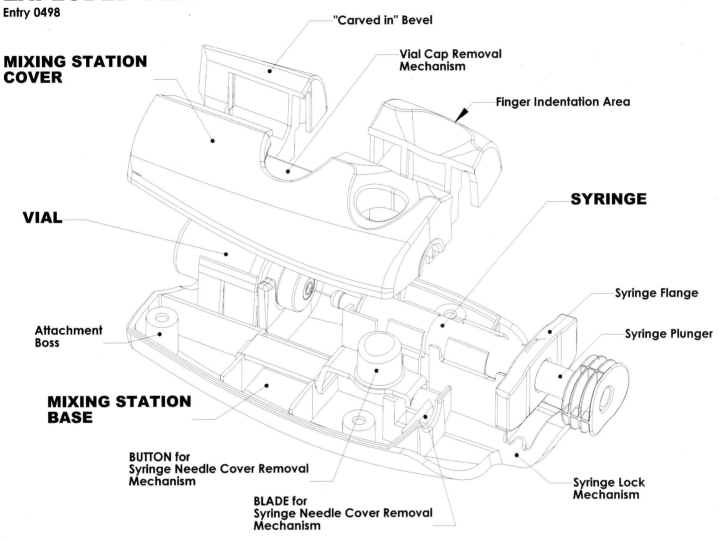

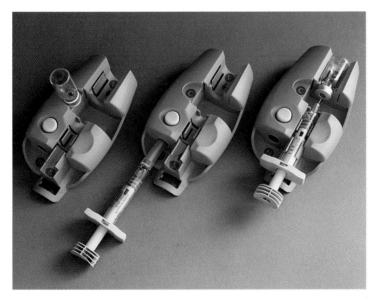

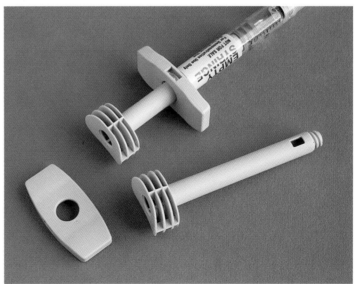

The BD Intima II™ Catheter

Ken Musgrave, director of **design development** for BD **Medical Systems,** doesn't buy into the *oft-quoted line* from *Field of Dreams,* "build it and **they will come."**

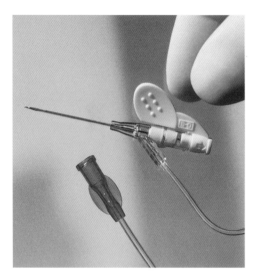

⊘ The BD Intima II™ features a wing, which is the primary user interface, embellished with an elliptical design and a series of raised touch bumps to emphasize where the clinician should grab.

He's seen that approach taken with too many products that ignore the user and fail miserably. When BD Medical Systems set out to design the BD Intima II™, an integrated intravenous catheter developed especially for use in China, they took the opposite tack, analyzed the user's problem, and went from there.

Though plastic IV catheters have been the U.S. standard for almost forty years, emerging markets like China still rely on the century-old steel needle sets. China simply didn't take to the over-the-needle IV, which leaves behind a plastic catheter for infusion therapy once the needle is removed from the body. The Chinese medical community found the old steel needles with tubing attached to the end easier to stick into a vein, even though they were harder on the vein than the plastic catheters. A steel needle can be used for only an hour or two. Every blood sample or infusion means another stick of the needle. By comparison, the over-the-needle plastic catheter can remain in place for ninety-six hours, requiring just one stick per average hospital stay.

Both the United States and Europe slowly made the shift, but the new technology never caught on in China, which lacked the economic structure to support the education needed to convert people from the old technology. The steel needle set does have one advantage—clinicians can connect an IV line to it in advance and fill it with fluid so that when they stick the needle into the patient, blood doesn't come out. The plastic catheter requires that pressure be applied to the vein at the right time to prevent blood from spilling out, which requires skill and can be tricky.

Initially, BD Medical Systems thought the most important feature in a new design would be the ability to preconnect. "If blood didn't come out, we'd have the problem solved," says Musgrave. Internal debate concluded that the insertion process was also an obstacle to using the plastic catheter, so designers revised their thinking to address both issues.

Throughout the process, the overwhelming challenge to determine how to communicate through design how the product was used. "This product had to be the stand-in for the clinical educator. The product had to provide most of the teaching to the clinician," explains Musgrave. It quickly became obvious that the key to design success was to mimic the old product as closely as possible. "We had to do it in a way that was intuitive and self-teaching to someone who wasn't familiar with the plastic over-the-needle catheter."

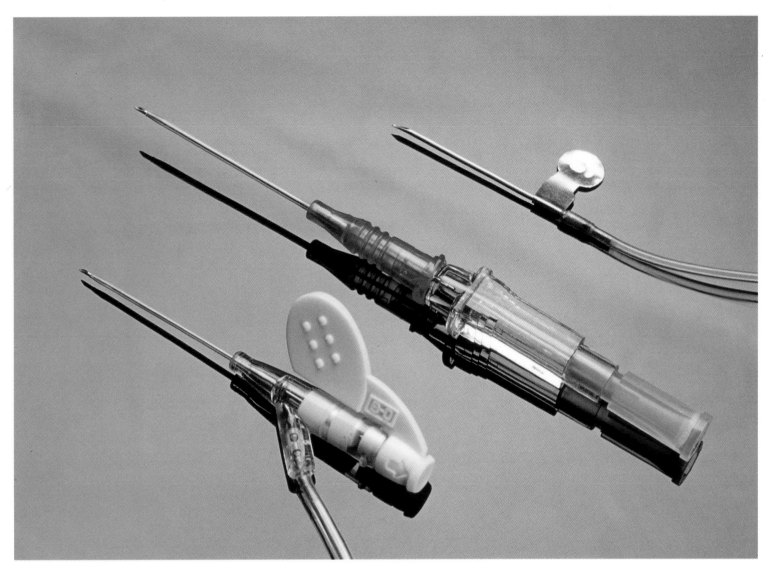

In 1997, the team was readying for a trip to China to present three versions of an alternative conventional plastic catheter with an extension tube on the right-hand side. With only three days to go, a number of the designers felt there was still a better way to do it. They dabbled in napkin sketches during off-hours and showed a fourth concept to the design group, then used the CAD system to generate a solid model. They quietly built the prototype with stereolithography parts that looked and functioned like real parts and had it ready from concept to delivery as a functioning model in three days.

"At that point, the project team became extremely supportive of it and excited about it and were willing to insert the fourth adaptation into their customer visits," Musgrave remembers. "Because we're a medical parts company, we're driven by statistics and controls, so you can't just throw in an extra concept at the last minute without changing the protocol, but the team was willing to do that. At the last moment, we changed the protocol to include the fourth concept, which was radically different than the others."

During the ten-day China trip, BD Medical Systems toured hospitals and showed all four concepts. Their experience was consistent throughout. In each case, they lay the four products on the table and asked the clinician to select the product they felt they understood best and do an insertion without instruction. "These

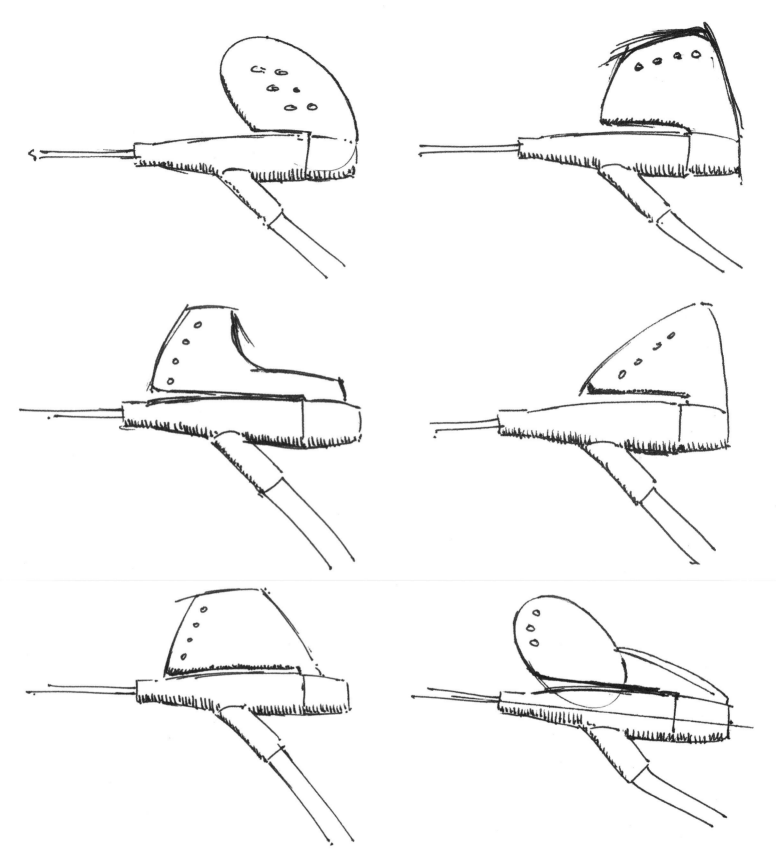

⬡ Early sketches of the wing.

were strictly steel needle users. They had never used or seen an over-the-needle catheter. We wanted them to understand through the design of the product how to insert it and remove the needle and leave the catheter behind. In a remarkable number of cases, the clinicians were able to pick up the fourth concept, look at it, understand how it works, make the insertion, and then realize that this grasping element, this wing, that they were holding was loose and needed to be removed. Through the product design, they were able to make the insertion and understand that they were supposed to remove the needle," says Musgrave. The fourth concept "was wildly successful in our customer studies."

"Most of work, after China, was dialing in details," adds Musgrave. "Once a design is completed, that is only the beginning with medical products." The team developed the manufacturing process, proved that the process results could be repeated, and conducted clinical studies to show the product was safe and effective. "The tooling process alone can take a year. It's a long, laborious process."

Musgrave urges designers never to get off track of the customer's ultimate requirement. "It is easy for the project team to be caught up in technical specifications, manufacturing restrictions, and other limitations, but at the end of day, this product has to be desired by the customer more than any other product. The customer has to be able to say, 'This is the product that is going to solve my problems.'"

"One thing that happens in a lot of companies is that they start developing this philosophy that the customer wants to buy what they want to build. Once you return the customer to the equation, you recognize that customers provide an emotional buying decision as well as a utility buying decision, and that they are looking for more out of a product than they've ever had before."

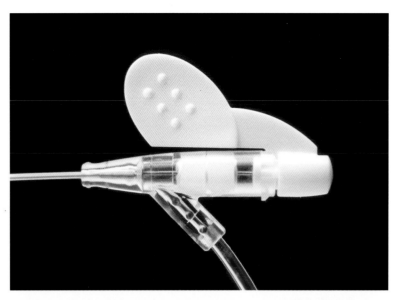

The custom adapter at the end of the extension tube follows the same elliptical motif with three touch bumps. The touch bumps emphasize where to grasp the connector and use the same functional aesthetic design language as the product's wing.

directory

PAGE 8
DESIGN FIRM: Olive 1:1, Inc.
ADDRESS: 589 8th Avenue, 2nd Floor, New York, NY 10018
212-965-9001
olive@inch.com
PRODUCT: Resolve System for Herman Miller
CLIENT: Herman Miller, Inc.

ADDITIONAL CREDITS
Design Team: Ayse Birsel, Allan Chochinov,
Stephanie Kubaner, Joe Stone

PAGE 12
DESIGN FIRM: IDEO
ADDRESS: 700 High St., Palo Alto, CA 94301
650-289-3400 (phone)
650-322-6321 (fax)
www.ideo.com
PRODUCT: Steelcase Leap Chair
CLIENT: Steelcase, Inc.
ADDRESS: PO Box 1967, Grand Rapids, MI 49501-1967
800-333-9939
www.steelcase.com

ADDITIONAL CREDITS
Design Teams: George Simons, Thomas Overthun, Tom Eich
of IDEO; Steelcase Industrial Design and Engineering

PAGE 16
DESIGN FIRM: Refac/Human Factors
ADDRESS: 115 River Road, Edgewater, NJ 07020
201-943-4400
lacotta@refac.com
PRODUCT: OXO Good Grips Bottle Stopper/Opener
CLIENT: Oxo International

ADDITIONAL CREDITS
Design Team: Cyan Godfrey, Bert Heinzelman,
Adam Sanchez, Skip Kirk

PAGE 20
DESIGN FIRM: Michael Graves & Associates
ADDRESS: 341 Nassau Street, Princeton, NJ 08540-4692
609-924-6409
PRODUCT: Target Toaster
CLIENT: Target Stores

ADDITIONAL CREDITS
Design Teams: Michael Graves, Donald Strum,
Tony Boczkowski of Michael Graves Design;
Ron Johnson of Target Stores; Stuart Naft of Black & Decker
Photography: Marek Bulaj

PAGE 24
DESIGN FIRM: Smart Design LLC
ADDRESS: 137 Varick Street, New York, NY 10013
212-807-8150
anthony@smartnyc.com
PRODUCT: OrangeX Ojex Manual Citrus Juicer
CLIENT: OrangeX

ADDITIONAL CREDITS
Design Team: Anthony Di Bitonto, Marco Perry,
Tim Kennedy, Alex Hochstrasser
Photography: Rick English (page 24, two images)

PAGE 28
DESIGN FIRM: Anderson Design
ADDRESS: 74 East St., Plainville, CT 06062
860-747-0707
davek@andersondesign.com
PRODUCT: Quick' N Easy Food Processor
CLIENT: Applica, a Black & Decker licensee

ADDITIONAL CREDITS
Design Teams: David Kaiser, Joseph Toro, Eric Price, and
Glen Nielsen of Anderson Design; Stuart Naft of Applica, Inc.

PAGE 32
DESIGN FIRM: Ancona 2, Inc.
ADDRESS: 22 W. 19th St., 5th Floor, New York, NY 10011
212-807-8772 (phone)
212-807-8831 (fax)
PRODUCT: Ekco Clip'n Stay
CLIENT: Ekco Housewares, Inc.

ADDITIONAL CREDITS
Design Team: Ancona 2, Inc. designers
Photography: Doug Fornuff ©1999

PAGE 36
DESIGN FIRM: Ecco Design, Inc.
ADDRESS: 16 West 19th Street, New York, NY 10011
212-989-7373
info@eccoid.com; jeff@eccoid.com
PRODUCT: Orca Mini Stapler
CLIENT: Hunt Corporation

ADDITIONAL CREDITS
Design Team: Jeff Miller, Eric Chan, Ethan Imboden,
Fede Carandini
Photography: Ecco Design (pages 36, 38, 39),
Ken Skalski (page 37)

PAGE 40
DESIGN FIRM: Staubitz Design Associates
ADDRESS: 111 Main Street, Collinsville, CT 06022
860-693-1139
SDA111@aol.com
PRODUCT: The Royal-Olivetti ASF Paper Shredder
CLIENT: Royal-Olivetti

ADDITIONAL CREDITS
Designer: Tim Repp

PAGE 44
DESIGN FIRM: Black & Decker Corporation
ADDRESS: 701 East Joppa Road, Towson, MD 21030
410-847-6559
scott.evans@bdk.com
PRODUCT: MOUSE™ Sander
CLIENT: Black & Decker Corporation

ADDITIONAL CREDITS
Design Team: D. Scott Evans, Mark Stratford

PAGE 48
DESIGN FIRM: The HeadBlade Co.
ADDRESS: 529 Montana Ave., No. 7
Santa Monica, CA 90403
310-395-8948
www.headblade.com
PRODUCT: The HeadBlade
CLIENT: The HeadBlade Co.

ADDITIONAL CREDITS
Design Team: Todd M. Greene, Richard Jazel,
Roger Musser
Photography: Michael Miller (page 49)

PAGE 52
DESIGN FIRM: Design Central
ADDRESS: 68 West Whittier Street, 4th Floor
Columbus, OH 43206
614-890-0202
tim@design-central.com
PRODUCT: Flexible Footwear
CLIENT: Flexible Footwear Technologies Ltd.
ADDRESS: P.O. Box 92, Sigel, PA 15860

ADDITIONAL CREDITS
Design Teams: Timothy A. Friar, Diana W. Juratovac,
Thornton, K. Lothrop, Oren Shai, and Rainer B. Teufel
of Design Central; Jerry F. Gumbert of Flexible Footwear
Technologies, Ltd.

PAGE 56
DESIGN FIRM: Astro Studios
ADDRESS: 818 Emerson St., Palo Alto, CA 94301
650-321-5635 (phone)
650-321-6627 (fax)
www.astrostudios.com
PRODUCT: Nike™ Triax Running Watches
CLIENT: Nike, Inc.
ADDRESS: 1 SW Bowerman Dr., Beaverton, OR 97005-0979
503-532-0151
www.nike.com

ADDITIONAL CREDITS
Design Teams: Rob Bruce, Kyle Swen, Brett Lovelady
of Astro Studios; Ray Riley, Gene Yanku of Nike Inc.

PAGE 60
DESIGN FIRM: Bleck Design Group
ADDRESS: 51 Middlesex St., N. Chelmsford, MA 01863
978-251-7474
jbleck@bleckdesigngroup.com
PRODUCT: SnoWalkers
CLIENT: Outtaboundz

ADDITIONAL CREDITS
Designer: James H. Bleck

PAGE 64
DESIGN FIRMS: Biokinetics Ltd., Design Workshop
ADDRESSES: Biokinetics Ltd., 2470 Don Reid Drive
Ottawa, ON K1H 8PS, Canada
Design Workshop, 70 Colonnade Road North
Ottawa, ON K2E 7L2, Canada
613-727-3880
www.dwcanada.com
PRODUCT: Sportscope Flex-Fit Bicycle Helmet
CLIENT: Sportscope, Inc.

ADDITIONAL CREDITS
Design Teams: Rob Watters, Aldo Balatti, John Tutton
of Design Workshop; Nick Shewchenko, Tim Bayne of
Biokinetics Ltd.

PAGE 68
DESIGN FIRM: Strategix I.D., Inc.
ADDRESS: 619 North Church Avenue, Unit 3
Bozeman, MT 59715
406-585-7909
PRODUCT: TR5 Stationary Bike
CLIENT: Athlon Fitness, LLC
ADDRESS: P.O. Box 542, 102 South Pine Street
Elverson, PA 19520

ADDITIONAL CREDITS
Design Team: Bill Clem, Marty Albini, Cory Williamson,
Pete Schenk (Park City Entertainment)

PAGE 72
DESIGN FIRM: Hobie Cat Company
ADDRESS: 4925 Oceanside Blvd., Oceanside, CA 92056
760-758-9100
www.hobiecat.com
PRODUCT: Hobie Mirage Kayak
CLIENT: Hobie Cat Company

ADDITIONAL CREDITS
Designer: Greg Ketterman

PAGE 76
DESIGN FIRM: Bombardier Inc.
ADDRESS: 565 Rue De La Montagne
Valcourt, Quebec JOE 2LO, CANADA
450-532-2211
denys.lapointe@recreation.bombardier.com
PRODUCT: Sea-Doo Challenger 1800
CLIENT: Bombardier

ADDITIONAL CREDITS
Design team: Inhouse

PAGE 80
DESIGN FIRMS: Lunar Design, Nova Cruz Products
ADDRESSES: Lunar Design
537 Hamilton Ave., Palo Alto, CA 94002
650-798-6328 (phone)
650-326-2420 (fax)
www.lunar.com
Nova Cruz Products
316 N. Essex Ave., Narberth, PA 19072
215-898-6727
www.xootr.com
PRODUCT: Xootr Scooter
CLIENT: Nova Cruz Products, LLC
ADDITIONAL CREDITS
Design Teams: Jeffrey Salazar, Jeff Smith, Mike Simmons,
Kris Bailey, Becky Brown of Lunar Design; Karl Ulrich,
Nathan Ulrich of Nova Cruz Products

PAGE 84
DESIGN FIRM: BMW Design Team Motorbike
ADDRESSES: BMW AG, Dept. ED-M,
Munich 80788, Germany
BMW North America, 300 Chestnut Ridge Road
Woodcliff Lake, NJ 07675
201-307-3910
PRODUCT: BMW K 1200 LT
CLIENT: BMW

PAGE 88
DESIGN FIRM: Design Continuum Italia
ADDRESS: Via Colletta, 69, 20137 Milano, Italy
02 5796871 (phone)
02 5543088 (fax)
www.dcontinuum@continuum.it
PRODUCT: Scorpio 270
CLIENT: Campingaz
ADDRESS: Route de Brignais B.P. 55
Saint Genis Laval, France 69563
0032-27145163
ADDITIONAL CREDITS
Design Team: Bruce Fifield, Aleksander Tatic,
Roberta Cantone, Stefano Casartelli, Thomas Sutton,
Kevin Oliver

PAGE 92
DESIGN FIRM: Fisher-Price, Inc.
ADDRESS: 636 Girard Ave., East Aurora, NY 14052
716-687-3000
Millerj2@Fisher-Price.com
PRODUCT: ViewMaster Discovery Channel™ Viewer
CLIENT: Fisher-Price, Inc.
ADDITIONAL CREDITS
Design Team: Jeffrey Miller, ViewMaster Creative
Activities Design Team

PAGE 96
DESIGN FIRM: Hauser, Inc.
ADDRESS: Stephen Hauser, 880 Hampshire Road,
Westlake Village, CA 91361
805-497-5810 (phone)
805-497-5820 (fax)
PRODUCT: Worm Light
CLIENT: Nyko Technologies
ADDRESS: 2311 S. Cotner Ave., Suite D
Los Angeles, CA 90064-1800
310-445-2550
www.nyko.com
ADDITIONAL CREDITS
Design Team: Kevin Hayes, John von Buelow,
Mark Westcott, Greg Mote, Jose Oleas

PAGE 100
DESIGN FIRM: IDEO
ADDRESS: 700 High St., Palo Alto, CA 94301
650-289-3400 (phone)
650-322-6321 (fax)
www.ideo.com
PRODUCT: Logitech Wingman Formula Force
CLIENT: Logitech, Inc.
ADDRESS: 6505 Kaiser Dr., Fremont, CA 94555
510-795-8500
www.logitech.com
ADDITIONAL CREDITS
Design Teams: Dave McVicar, Fred Swan of Logitech;
Joe Tan, Phil Grebe, Nick Oakley, David Tonge,
Rico Zirkendorfer, Symon Whitehorn, Wink Thorne,
Phil Hobson of IDEO San Francisco
Photography: Steven Moeder (page 101)

PAGE 104
DESIGN FIRM: Flextronics (previously Palo Alto
Products International)
ADDRESS: 567 University Ave., Palo Alto, CA 94301
650-327-9444 (phone)
650-327-9446 (fax)
www.flextronics.com
www.paloaltoproducts.com
PRODUCT: Rocket eBook
CLIENT: NuvoMedia, Inc.
ADDRESS: 310 Villa St., Mountain View, CA 94041
650-314-1200
www.nuvomedia.com
ADDITIONAL CREDITS
Design Teams: Ralf Gröne, Dallas Grove, Ricardo Penate,
Livius Chebleu of Flextronics (originally Palo Alto Prod-
ucts International); Martin Eberhard, Mark Tarpenning,
Tom Huber of NuvoMedia, Inc.
Photography: Dallas R. Grove, Rocket e-Book Design
Development

PAGE 108
DESIGN FIRM: Philips Design
ADDRESS: Building HWD, P.O. Box 218
Eindhoven, 5600 MD, Netherlands
+31-40-27-59-066
annemieke. Froger@philips.com
PRODUCT: NewVision TV
CLIENT: Philips
ADDITIONAL CREDITS
Design Team: Rod White, Raymond Wong

PAGE 112
DESIGN FIRM: Thomson Consumer Electronics
ADDRESS: 10330 North Meridian Street
Indianapolis, IN 46290
317-537-3232
frostc@tce.com
PRODUCT: ANT-500 Digital Antenna
CLIENT: Thomson Consumer Electronics
ADDITIONAL CREDITS
Design Team: Christopher Frost, Steve Schultz

PAGE 116
DESIGN FIRM: Motorola, Inc.
ADDRESS: 8000 West Sunrise Blvd.
Fort Lauderdale, FL 33322
954-723-5063
esr003@email.mot.com
PRODUCT: Motorola i1000™ Wireless Communicator
CLIENT: Motorola, Inc.
ADDITIONAL CREDITS
Designer: Scott Richards
Photography: Jon Mazey

PAGE 120
DESIGN FIRM: Ashcraft Design
ADDRESS: 11832 W. Pico Blvd., Los Angeles, CA 90064
310-479-8330 (phone)
310-473-7051 (fax)
info@ashcraftdesign.com
PRODUCT: Infinity Prelude MTS Loudspeaker
CLIENT: Infinity
ADDRESS: 250 Crossways Park Dr., Woodbury, NY 11797
516-496-3400
www.infinitysystems.com
ADDITIONAL CREDITS
Design Team: Daniel Ashcraft, Trung Phung, Reiko Abo,
David Wathen, Deanna Griffith

PAGE 124
DESIGN FIRM: RKS Design, Inc.
ADDRESS: 350 Conejo Ridge Ave.,
Thousand Oaks, CA 91361
805-370-1200 (phone)
805-370-1201 (fax)
PRODUCT: Benwin Executive Speakers
CLIENT: Kquest/Benwin
ADDITIONAL CREDITS
Design Team: Ravi K. Sawhney, Hiro Teranishi,
Cary R. Chow, Lance Hussey, Christopher Glupker

PAGE 128
DESIGN FIRM: Cesaroni Design Associates
ADDRESS: 1865 Grove Street, Glenview, IL 60025
847-724-8840
www.cesaroni.com
PRODUCT: KSM32 Studio Microphone
CLIENT: Shure Brothers, Inc.
ADDRESS: 222 Hartrey Avenue, Evanston, IL 60202-3696
847-866-2415
meuniergeorge@shure.com
ADDITIONAL CREDITS
Design Teams: Curt Cruver of Cesaroni Design;
Ken Kochman, Sean Sweeney of Shure Brothers, Inc.
Photography: Shure Brothers, Inc.

PAGE 132
DESIGN FIRM: Altitude, Inc.
ADDRESS: 363 Highland Ave., Somerville, MA 02144
617-623-7600
brianmatt@altitudeinc.com
PRODUCT: DeWalt Worksite Radio/Charger
CLIENT: Black & Decker Corporation
ADDRESS: 701-East Joppa Road, Towson, MD 21286
410-847-6559
scott.evans@bdk.com
ADDITIONAL CREDITS
Design Teams: Brian Matt, Daniel Cuffaro, Charles Sears
of Altitude, Inc.; Donald Zurwelle, Martin Gierke of
Black & Decker
Photography: Eric Khulin

PAGE 136
DESIGN FIRM: Yamaha Corporation of America and Japan
ADDRESS: 10-1 Nakazawa-cho,
Hamamatsu 4308650, Japan
+81-53-460-2883
www.yamaha.co.jp
PRODUCT: Yamaha Compact Silent Electric Cello-SVC 200
CLIENT: Yamaha Corporation of America and Japan
ADDITIONAL CREDITS
Design Team: Masahiro Ikuna, Shinya Tamara

PAGE 140
DESIGN FIRM: Hauser, Inc.
ADDRESS: Stephen Hauser, 880 Hampshire Road,
Westlake Village, CA 91360
805-497-5810 (phone)
805-497-5820 (fax)
PRODUCT: NEC Z1 Personal Computer
CLIENT: Packard Bell NEC
ADDRESS: 1 Packard Bell Way, Sacramento, CA 95828
916-388-0101
www.packardbell.com

ADDITIONAL CREDITS
Design Team: Peter Wyatt-Brandenburg, Kevin Clay,
Stan Wada, Rebecca Kelley, Kevin Nguyen, Oliver Duncan,
Colin Greenidge, V.J. Nalwad, John Hoppe, Matias Ocana,
Jose Oleas, Lance Chikasawa

PAGE 144
DESIGN FIRM: Product Insight, Inc.
ADDRESS: One Post Office Square, Acton, MA 01720
978-264-4450
www.productinsight.com
PRODUCT: SmartGlas Flat Panel Display System
CLIENT: PixelVision, Inc.
ADDRESS: 43 Nagog Park, Acton, MA 01720

ADDITIONAL CREDITS
Design Teams: Bryan Hoteling, John MacNeill,
Jon Rossman of Product Insight; Stuart Morgan,
Arthur J. Flagg III of PixelVision
All images: Product Insight, Inc.

PAGE 148
DESIGN FIRM: Pentagram Design, Inc.
ADDRESS: 387 Tehama St., San Francisco, CA 94103
415-896-0499
PRODUCT: Stowaway Portable Keyboard
CLIENT: Think Outside

ADDITIONAL CREDITS
Design Teams: Robert Brunner, Benjamin Chia of Penta-
gram; Sung Kim, Peter Cazlet of Function Engineering;
John Tang of Think Outside

PAGE 152
DESIGN FIRM: Microsoft, Inc.
ADDRESS: One Microsoft Way, Redmond, WA 98052
425-936-9408
www.microsoft.com
PRODUCT: IntelliMouse Explorer
CLIENT: Microsoft, Inc.

ADDITIONAL CREDITS
Design Team: Steven Fisher, Carl Ledbetter,
Jonathan Hayes, Hugh Mcloone, Karen Baker, Ken Fry

PAGE 156
DESIGN FIRM: Speck Product Design
ADDRESS: 227 Forest Avenue, Palo Alto, CA 94301
650-462-9095
www.speckdesign.com
PRODUCT: Bandit™
CLIENT: Speck Product Design

ADDITIONAL CREDITS
Design team: Josh Ferguson, Craig Janik, Matt Rohrbach

PAGE 160
DESIGN FIRM: Design Edge
ADDRESS: 316 North Lamar Boulevard, Austin, TX 78703
512-477-5491
www.designedge.com
PRODUCT: "C" Shell Compact Disc Holder
CLIENT: Bobinvention

ADDITIONAL CREDITS
Designers: Daniel Tagtow, Pearce Jones of Design Edge;
Bob Lakoski of BobInvention

PAGE 164
DESIGN FIRM: Compaq Computer Corporation
ADDRESS: 20555 SH 249, Houston, TX 77070-2698
281-514-5191
www.compaq.com
PRODUCT: Hot Plug SCA Hard-Drive Tray
CLIENT: Compaq Computer Corporation

ADDITIONAL CREDITS
Design Team: Keith Kuehn, Peter Barron

PAGE 166
DESIGN FIRM: Symbol Technologies, Inc.
ADDRESS: One Symbol Plaza, MS B-18,
Holtsville, NY 11742
631-738-2400
arh@symbol.com
PRODUCT: CS2000
CLIENT: Symbol Technologies, Inc.

ADDITIONAL CREDITS
Design Teams: Meg Hetfield, Greg Jones of Symbol
Technologies, Inc.; Mirzat Koc of MachineArt Design
Team; Curt Croley of Kaleidoscope
Photography: Bill Albrecht Photography

PAGE 170
DESIGN FIRM: Fitch
ADDRESS: 10350 Olentangy River Rd.,
Worthington, OH 43085
614-841-2122
clare_ross@fitch.com
PRODUCT: Virtual Ink mimio™
CLIENT: Virtual Ink Corporation

ADDITIONAL CREDITS
Design Teams: Richard Watson, Dave Oliver,
Jason Short, Alexander Mueller, Bill Hartman,
Bob Hayes, Dave Cyphert of Fitch; Mike Mahota
of GE/Fitch; Greg McHale, Yonald Chery, Bob Hoefer
of Virtual Ink
Photography: Mark Steele

PAGE 174
DESIGN FIRM: Herbst Lazar Bell, Inc.
ADDRESS: 61 Hickory Drive, Waltham, MA 02154-1196
781-890-5911
ckeane@hlb.com
PRODUCT: Eclipse Gasoline Dispenser
CLIENT: Marconi Commerce Systems

ADDITIONAL CREDITS
Design Team: Charles Keane, Cheryl Felix Flender,
Ward Fritz

PAGE 178
DESIGN FIRM: Ingersoll-Rand
ADDRESS: 1467 Rte. 31 South, Annandale, NJ 08801-0970
908-238-7148
scott_price@ingerrand.com
PRODUCT: IR2080 Fleet Air Impact Wrench
CLIENT: Ingersoll-Rand

ADDITIONAL CREDITS
Design Team and Image Credits: Scott Price,
Mike Loomis, Pat Livingston

PAGE 182
DESIGN FIRMS: Crown Equipment Corporation,
Design Central, Ergonomic Systems Design, Inc.
ADDRESS: Crown Equipment Corporation,
14 West Monroe Street, New Bremen, OH 45869
419-629-2311
www.crown.com
PRODUCT: SC4000 Series Sit-Down Counterbalanced
Electric Lift Truck
CLIENT: Crown Equipment Corporation

ADDITIONAL CREDITS
Design Teams: Baron Brandt, Doug Goodner,
Mike Hemry, Jeff Burger, Jim Kraimer, Don Brown,
Rainer Teufel of Design Central; Steve Casey of
Ergonomic Systems Design, Inc.

PAGE 186
DESIGN FIRM: Designology, Inc.
ADDRESS: 7641 E. Gray Road, Scottsdale, AZ 85260
408-443-3227 (phone)
480-443-3254 (fax)
inquire@designology.com
PRODUCT: HiSonic Head Gear
CLIENT: Hearing Innovations, Inc.
ADDRESS: 9040 S. Rita Road, Suite 2250,
Tucson, AZ 85747
520-663-0544
www.hearinginnovations.com

ADDITIONAL CREDITS
Design Teams: Roy Fischer, Randall Toltzman,
Randsom Brown-IDSA, of Designology, Inc.;
Art Przybyl of Hearing Innovations, Inc.

PAGE 190
DESIGN FIRM: GE Medical Systems
ADDRESS: 3000 North Grandview Boulevard, W-651,
Waukesha, WI 53188
262-544-3354
lawrence.murphy@med.ge.com
PRODUCT: SIGNA OpenSpeed MRI
CLIENT: GE Medical Systems

ADDITIONAL CREDITS
Design team: Lawrence Murphy, Douglas Dietz,
Osamu Furuta, Seth Banks, Lawrence Fenske

PAGE 194
DESIGN FIRM: Product Genesis
ADDRESS: 245 Bent St., Cambridge, MA 02141
617-234-0070 (phone)
617-354-8304 (fax)
www.productgenesis.com
PRODUCT: NeuroMetrix NC-stat™
CLIENT: NeuroMetrix, Inc.
ADDRESS: One Memorial Dr., Cambridge, MA 02142
617-225-7774
www.neurometrix.com

ADDITIONAL CREDITS
Design Teams: Pierre-Yves Dubois, Steve Meister
of Product Genesis; Shai Gozani of NeuroMetrix, Inc.

PAGE 198
DESIGN FIRM: Coleman Product Design, Inc.
ADDRESS: 433 Belmart Avenue F, Suite 209,
Seattle, WA 98102
206-320-0604
www.colemanproductdesign.com
PRODUCT: Mixing Station and Syringe Components
CLIENT: Immunex Corporation

ADDITIONAL CREDITS
Designer: Will Zolentrou

PAGE 202
DESIGN FIRM: BD Medical Systems
ADDRESS: 9450 South State Street, Sandy, UT 84121
801-565-2300
PRODUCT: The BD Intima II Catheter
CLIENT: BD Medical Systems

ADDITIONAL CREDITS
Photography: Derek Smith